1996

ART IN CONTEXT

FOURTH EDITION

ART IN CONTEXT

FOURTH EDITION

JACK A. HOBBS

Illinois State University

HBJ

Harcourt Brace Jovanovich, Publishers

San Diego New York Chicago Austin Washington, D.C.
London Sydney Tokyo Toronto

Cover Credit: Claes Oldenburg and Coosje Van Bruggen, *Spoonbridge and Cherry,* 1987–88. Stainless steel and painted aluminum. Photograph courtesy of the Greater Minneapolis Convention and Visitors Association.

ISBN: 0-15-503472-3
Library of Congress Catalog Card Number: 90-80975
Printed in the United States of America.

To *the memory of*
EDGAR,
CYNTHIA,
and
ETHEL HOBBS

Preface

In this fourth edition, the size of the book, the number of pictures, and the amount of color have increased considerably, while the basic approach of *Art in Context* remains unchanged. The three part division (Perceptual Context, Human Context, and Historical Context) introduced in the first edition remains the same. Also continued are the chronology and glossary that were introduced in the third edition. Most importantly, the original idea of treating art *in context*, has not changed. In the first edition such an approach was novel. Today, the importance of interpreting art as part and parcel of its cultural-historical setting is widely recognized. The word "context" is used increasingly in contemporary critical vocabulary.

There are important changes in this edition: Part One has gone from four chapters to six. The discussion of the visual elements (Chapter 2) was enlarged to such a degree that the principles of design had to be moved to Chapter 3, where they are joined by a new discussion on art criticism. The additions of film, video, computer art, and crafts required two chapters (4 and 5) on art media instead of one. In Part Two, there is a new chapter about religious imagery (Chapter 9). The other three chapters in Part Two have been much enriched by additional examples and text. In Part Three, a new chapter (Chapter 11) overviewing art from the Renaissance to Modernism, together with a discussion of stylistic change, has been added.

As in the previous editions, each of the three parts deals with a basic context of art. Part One, Perceptual Context, examines the influence of artists' and viewers' cultural backgrounds on what they see. Part Two, Human Context, is organized around major themes of art. It demonstrates the reciprocal relationship between art and life by analyzing, for example, why artists of different cultures and times depict nature in markedly different ways. Finally, Part Three, Historical Context, examines the process of change in art, along with examining some historical developments. Chapter 14, The Late Twentieth Century, has been updated to bring the student to the brink of the twenty-first century.

Organization according to topics and themes of art permits a freer treatment than does the traditional historical approach. Works from different periods, places, and media are compared and contrasted in ways that provide readers with a vivid sense of the purposes of art. Accordingly, wherever feasible, works have been selected that serve not only to illustrate a particular point but to offer striking juxtapositions, encouraging students to experience the excitement of making their own discoveries and connections and drawing their own conclusions.

Once again I thank the professors and doctoral students at Illinois State University whose advice I sought while writing previous editions, and whose ideas are preserved in this fourth edition. I especially thank Jayne Craig, doctoral student, who provided ideas for the new section on crafts; Richard Finch, Associate Professor of Art, who advised me on the media of drawing and printmaking; Barry Moore, Professor of Art, who provided resources for the new section on computer art; Ronald Mottram, Professor of Theatre, who read the new sections on film and video; and Jerry Stone, McFee Professor of Religion at Illinois Wesleyan University, who gave generously of his time in examining several drafts of the new chapter on religious imagery. I also wish to recognize Berkley W. Chappell, Oregon State University; Frederick Evers, Northeastern Illinois University; Marion Jackson, University of Michigan; Barry Krammes, Biola University; David Pactor, Broward Community College; Jim Rodea, University of San Diego; Jerry A. Schefcik, University of Nevada, Las Vegas; and William Squires, University of Georgia.

I thank Debbie Hardin, my house editor at Harcourt Brace Jovanovich, for her moral support, as well as her expertise during the editing process. I also thank Socorro P. González, production editor; Don Fujimoto, designer; Cindy Robinson, art editor; and Mary Kay Yearin, production manager for their efforts during production. Finally, I thank Julia Berrisford, for her patient help and advice during the initial stages of the project.

Contents

ART IN CONTEXT

FOURTH EDITION

PART ONE — Perceptual Context

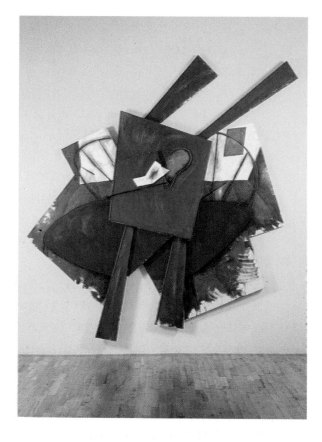

What we see depends in large part on *how* we see. Our perception of an ordinary object, a hamburger, for example, is affected not only by the visual data of its shape and color but also by our knowledge of hamburgers—which includes such things as their taste, smell, feel, and ability to satisfy hunger. ¶What we see in a work of art also depends on a combination of visual information and past experience. The ability to perceive images in the lines and shapes that artists put on a piece of paper or canvas is not automatic. We need practice and experience simply to interpret the kinds of pictures that are widely familiar in our own society. ¶The aesthetic horizons of today are broader than those of the past. Art museums and art books show art not only from our own society and our own time but from those of the past and those of other parts of the world. Furthermore, the artists around us are constantly developing new forms of art. The knowledge and perceptual habits we have developed for looking at art in the past may therefore be inadequate for the present. ¶Part One focuses on the perceptual context of the visual arts, beginning with Chapter 1 which deals with the relationships between art and culture. Chapter 2 reviews the visual elements—colors, shapes, lines, and so forth. Chapter 3 explains the strategies artists use to manipulate the elements in creating a work, and provides a method for critically examining those strategies. Chapters 4, 5, and 6 review the diverse materials and tech-

niques that artists and architects use to create their works—media that in today's world of art can range from charcoal to computers. ¶To understand art, one must first be aware of its perceptual context. Part One, thus, is foundational to Parts Two and Three.

CHAPTER 1

CONTEXT

NONVERBAL COMMUNICATION

WHEN WE SPEAK OF "language," we ordinarily think of a system of communicating with words and sounds. But language, taken in a larger sense, can mean any system of communicating. For example, one *nonverbal* language is the one that has been popularly dubbed "body language." We all use body language every day. Indeed, we use it almost every moment of every day, for we say few things that we do not accompany with a gesture or a change in facial expression—consciously or unconsciously—that says something, also. Very often we can figure out what people are talking about without even hearing their voices. Sometimes we can tell what they *really* mean even though what they say is just the opposite.

Most of the body-language signals people make are conventions that have developed within their particular culture or subculture. For example, the gesture that a Spaniard makes to indicate "come here" is almost the opposite of the same gesture that an American makes. Some Asians are likely to be expressing anger if their eyes open wider, whereas Occidentals usually express surprise that way. It might be more accurate to speak of body "languages," since they seem as numerous as spoken languages.

ART AS LANGUAGE

The visual arts are also nonverbal languages. We all know that paintings communicate, and that we are able to derive some information from them more effectively than we can from words. A great many words would be needed to describe a miracle performed by a saint or what the Rocky Mountains looked like in 1848

with the same degree of detail found in a painted image of such a subject. But few of us are aware of the fact that obtaining information from an image is not automatic—not even from the most realistic picture of a familiar subject. We have to be able to "read" a particular system of distortions that has been used to translate the original three-dimensional scene into a two-dimensional reproduction.

In some ways, learning a visual language is like learning a spoken language. For example, most Americans learn to read the language of cartoons and photographs in very much the same manner they learn English. Their parents explain the vocabulary and the grammar of comic strips by reading the text and translating the pictures for them ("The little boy is unhappy. See the tears?") and tell them what to look for and how to identify it in home snapshots ("This is your birthday party. See Grandma?"). Learning to read a photograph may not sound like much of a challenge, but in fact there are people who have never learned to do this. In *The Shape of Time,* art historian George Kubler describes an experience with a Peruvian shepherd who had never seen a photograph before.

> . . . when I produced a photograph of him . . . he was unable to orient the flat, spotty paper or to read it as a self-portrait, for want of those complicated habits of translation which the rest of us perform from two to three dimensions without effort.

The Peruvian shepherd, because of a lack of experience with these particular pictorial conventions, could not even identify his own image. But we who have grown up with photography and movies take these things so much for granted that it is hard for us to imagine anyone in the world not being able to grasp their meanings immediately. In order to understand this, let us turn the situation around and look at an image that is not familiar to the average American.

An Alaskan Mask

We would not say that this Alaskan Indian mask (Figure 1-1) has no meaning at all for us. We recognize the image of a face, which immediately generates associations. But how well do we actually understand it? Before going further, let us try to decide exactly what it is we see. The following description will be simple and objective—that is, limited to statements about the appearance of the mask that all of us could agree with.

To begin with, it is obviously not a realistic image of a face. So, we may say that it is a "stylized" face. Unlike most faces, which are symmetrical, this one is notably asymmetrical. Although the mask

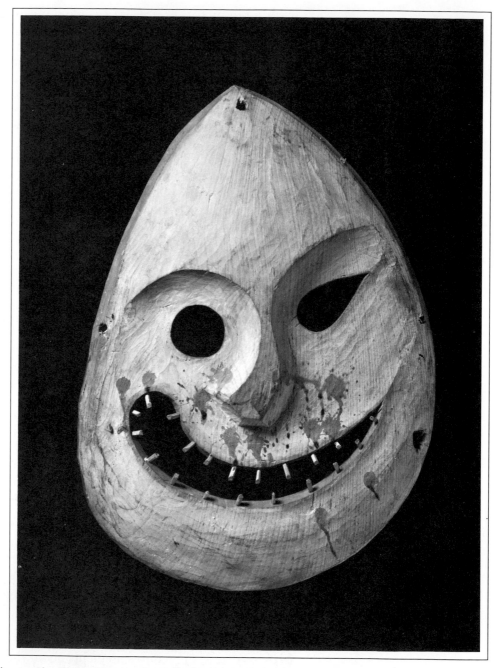

1-1 Eskimo mask, Alaska. Museum für Volkerkunde Staatliche Museen Preussischer Kulturberlitz, Berlin.

itself is mostly convex, the areas around the eyes are concave. One eye is circular, the other almond-shaped—reflecting the shape of the whole mask. A spiral movement starts along the left edge of the scroll-shaped nose, moves around the circular eye, and is carried by the mouth to the right side of the face. There it almost joins with the S-shaped line that forms the right eyebrow and the right edge of the nose. The surface of the mask reveals the marks of the carver's tool and a spattering of color around the mouth; otherwise, there is a lack of detail.

So much for a simple, objective description; arriving at a valid interpretation is much more difficult. Based on our experiences with images of faces in traditional, American art, we would read the upturned mouth as smiling or laughing. The almond-shaped eye, because it is narrower than the round eye, suggests winking. Beyond these observations, however, we are apt to become frustrated. The mask contains little information, and the unusual features raise more questions than they answer. For example, we are unaccustomed to such radical asymmetry in facial images. Why are the eyes different shapes? Why is the nose twisted and the mouth off to the side? Does the mask represent someone who has been frightened? Or does it represent a simple-minded person, or a person who is mad?

We soon become aware that our cultural background is inadequate for helping us to interpret the mask. Even when we were told that it represents a man-eating mountain demon with a blood-stained face, many things would remain unclear. We still would not know how those people regarded demons. Were all demons alike? Was this one to be feared or pitied? Did the Alaskan Indians represent both their benevolent and malevolent spirits with lopsided faces? Obviously there are many questions that need to be answered before we can begin to understand this particular artwork. We can enjoy looking at it, but we are not able to fully interpret it.

Peanuts

Americans looking at a comic strip of Charlie Brown and his dog Snoopy (Figure 1-2) can understand what is going on and relate it to their own experience, even though it is an improbable situation. If they had never seen the *Peanuts* comic strip before but were reasonably well-informed and three years old or older, they would still understand that this is a picture of a little boy and his pet dog. But if we look at Charlie Brown's face as closely as we did at the Alaskan mask, we will realize that it actually has less detail and is less realistic than the mask. Everything is expressed with extreme economy. When he speaks, Charlie Brown's mouth, like that of the

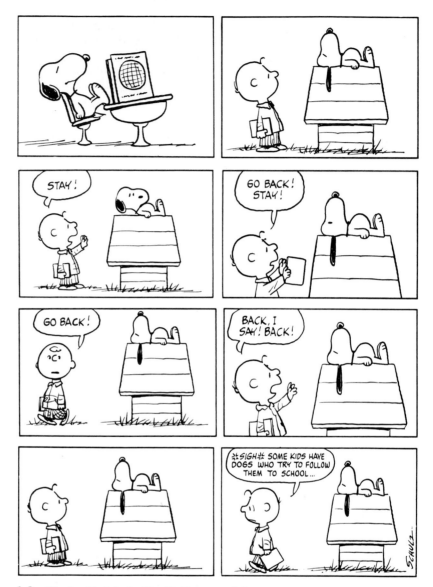

1-2 Charles M. Schulz, Charlie Brown and Snoopy.
© 1973 United Feature Syndicate, Inc. Reprinted by permission.

mask's, is a simple void. In the final frame, however, it is downturned, which we interpret as unhappiness. The eyes are no more than a pair of dots bounded by curved lines, but they help us to define his reaction. Charlie Brown's hair is an abstract scrawl above his eyes, and Snoopy's nose is a black dot stuck to the side of his face. But because we are so familiar with these conventions of drawing, we grasp their meaning at a glance.

There is more meaning in *Peanuts* than just the depictions of a boy and a dog. At times it reveals a great many things about the anxieties of growing up in suburban America, public schools, and peer relationships. In order to understand these themes in *Peanuts,* one has to have some familiarity with twentieth-century American culture. And it also helps if one is familiar with the ways in which these themes have been treated not only by cartoons but also by movies, television, and novels. People who lack this knowledge are at a disadvantage in understanding *Peanuts*—just as we are in understanding the image of a mountain demon when we know so little about Alaskan culture.

Picasso

People who are unfamiliar with the work of Pablo Picasso or who are unwilling to accept his personal artistic language often do not care for paintings like *First Steps* (Figure 1-3). They are apt to criticize such things as the stylized hands and feet, the lopsided faces and bodies, the simple eyes, and the abnormally foreshortened head of the mother. Oddly enough, these same people are rarely aware of the radical distortions of anatomy that are committed daily in *Peanuts* and other comic strips. However, the difference between the paintings by Picasso and the cartoon by Charles Schulz does not rest only on the fact that the latter uses more familiar conventions. A Picasso painting is not meant to be as easily understood as a frame of a Schulz cartoon.

Describing *First Steps* is a rather formidable task compared to that of describing the mask or the picture of Charlie Brown, so we will concentrate on only its more conspicuous aspects. The dominant feature in the painting is the child's face, especially the eyes, which are wide ellipses staring straight at us. Like the Alaskan mask, the shape of the head and the arrangement of facial features are asymmetrical. But unlike the mask, which is dominated by a single spiral direction, the face of the infant is made up of lines and shapes that come and go in many directions. The mother's face, which appears smaller than the child's, seems to be looking downward. Her head, neck, and body arch around the infant, while her elongated hand on the right side seems to be both prodding and supporting the child's hand. Although we recognize the forms of two different people, the many shapes and lines within the picture tend to confuse their separateness so that, in places, the bodies of the mother and child seem to merge. This merging effect can be seen at the top of the painting, where the arched lines of the mother's head, eyes, and breasts complement the lines in the child's head; at the right and left sides, where the stubbier lines of hands

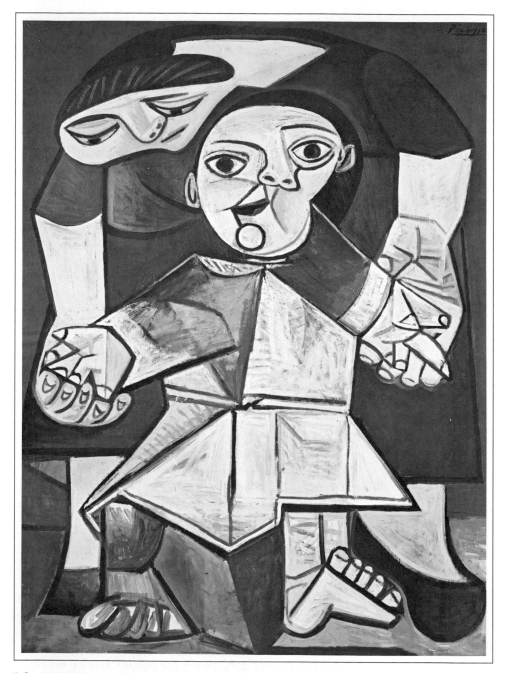

1-3 Pablo Picasso, *First Steps,* 1943. Oil on canvas, 51¼″ × 38¼″.
Yale University Art Gallery, New Haven, Connecticut
(gift of Stephen Carlton Clark).

interpenetrate; and at the bottom, where legs, feet, and ground are all warped in similar ways.

We can identify the subject of Picasso's painting because it is close enough to forms of representation that we already understand—in particular to the forms of comic strips. (This is largely because Picasso's art influenced artists who draw cartoons, not the other way around.) We can also appreciate some things about the way *First Steps* is presented because elements of it—the archlike protective shape of the mother, for example—are simple and direct enough for us to grasp. But some of us may encounter problems if we try to go beyond the subject matter and these few elements. Why, for instance, does the child's face look the way it does? Someone unfamiliar with art might rightly guess that there is some relationship between these distortions and those of children's paintings. But *First Steps* relates to many other kinds of art, including tribal masks, Picasso's early Cubist works, and even Christian Madonnas (Figure 1-4). The fact is that without some knowledge of

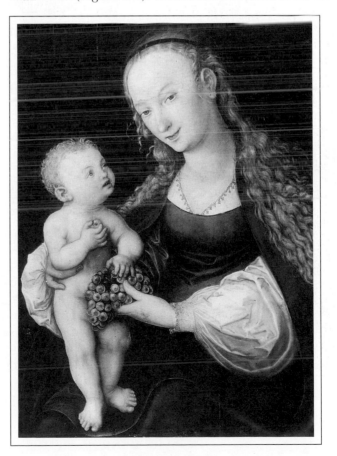

1-4 Lucas Cranach the Elder,
Madonna and Child, c. 1535.
Wood, 28″ × 20½″.
Budapest, Museum of Fine Arts.

the language of Western art and the themes that have been important in the past, we cannot appreciate the richness of this painting or grasp much of its meaning.

The meaning of Picasso's *First Steps* is more than the simple act that the title helps us discover in these shapes and colors—a mother helping with her child's first steps. To stop at this level of meaning is to seriously impoverish an exceptional work of art. First steps are, after all, a major moment in the life of any human being—"a moment of crisis in which eagerness, determination, insecurity, and triumph are mingled," as former director of the Museum of Modern Art Alfred Barr once wrote of this painting. Picasso used a particular artistic language to express this deeper meaning, and we can find it there if we know how to read his work. It is in the way the child's face is distorted, in the radiating lines of the child's clothing, the awkward balance of the small body, the protective domelike shape of the mother, and at least a dozen other details. All of these help to convey the emotions of this extraordinary moment.

ART AS ABSTRACT FORM

Meaning is not the only thing we can get from a work of art. We can also derive satisfaction from an appreciation of its *form:* its abstract colors, its lines and textures, and the ways in which these things are combined. For example, looking at the Alaskan mask we might spend less time trying to determine its meaning and more time considering such things as its unusual texture, the random spatters of color, and the relationship of the openings to its overall shape. Looking at the Picasso, we could spend an enjoyable time observing and appreciating its bold contrasts of light and dark, its complex patterns, and the solid construction of its composition. In fact, there are many who place an enormous value on responding to art in this way. And some art—especially certain kinds of twentieth-century abstract art—seems intended to be appreciated only in this way.

Most, however, believe that a full appreciation of an artwork, even a very abstract one, involves not only responding to its form but also seeking its meaning—the unique way in which it contributes to our understanding of the world. To accomplish this degree of appreciation and to derive the most from art requires knowledge, patience, and—most importantly—an open mind.

SOME BASIC TERMINOLOGY

The terms *medium, subject matter, form,* and *content* refer to different aspects of a work of art and constitute a systematic way of thinking about it.

Medium refers to the materials and methods employed in creating a work. The medium of the mask is carved wood, that of the comic strip is pen and ink on paper, and that of *First Steps* is oil paints applied to canvas. Medium and media (plural) also refer to general categories of art such as *popular art, sculpture,* and *painting.*

Subject (subject matter) refers to people, objects, or places represented in a work: the face in the mask; the boy, dog, and doghouse in the comic strip; the woman and child in the painting. Like *medium, subject* can also refer to general categories (themes) such as *childhood* or *religion.*

Form, as defined earlier, refers to the lines, colors, and textures, and how these are combined in a work.

Content refers to the meaning of a work. Meaning, as we learn from the examples in this chapter, is based on a response to a combination of medium, subject, and form.

SUMMARY

When confronting an artwork, one does not ordinarily stop to consider it as a language and then as an abstract form, or deal with each of the aspects one by one. The natural thing to do is to respond to it as a whole. Indeed some critics insist that to do otherwise—to "dissect" a work in terms of the various approaches discussed thus far—does more harm than good.

The most important benefit of art may be its capacity for capturing our undivided attention, a kind of intense involvement often described as the *aesthetic experience.* However, this does not mean we should not pause to reflect, to take stock of what we see as well as our reactions to it. To do so in an honest and systematic way helps us not only to know more about art (and ourselves), but also to enjoy more fulfilling experiences in our future encounters with art.

CHAPTER 2

THE VISUAL ELEMENTS

A PAINTING LIKE Georges Seurat's *Bathing at Asnières* (Figure 2-1) is obviously—to us—a picture of boys gathered along a riverbank on a summer day. But let us imagine for a moment how it might appear to the Peruvian shepherd of Chapter 1. If he were to describe what *he* saw as precisely as he could, he might tell us that it is a flat, rectangular surface covered with patches of color.

Seurat himself would probably have described this painting in very much the same way. For the fact is that he was more concerned with arranging the *visual elements* of the painting—colors, shapes, lines, textures, and space—than he was with the recreation of a particular scene. Artists of any sort, whether they make paintings, design buildings, or weld scraps of iron into sculptures, are always basically concerned with the visual elements. This is true whether the work is intended to look like a group of swimmers on a riverbank or an abstract collection of shapes and colors.

By the same token, the viewer must understand something of the visual elements—the form of a work—in order to fully appreciate and enjoy a work of art. To be unaware of the ways that Seurat meticulously organized the visual elements in *Bathing at Asnières* is to miss a great deal of what the painting has to offer. In the following pages, therefore, we will examine these elements in some detail and try to establish a fairly precise and useful set of definitions for them.

COLOR

The problems of defining the elements of art begin almost with the first sentence one writes. So many writers on art have approached the visual elements in so many different ways that there is often great disagreement over exactly what the elements are and how

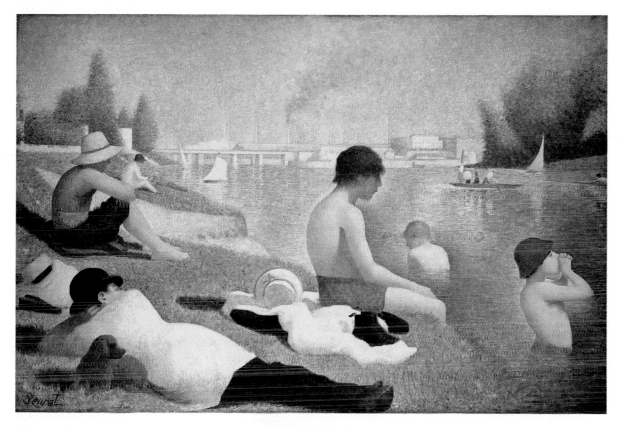

2-1 Georges Seurat, *Bathing at Asnières*, 1883–84. Oil on canvas, 6′ 7″ × 9′ 11″.
Reproduced by courtesy of the Trustees, The National Gallery, London.

they should be dealt with. For example, design books tend to treat
light and dark as a separate element. In art appreciation books, how-
ever, it is often used to refer to one property of color.

If we accept the idea of black, white, and gray as being part of
color, then we may say that color is basic to the other visual ele-
ments. It is through variations of color that we distinguish shapes,
lines, textures, and space.

In order to understand the role of color in art and vision, we
must analyze it in terms of three basic properties: *hue, value,* and
saturation. Although all three are continually and inseparably pres-
ent in normal vision, they can be separated in theory and isolated
for purposes of analysis.

Hue

Isaac Newton demonstrated that when a beam of light passes
through a prism it divides into seven colors (Figure 2-2). Sometimes
called the *spectrum* colors, each of the seven colors represents a

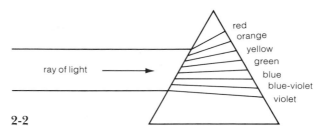

2-2

different ray of light. For reasons still not fully understood, only the rays of the spectrum—which comprise just a fraction of the total number of light rays—are visible to the human eye.

Hue refers to the qualities of these mysterious rays that enable us to distinguish one color from the other. A particular hue can be determined with great precision by measuring the wave frequency of a ray with scientific instruments, but for everyday purposes this is certainly not necessary. The words for color that everyone learns in childhood are quite sufficient for communicating to other people what we mean. The words yellow, red, blue, green, purple, and orange are rarely confused by English speakers with normal vision.

Three of these hues—yellow, red and blue—are called *primary colors* because they can be combined to create any of the others, except black or white. (Technically, the three primaries are *yellow, magenta*—a slightly purplish red—and *cyan*, a turquoise blue.) Yellow combined with red produces orange, yellow combined with blue produces green, and red combined with blue produces purple. The three new colors—green, purple, and orange—are called *secondary colors*. These relationships can be illustrated with the use of a *color wheel*—or color circle as it was called by Newton, the man who originally designed it—a circular chart on which each secondary color is placed between the two primary colors of which it is composed (Figure 2-3). Most color charts also include *tertiary colors*, those that lie between the primaries and secondaries and are created by making unequal mixtures of any two of the primaries; many variations are possible. The names of these colors are somewhat arbitrary and often exotic—such as cerulean, aqua, and peacock, to name but a few of those that lie between blue and green. Finally, combining all three primaries (or a primary with the secondary color opposite it on the color wheel) produces dull versions of the hues, or browns and grays.

Hues that are situated alongside one another on the color wheel are called *analogous* colors. Hues directly opposite each other are called *complementary* colors. In addition to being opposite each other on the color wheel, complementaries are opposite in hue. For example, blue has nothing in common with its complement orange, which is composed of red and yellow. Seurat took advantage of this

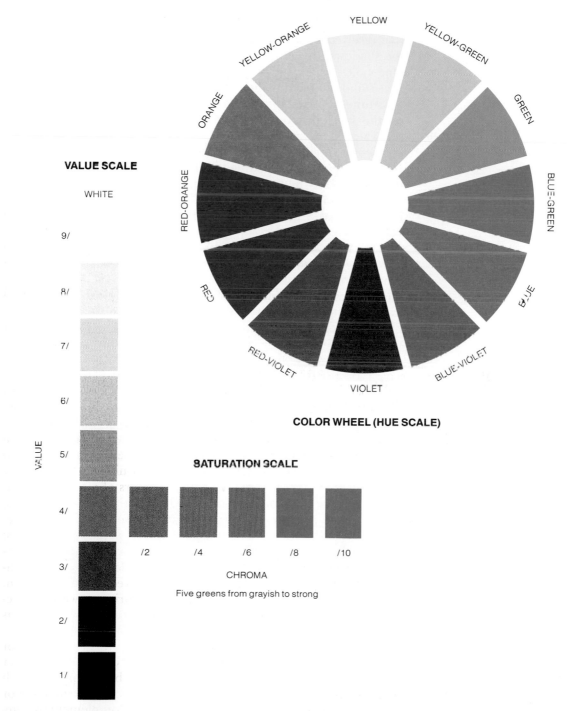

VALUE SCALE

WHITE

9/

8/

7/

6/

5/

VALUE

4/

3/

2/

1/

BLACK

COLOR WHEEL (HUE SCALE)

SATURATION SCALE

/2 /4 /6 /8 /10

CHROMA

Five greens from grayish to strong

opposition in *Bathing at Asnières*. He painted many of the surfaces that received the direct light of the sun in variations of orange and the shadows in variations of the complement of orange—blue or blue-violet. Seurat further employed complementaries to make figures stand out from the background—a juxtaposition of opposites sometimes referred to as *hue contrast*. The orange cap of the bather on the far right contrasts sharply with the background blue of the water.

Seurat often used an unusual method for producing different color effects. Rather than blending hues before applying them to the canvas, he would apply them unmixed in separate little strokes, allowing them to blend in the viewer's vision—provided the viewer is standing at a normal distance from the canvas. This effect is known as *optical mixing*, and it is the opposite of hue contrast (in which relatively large areas of color are made to appear more separate). We can see the principle at work in the blue-green of the water, which Seurat painted by daubing several hues—mostly blues, greens, and whites—directly on the canvas rather than physically mixing them beforehand. (The same principle was later applied to color printing, with only the three primaries and black ink used to recreate even as complex a subject as this painting.)

Value

The range of light and dark in color is called *value* (see value scale, Figure 2-3). Had Seurat chosen to paint *Bathing at Asnières* with just a single hue—say, red (Figure 2-4)—we would still be able to distinguish the riverbank and the boys and the water because of the

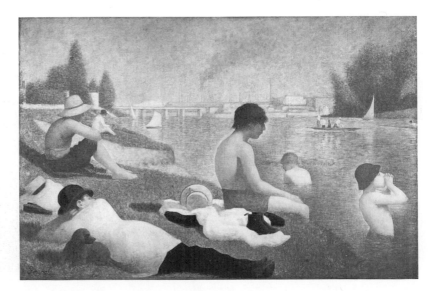

2-4 Georges Seurat, *Bathing at Asnières*. An example of an all-red painting.

different values of red. We could easily make out the shapes of figures and details on the basis of their differences in light and dark, for we could read the all-red visual field essentially the same way that we would read a black-and-white photograph.

The range of light and dark we experience in everyday vision is much more relative than we often realize. We tend to think that a white sheet of paper is always the same white, whether it is in bright light or shadow. This effect is referred to as *color constancy*. Normally, we see the color of an egg as a uniform off-white over all of its curved surface (Figure 2-5). Yet, if we look at the image in this photograph as a pattern of lights and darks, we can easily see a great difference in color—specifically the values of the color—between the top and bottom of the egg. Color constancy, then, points up one of the discrepancies between optical data and the mind's interpretation of those data in the everyday business of viewing our world.

Artists, aware of the factor of color constancy, use different values to make an image of something appear three-dimensional. The method for picturing the effect of reflected light as it plays across a surface—whether the surface is that of an egg or a human body—was developed several centuries before the time of Seurat. Called *chiaroscuro*, from the combined Italian words for light and dark, the method of shading is admirably demonstrated in a study of the boy wearing a straw hat that Seurat drew in preparation for his painting (Figure 2-6). Using broad strokes of crayon on rough-grained paper, the artist skillfully manipulated light and dark values to suggest the volumes of the boy's body and clothing.

Like hue contrasts, *value contrasts* were used in *Bathing at Asnières* to help set off the figures from their surroundings. We can see the adjustments of color in the river where it forms the back-

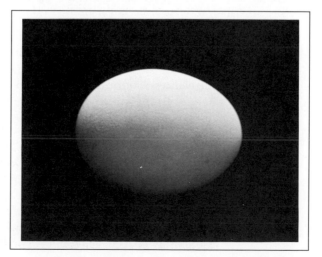

2-5 Example of color constancy.

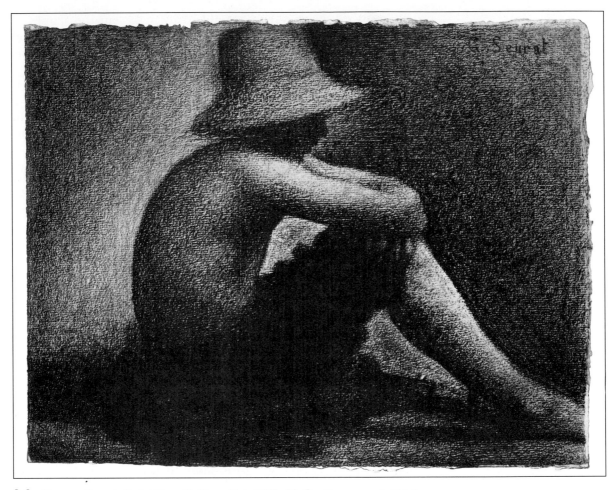

2-6 Georges Seurat, *Seated Boy with Straw Hat*, 1883–84. Conté crayon on paper, 9½″ × 11⅞″. Yale University Art Gallery (Everett V. Meeks Fund).

ground of the central figure. The values of blue touching the shaded parts of the boy—his face, neck, and back—are lighter; those touching the sunlit portions are darker. The artist also adjusted the values around the figures in the water. By so doing, Seurat helped to make these figures stand out from their surroundings.

As is the case with hue, values are subject to optical mixing. Side-by-side black and white lines or brushwork can appear to be shades of gray. In the woodcut *The Four Horsemen of the Apocalypse* (Figure 2-7) we see a masterful use of chiaroscuro: The sixteenth-century German artist Albrecht Dürer used only black ink and the white of the paper, yet the work appears to have a wide range of *middle values,* or grays. If we look carefully, we can see that any of these middle values is actually the result of optical mixing caused by the closely spaced black lines.

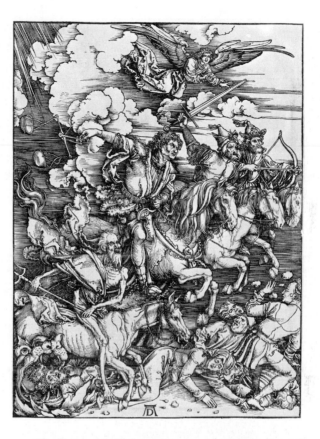

2-7 Albrecht Dürer, *The Riders on the Four Horses from the Apocalypse,* c. 1496. Woodcut, 15¼″ × 11″. Metropolitan Museum of Art, New York (gift of Junius S. Morgan, 1919).

Similar to optical mixing is an effect referred to as the *assimilation effect,* in which a pattern of small units of one color superimposed over a different background color seems to cause the color underneath to shift its value and hue somewhat toward that of the pattern. The red of the background in *All Things Do Live in the Three* (Figure 2-8) is actually the same throughout, but it appears to be two or three different reds forming subtle but clearly distinguishable diamond-shaped patterns across the canvas. Artist Richard Anuskiewicz accomplished this illusion by overlaying the red with a system of uniform dots of blue-green, green, and yellow-green.

Saturation

Saturation refers to the relative purity of a color on a scale from bright to dull (see saturation scale, Figure 2-3). Most paints have intense colors to start with; thus an artist who desires a strong blue uses the paint straight from the tube. A less intense, or "muted," blue can be made by mixing blue with brown or with its complement, orange. Some colors are so muted—such as black, white, gray, and most browns—that they are sometimes called *neutrals.*

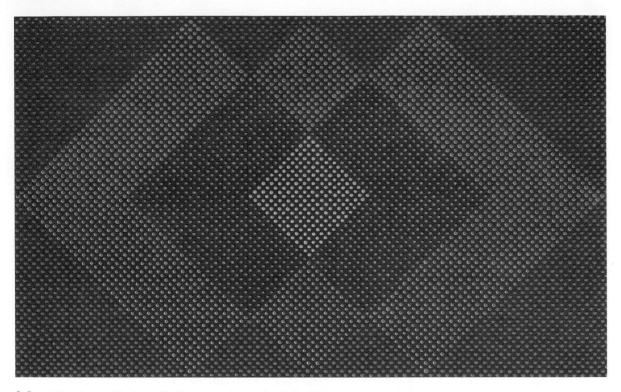

2-8 Richard Anuskiewicz, *All Things Do Live In the Three*, 1963.
Acrylic on masonite, 21⅞″ × 35⅞″. Collection Mrs. Robert M. Benjamin, New York.
© Richard Anuskiewicz, 1980.

Typically, most colors in a painting are intermixed and, as a result, tend to be varieties of muted hues, such as "olive green," "brick red," "burnt orange," and "goldenrod yellow." Seurat, however, did not always mix his pigments; he preferred to use bright colors applied in individual strokes. In Figure 2-1, the river, in addition to blues and blue-greens, contains dots of orange that, had they been mixed with the other paint, would have produced a dull, grayish blue. Instead, the orange interacts in our vision without sacrificing the intensity of either. We see a vibration of color, an appropriate equivalent of sparkling water.

Expressive Use of Color

According to some studies color can, given the right conditions, raise or lower a person's blood pressure, calm disturbed children, or even affect people's perception of room temperature.[1] These

[1] Birren, Faber, *Principles of Color.* New York: Van Nos Reinhold, 1969

are just some of the alleged powers of color. Artists and designers—whether or not they are aware of the research (or folklore)—are certainly aware that, of all the elements, color seems to have the most impact on people's feelings. However, most artists are more interested in color's expressive and aesthetic effects than its alleged psychological effects.

People probably do not respond in a particular way to a particular color without additional stimuli. Yet, if given a list of colors to match with a list of descriptive adjectives, there would probably be a high level of agreement. For example, if asked to identify a "cheerful" color, most would probably choose yellow rather than blue, a bright color rather than a dull one, or a light value rather than a dark one (or the reverse if one had to match the same colors with "sad"). Hues are often identified with thermal qualities—"warm" and "cool." Reds, yellows, and oranges are considered warm; blues, greens, and violets are considered cool. Correspondingly, warm colors tend to be stimulating and cool colors tend to be relaxing. As warm colors are more "extroverted," they receive more attention, and therefore tend to advance while cool colors recede. Thinking of color this way no doubt relates to our existential associations with such things as fire or blood on the one hand, and sky and water on the other. There may also be a physiological basis; the light rays of warm colors have longer wavelengths than cool colors, and we might respond to this difference physically.

Colors rarely appear in isolation—in artworks or otherwise. Therefore, it is more important to appreciate their effects in combination with one another. The ways of combining colors are virtually infinite, which means that the imaginative artist or designer has infinite possibilities at his or her disposal. But there are a number of classic combinations—often called color *harmonies*—that an artist or designer may consider. A few of these are reviewed below.

A *complementary* combination provides maximum contrast because it consists of opposite hues. Recall that Seurat used this combination to make the boy (his cap and his shorts) stand out from the background water (Figure 2-1). In other contexts complements are so opposite they tend to clash, unless one of them is muted. For example, red and green might not look good paired, but bright red paired with olive green, or bright green paired with brick red would be more acceptable. Some artists prefer a *split complementary* combination, in which one hue is combined with hues on either side of its complement (Figure 2-9). Anuskiewicz's *All Things Do Live in the Three* (Figure 2-8), in which red is pitted against blue-green, green, and yellow-green, is an example of such a combination.

A *triad* combination consists of equidistant hues on the color wheel such as the primaries, the secondaries, or the tertiaries. Due

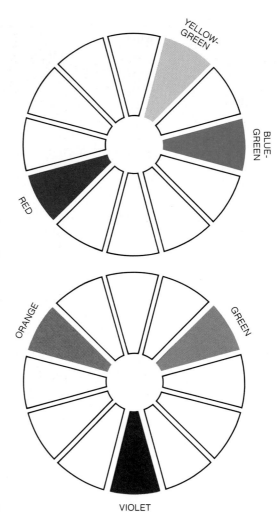

2-9　A Split Complementary Combination

2-10　A Triad Combination

to their mutual differences, primary colors would tend to be less compatible than secondary colors (Figure 2-10) in such a combination. Perhaps André Derain had this in mind as he used variations of primarily orange, violet-blue, and green in his painting *London Bridge* (Figure 2-11). Although bright, the colors in this work are agreeable.

Unlike the hues in complementary or triad combinations, those in an *analogous* combination (adjacent hues, such as blue and blue-green) have strong family resemblances (Figure 2-12). Although compatible, they differ enough to provide interest. If necessary, contrast can be strengthened by varying their values. The richness of Claude Monet's *Palazzo da Mula, Venice* (Figure 2-13) is due to

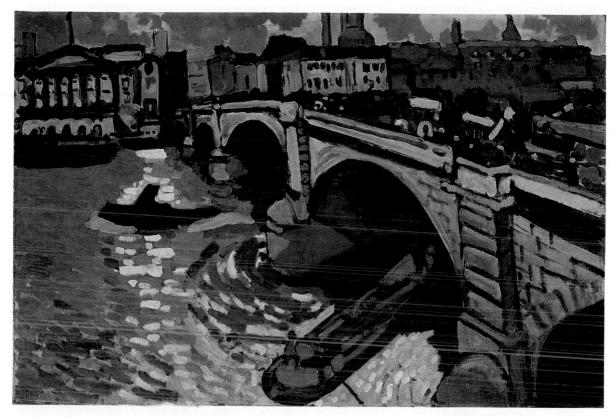

2-11 André Derain *London Bridge*,
1906. Oil on canvas, 26″ × 39″.
Collection, The Museum of Modern Art,
New York (gift of Mr. and Mrs. Charles
Zadok).

This painting illustrates the use of a triad
combination.

2-12 An Analogous Combination

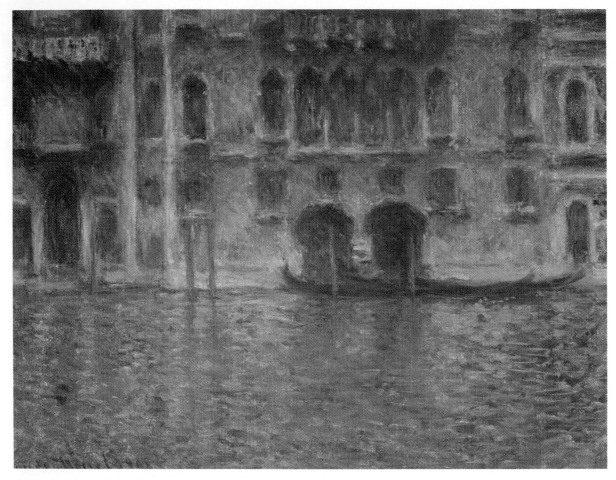

2-13 Claude Monet *Palazzo da Mula, Venice,* 1908. Canvas, 24½ × 32″. National Gallery of Art, Washington, D.C. (Chester Dale Collection).

This painting illustrates the use of analogous colors.

the artist's skillful use of analogous hues—from lilac to yellow-green, or, as director emeritus of the National Gallery in Washington John Walker describes them: "amethysts, turquoises, and emeralds."

A *monochromatic* combination consists of different values of a single hue (recall the example in Figure 2-4 in which Seurat's painting of bathers is presented in different values of red). Because they are based on one hue, the colors in a monochromatic combination have no trouble coexisting. However, the gain in compatibility is offset by a loss in interest. Clearly, the original version of the Seurat painting (Figure 2-1) is more exciting than its monochromatic version.

Colors in art (or life) are part of a context. For example, what we perceive as green in the Seurat painting is influenced by the fact

that we know green is the color of the grassy bank and the distant trees—and this is the only green in the picture. But if Seurat's green were placed beside a truly bright green, it might not appear particularly green at all. The choice of a color or combination of colors is related to many factors: subject matter, expressive needs, taste, and finally, the artist's intuition about what seems to work best.

SHAPE

It was pointed out earlier that technically we cannot perceive shapes or anything else without color. But we certainly can *conceive* of shapes independent of their color, and we tend to see ourselves and the objects we live with in terms of their characteristic shapes. Indeed, in our everyday commerce, shape may be more important than color.

Two-Dimensional Shapes

We live in a three-dimensional world, surrounded by space and filled with three-dimensional objects. But many of us—especially students and teachers—are deeply involved in a two-dimensional world of words, graphs, maps, symbols, and pictures printed on flat pages or projected on flat television or movie screens. The earliest races of humans may not have thought in two-dimensional terms at all. The earliest images that we know of occurred around 15,000 years ago when Ice Age artists painted animals on cave walls (the first written language occurred around 6,000 years ago). After that making marks on a flat surface—whether they functioned as images, symbols, or patterns—became one of the most common types of human communication.

In order to survey the nature of shape perception in two dimensions, it would be helpful to review two principles developed by Gestalt psychologists. The first of these, the *figure-ground principle,* has to do with our tendency to divide a visual pattern into two kinds of shapes—figure and ground. A figure appears to stand out, to be "on top of" a ground; a ground, on the other hand, appears to be underneath and surrounding a figure. For example, printed letters usually are figures while the white page is the ground. As a general rule, smaller and darker shapes are figures while larger and lighter ones are grounds. (Artists sometimes use the terms "positive shapes" and "negative shapes"; designers sometimes use the term "counter-change" for an alternating pattern of black and white.) Figures, however, do not have to have solid colors. The outlined

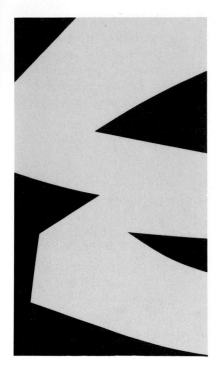

2-14 Ellsworth Kelly, *Untitled*, 1960. Oil on canvas, 86″ × 49″. Private collection. Courtesy Jason McCoy, Inc.

shapes of Charlie Brown and Snoopy (Figure 1-2) function as figures.

When we look at the world around us, we normally see objects and people as figures and their surroundings as the ground ("background," as we usually say). This habit of perception applies as well to the way we perceive Seurat's riverbank scene; indeed, realistic pictures like this can be likened to windows. But whether something is figure or ground can also depend on its circumstances and how we attend to it. The reclining man in Seurat's picture usually functions as a figure, but if we concentrate on just his ear, then he becomes the ground and the ear alone becomes the figure.

Although abstract paintings lack the familiar visual cues of realistic paintings, we tend to perceive their patterns as figure-ground relationships. However, these relationships may not always be so obvious or stable. At first view, one is likely to see the white shape—the single, unbroken form—of Ellsworth Kelly's painting (Figure 2-14) as the figure and the black shapes around it as the ground. In other words, it looks like a black canvas with a large white shape painted on it. Yet, with little effort, one can also see this painting in exactly the opposite way—a white canvas with four separate black shapes painted on it. This reversal of figure and ground—a flip-flop one can almost feel when changing from one way of looking at it to the other—is difficult to accomplish with more complex abstract works like *The City* (Figure 2-15) by Fernand Léger. However,

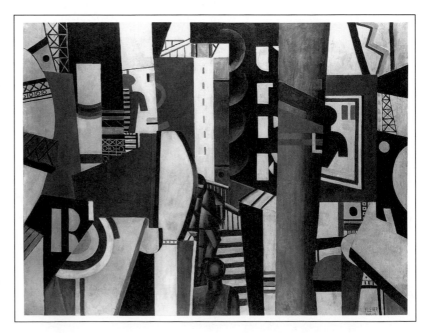

2-15 Fernand Léger, *The City*, 1919. Approx. 7′ 7″ × 9′ 9″. Philadelphia Museum of Art (A. E. Gallatin Collection).

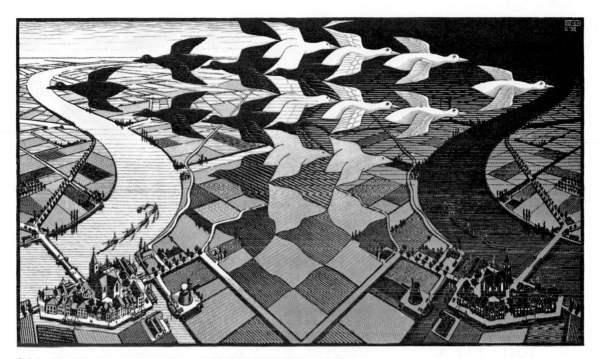

2-16 M. C. Escher, *Day and Night*, 1938. Woodcut, 15¼″ × 26¾″.
©1990 M. C. Escher Heirs/Gordon Art-Baarn-Holland

the relationships between positive and negative and between near and far are less stable in the Léger than they are in a realistic work such as Seurat's. Meanwhile, with one of M. C. Escher's fantastic illustrations (Figure 2-16), figure-ground reversal is not only possible but nearly impossible to avoid and is an essential part of the work.

The second principle of perception that is helpful for us to understand is *closure*, the tendency for incomplete figures to be perceived as complete. Closure occurs, for example, when a person sees a square in an arrangement of four dots—the mind's eye fills in and completes the latent connections along the sides of the figure (Figure 2-17). Oriental artists who deliberately practice expression through absence of detail are especially skilled at eliciting the

2-17

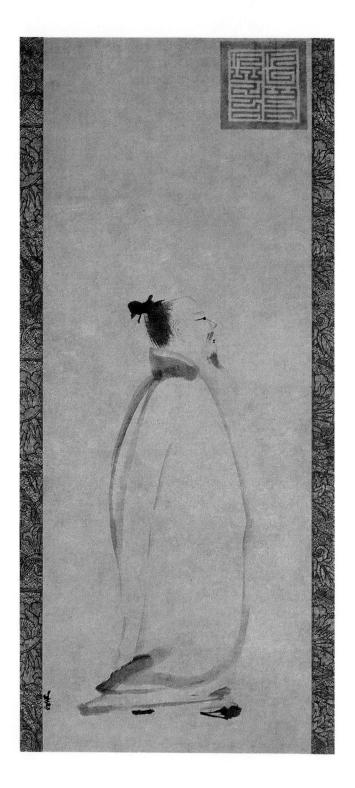

2-18 Lang K'ai, *The Poet Li Po,*
13th century. Ink on paper.
42⅞″ × 13″. Tokyo National
Museum.

help of the mind's eye. Although the representation of a poet (Figure 2-18) by Liang K'ai, a thirteenth-century Chinese artist, was drawn with the utmost economy of line, the needed details to complete the image of a fully-robed, dignified sage is easily provided by our imagination.

Representing Three-Dimensional Shapes

The constancy of perception is an important factor in any discussion of three-dimensional (solid) shapes. If we perform the simple act of turning the cover of a book, we can witness the paradox of *shape constancy*. As the cover turns, its rectangular shape goes through a series of distortions (Figure 2-19). It changes to a trapezoid that grows progressively thinner, until at one point it becomes nothing more than a line that is the thickness of the cover material—its ultrathin shape contrasting with that of the remainder of the unopened book. But what we actually perceive is an unchanging rectangular book cover swinging on the hinges of its binding.

The phenomenon of shape constancy, like color constancy, must be dealt with by artists who try to represent the third dimension in a flat picture. In a sense they must distort a form to make it appear undistorted. The drawings in Figure 2-19 are a good example. The artist radically shortened the width of the cover in those drawings where it was necessary to make it appear to be a tilted plane in three-dimensional space. This is called *foreshortening*. To foreshorten rectangular shapes like a book cover or side of a box is relatively easy; to foreshorten the limbs of a human body certainly is not. Imagine, for example, the skill required to present a close-up view of a preacher giving a fiery sermon, as in the ink drawing *Preacher* by Charles White (Figure 2-20). The man's face, arms, and hands are represented so convincingly that, unless the picture is studied closely, one is unaware that these have been radically foreshortened, particularly the right forearm.

A closer study may also reveal to the unsuspecting viewer that the artist made the preacher's hands, especially the right one, very

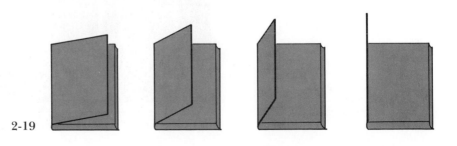

2-19

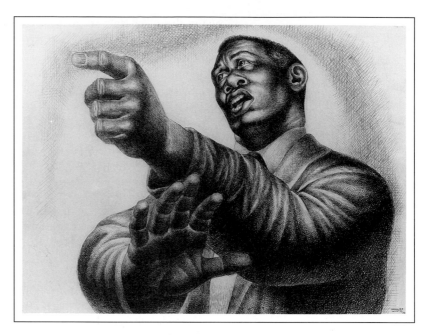

2-20 Charles White, *Preacher*,
1952. Ink on cardboard
21⅜″ × 29⅜″. Whitney Museum
of American Art, New York.

large in proportion to the rest of his body. Of course the reason is
that his hands are closer to us. Because of our normal expectations
as viewers, the hands do not appear to be abnormally large. This is
explained by our tendency to perceive objects as being a certain size
no matter how close or far away they may be—a phenomenon
called *size constancy.* A striking demonstration of this phenomenon
is seen in a photograph of a row of posts that stretches away from
the camera (Figure 2-21). The last post in the row has been exactly
duplicated just to the left of the nearest one, but the contrast be-

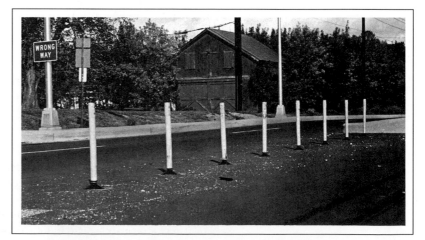

2-21

tween them appears so obvious that we are tempted to measure and compare the two. Were it not for the duplicated image, we would assume that the last post is more or less the same size as the first one.

As proof of the power of this phenomenon and the difficulty that artists have in dealing with it, one might cite the fact that it was not until a few hundred years ago that painters began to represent the world of three dimensions on a two dimensional surface with any real success. Apparently it was difficult for them to understand that by making something smaller in a picture, they could make it appear farther away—rather than simply smaller in size.

Three-Dimensional Shapes

Three-dimensional shapes, those with width, height, and depth, are the bases of the sculptor's art. (The term "mass" is sometimes used to refer to such a shape, particularly if it is thick and solid.) The crucial visual difference between a painting and a piece of sculpture is that the latter offers a variety of interesting vantage points from which it may be seen. Each point reveals a different configuration of the sculpture's various parts. For example, in Pablo Picasso's *Bust of Sylvette* (Figure 2-22), Sylvette's head is on the left, the center, or on the right, depending on the viewer's position. By contrast, the relationships in Seurat's painting would not change, regardless of the viewer's position; the men on the bank would always be on the left, and the boys in the water always on the right.

The factors of shape and size constancy (discussed earlier) help a viewer to fuse the multiple views of a sculpture into a single perception, especially if the sculpture is realistic. But in the case of an abstract sculpture, especially one like *Bust of Sylvette* that employs a novel composition, the various views are not easily understood, and therefore the sculpture is not easily comprehended as a whole.

Expressive Use of Shapes

Just as colors are classified as warm or cool, shapes are often classified as *closed* or *open, organic* or *geometric,* and *rectilinear* or *curvilinear.*

As the term would imply, closed shapes tend to be solid, self-contained shapes with little or no openings; likewise, open shapes

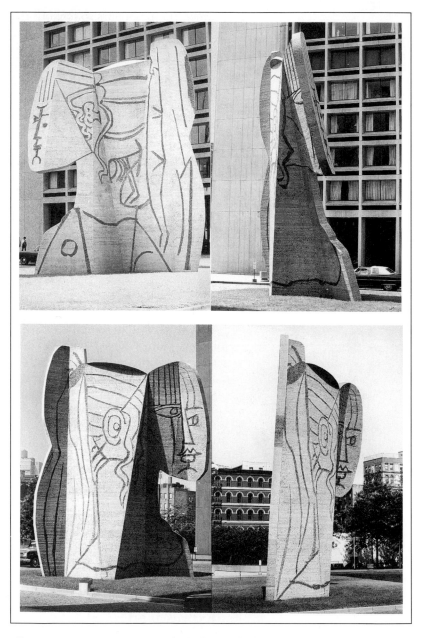

2-22 Pablo Picasso, *Bust of Sylvette*, 1967. Concrete and black Norwegian basalt aggregate, 36′ high. Courtesy of New York University.

allow space to penetrate their boundaries. Constantin Brancusi's *The Kiss* (Figure 2-23), in which sexual union is wittily expressed in terms of a single solid form, is an extreme example of a closed shape in sculpture, while Richard Hunt's abstract *Drawing in Space* (Figure 2-24) is an extreme example of an open shape. Among the ink drawings we've seen, the shapes in the Chinese work by Liang

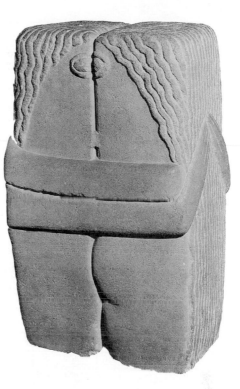

2-23 Constantin Brancusi, *The Kiss*, 1910. Stone, 19¾" high. Musée National d'Art Moderne, Paris.

K'ai (Figure 2-18) are quite open, while the preacher in the White drawing (Figure 2-20) is rather closed.

Organic (or *biomorphic*) shapes have irregular contours, and are associated with objects and creatures of the natural world. Geometric shapes, which have perfectly straight or curved contours (or combinations thereof), are associated with manufactured objects (although some natural objects, like ice crystals and snow flakes, are also geometric). Organic shapes, whether in abstract works or realistic works, are not only more suggestive of the natural world but also seem to be less "alienating" than geometric shapes—especially the rectilinear kind (refer to the explanation that follows)—that tend to be cold or aloof. On the organic-geometric continuum, the Picasso (Figure 2-22) is mostly organic, and the Brancusi (Figure 2-23) and Hunt (Figure 2-24) are geometric. Likewise, the Seurat (Figure 2-1) is primarily organic, while the Léger (Figure 2-15), which portrays the modern city as some sort of industrial monster, is primarily geometric.

The last division of shapes can be related to the controversial issue of gender stereotypes. Rectilinear shapes (those with predominately straight contours) are associated with masculinity, and curvilinear shapes (those with predominately curved contours) with

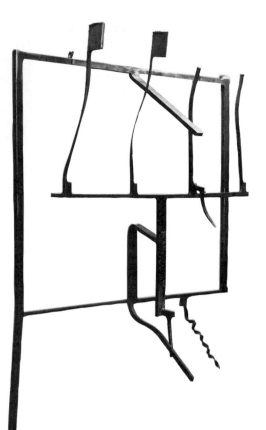

2-24 Richard Hunt, *Drawing in Space, No. 1*, 1977. Welded steel, 34″ high. Collection of the artist.

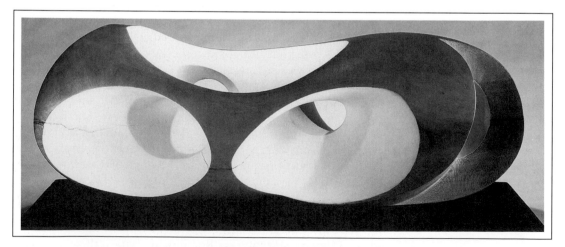

2-25 Barbara Hepworth, *Pendour*, 1947. Painted wood, 10¼″ × 27¼″ × 9″. Hirshhorn Museum and Sculpture Garden, Smithsonian Institution, Washington, D.C. (gift of Joseph H. Hirshhorn, 1966).

femininity. Thinking about shapes this way relates to real biological differences between men and women. But also, rightly or wrongly, rectilinearity connotes the attributes of strength and rigidity, while curvilinearity connotes grace and sensuousness. By this account, Barbara Hepworth's *Pendour* (Figure 2-25), a graceful combination of convex and concave, is clearly more feminine than either the Hunt or Brancusi sculptures. However the sensuousness of Hepworth's sculpture is owing to the quality of its texture almost as much as it is to the quality of its carefully orchestrated curves.

LINE

Lines can be perceived virtually anywhere: the wrinkles of a person's face, the veins of a leaf, the spiny ridges on a seashell, or the wind-etched surface of a sand dune. But we probably come across lines most often on paper in the form of drawings, diagrams, printed words, notations, doodles, and so on. A line is simply a thin mark made by a tool such as a pencil, pen, or brush. People begin early in life looking at drawings made with lines, such as those in storybooks and comic strips. People also begin making lines themselves at early ages—first in the form of random scribbles inspired by the pride of being able to leave personal marks on paper (or walls) and later in the form of rudimentary images or symbols, when children begin to name the scribbles.

In art, lines can be used to represent objects in a simple, direct way—by describing their outer contours. The cartoon characters Charlie Brown and Snoopy (Figure 1-2) and the opening book cover (Figure 2-19) are two examples in which lines function primarily as outlines. The images are flat, having little more depth than that afforded by the most basic kind of figure-ground relationship. But lines can also be employed to represent a subject in far more complicated ways, even going so far as to suggest texture and three-dimensional shapes. In the drawing of his mother (Figure 2-26), Albrecht Dürer described the bony structure of the brow, nose, cheeks, mouth, and chin of the face, and the tendons of the neck as these are both revealed and concealed by leathery, sagging flesh. He also showed the heavy-lidded protruding eyes, the wrinkled forehead, and a few strands of hair as well as the folds and gatherings of the veil. In places the artist employed fine, closely spaced lines (called *hatching*) to indicate shadows or touches of chiaroscuro. But he accomplished the effects of depth—the numerous bumps and hollows—mostly by means of single lines that are light or dark, thick or thin.

Unlike the drawing of Barbara Dürer, *Bathing at Asnières* (Figure 2-1) conveys the sense of depth by use of chiaroscuro rather

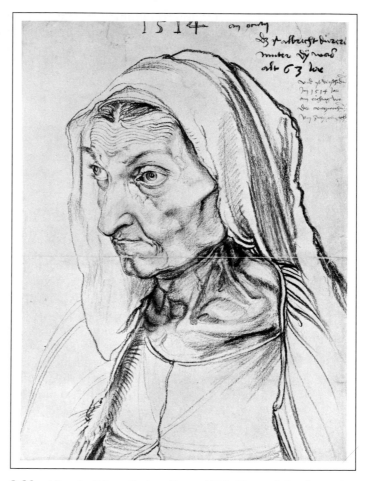

2-26 Albrecht Dürer, *Barbara Dürer*, 1514. Charcoal drawing, 22″ × 23″.
Kupferstichkabinett, Staatliche Museum, Preussischer Kulturbesitz,
Berlin (West).

than line. Indeed, one might have a hard time locating any lines at
all in Seurat's paintings. But many "invisible" lines are implied by
the boundaries that separate objects from one another or from
their surroundings—such as the edge of the riverbank and the con-
tour of the man lying down. Such a line is also implied at the hori-
zon. Although far from being a single, unbroken line, the horizon
extends from one side to the other—both because of and in spite of
trees, a bridge, and buildings. Closure helps us complete the hori-
zon just as it does the square in Figure 2-17.

Another kind of invisible line is a *line of sight*, that is, the imagi-
nary straight line along which a person looks. With the help of
closure, lines of sight can be "drawn" in the mind's eye to complete

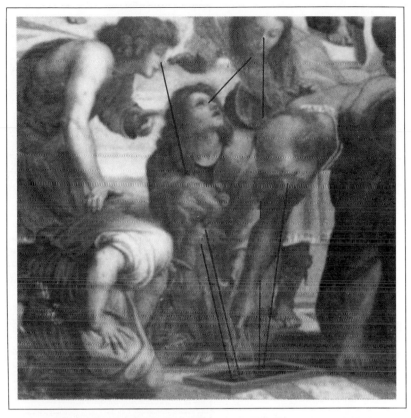

2-27 Raphael, *The School of Athens* (Detail), 1509–11, Fresco, 25′ 3¼″ at base, Stanza della Segnatura, Vatican Palace, Rome. Photo: Vatican Museum. Detail of Raphael mural showing lines of sight

connections between figures and things they may be looking at within a picture. Notice the lines of sight in a detail of Raphael's *The School of Athens* (Figure 2-27), which shows Euclid, a balding sage demonstrating a mathematical problem on a little slate for the benefit of some students. All of the figures are looking at the slate, except for one member of the group who glances up at another student looking over his shoulder. Although invisible, these lines help to call attention to Euclid's project, to connect the figures to one another, and even to enliven the scene.

Expressive Use of Line

Like shapes—to which they are closely related—lines can be organic, geometric, rectilinear, or curvilinear. They can also be thick or thin, and light or dark. Contrast the thin austerely rectilinear

2-28 Agnes Martin, *Untitled #8*, 1988. Acrylic and pencil on canvas, 72″ × 72″. Courtesy of The Pace Gallery, New York.

lines of Agnes Martin's *Untitled #8* (Figure 2-28) with the ropy convoluted lines of Jackson Pollock's *No. 3* (Figure 2-29). Clearly, lines do not have to represent anything to have character, and therefore meaning.

Because they are often the result of real movement—of pencils, pens, brushes, and so forth—lines tend to embody both movement and direction. The impulsive lines of Pollock's *No. 3,* for example, are a visible record of Pollock's impulsive movements— whether he poured or brushed the paint. As an artist's movements are a reflection of his or her decisions in making a work, lines are, in a sense, a record of the artist's personal thinking and feeling. This is especially true in the case of drawings, abstract or otherwise.

Käthe Kollwitz made a number of works about suffering, death, and human vulnerability. The intensity of feeling in her *Death Seizing a Woman* (Figure 2-30) is evoked by the boldness of the lines and their abrupt shifts in direction, as well as by the symbol of death and the look of terror in the woman's face. Indeed, if we

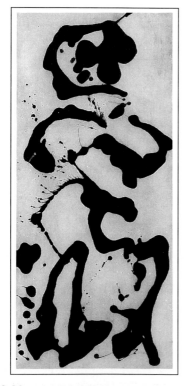

2-29 Jackson Pollock, *No. 3*, 1951. Oil on canvas, 56⅛″ × 24″. Private collection.

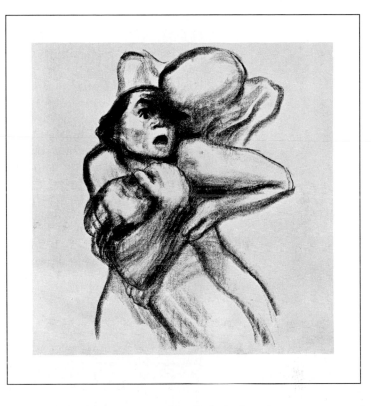

2-30 Käthe Kollwitz, *Death Seizing a Woman*, 1934. Plate IV from *Death* Lithograph, printed in black 20″ × 14⁷⁄₁₆″. Collection, the Museum of Modern Art, New York. Purchase Fund.

ignore the subject matter of Kollwitz's drawing, we can see that her forceful strokes have much in common with Pollock's.

TEXTURE

The term *texture* is used to refer to the surface qualities of things—for example, the hard smooth feeling of an egg or the soft smooth feeling of velvet. The best way to experience the texture of anything is to touch it. Yet most of our day-to-day information about texture comes from simply looking at things.

Visually, information about texture is transmitted by the way in which different materials affect the light that falls on their surfaces. A surface rough with bumps or pores will cast many little shadows. A matte surface will absorb light; a glossy one will reflect it. In other words, these textures can be perceived by the eyes in essentially the same way that color and shape are perceived.

In painting, texture can take two different forms. In representational works it can be simulated with patterns of light and dark. It can also be a characteristic of the materials themselves—the paint, the canvas, or some substance that is attached to the surface or mixed with the paint. Usually one or the other of these forms

predominates. In Ivan Albright's *Into the World There Came a Soul Called Ida* (Figure 2-31), the simulated textures of a wicker chair, a vanity, cosmetic jars, clothing, and, especially, middle-aged flesh do much of the work in suggesting the process of human aging and deterioration. In Jean Dubuffet's *Tree of Fluids* (Figure 2-32), it is the paint itself that seems to be deteriorating. Here the material existence of the art object participates symbolically in a statement about the universal fate of biological and spiritual decay.

Some paintings exhibit both simulated texture and actual texture. At first glance, the simulated textures in Édouard Manet's *Flowers in a Crystal Vase* (Figure 2-33), the soft, delicate surfaces of the petals, which one can almost smell, and the hard, reflective surface of the glass, are most apparent. But the viewer can also see and appreciate the texture of the paint itself, especially with regard

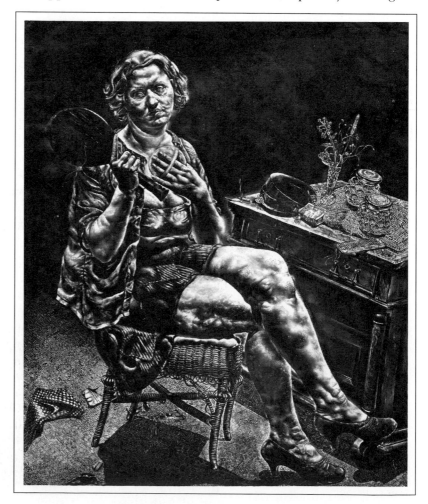

2-31 Ivan Le Lorraine Albright, *Into the World There Came a Soul Called Ida, (the Lord in His Heaven and I in My Room Below)*, 1929–30. Oil on canvas, 56⅛″ × 47″. The Chicago Art Institute of Chicago (gift of Ivan Albright, 1977. 34). Photograph © 1990. All rights reserved.

to the imprint of Manet's deft brushwork—the subtle daubs and smears that created the illusion of flowers and crystal.

Texture is even more fundamental in sculpture than it is in painting. For centuries, many of the best sculptures have emphasized the textures of both the materials used in them and the materials of the objects they represent. As the art historian Herbert Read pointed out:

> For the sculptor, tactile values are not an illusion to be created on a two-dimensional plane: They constitute a reality to be conveyed directly, as existent mass. Sculptor is an art of *palpation*—an art that gives satisfaction in the touching and handling of objects. That, indeed, is the only way in which we can have direct sensations of the three-dimensional shape of an object.

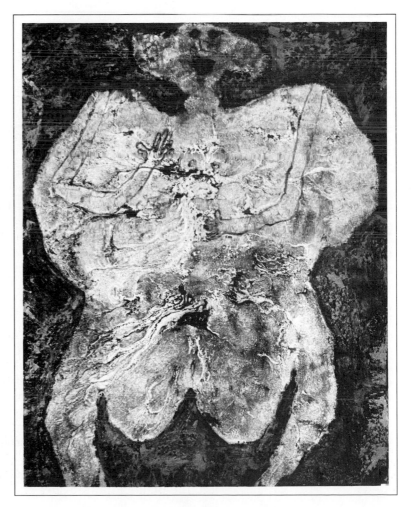

2-32 Jean Dubuffet, *Tree of Fluids (Body of a Lady)*, 1950. Oil on canvas, 45⅝″ × 35″. Secrétariat de Jean Dubuffet.

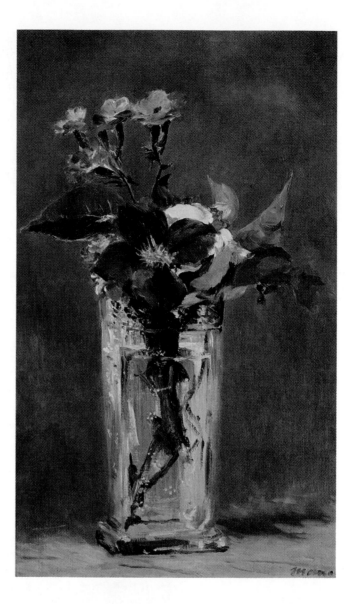

2-33 Édouard Manet, *Flowers in a Crystal Vase*, c. 1882. Canvas, 12⅞″ × 9⅝″. Louvre, Paris.

Read went on to lament the fact that visitors to museums are not allowed to touch the artworks. But he would no doubt concede that human visual perception, assisted by past experience and a little imagination, is enormously capable of appreciating the tactile values of a piece of sculpture without actually touching it. It would certainly be a pleasant experience to pick up the horse (Figure 2-34) made of fired clay (ceramic) by a fifth-century Japanese artist, and feel its texture directly. But although we cannot touch the object, the photograph provides enough cues for us to compare the

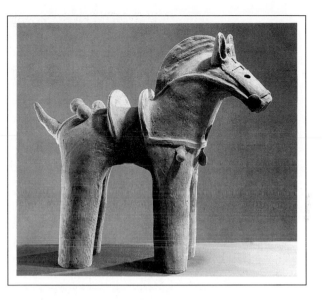

2-34 Haniwa horse, fifth to sixth centuries A.D. Terra Cotta. The Cleveland Museum of Art (gift of Mrs. Henry Norweb, 57.27).

sculpture with our memories of other ceramic objects, and to imagine its matte surfaces, contours, edges, weight, and perhaps even its smell.

SPACE

Space can be thought of as the "empty shape" that exists around solid shapes (masses). Can we see space? To the extent that air, or atmosphere, is not really empty, space can be seen under certain conditions—and painters are able to depict it. (More will be said about this under the topic of aerial perspective a little later in the chapter.) Under most conditions, however, space is relatively transparent. Yet we are aware of it at all times, and, like solid shapes, it can be described and measured. Space is really seen by its boundaries—where it touches objects and other solid shapes. For example, the space of a room is defined by the ceiling, floor, walls, and objects in the room. By looking at these things we can see the space well enough to describe it (interior space is sometimes referred to as *volume*). Outdoor space is defined by the land, trees, and buildings it touches (while its outer limits may be the horizon and the dome of the sky). The complementary relationship between solid shapes and space in our perception of the three-dimensional world is similar to that between figure and ground in our perception of two-dimensional pattern.

We also experience space through *kinesthetic sense*—our feeling of the position and movement of our bodies. If we were blindfolded, the only way we could perceive and adjust to the space of a

strange room would be by moving about in it—perceiving it with our kinesthetic sense (along with our tactile sense). And although we see, we still sense the space surrounding us by how it feels to move through it, and we invariably do this in our imagination when not actually moving. Like texture, for which the eyes are aided by the sense of touch, the element of space is experienced cooperatively through vision and movement.

Architecture and Sculpture

Space is a most important element for the architect, who is concerned about designing it for human use. Michelangelo, famous as a sculptor and painter, also undertook several architectural projects, including the redesigning of Rome's Capitoline Hill (Figure 2-35). His solution was to redesign the front of one of the two buildings already on the hill and add a third building to create a symmetrical, trapezoidal public square. To accent the shape of the square and to set off the statue of Marcus Aurelius in its center, Michelangelo provided a strikingly decorative oval pavement. Most squares of the time were closed on all four sides by buildings; Michelangelo chose to leave this square open on one side, with a low balustrade to define the limits of the square. Today's visitor to the

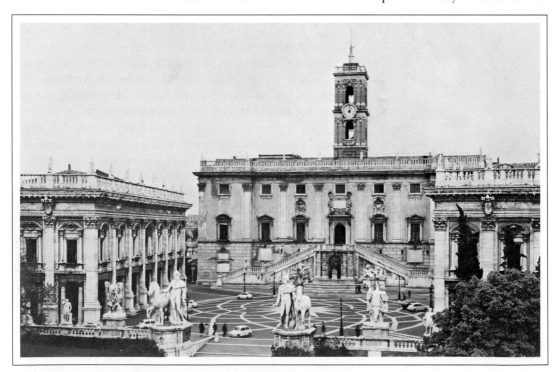

2-35 Michelangelo, Capitoline Hill, Rome, designed c. 1537.

Capitoline Hill experiences not only the majesty of the ancient buildings but the drama of being inside an ordered, symmetrically balanced, and partly closed space.

The interaction of shape and space, or positive and negative, is an important concern of most modern sculptors, who, like Hepworth, tend to include openings in their works (Figure 2-25). Traditional sculptures are usually solid, relatively closed shapes. Abstract sculptures like Hunt's (Figure 2-24) are often very open, allowing for a maximum of shape–space interaction. The effects of this interaction are especially apparent as one views the piece from different angles.

Space in Pictures

Modern artists, especially those who produce abstract works, often use the term space to refer to the two-dimensional surface of the picture plane (similar to the way we used the term ground earlier). Whether they make works as simple as Kelly's (Figure 2-14) or as complex as Léger's (Figure 2-15), abstract artists are concerned about designing the "space" of this essentially two-dimensional environment. But this concern is not exclusive to twentieth-century artists. Seurat, as we shall see in Chapter 3, was particularly concerned about designing the pictorial space in *Bathing at Asnières*, treating the men and boys almost as if they were silhouettes in an abstract arrangement of colors.

Perhaps Seurat's men and boys (Figure 2-1) can be perceived as abstract silhouettes. But they can also be perceived as three-dimensional people occupying real space—an illusion that we willingly submit to when viewing pictures like this.

Seurat created this illusion using a variety of techniques. Two of them already discussed—chiaroscuro and foreshortening—were used to render each person and object with a sense of depth. The artist also employed several methods to make these persons and objects appear to exist in space—nearer to or farther away from the viewer.

One of the most obvious of these methods is the *placement* of things higher or lower in the picture; we tend to see things that are higher as being farther away. Another is *scale*, or making things in the distance smaller; for example, the farthest man on the bank is not even as large as the brim of the nearest man's hat. Still another way is *overlapping*—one thing set in front of another, such as the dog and the man—which also strengthens the impression of nearness or farness. A further set of cues is provided by the artist's use of *aerial perspective*, a method that simulates the effects of color in the atmosphere. Sometimes air contains high amounts of particulate matter—as with the smoke in the distance in Seurat's painting—

that can be seen easily. But even without the presence of smoke, air is dense enough to affect the appearance of objects: The farther away they are, the softer their outlines and the more subdued their colors. Seurat, who used a whole palette of colors, created this effect by subduing the contrasts of hues and values in the bridge and buildings on the horizon.

Gradient of texture and detail is yet another system for suggesting depth. Gradients can be seen in the grassy bank of the Seurat painting, where the blades of grass gradually turn into a generalized texture as they move farther back in the picture.

The most traditional system of spatial representation that Seurat employed is *linear perspective,* which dictates the relative sizes of things according to their distance from the viewer. This technique was not completely developed until the fifteenth century—when it became widely used in nearly all painting—but it continued to be used extensively until the twentieth century. Its basic principles can be demonstrated easily in a set of drawings of a football field. The simplest form of linear perspective is single-point perspective (Figure 2-36), in which all the lines moving away from the viewer meet (if continued) at one point—the *vanishing point*—on the horizon. Note that the yard lines and the crossbars of the goalposts, if extended, meet at the vanishing point. The same is true for the dotted lines connecting the tops of the goalpost uprights and the light poles. (Indeed, the heights of these things are established by means of lines extended to the vanishing point.) The remaining lines are either vertical, such as the light poles and uprights, or horizontal, such as the sidelines. Accustomed to this system of representation since childhood, we are able to interpret the yard lines as being at right angles to the sidelines, and, as long as the vanishing point is on the horizon, we think of them as being level with the plane of the ground.

Pictures that use two or more vanishing points (Figure 2-37) accommodate more complicated views of things. Whereas the single-point system works only for a line of sight that is perpendicular to the horizontal lines of the things being viewed, the two-point system works for all other lines of sight, including one that might occur if the viewer were sitting at the corner of the field. Note that

2-36 Single-Point Perspective

2-37 Multiple-Point Perspective

the sidelines are not horizontal and, if extended, would meet at their own vanishing point. And anything else, like the bandmaster's platform that sits at an angle to the field, would have its own set of points. The final illustration (Figure 2-38), showing a single-point perspective of one end of the field, demonstrates the effect of lowering the horizon (or eye-level) line.

One-point perspective was very popular after it was developed in the fifteenth century. While most artists in that century used it in rather obvious, and not always appropriate ways, in the early sixteenth century Raphael used it very effectively in his *The School of Athens* (Figures 2-27 and 2-39). Lines going back in depth, such as the moldings below the ceiling vaults and the edges of the pavement tiles, will meet, if extended, at a point near the left wrist of Plato (the left figure in the middle). The location of this point establishes the eye level and the horizon line (which is in the distance behind the figures). Because of the eye level's relatively low position, we look up to the men in the rear, a fact that contributes to their heroic appearance, and up to the vaulted ceiling, which contributes to its sense of grandeur.

Not everything in this mural conforms to the one-point system. The block of marble in the foreground on which rests Heraclitus (reputedly, a portrait of Michelangelo) is in two-point perspective; however, only the left point is within the frame of the picture.

Although Seurat's painting presents a much more complicated problem than that of a football field, or even that of a vaulted building, we can still see that the sizes of the people are progressively reduced according to their relative distances. The horizon, or eye level, is an implied line just below the distant bridge and it intersects the head of the large boy. The vanishing point could be

2-38 Single-Point Perspective from a Low Angle

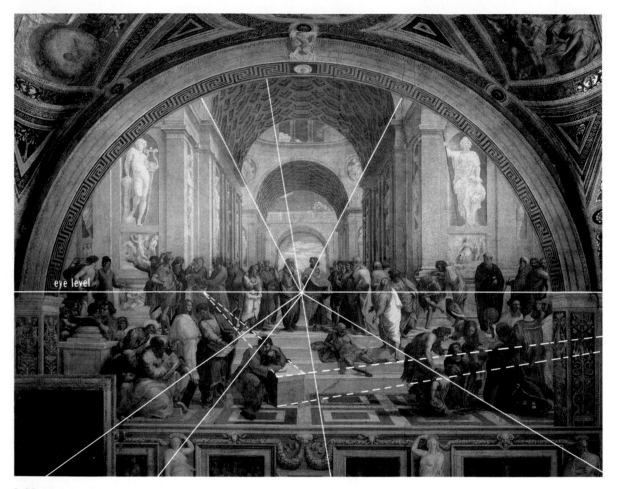

2-39 Raphael, *The School of Athens*, 1509–11. Fresco, 25′ 3¼″ at base.
Stanza della Segnatura © Vatican Palace, Rome. Photo Vatican Museums.
An example of the eye level line, main vanishing point, and the left
vanishing point for the block of marble in the foreground.

located close to where that line and the riverbank intersect (Figure
2-40). However, to determine where Seurat himself placed the van-
ishing point (if he in fact used one) is difficult, because the few
linear features of the picture are almost all on the horizon.

Many twentieth-century painters deliberately avoid using lin-
ear perspective, as well as some of the other methods for creating
traditional illusions of depth. But this does not mean that modern
paintings lack depth entirely. Recall earlier discussions of figure-
ground relationships and how warm colors advance and cool colors
recede. All abstract works, even the flattest ones, evoke some sense

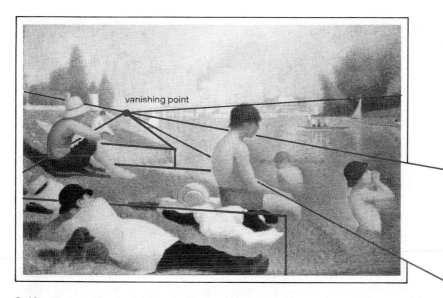

2-40 Georges Seurat, *Bathing at Asnières*, 1883–84. Oil on canvas, 6'7" × 9'11".
Reproduced by courtesy of the Trustees, The National Gallery, London.
An imaginative reconstruction of how this painting may have been organized
according to one-point perspective. The riverbank is visualized as a large
sloping dock; a clone of the largest boy has been placed in the water so that
he is on the same plane as the other boys.

of depth. Picasso's *First Steps* (Figure 1-3) and Léger's *The City* (Figure 2-15) are good examples of a shallow, nonillusionistic space in which the push and pull of depth is due to color, figure-ground, and even some touches of chiaroscuro and foreshortening. The subtle depth of Anuskiewicz's painting (Figure 2-8) depends entirely on the effects of advancing and receding hues.

SUMMARY

At the beginning of the chapter we said that while Seurat's painting is obviously a picture of boys gathered along a riverbank, it is also a rectangular surface covered with patches of color. The balance of the chapter is devoted to explaining the visual elements involved in creating the picture and their roles in everyday seeing as well as in works of art.

The next chapter completes the discussion by presenting several ways of manipulating and combining these elements in order to achieve certain expressive goals, as well as to create a pleasing composition.

CHAPTER

3

COMPOSITION AND CRITICISM

IN ORDER TO UNDERSTAND how the visual elements discussed in Chapter 2 function in a work of art, we must also examine how these elements work together as a team. *Composition* ("putting together") is the term used to describe this teamwork. Art criticism, on the other hand, is involved in *de*composition—that is, separating a work into its parts to find out their interrelationships. Before saying more about criticism, we will review the subject of composition.

COMPOSITION

When he composed *Bathing at Asnières* (Figure 3-1), Seurat was principally concerned about two things: that the picture be a convincing illusion of boys and men on a riverbank, and that it also be a pleasing and interesting artwork. Of the two, no doubt the desire to make a pleasing and interesting artwork was uppermost in his mind. Thousands of artists in Seurat's day could make realistic scenes, but few shared his commitment and ability to create compositions as highly-ordered as his.

While there are no rules for composing an artwork, there are some guidelines, known as *principles of design*. These principles—all of which are interrelated to a greater or lesser degree—can be categorized as: *Unity and Variety, Movement and Stability, Scale and Proportion,* and *Balance.* Different works will be used to illustrate the application of each of these principles; however, *Bathing at Asnières* will be used throughout to illustrate their application in a realistic (or figurative) work, and Hans Hofmann's *Rhapsody* will be used to illustrate their application in an abstract work.

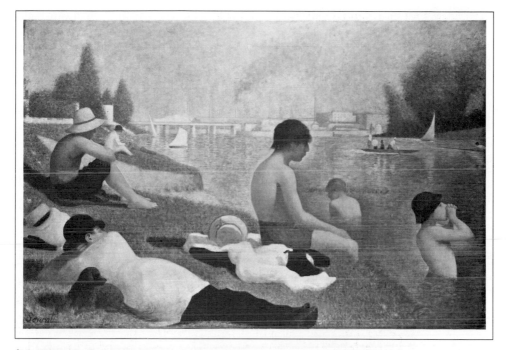

3-1 Georges Seurat, *Bathing at Asnières*, 1883–84. Oil on canvas, 6'7" × 9'11".
Reproduced by courtesy of the Trustees, The National Gallery, London.

Unity and Variety

Unity describes the way in which an artwork is treated as a single, indivisible whole. *Variety* describes the differences in the work, involving subject matter, visual elements, or even materials. Too much (or too little) of either unity or variety can be a bad thing. A forty-piece orchestra playing the same note over and over would have unity but sound monotonous. The same orchestra playing forty different tunes at the same time would have variety but sound chaotic. The first situation is too easy for the perceiver; the other, too difficult. Both situations are boring. We prefer music that is well-*composed,* music in which unity and variety are reconciled.

The relationship between unity and variety in art is somewhat *dialectical*—in other words, the two are opposites, or *antithetical.* But they are fruitful opposites that work together rather than against each other—a little like male and female. In dialectical terms, *thesis* (unity) and *antithesis* (variety) are needed to produce a *synthesis*, or, in this case, a satisfactory composition. The measure of this synthesis is proportional to the amount of variety that needs to be reconciled. Obviously, the greater the variety, the more difficult it is to achieve a synthesis. Because of their simplicity, Martin's *Untitled #8*

(Figure 2-28) and Eero Saarinen's Gateway Arch at St. Louis (discussed later in the chapter)—elegant as both these works are—did not require heroic efforts to achieve this synthesis. By contrast, *Bathing at Asnières* and *Rhapsody* (Figure 3-2), each of which possesses quite a bit of variety, did require effort and skill on the part of Seurat and Hofmann to accomplish their ends.

One of the strategies used to unify these compositions is *grouping* things close together to form fewer units for the eye to contend with. (We do this when we straighten a messy desk by organizing a

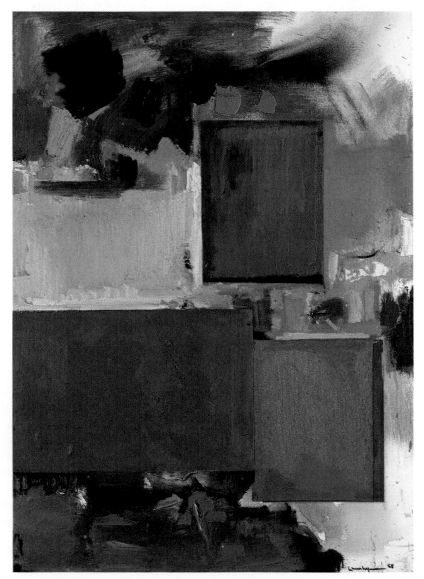

3-2 Hans Hofmann, *Rhapsody*, 1965.
Oil on canvas,
7′¼″ × 5′½″ The Metropolitan Museum, New York
(gift of Renate Hofmann, 1975, 1975. 323).

hodgepodge of separate papers, writing tools, books, and coffee cups into larger and tidier-looking units.) Notice in *Bathing at Asnières* the grouping of figures and objects: the three boys are on the right; the man and the dog are on the left; and the trees and buildings are in the distance. Notice in *Rhapsody* the groups of the rectangular shapes are mostly in the middle of the canvas.

A way to connect things without grouping them together is through *similarity,* especially similarity of color (just as we coordinate clothes by repeating a color in a scarf, tie, belt, shoes, handbag, and so forth). Color similarity was used by both artists to make important visual connections. Notice Hofmann's use of bright red in the large rectangle, the stripe on the right side of the blue rectangle, and the two red spots above the blue rectangle. Notice how bright blue is repeated in the bottom of the canvas, the blue rectangle itself, and also in a little spot in the upper left corner. Seurat used variations of red-orange in the hair and trunks of the large bather, the hat and trunks of the bather in the water, the hair of the dog, and cloth of the pillow underneath the boy with the straw hat, and even the band of the hat itself. Examples of shape similarity can be found in both works: Hofmann's rectangles, which echo the rectangle of the canvas itself; and Seurat's pervasive use of a dome shape in the heads and hats of the men and boys.

Another organizational strategy is *dominance,* emphasizing one part or area of a picture more than others. Dominance is to composition something like a leader is to a team; it tends to be the focal point. Clearly, the dominant feature in the Seurat is the large boy sitting on the bank. This is so for a number of visual reasons: his size (second only to that of the man lying down), his centralized location, and the strong contrast between the dark values of his head and the lighter values surrounding it. A feature can dominate simply because it is different. The man with the upraised arms in Francisco Goya's *The Third of May, 1808* (Figure 3-3) is the outstanding figure, even though he is neither the largest nor the most central. One reason is that his shirt is the only significant splash of white in a very dark canvas. He stands out also for reasons not purely visual: he is obviously a victim (a psychological factor) with upraised arms (which is both visual and psychological). Unlike the Seurat and Goya paintings, Hofmann's *Rhapsody* has no single dominant feature; it has three, specifically, the three brightly-hued rectangles. The most dominant of the three is difficult to determine.

Still another way of creating unity is *continuation,* a line or series of objects that continues relatively uninterrupted through a large part of the composition. The row of soldiers in *The Third of May, 1808* is one example. The edge of the riverbank and the horizon line in *Bathing at Asnières* are others. Continuation is also prompted

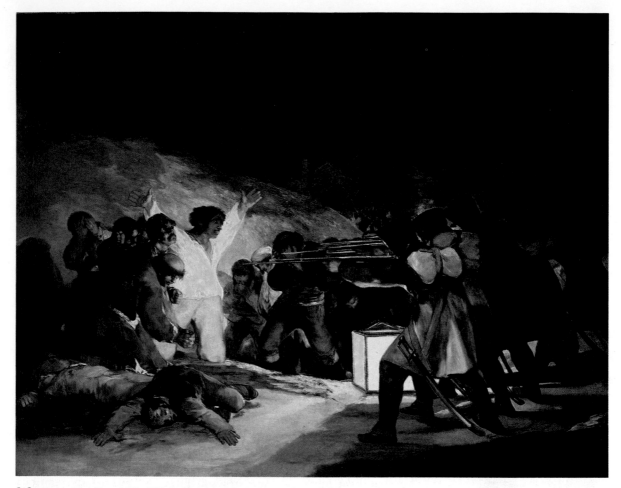

3-3 Francisco Goya, *The Third of May, 1808*, 1814. Oil on canvas,
approx. 8'8" × 11'3". Museo del Prado, Madrid.

by lines of sight; recall those in Raphael's *School of Athens* (Figure
2-39). While both the Seurat and the Goya contain lines of sight,
the latter also contains lines of "fire" (the direction in which the
guns are pointing). Again, *Rhapsody* does not provide as clear an
example of this strategy. But one can detect directions along not
only the edges of the rectangles, but also along those of some of the
free-form shapes as well.

Movement, Stability, and Rhythm

Movement and stability, like unity and variety, are opposites. Both
are needed in a work of art: absence of movement creates a situa-
tion of stasis; absence of stability results in endless restlessness. The

challenge is to get both movement and stability to work together, a challenge that was met by Renaissance artists in the early 1500s. A case in point is Raphael's *School of Athens* that, although containing a variety of lively movement in its figures, is nevertheless very stable.

A recognizable image, whether a picture or a sculpture, preserves a moment in time. By stopping time, it implies a relationship to time, and also to movement. The subject may be as motionless as Manet's *Flowers in a Crystal Vase* (Figure 2-33) or as active as the men and animals in Peter Paul Rubens' *The Lion Hunt* (Figure 3-4). The quiet activity of the men and boys on Seurat's riverbank falls somewhere between the two.

Other variables on the movement–stability continuum are related to the abstract form of a work. Certain configurations of line, shape, and color favor movement: diagonal directions, sharp corners, agitated or curvilinear lines, organic shapes, bright hues, contrasting colors, and visual complexity in general. Study the form of

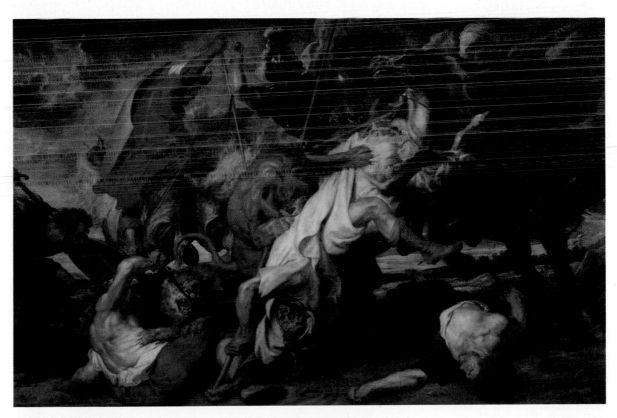

3-4 Peter Paul Rubens, *The Lion Hunt,* 1617–18. Approx. 8′2″ × 12′5″. Alte Pinakothek, München.

Rubens' painting (if necessary, squint at it, or turn it upside down so that you see just the form and not the figures). The twisting of the figures, the diagonals of the spears, and the complexity of the design not only suggest movement but *rapid* movements. Another kind of movement results from the tendencies of colors or patterns to advance or recede. The alternating figure-ground of Escher's *Day and Night* (Figure 2-6) is one example of this movement; the color interaction of Anuskiewicz's *All Things Do Live in the Three* (Figure 2-8) is another. Like Anuskiewicz, Bridget Riley specializes in *optical* paintings whose abstract patterns create visual tensions as well as movement. Notice how the pulsing lines of her *Current* (Figure 3-5) advance, recede, and bend in ways that are disorienting. Hofmann's *Rhapsody* is not an optical painting. His vigorous brush strokes, especially those in the upper section of the canvas, resemble the animated forms in Rubens' *The Lion Hunt* more than the patterns of Riley. But at the boundary line between the red and blue rectangles a different kind of movement is at work. Stare at that line for a half minute or so (Figure 3-2). The interaction of

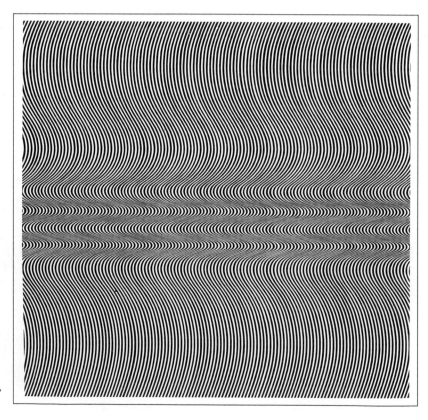

3-5 Bridget Riley, *Current*, 1964. Synthetic polymer paint on composition board, 58⅜″ × 58⅞″. Collection, The Museum of Modern Art, New York (Philip Johnson Fund).

those two highly-saturated colors creates visual tensions similar to those found in the works of Anuskiewicz and Riley.

As stated earlier, any subject implies movement to some extent. But obviously some subjects, like still lifes, architecture, landscapes, and people or animals involved in quiet pursuits, imply stability as well. Meanwhile, abstract forms that favor stability include vertical and horizontal directions (especially the latter), right angles, geometric shapes, straight lines, triangular composition, dull hues, moderate color contrasts, and, in general, simplicity. In Holland, not far from Rubens' home region of Flanders, Pieter de Hooch painted ordinary people in ordinary, domestic settings. Compare his *Interior of a Courtyard, Delft* (Figure 3-6) with Rubens' *The Lion*

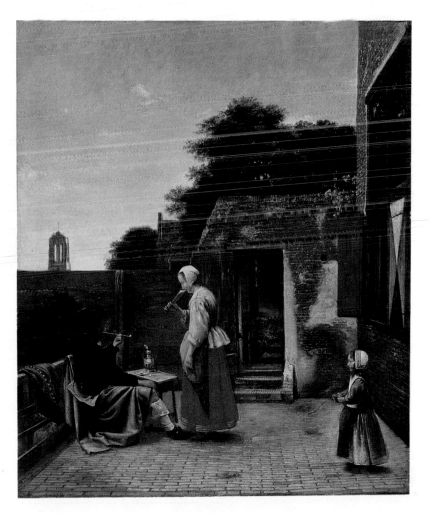

3-6 Pieter de Hooch, *Interior of a Courtyard, Delft*, c. 1658–60. Oil on canvas, 26¾″ × 25″. Mauritshuis, The Hague.

Hunt. The difference in subject matter is obvious. Notice, though, how the character of de Hooch's form—the absence of diagonals, the pervasive use of horizontals, the subdued contrasts of color, and the simplicity of the design—complements the mood of repose.

In some lists of design principles, *rhythm* is considered separately. But in fact, rhythm is part of the issue of movement. A foot-tapping beat in music enhances a tempo, but also controls it. Likewise, rhythm in art fosters direction and movement, but controls the pace of this movement. It is, in a sense, *structured movement.*

Some rhythms, such as those found mostly in architecture, craft objects, and geometric art, are formal in character. These can be simple structures in which the same shape, line, or module is repeated without variation—as in, for example, Martin's horizontal lines (Figure 2-28) or Anuskiewicz's diamond-shaped modules (Figure 2-8). Or they can be alternating—similar to the accented rhythm of a waltz in which only one beat is stressed (as in *1, 2, 3, 1, 2, 3,* and so on). Islamic craftsmen, known for *arabesque* designs like those embellishing the ceiling of a mosque (Figure 3-7), have left a marvelous legacy of all kinds of rhythms. Study the designs within the radial-shaped dome itself. The wider segments, filled with stylized plant designs, are alternated with narrower segments decorated with geometric figures (in themselves examples of formal rhythm). But look again; there are four different plant designs. Musically, the rhythm of the dome would be diagrammed as follows: *1, 2, 2, 2, 3, 2, 4, 2, 1, 2,* and so forth. A third kind of formal rhythm consists of repetitions that progress from small to large, dark to light, and so forth. The geese in Escher's *Day and Night* (Figure 2-16), which progress from figure to ground, is one example. The pavement bricks of de Hooch's Dutch courtyard which decrease in size as they recede into the picture, is another example of progressive rhythm.

Most rhythms in paintings and sculptures are informal, their repetitions being much less mechanical than those in the preceeding examples. The pattern of lances, spears, swords, and knives in the *The Lion Hunt*—all of different shapes and sizes but all aimed at the center of the picture—constitutes a rhythm. In *Bathing at Asnières,* the clearest example of rhythm consists of the repeated forms of the bridge supports and of the buildings stretched across the distant horizon. Other, more subtle rhythms, can be inferred from the curved lines that are repeated in the backs of most of the figures, or from the dome shapes repeated in the heads and hats. The patterns of Hofmann's brush strokes in *Rhapsody* are still another example of informal rhythm.

Like their Renaissance predecessors, Seurat and Hofmann strove to harmonize movement and stability in their works. While

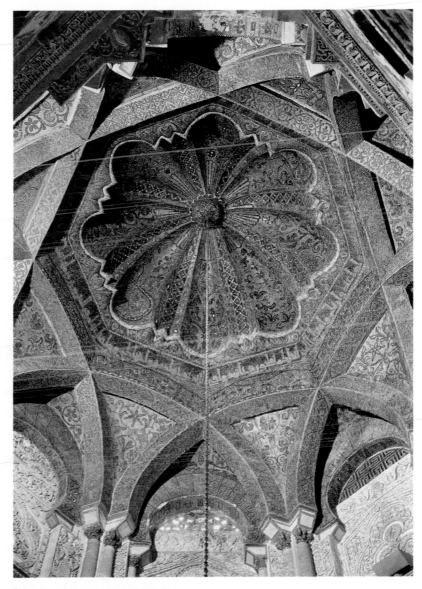

3-7 Dome, mosque at Cordoba.

Bathing at Asnières is animated by hue contrasts (see Figure 2-1), organic shapes, and some rhythms, it is stabilized by its studied arrangement of figures and objects, the simple forms of the people, and the horizontal format. Because of the inactivity of the men and boys, it emphasizes repose more than energy. Hofmann's painting is animated by lively brushwork and highly-charged color, but these are tempered by the use of rectangles, and by the employment of a

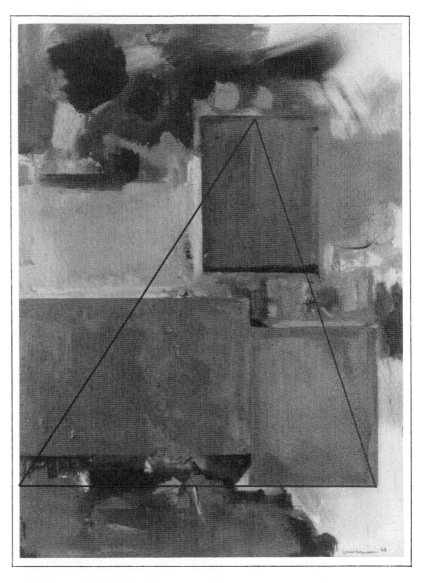

3-8 Hans Hofmann, *Rhapsody*, 1965.
Oil on canvas, 7′¼″ × 5′½″.
The Metropolitan Museum, New York.
(gift of Renate Hofmann, 1975,
1975. 323).

triangular arrangement of these rectangles (Figure 3-8)—a compositional strategy as old as the Renaissance. In the final analysis, however, *Rhapsody* emphasizes vitality and energy much more than repose.

Scale and Proportion

In art, scale is taken to mean the relative size of a piece—compared to the human body or to other pieces in its class. For example, the scale of Eero Saarinen's Jefferson National Expansion Memorial

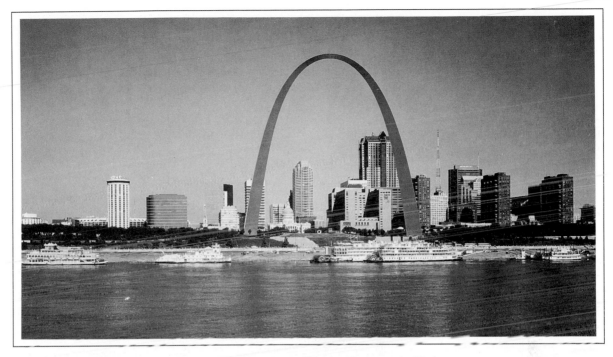

3-9 Erro Saarinen, Jefferson National Expansion Memorial *(The Gateway to the West)*, St Louis, Missouri, 1966.

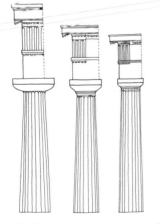

3-10 Changes in Doric-order proportions.

(Figure 3-9), a monument that dominates the skyline of St. Louis, is large by any standard: the human body or other outdoor sculptures. Compared to most canvas paintings, *The Third of May, 1808* (Figure 3-3) and *The Lion Hunt* (Figure 3-4) are large in scale—a fact that may elude the viewer who sees these works only in reproduction. (Note: the dimensions of every work in this book are shown in the source information by the figure.) Proportion, meanwhile, refers to the relationships among the various parts and the relationship of part to whole within an individual piece. The ancient Greeks were obsessed with what they perceived to be ideal, or perfect, proportions. Polyclitus devised a complete canon (a set of rules) of proportions for the human body, specifying, even, the numerical ratios between finger and hand and between hand and forearm. His canon was used by all fifth-century B.C. Greek artists, and was consulted even by artists in later centuries. Greek architects refined the proportions of the Doric temple—as one can see by reading the silhouettes from left to right in Figure 3-10 so that the latest column, compared to the earlier columns, is slenderer in proportion to its own height, and taller in proportion to the height of the whole temple. Greek mathematicians advised an ideal ratio, known as the *golden section* (Figure 3-11). Plato considered the

3-11 a) The golden section consists of cutting a segment of a line into two segments so that the smaller segment is to the larger segment as the larger is to the whole. The ratio of BC to AB equals that AB to AC (a ratio of approximately 1:16). b) This ratio can be used, for example, to determine the proportions of a rectangle.

golden section a universal principle; Aristotle compared it to ethics; medieval scholars called it the "divine proportion." Although few writers today take the golden section seriously, there are still those who believe that rectangles based on its proportions are the most pleasing.

The rectangles of most canvases (including Seurat's and Hofmann's), however, are not based on the golden section. Artists tend to base their proportions, whether with regard to the dimensions of

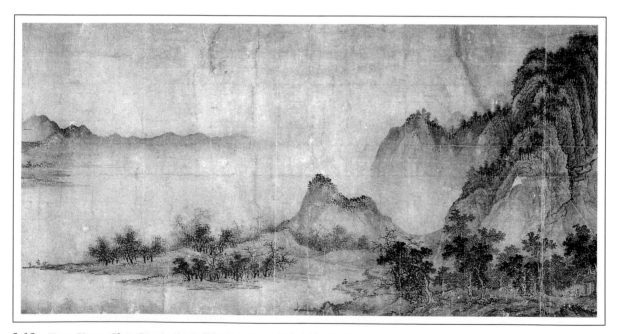

3-12 Tung Yuan, *Clear Day in the Valley* (detail), twelfth–thirteenth centuries. Handscroll, ink and slight colors on paper, 14¾″ × 59¼″. Courtesy Museum of Fine Arts, Boston (Chinese and Japanese Special Fund, 12.903).

a canvas or to the relationships within a composition, on intuition, expressive needs, and other priorities rather than divine numbers. The airy vastness of Tung Yuan's *Clear Day in the Valley* (Figure 3-12) overwhelms the tiny people—seen strolling at the end of the peninsula on the left and on a trail in the lower right. By contrast, in Seurat's picture the people dominate; even in the distant parts of the scene this dominion is signified by the bridge and buildings on the horizon. One reason for the dramatic difference with regard to the proportional relations of nature to people in the two pictures has to do with two profoundly different world views. Asians extol nature much more than do Europeans and Americans. Asians subordinate their wills to nature's will, rather than the Western people's tendency to do the reverse. To Westerners, humanity rules nature, to Orientals, humanity is part of nature. The Oriental attitude accounts for the priority given to nature in Chinese and Japanese depictions of it.

Balance

Balance refers to equilibrium. Often, when the subject of balance comes up, it concerns automobile tires or seesaws. A tire's weight should be equally distributed along its circumference; people on either side of a seesaw plank need to be the same weight. So what do these facts have to do with art?

A tire is analogous to *radial symmetry* in art—that is, identical or very similar elements radiating from the center of a design. The octagonal ceiling of the mosque (Figure 3-7) is an example of radial balance; the 12-place color wheel in Figure 2-3 is another. Likewise, the seesaw analogy pertains to *bilateral symmetry*—that is, identical, or mirror image, elements on either side of a vertical line in the center. This kind of balance is much more common than radial balance, particularly in architecture: Michelangelo's Capitoline Hill (Figure 2-35), Saarinen's monumental arch (Figure 3-9), and a Doric column (Figure 3-10) are examples of bilateral symmetry. Bilateral is also fairly common in painting and sculpture: the examples in Chapter 2 by Anuskiewicz (Figure 2-8), Brancusi (Figure 2-23), and Martin (Figure 2-28) all come to mind. Sometimes two sides of a composition are similar enough to imply bilateral symmetry, but varied enough to challenge you to identify the differences. Called *approximate symmetry*, this type of balance is something like non-identical twins on a seesaw. The elaborate Mayan relief of a human figure in the jaws of a dragon (Figure 3-13) displays slight variations on either side of its central axis. Indeed the boulder from which it was carved is only approximately symmetrical, but this is not apparent at first glance. In chapter 2, the Escher woodcut (Figure 2-16), in which day on the left transposes to night on the right,

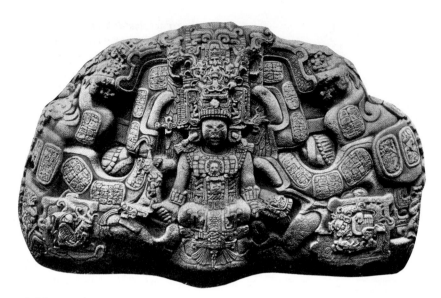

3-13 *Great Dragon*, sixth century A.D. Stone, 7′3″ high. Maya, Quirigua, Mexico.

and the Raphael mural (Figure 2-39), in which a throng of noble sages add variety to a dramatically symmetrical architectural setting, are both good examples of approximate symmetry.

So much for the easy kinds of balance. The most common kind in art is *asymmetrical* balance, in which the elements on either side of a central dividing line are *not* identical. To artists, this situation is much more of a challenge—akin to balancing apples and oranges, or a fat uncle and a six-year-old niece on a seesaw. In a picture, this challenge can be explained in terms of balancing *visual weights* and *psychological weights*. Visual weight refers to such things as the relative size, brightness, or amount of contrast of one or more of the visual elements. Psychological weight usually refers to the relative importance of a person or object in the picture.

Among the "heaviest" in visual weight in Seurat's composition are: the man lying down, because of his size and the value contrasts of his white towel and smock set against the dark colors of the hat, trousers, and dog; the central bather, because of his size and location; the central bather's white towel, because of its extreme lightness; and the bather on the right, whose orange hat in combination with the blue background provides the strongest hue contrast in the painting. Unlike actual weights, visual weights cannot be accurately measured; so it is difficult to determine exactly how a large figure with a white smock balances a small one with an orange hat. However, considering everything with visual weight (including the boy with the straw hat, whose size and color are also relatively promi-

nent), it would seem that there is more weight on the left than on the right. But in a representational picture, one cannot overlook the importance of psychological weight. In this case, the right side prevails because, for one thing, a river has more psychological importance than a riverbank; for another, almost all of the people are facing right; and, finally, the most important figure—the large bather—is slightly to the right of center. Thus we can probably say that the slightly heavier visual weight on the left is counterbalanced by the heavier psychological weight on the right.

Because the Hofmann work is completely abstract—lacking not only images, but also symbols—psychological weight is not a factor. In terms of visual weight, the red rectangle is no doubt the heaviest; besides being the largest feature, it is red (the spectrum hue with the longest wave lengths), a color that is an attention-getter. But its position is very off-center, a fact that would pull the picture down and to the left except for countervailing forces that tug the composition in the opposite direction. One tug is the apex of the triangle mentioned earlier (Figure 3-8) that helps to draw our attention to the upper right. Other forces involve color: the only violet in the composition is in the upper rectangle, again, drawing our attention in that direction; the blue rectangle exerts a strong rightward pull; and the narrow red stripe on the right of the blue rectangle reinforces that pull (discover how the balance of *Rhapsody* is upset simply by placing a pencil over the red stripe).

The general feeling when looking at *Rhapsody* is that of balance (this feeling may be a better test than that of trying to add up all the visual weights and to compare the two halves of the picture). Hofmann, who was a famous teacher as well as a famous painter, was concerned with the push–pull of compositional tensions in abstract painting. Having had first-hand contact with some of the famous modern masters in Europe, Hofmann became a guiding light for a whole generation of young American painters in the 1940s and 1950s. He was one of the seminal influences in the development of a new school of painting called Abstract Expressionism (Chapter 7). A half century earlier in France, Seurat had a similar impact on the progressive art of his time. More than most artists, before or since, Seurat was preoccupied with the principles of good composition, and desired to generate an impression of harmony and repose in the viewer.

But observing the principles of design is not in itself sufficient to create a great work of art, and many great works do not reflect all of the principles. Indeed, judging by much contemporary art, one would think that the principles were made to be broken as much as to be observed. Anuskiewicz's *All Things Do Live in the Three* (Figure 2-8), for all its brilliant color, lacks variety; Martin's *Untitled #8*

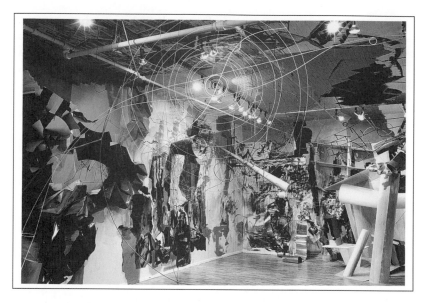

3-14 Judy Pfaff, *3-D:* Installation
at Holly Solomon Gallery, 1983.
Mixed media, 45′ × 22½′

3-15 Yves Klein, *IKB 175*, 1957.
Pigment on canvas, 19½″ ×
23⅓″ × 2″. Musée d'Art Moderne
de St. Etienne.

(Figure 2-28) lacks variety, dominance, and movement; Riley's *Current* (Figure 3-5) lacks dominance and, most notably, stability.

These abstract works at least provide us with discrete shapes and patterns to ponder, however. In some experimental works even these virtues are lacking. At one end of the aesthetic spectrum is *3 D* (Figure 3-14), an installation by Judy Pfaff; at the other end is *IKB 175* (Figure 3-15), a canvas painted one color (blue) by Yves Klein. The former is all movement and flux, the latter is pure stasis. In both, the issues of unity, variety, proportion, and balance are irrelevant. In the Klein, even the issue of figure-ground is irrelevant.

CRITICISM

As we have said, criticism involves separating a work into its parts to find out their interrelationships. This is called analysis. A critic certainly analyzes, but that is not all. There is also a creative aspect to criticism, as the critic must formulate a defensible opinion about the work in question.

Edmund Feldman, a well-known writer on art, has identified four stages of what he calls "the critical performance"; description, formal analysis, interpretation, and judgment.[1] He is not necessarily referring to *professional* criticism, the type that is published in newspapers, news magazines, and the art press. In principle, Feldman's stages apply to that kind of criticism. But in practice, a professional critic does not always use each of these stages, let alone give them equal emphasis or use them in any particular order. These stages comprise a method that anyone can use to examine a work of art. It is an inductive method, proceeding from the particular to the general. If followed thoughtfully, this method of examination prevents one from coming to premature conclusions before all the evidence is in. A written critique does not necessarily have to mechanically follow the four stages, but the writer should go through the operations of description and analysis before interpretation, *and* before judgment.

Description

The object of this stage of criticism is to identify and record individual facts about the work. The name of the artist (or culture), title, medium, dimensions, and date can be quickly gleaned from the

[1] Feldman, Edmund Burke. *Varieties of Visual Experience: Art as Image and Idea.* Englewood Cliffs, NJ: Prentice-Hall, 1981.

label information. The descriptions of the subject matter, the form, and, if necessary, relevant information about the effects of the medium are more challenging. Objectivity is very important. Interpretation, such as "Goya's *The Third of May, 1808* is about atrocity," or judgment, such as "Saarinen's arch is a beautiful monument," is entirely inappropriate—even though such statements may seem patently obvious. Even to identify the people on the left side of Goya's painting as "innocent civilians" is questionable; to say that they "*appear* to be civilians" would be more acceptable. All statements at this stage must stand the test of general agreement among a group of reasonable people seeing the same thing.

For representational works like *The Third of May, 1808,* description entails an inventory of the subject matter as well as the visual elements and the effects of the medium. For abstract works like *Rhapsody,* in which subject matter is absent, pointing out the visual elements and such things as the quality of the paint becomes very important. The lengthy statements in Chapter 1 about the Alaskan mask (Figure 1-1), the Peanuts comic strip (Figure 1-2), and Picasso's *First Steps* (Figure 1-3) are good examples of objective description about semi-representational works: "The surface of the mask reveals the marks of the carver's tool and a spattering of color around the mouth . . ." " . . . the face of the infant is made of lines and shapes that come and go in many directions." The first excerpt refers to aspects of subject matter, color, and medium; the second, to aspects of subject matter, lines, shapes, and directions. In Chapter 2, the statement that "The red of the background in *All Things Do Live in the Three* (Figure 2-8) is actually the same throughout . . ." is a claim about color in an abstract work. The following comment on Morris Graves' *Blind Bird* (Figure 3-16) is a good example of description by professional critic Ron Glowman: "Its eyeless sockets and beak are modeled, while the body appears as a dark oval. Its feet and the rock it is perched upon are caught in constricting webs of white line."[2] Notice how aspects of the subject matter have been woven together with claims about shape, line, and color.

Formal Analysis

The object of formal analysis is to identify relationships. Using the information from the description stage, especially that which pertains to the form, a critic would identify the ways in which lines, shapes, colors, and so forth have been organized and interrelated. These include similarities, contrasts, continuities, and overall quali-

[2] Glowen, Ron. "Morris Graves: East and West." *Art in America 72,* 8 (September, 1984):191.

3-10 Morris Graves, *Blind Bird*, 1940. Gouache on paper, 30⅛″ by 27″.
Collection, The Museum of Modern Art, New York.

ties. Are colors and shapes repeated? Are some things vividly different in size, shape, color, or light and dark? Are there rhythms or continuities? Are there any significant connections between formal elements and subject matter—such as the use of a cool color to emphasize the coldness of a winter landscape? Such overall qualities as "basically rectilinear," "roughly-textured," or "brightly-colored" are germane to identify at this stage.

The principles of design are about relationships; therefore, the first part of this chapter contains many statements related to the analysis of such relationships: " . . . its position is very off-center, a fact that would pull the picture down and to the left except for countervailing forces that tug the composition in the opposite direction." Or "While *Bathing at Asnières* is animated by hue contrasts,

organic shapes, and some rhythms, it is stabilized by its studied arrangement of figures and objects, the simple forms of the people, and the horizontal format."

Interpretation

The object of this stage is to arrive at the meaning or content of the work under question. What feelings, ideas, or emotions does it evoke that can be related to the description and analysis? This is perhaps the most creative part of the critical process. Feldman suggests that the critic *hypothesize* a meaning, and then try to support his or her hypothesis by referring to the information obtained in the previous stages. For example, to defend the notion that "*Rhapsody* emphasizes vitality and energy much more than repose," the critic might argue that its "lively brushwork and highly-charged color" outweigh the sedentary effects of its rectangles and triangular arrangement. To say that *Bathing at Asnières* "describes a quiet moment of summer torpor" could be defended by referring to both the subject matter and the composition—in other words, "the studied arrangement of figures and objects, the simple forms of the people, and the horizontal format."

So far in our examples, we have illustrated some ways in which interpretation can be based on the *visible* properties of an artwork— its images and composition as revealed in the process of description and analysis. Recall that the description stage also includes label information such as the title and the date. Sometimes this is helpful; no doubt the title *Rhapsody* gives us a clue as to the artist's intentions. But often this information is limited or ambiguous. For example, the title, *Tree of Fluids (Body of a Lady),* for Dubuffet's thickly-painted image of a woman (Figure 2-32) raises more questions than it answers. Although it helps us to identify the gender of the image, the title still leaves us to puzzle over its meaning and its relationship to Dubuffet's deliberately primitive style. Is it intended to equate females with sap rising in a tree? Perhaps it is a reference to some vital creative principle—just as Dubuffet's style is intended to evoke a sense of élan vitale. If so, why the term "lady" rather than "woman"?

This discussion on interpretation brings us around to the point made in Chapter 1 about the fact that what we see in a work of art—any work of art—depends on a combination of visual information and past experience. While *Bathing at Asnières* may not be as demanding on our understanding as *Tree of Fluids (Body of a Lady),* it nevertheless depends on our experience of summer pastimes and

their connotations. Theoretically, an abstract work like *Rhapsody* does not depend on such knowledge, but it nevertheless requires the viewer to have some experience with the aims and premises of modern, abstract painting—including, perhaps, knowledge of the principles of design. Obviously, complex works, like *Tree of Fluids* or works from unfamiliar cultures and times, like *Clear Day in the Valley* (Figure 3-12), require sophisticated knowledge to determine their content. Interpretation, then, is based on description and analysis *plus* whatever can be brought to bear from the critic's knowledge, ideas, and past experience.

Judgment

The object of judgment is to determine the quality or lasting importance of a work. Initially a viewer, even one who is playing the role of a critic, may judge a work by his or her personal response. There is no reason to be dishonest or to conceal one's feelings. If a person is knowledgeable about art, such feelings can sometimes be a reliable source for judging quality. But there is a difference between personal feelings about a work and the public value of that work. It is certainly possible—and legitimate—to like a bad artwork, or to dislike a good one.

The question is: what criteria should we use to determine excellence in art? This is perhaps one of the most difficult questions in the world. To answer it in detail is beyond the scope of this chapter or even of this book. But some of the criteria that different critics have used—whether explicitly or implicitly—will be analyzed in this section. As with interpretation, not all of the criteria are involved with the visible properties of works.

Design quality Variety, unity, movement, balance, and so forth. Using design principles as criteria in art criticism relates to a twentieth-century doctrine of art called *formalism*. Although formalist critics do not necessarily refer to the principles of design as we have articulated them, the focus of their interpretations and judgments is almost exclusively on the form of a work.

Expressiveness How effectively the work expresses or reflects a theme or world view. In contrast to formalism, this criterion takes into consideration such things as subject matter and symbols. The subject matter itself, however, is not as important as the vividness of its presentation or embodiment. Expressiveness can also be a judgment about the strength of human feelings aroused by the work. In this sense expressiveness is related to a twentieth-century doctrine called *expressionism*. In some ways the opposite of art that stresses

formalistic values, expressionistic art tends to exhibit distortion, fragmentation, and the communication of overstressed emotion. A critic with a taste for expressionism would tend to look for different qualities in a work than would a formalist.

Originality A judgment about the work's inventiveness or novelty. Does it display a fresh theme, or a fresh treatment of an old theme? Is the medium unique in some way? Originality operates at different levels, depending on an individual's past experience with art. What appears to be very fresh to some people may in fact be quite derivative. The degree of originality in a work, therefore, is not purely a visual matter. Although not always openly stated as such, originality was the driving force behind much of the art created so far in the twentieth century. It also seems to have been the criterion for judging much of Western art going back to the early Renaissance. In other words, a high value tends to be placed on works by artists who pioneered new ideas of style, theme, or medium.

The fame of the artist, the importance of the artwork in the history of art, the demand for the artist's work, the market value of the work, and the opinions of critics, collectors, art dealers, and art historians have been criteria for judging art. Yet none of these criteria are directly related to the visual properties of a work. However, for purposes of assessing the public value of a particular piece, any of these could override such criteria as design quality or expressiveness.

There is no single criterion or even a single cluster of criteria for judging excellence in art. Not only do different kinds of art require different criteria, but there are different schools of thought about what constitutes good art.

SUMMARY

Composition is the act of organizing an artwork. Even such seemingly random pieces as Pfaff's *3D* (Figure 3-14), and such simple paintings as Klein's one-color *IKB 175* (Figure 3-15) require some process of ordering. If nothing else, Klein chose the shade of blue and determined that the dimensions would be $19\frac{1}{2}$ by $23\frac{1}{2}$ inches. Many decisions are involved in composition. The principles of design are guidelines, a system of strategies, available to the artist. Bear in mind, though, that many great artists, past and present, have not always followed the guidelines.

Criticism is the act of analyzing, interpreting, and judging a work. Like the principles of design, the stages of criticism are guidelines that may or may not be followed by professionals. These stages are recommended for the student of art.

Much is made of the fact that it takes a lot of learning to make art; it is equally true that it requires learning to see art. This chapter is intended to give some insight into the ordering processes of both the artist and the critic as these relate to what the viewer perceives— insight that will enhance appreciation and enjoyment of works of art. The issue is not "knowing what you like," but "liking what you know."

CHAPTER

4

TWO-DIMENSIONAL MEDIA

THE MATERIALS OF WHICH an artwork consists affect its appearance as much as any of the visual elements and principles of design discussed in the preceding chapters. A picture will not look the same in oil as in mosaic or in watercolor, not only because of the appearance of each material, but also because each material requires the artist to work in a different way.

The materials and techniques involved in making a work are known as the *medium*. Oil paint is a medium, as are marble, bronze, and photography. An art appreciation book written a century ago would have included a relatively small number of media. But in the late twentieth century, new media, new concepts of art, acceptance of some media that had not previously been considered art, and rediscoveries of some ancient media have greatly expanded this number. In order to examine these media, we will classify them under the broad headings of two-dimensional and three-dimensional. This chapter reviews two-dimensional media; Chapter 5 will focus on three-dimensional media.

The media reviewed in both chapters will be confined primarily to the *fine arts*—in other words, art found in galleries and museums, or reviewed in city newspapers, arts magazines, or college text books—as opposed to the *applied arts*—in other words, advertising, illustration, comic strips, Hollywood movies, commercial television, interior decoration, industrial design, and so forth. Many of the media reviewed here are used in both the fine arts and the applied arts, but many others, like mosaic, are rarely used in the applied arts.

MOSAIC

Mosaic is a medium that is not common today. A design composed of numerous pieces of stone or glass—*tesserae*—set in cement, mosaic was among the most popular media in the ancient world and in the early days of Christianity. Its heritage goes back to at least the

eighth century B.C. when it was used as flooring, before people discovered that the stones could be arranged in decorative patterns to ornament a wall, ceiling, or floor. In some ways more like a crossword puzzle than a painting, a mosaic requires an artist to create a design or picture by piecing together many bits of color. Nevertheless, it has been called "painting in stone." And to the extent that mosaic is colorful, durable, and part of a wall or ceiling, it is similar to fresco.

The Romans, who embedded mosaic designs in walls and floors, used tesserae of variously colored pieces of stone. When making a wall mosaic, Roman artists often copied realistic paintings. To imitate the effects of texture, shading, and atmosphere with thousands of minute tesserae was indeed a formidable task. For floor mosaics, Roman artists often resorted to simpler figure-ground relationships set with cubes of marble.

The early Christians, who covered the walls and ceilings of their churches with mosaics, used pieces of glass rather than stone. Because glass reflects, and because tesserae do not lie on a uniformly flat plane, they reflect in all directions. Imagine the inside of Rome's Santa Maria Maggiore church filled with mosaics like *The Parting of Lot and Abraham* (Figure 4-1). This one was intended to

4-1 *The Parting of Lot and Abraham,* c. 430 A.D. Mosaic. Santa Maria Maggiore, Rome.

dramatize a legendary moment in the history of the Jews for early Christian worshipers, many of whom did not own bibles or were unable to read. Because of the intent, and also because of the mosaic medium, the artist composed the scene with large masses representing Abraham and his family on the left and Lot and his family on the right. The figures of both are stated boldly with easily readable postures and gestures; there is no question that the two are splitting company. Still, the starkness of the design and figures is tempered by the surface reflection—a radiance befitting the mystery of an early Christian church.

PAINTING

There are a variety of media that come under the heading of painting. All of them consist essentially of applying colors made of *pigments* mixed with a *vehicle* (a liquid such as egg yolk or oil) to a *support* (a surface of some kind, such as canvas or wood). Oftentimes a vehicle is combined, in varying degrees, with a *thinner,* such as water or turpentine. A thinner lowers the viscosity of the paint so that it can be spread more easily.

Fresco

Fresco is the art of making murals (wall pictures) by painting on wet plaster with pigments mixed with water. (Sometimes this method is termed *true* fresco to distinguish it from fresco *a secco*—a painting on dry plaster.) In the late Middle Ages (c. 1300s), fresco replaced mosaic as the preferred medium for murals. It was the method used by Giotto di Bondone to create a cycle of pictures on the life of Christ for the Arena Chapel in Padua, Italy. Because plaster dries rapidly, Giotto was forced to plan ahead to ensure that each application of fresh plaster matched the shape of a figure (or a shape within that shape) and that he could complete that part of the picture before it dried. He was unable to make corrections or repaint any area without removing the old plaster and entirely redoing the unsatisfactory portion on a new base. This meant that he had to develop not only a carefully planned composition but carefully planned working strategies for each day that he worked on the mural. Because of its nature, fresco is best suited for compositions that stress large well-defined, statuesque figures—for example, Giotto's *Meeting at the Golden Gate* (Figure 4-2). But the nature of the medium did not prevent Giotto from representing such delicate emotions as those expressed in the tender embrace of Joachim and Anna (who have just been told that Anna will give birth to Mary, the mother of Jesus).

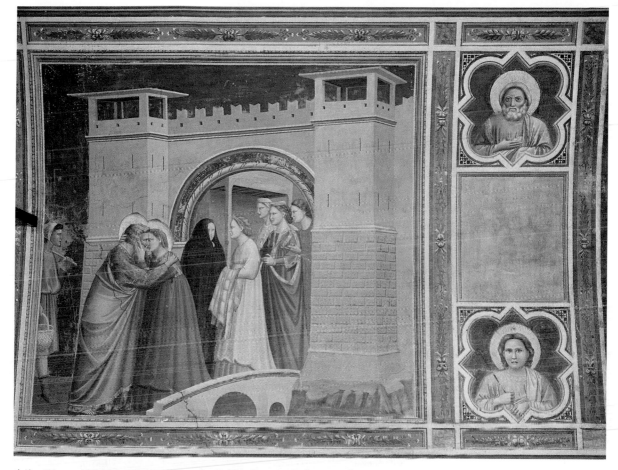

4-2 Giotto di Bondone, *Meeting at the Golden Gate*, early fourteenth century. Fresco. Arena Chapel, Padua.

Although practiced by the ancient Greeks and Romans, true fresco enjoyed its greatest popularity and highest level of development during the Renaissance—exemplified in the works of Giotto and, much later, Raphael (Figure 2-39) and Michelangelo (Chapter 9). Because, like mosaic, fresco literally is *in* the wall (and not a film of paint *on* the wall), it can better withstand the effects of air pollution, as well as wear and tear in general. A fresco will survive as long as the building to which it is attached does.

Tempera

For smaller movable works, such as altarpieces, artists in Giotto's time used wood for support. They painted with *egg tempera*, a medium of pigments mixed with egg yolk and water. [Egg yolk, a

natural emulsion, has been the traditional base for tempera, although today many different emulsions—based on such substances as casein (a milk product), gum arabic, and wax—are used.] When applied to a surface covered with a thin coat of *gesso* (a substance similar to plaster of paris), a film of tempera produces a durable matte finish. Unlike fresco, tempera allows artists to repaint an area when necessary to effect changes or corrections. Yet like fresco, tempera dries rapidly and does not blend easily. Color mixing must be accomplished by painting two or more layers of paint with short fine brush strokes, allowing lower layers to optically mix with upper layers. The rapid drying, however, allows the artist to overpaint previously painted areas and to continually improve effects of shading or texture.

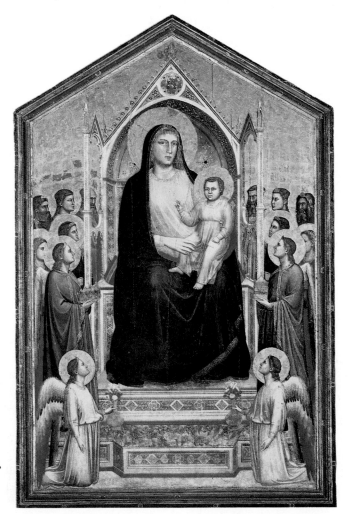

4-3 Giotto, *Madonna Enthroned,* c. 1310. Tempera on wood, 10′8″ × 6′8″. Galleria degli Uffizi, Florence.

Because of its inherent characteristics, tempera lends itself to patient execution and delicacy of treatment. Although the people in Giotto's altarpiece, *Madonna Enthroned* (Figure 4-3), are just as fully developed and "sculptural" as the ones in his fresco (Figure 4-2), the textures and details (as in the gilded background, the throne, and the gifts of the angels) are much more refined. The same delicacy, combined with tempera's soft, matte finish, is present in *Daydream* (Figure 4-4) by Andrew Wyeth, one of the few artists today who use the medium. As in many of Wyeth's works, this one evokes a mood of quiet detachment—here, combined with nuances of sexuality—a quality to which tempera seems well suited. Still, the advantages that tempera may have for artists like Wyeth would be disadvantages for others. Its working tendencies do not lend it to dramatic subjects or lively, spontaneous-looking effects. Also, tempera colors tend to change while drying, making it difficult to predict the final results.

4-4 Andrew Wyeth, *Daydream,* 1980. Tempera on wood, 20″ × 27″. The Armand Hammer Collection, Los Angeles, California.

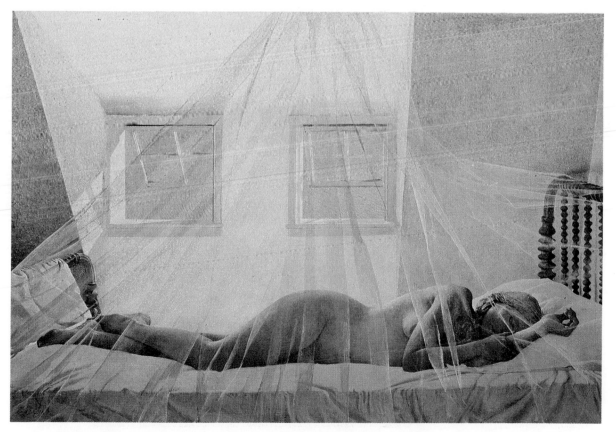

Oil

Beginning in the early 1400s, Flemish artists began to mix pigments with oil. They used the medium in a limited way, applying it in thin, translucent (partially transparent) films of color over a tempera "underpainting"—the initial stage of a picture in which the drawing and values were established in monochrome (one color). This combination of tempera and oil permitted Flemish artists to make altarpieces and portraits full of realistic detail and enamel-like colors, notable to this day for their superb craftsmanship (Figure 4-5). In the late 1400s, specially treated canvas was introduced as a support to replace wood. By the early 1500s, Venetian artists began to omit the tempera underpainting stage, using the oil medium from start to finish. Thus the era of oil-on-canvas—the most popular medium in the visual arts—was born. One reason for its popularity had to do with the lighter weight of canvas. But the premiere breakthrough was the versatility of the oil paint itself. Unlike fresco or tempera, oil paint dried slowly enough for an artist to take up or leave off wherever and whenever convenient and to change an area at will. Paradoxically, the slow-drying medium permitted artists to work not only more freely but more quickly. Contrary to tempera, the consistency of oil paint is not relatively fixed. Oil can be as thick as peanut butter or as thin as water; it can be translucent or opaque. Thus, it allows for an unlimited range of color and textural variations. To catalog the different ways oil can be used and the effects that can be obtained from its use would be virtually to recite the history of European painting from the fifteenth century to the present. We have already seen more than a dozen examples of oil-on-canvas paintings—both realistic and abstract—in the pages of this book. Some, like Monet's *Palazzo Da Mula, Venice* (Figure 2-13), Manet's *Flowers in a Crystal Vase* (Figure 2-33), and Rubens' *The Lion Hunt* (Figure 3-4), especially exemplify the textural richness and fluid effects usually associated with the medium. It's almost impossible to imagine these works being painted in another medium. Perhaps the one painting of all that we have seen that is most exemplary of the medium is Hofmann's *Rhapsody* (Figure 3-2). Indeed its content is—as much as anything—about oil paint itself.

Acrylic

Many abstract artists share with Hofmann the appreciation of paint and its expressive capabilities; by eliminating the subject matter and any kind of imagery, they call to the viewer's attention these very qualities. Some artists are now using *acrylic paint,* a synthetic

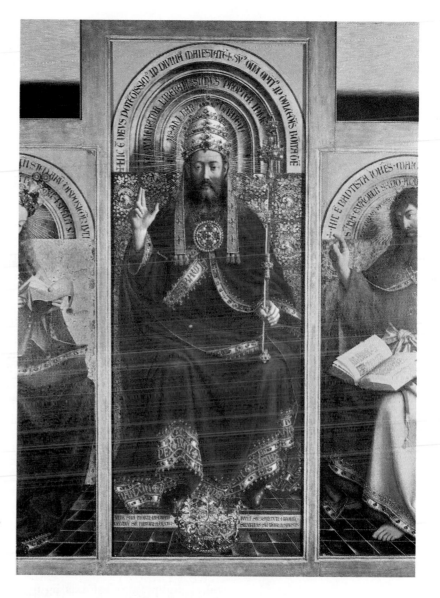

4-5 Hubert and Jan van Eyck, detail of *God the Father*. From *The Ghent Altarpiece*, 1432. Tempera and oil on panel. St. Bavo, Ghent.

medium consisting of pigments mixed with polymer first developed following World War II. While acrylics can be used to imitate almost every effect of oils, they are even more versatile. To the untrained eye, acrylic paintings may be indistinguishable in appearance from oil paintings—especially if the works in question are relatively traditional. But to the artist who works with this medium, they are very distinguishable. Oil offers far more resistance to the brush. Acrylic can be mixed with water and is much faster drying, traits that can be considered either advantages or disadvantages

4-6 Sam Gilliam, *Seahorses*, 1975. Acrylic on canvas, largest piece 30′ × 90′. As exhibited at the Philadelphia Museum of Art. Courtesy of the artist and the Middeudorf Gallery.

depending on what the artist is trying to do. Sam Gilliam turns the water-soluble characteristic of acrylic into an aesthetic advantage by soaking the paint directly into raw canvas—something he would be unable to do with oil, since oil decays cloth. (For oil paintings, canvas has to be treated by *sizing*—applying a material such as glue to seal its surface—prior to the application of the paint.) In a work like *Seahorses* (Figure 4-6), the paint permeates the canvas, staining it rather than lying on the surface in layers of varying thicknesses.

Watercolor

Watercolor consists of painting with pigments mixed with water on white paper. (Today, the pigments are usually bound in gum arabic and packed in tubes.) Like the canvas in Gilliam's work, the paper in a watercolor is stained with color—the white of the paper mixing optically with the color of the paint. The lightness or darkness of a color is established by the ratio of water to pigment (whereas with oil or tempera, a color is lightened by the addition of white). A translucent film of watercolor applied with brush to an area of paper is called a *wash*.

Historically, watercolors were used as studies for larger paintings or for applying washes to drawings or prints to add a bit of color. But in the nineteenth century, watercolors came to be used as a medium in their own right by such artists as Winslow Homer (Figure 4-7). Because of their convenience and fresh results, watercolors are especially effective for outdoor subjects. However, they are not easy to use. Errors are ineradicable and colors cannot be

4-7 Winslow Homer, *The Berry Pickers,* 1873. Watercolor, graphite and gouache, 9¾″ × 13⅞″.
Collection of Mr. and Mrs. Paul Mellon, Upperville, Virginia.

changed, except to be made darker. Inexperienced artists tend to produce muddy rather than fresh colors. But, in the hands of skilled artists, watercolors are quite marvelous.

Gouache

Gouache is opaque watercolor. Unlike transparent watercolor, gouache does not depend on white paper for achieving white or light colors. Its whiteness comes from the use of white pigments. There is some controversy among artists as to what constitutes true gouache—whether it consists of simply mixing standard watercolors with white tempera, or by formulating a special mixture from the start. Regardless, though gouache is somewhat less tricky to use than watercolor, it is capable of imparting some of the same sense of freedom and spontaneity—a capability that was put to good use by Morris Graves in the contrasting lights and darks of his mysteri-

ous *Blind Bird* (Figure 3-16). Recall the somber bird whose feet, according to one critic, are "caught in constricting webs of white line" that seem almost to be illuminated by some inner source.

Airbrush

A modern technique that has enabled artists to achieve effects previously impossible is the *airbrush*, a type of miniature spray gun that can be adjusted from a narrow, pencil-thin jet to a broad mist of paint. The instrument never touches the canvas and can be used to produce an absolutely smooth, evenly shaded surface on the painting. The first group of artists to make serious use of it was the Photo–Realists of the late 1960s who adapted it to a technique similar to commercial color printing processes in which colors are separated prior to printing.

DRAWING

Drawing consists of making marks—usually of a single color on a support, usually paper—and including the color of the support as part of the work. Historically, drawings, like watercolors, were used for recording quick descriptions or planning larger works such as paintings or sculptures. And they are still used for these purposes. But for centuries in China, ink drawings had been highly esteemed as finished works of art and, as early as the eighteenth century in the West, artists began to create and sell drawings as works of art. Because they are the least complicated of all the media, drawings are thought to be more spontaneous and therefore more reflective of an artist's thinking. For this reason they are collected and highly valued whether or not they were originally intended to be works of art.

Such dry media as pencils, sticks of charcoal, chalk, and crayons are probably the most common and convenient tools for making drawings. The artist makes marks or lines directly on the paper. Chiaroscuro and variations of value are created by different degrees of pressure on the drawing tool; recall the conte crayon drawing by Seurat (Figure 2-6). These variations can also be achieved by the close or wide spacing of small lines (hatching). In either case, the color of the paper mixes optically with the color of the marks.

When using a pencil (which contains a combination of clay and graphite), the degree of darkness can be controlled by one of the means stated previously, but also by the degree of hardness of the pencil. A hard pencil produces thin, light lines; a soft pencil produces thicker, darker lines. To produce his highly accomplished *Feline Felicity* (Figure 4-8), Charles Sheeler employed almost all the pencil techniques available: varying pressure, hatching, using

4-8 Charles Sheeler, 1934. *Feline Felicity*, Conte crayon on white paper, 14⅛″ × 13¼″. Courtesy of The Fogg Art Museum, Harvard University, Cambridge, Massachusetts, (Louise E. Bettens Fund).

different grades of pencils, and probably others. Notice not only the detail but the infinite variety of values in this virtually photographic rendering. Compare it to Felix Klee's pencil drawing of the same subject (Figure 4-9). Rather than attempt to rival photography, Klee captured the essence of "felinity" as well as, if not better

4-9 Felix Klee, *Fritzi*, 1919. Pencil. 7⅝″ × 10⅝″. Collection, The Museum of Modern Art, New York, (gift of Mrs. Donald B. Straus).

than, Sheeler with just a few carefree strokes. Indeed the lack of visual information in Klee's drawing encourages more viewer involvement. Both drawings exemplify valid, though very different, ways of using pencil.

Next to pencil, charcoal (literally, wood turned to coal) is the most popular of the dry media. Also, charcoal—whether "vine" (thin, brittle sticks) or "compressed" (thick, chalklike sticks)—comes in different degrees of hardness. Because it produces marks and values easily, and also erases easily, charcoal is ideal both for students and for professionals who work instinctively. Edgar Degas, one of the most instinctive drawers of all time, used the medium in a variety of ways—the sharp end of the stick for lines, the blunt side for dark smudges, and probably even his fingers for lighter smudges—to indicate the contours and volumes of a woman's body in *After the Bath* (Figure 4-10). Moreover, the spontaneity of these marks and smudges are reminiscent of the brusque movements the woman would employ to dry her hair. Finally, it should be men-

4-10 Edgar Degas, *After the Bath*, 1890–92. Charcoal drawing on pink paper, 19¾″ × 25⅝″. Fogg Art Museum, Harvard University, Cambridge, Massachusetts, (bequest of Meta and Paul J. Sachs).

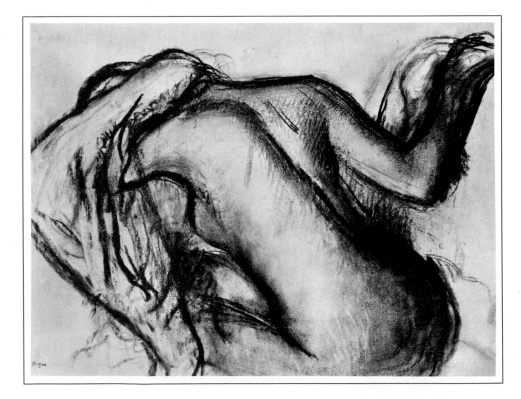

tioned that the advantage of charcoal's easy erasability can be a disadvantage: unless sprayed with fixative (shellac mixed with alcohol) or framed under glass, the surface of a picture made with charcoal is easily smeared or dusted away.

Mary Cassatt, a colleague of Degas', could use a stick of charcoal with equal verve. This is demonstrated by her *Sara in a Large Flowered Hat, Looking Right, Holding Her Dog* (Figure 4-11), though the medium in this case is *pastel*, not charcoal. Similar to charcoal in both substance and function, pastel is actually a high quality form of colored chalk (precipitated chalk, pigment, and powdered gum). The obvious difference between it and other dry media is the fact that pastel comes in a variety of hues. It is also difficult to classify as

4-11 Mary Cassatt, *Sara in a Large Flowered Hat, Looking Right, Holding Her Dog,* c. 1901. Pastel on paper, 27⅝″ × 21⅝″. Berry-Hill Galleries, New York.

a medium: is it more akin to drawing or to painting? Cassatt's picture, for example, is on paper, but it resembles a painting, specifically, an Impressionist painting (Chapter 12). When introduced in the 1700s, pastel was very popular with portrait painters, as it allowed the artist to use a variety of colors without the annoyance of mixing paints or preparing canvas. Still, a picture in pastel, like one in charcoal, is quite fragile and therefore needs to be either sprayed or framed in glass.

Unlike dry media, ink—part of the wet media—does not come in different grades of hardness, nor does it allow the artist to produce variations of value by varying the pressure on the tool. Chiaroscuro, shadows, and values have to be created by hatching and crosshatching. Sir David Wilkie, a popular nineteenth-century illustrator, used a pen almost as freely as Degas used a stick of charcoal. In *Arrival of the Rich Relation* (Figure 4-12), Wilkie effectively described the conditions of a street at night illuminated by light coming from an open door. Perhaps more important, though, is the way in which his vigorous lines—running and crossing each other in all directions—reflect the robust humor of the subject.

Instead of a pen, Diego Rivera used a brush loaded with ink to create the bold lines of *Mother and Child* (Figure 4-13). To emphasize the three-dimensional character of the stocky woman and child, and to provide accents throughout the composition, Rivera

4-12 Sir David Wilkie, *Arrival of the Rich Relation*. Ink on paper, 9¾″ × 12⅜″. The Fine Arts Museums of San Francisco, Achenbach Foundation for Graphic Arts, (Archer M. Huntington Fund).

4-13 Diego Rivera, *Untitled (Mother and Child)*, 1936. Ink drawing on paper, 12⅛″ × 9¼″. San Francisco Museum of Modern Art (Albert M. Bender collection, gift of Albert M. Bender).

varied slightly the pressure on the brush and thereby varied the widths of the lines. Notice though that the opacity of the lines is constant. However, like watercolor, ink can be made translucent in varying degrees by diluting it with water. A translucent film of ink applied with brush to paper is called *ink wash*. When handled skillfully, ink washes are capable of producing a wide range of values. Among the finest examples of ink wash are those by Chinese landscape artists (Figure 3-12).

PRINTMAKING

Like drawings, prints of all kinds are usually produced on paper, but differ from drawings in that they involve the production of numerous identical copies, or *editions*, of a single image by means of partially mechanical methods. (Another difference is that the ink used in printmaking is usually thick and oil based rather than fluid and water based.) It is important to know that each edition is considered an original work of art, even though in some cases they may number in the thousands. Today, most printmakers produce only a limited number of editions and then destroy the *plate*—in other

words, the piece of wood, metal, or stone from which the image was made.

Since paper was first invented by the Chinese it is not surprising that they were the first to invent the woodcut—the most ancient form of printmaking—for the purpose of making pictures. In the West, printmaking first came into use in the fifteenth century mainly as a way to produce cheap substitutes of religious paintings. It was also used to illustrate books and periodicals and to reproduce famous works of art. In the days when travel was limited and photoreproduction was nonexistent, prints were the major way of spreading the knowledge of art from one country to another. Today printmaking, like painting and drawing, is considered one of the fine arts.

Woodcut

4-14 Relief printing.

The *woodcut,* a form of *relief printing* (Figure 4-14), is made by drawing an image on a block of wood (along the grain), cutting away the areas that are to remain white, and leaving the areas and lines to be printed raised. After the image has been rubbed with ink, it can be transferred to a piece of paper under moderate pressure. When we consider that the artist is forced to think in reverse—that is, to create lines by leaving, rather than by cutting, thin ridges of wood— we cannot help but admire the precision and control that made possible such complex and fine-lined pictures as those by Dürer (Figure 2-7) and Escher (Figure 2-16).

In terms of sheer virtuosity a *wood engraving,* such as that used for the title page of *The Ancient Mariner* (Figure 4-15) by Gustave Doré, is perhaps even more remarkable. Wood engraving, as distinguished from regular woodcut, involves cutting the image into the *end-grain* of a block of wood. Because the end-grain—particularly of a block of boxwood—is hard and close in texture, it permits the production of very fine lines and therefore a range of values and textural effects usually associated with painting. First discovered in the late eighteenth century, wood engraving became a vital part of the technology of commercial printing in the nineteenth century, especially in Victorian England. At that time wood-block was the only available means by which pictures could be printed with text in a single pressing on the same page, and a wood engraving was hard enough to withstand several printings. Consequently wood engraving became a virtual industry as master engravers and black-line copyists were hired by the thousands to keep pace with the demands of the Victorian popular press.

In contrast to most wood engravings, *Self-Portrait* (Figure 4-16), a woodcut by Käthe Kollwitz, is an outstanding print because of its

4-15 Gustave Doré; title page of
The Ancient Mariner, 1875.
Wood engraving.

expressive power rather than its technical virtuosity. Instead of a
multitude of fine lines, *Self-Portrait* is a study in stark black and
white that makes no attempt to conceal the marks of the artist's
gouge. Indeed, in order to foster a more blunt and anguished ef-
fect, and to avoid the appearance of commercial line blocks,
Kollwitz experimented with soft woods, even plywood, for making
prints.

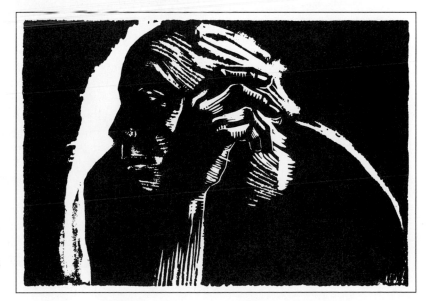

4-16 Käthe Kollwitz, *Self-Portrait*,
1924. Woodcut, 8″ × 11¾″.
Collection, Klipstein 202.

Intaglio

4-17 Intaglio printing.

Intaglio printing (Figure 4-17) is the opposite of relief printing. The image is cut into a metal plate (usually a sheet of cold-rolled copper) and, after ink has been rubbed into the lines, transferred to a sheet of paper under extreme pressure. The metal plate may be cut with special gouges called burins (*engraving*), scratched with a needle (*dry-point*), or dissolved with acid (*etching*). In etching, the most popular of these three methods, the plate is covered with a wax-based material and lines are drawn in this coating with a needle. When the plate is placed in acid, the exposed parts are eaten away. Shadings can be achieved by stopping out some lines and by allowing other lines to be bitten deeper by repeated immersions in the acid.

In *Three Trees* (Figure 4-18) by Rembrandt van Rijn, the velvety blacks in the trees and in the land on the right are the result of dense, deeply bitten masses of lines. On the left, some of the lines in the sky and in the distant plain—where canals crisscross the valley—appear to have been etched only once or twice, or perhaps dry-pointed. At any rate, Rembrandt's print demonstrates the medium's possibilities for both linear and tonal variety.

4-18 Rembrandt, *The Three Trees*. Etching. Courtesy Museum of Fine Arts, Boston, (bequest of William Norton Bullard). © 1990 Museum of Fine Arts, Boston. All rights reserved.

4-19 Francisco Goya,
The Bogeyman is Coming, 1797–98.
Etching and aquatint, 8½″ × 6″.
The Metropolitan Museum of Art,
New York.

Still another way of achieving tonal variety involves bonding particles of resin to the plate to create a fine granular surface. When the plate is placed in acid, only the minute interstices between the grains of resin are bitten. The effects of this method, called *aquatint,* can be seen in the somewhat gritty, but very menacing, shadows of Francisco Goya's *The Bogeyman is Coming* (Figure 4-19).

Lithography

Lithography is a *planographic* system of printing in which the image is neither above nor below the surface of the plate (Figure 4-20). It involves drawing or painting directly onto the flat surface of a special form of limestone or a zinc or aluminum plate with a greasy crayon or liquid. Of course, grease accepts oily ink and repels water. During the printing process, the surface is dampened. The exposed areas, being wet, do not accept the ink. When paper is

4-20 Planographic printing.

pressed against the inked plate, a facsimile (in mirror-reverse) of the drawing is produced. Not long after its invention in the late eighteenth century, it was discovered that the technique could be improved by treating the drawn surface with a solution of nitric acid and gum arabic to fix the image and integrate it with the surface. Lithography allows more freedom and directness in the drawing phase and a great variety of line, texture, and shading. Because the final print reflects the texture of the original crayon marks (when a litho-crayon is used), a lithograph often resembles a crayon or charcoal drawing—as in Kollwitz's *Death Seizing a Woman* (Figure 2-30). In recent years lithography, especially color lithography in which a different plate is used for each color, has experienced a significant revival. Many artists, better known for their work in painting or sculpture, have collaborated with master lithographers to experiment with the medium and have produced dazzling results—as in *Views of Hotel Well III* (Figure 4-21) by David Hockney.

4-21 David Hockney,
Views of Hotel Well III, 1985.
Multi-colored Lithograph,
48½″ × 38½″. © Copyright
David Hockney/Tyler Graphics Ltd.
1985.

Silkscreen

Silkscreen or *serigraphy,* the most recently developed of the popular forms of printmaking, consists of silk, organdy, or similar open-meshed material stretched tightly over a frame. An image or design is made by blocking out parts of the screen with glue, plastic strips, or photographic emulsions, leaving the remainder open for ink to pass through. Essentially, silkscreen is a type of stencil; any area not blocked out by the stencil will be printed. Printing is accomplished by placing the screen on the surface to be printed and pushing viscous ink across the mesh with a squeegee. Silkscreen does not require heavy presses; an organdy frame is less expensive than a wood block, copper plate, or litho stone; and the techniques are relatively fast and uncomplicated. These are the principal reasons why silkscreen has become a popular medium, both in the fine arts and the applied arts. But the fact that it also lends itself to sharp definition and bright, flat colors, has proved an important attraction to artists like Robert Indiana, whose image *LOVE* was first realized as a painting, then as a silkscreen (Figure 4-22), and even

4-22 Robert Indiana, *LOVE*, 1967.
Courtesy Virginia Lust Gallery.

as metal sculpture. Becoming famous in the late 1960s as an emblem of the "flower power" generation, *LOVE* was even authorized as an American postage stamp.

PHOTOGRAPHY

Still photography, even more than printmaking, involves mechanical processes and chemistry, and, like printmaking, is capable of producing identical editions. A virtually unlimited number of prints can be made from a single film negative, an item that is to the photographer what an etched plate is to the printmaker.

Photographers, however, instead of making images largely by hand, select subjects from the environment and capture the light reflected from those subjects on chemically treated, light-sensitive film. A camera is essentially a dark box with a lens in the front that projects the light onto a film. Making the image visible and permanent (developing) requires immersing the film in certain chemicals. In black and white film, the result is a translucent negative image in which the blacks are clear and the whites are almost opaque. A positive print, the photograph itself, is made by passing light through the film negative onto sensitized paper, again producing a latent image that must be developed. Exposing the print and then developing it in a darkroom often involves such hand methods as manipulating the amounts of light exposure over different areas of the print and controlling the effects of the chemical bath.

The creative challenges involved in producing photographs concern gaining control of a mechanical process by making a series of selections each time one takes a picture. Among other things, the photographer must choose the type of film, subject, lighting, camera distance, point of view, and—depending on the type of camera—the focal length of the lens, width of the lens opening, and shutter speed. The photographer also has the option of controlling aspects of the exposure and development of the print in the darkroom. These are some—perhaps the most important—of the variables in making a photograph, but certainly not all of them.

The variables—the numerous possibilities for different results even when using the same subject—might call into question the popular notion that a photograph is a true record of something seen. Nevertheless, a photograph does have a special relationship to its subject that a painting, no matter how realistic it may be, can never attain. As critic Susan Sontag explained, a photograph "is not only an image . . . it is a trace, something directly stenciled off the real, like a footprint or a death mask." It is doubtful that Dorothea Lange's *Migrant Mother* (Figure 4-23) would convey the same sense

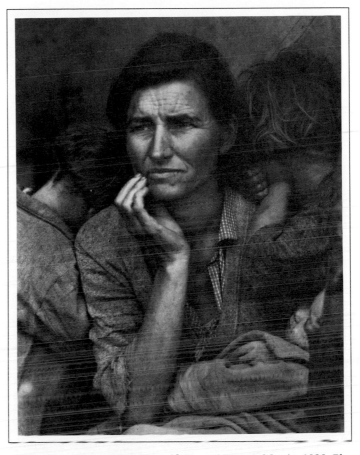

4-23 Dorothea Lange *Migrant Mother, Nipomo, California*, 1936. Photograph. Courtesy of the Dorothea Lange Collection, The Oakland Museum. © The City of Oakland, 1990.

of a real person existing at a certain place and time if it had been a painting instead of a photograph. And since this picture was part of a report on California workers Lange was commissioned to do in the 1930s, authenticity was an issue. But the effectiveness of the picture in evoking a story about family life and conditions in general during the Great Depression reveals that Lange was able to use the medium's variables for expressive ends as well as reporting.

Like Lange, Cindy Sherman specializes in photographs of people (Figure 4-24). But her art is about a very different world than Lange's. She addresses our popular-culture heritage through images vaguely suggestive of movie stars, soap-opera heroines, entertainers, and so forth. Though subtle, indirect, even ambiguous, her photographs are nevertheless evocative of contemporary society—

4-24 Cindy Sherman, *Untitled,* 1983. Photograph.

especially concerning the role of women. Sherman's methods are also very different than Lange's. Rather than seek real situations to photograph, she creates fictitious situations by using costumes, special props, and herself as model.

Jerry Uelsmann uses darkroom technology rather than costumes and props to create his fictions. But the power of his photographs rests in large part on the medium's aura of believability. In one of his works (Figure 4-25), we see the union of a tree and a gigantic leaf—a compelling and disturbing image that violates our common-sense perception of the world. The veins of the leaf can be seen as the tree's roots (as if we were looking at an X-ray photograph). Or the leaf can be seen as the tree and the real tree as the

4-25 Jerry N. Uelsmann, *Untitled,* 1964. Photograph. Collection the artist.

roots, if we turn the photograph upside down. The symmetry of nature is made strikingly visible in this photograph. Uelsmann created this print by integrating the images of two or more negatives in the darkroom. (Light exposures can be controlled to make parts of the print lighter or darker, according to the plan of the artist.) Uelsmann calls his method "post-visualization," because the greater part of the creativity does not take place in the camera—which he uses more or less conventionally—but in the darkroom.

FILM

Though pictures often *express* movement in different ways—as in the body language of the woman in Degas' *After the Bath* (Figure 4-10) or in the frenetic lines of Wilkie's *Arrival of the Rich Relation* (Figure 4-12)—they are nevertheless static. All the media reviewed thus far consist of static art. But *film* (and other media such as video

and some computer art) goes beyond merely expressing movement; film actually moves—or, to be more exact, it produces the illusion of movement.

The mutoscope, a precursor of film, was a machine that riffled a series of photographs before the viewer's eyes at the turn of a crank (Figure 4-26). Each photograph showed a slightly different action and, as it passed before the viewer, stopped for a tiny fraction of a second. If the crank were turned rapidly, the riffling became relatively invisible, and, because of a tendency called *persistence of vision,* the illusion of motion appeared. If the crank were turned too slowly, the individual pictures began to separate, and the illusion disappeared. Like the mutoscope, a movie projector displays still pictures in rapid succession—except, of course, the pictures are printed on a long strip of film and projected on a screen. Such pictures are made with a motorized camera through which film is fed in a rapid stop-and-go motion identical to that of the projector. The rate of this motion is 24 pictures (or frames) per second, the standard rate of sound film.

The filmmaker, like the still-photographer, considers such things as lighting, point of view, and the placement of a scene within the frame; but he or she must also contend with movement

4-26 Mutoscope: an early twentieth-century machine that produced the illusion of motion by turning a crank.

in the scene, and sometimes with the movement of the frame itself. The basic elements of film art are the *shot*, an unbroken segment of a scene or action, and the *sequence*, a series of shots. In making a shot a camera can remain in a fixed position (with movement coming entirely from the scene) or it can *tilt* (pivot up and down), *pan* (pivot sideways), *track* (follow an action), or *zoom* (move closer or farther from an object). After a film is shot, it must be edited—that is, segments of it are cut and spliced to compose the final array of shots and sequences. Some say that editing is the most creative part of filmmaking.

The camera work of *Rashomon*, a complex film directed by Akira Kurosawa, illustrates the expressive potential of movement. Set in medieval Japan, *Rashomon* centers around a single incident, the killing of a samurai (the Japanese equivalent of a knight), as reported by four different eyewitnesses: a bandit, the samurai's wife, the samurai himself (whose account is relayed through a medium), and a woodcutter. All of the accounts—which are presented as reenactments of the killing—contradict one another. To not only dramatize their differences but also to shed light on the motives of each narrator, Kurosawa endows each reenactment with different camera work: a rapidly moving, shifting camera is used to describe the bandit's romantic account of his role (Figure 4-27); a slowly-paced camera emphasizes the wife's self-described tragic role; a

4-27 Akira Kurosawa, Rashomon, 1950.
Film.

similarly slow camera describes the samurai's version to suggest that he died nobly; and an "objective" camera accompanies the account of the woodcutter, an impartial observer. The latter reveals the farsical nature of the combat between the bandit and the samurai and the perfidy of the samurai's taunting wife. In the first three versions, the camera is aimed at the character telling the story, to suggest the subjectivity of his or her account. Only in the woodcutter's version does the camera probe the actions of every character impartially. Since its release in 1950, *Rashomon* has set a standard for the use of camera movement to define action, motive, and mood. Like other high-quality classics of commercial film, this one is considered a work of fine art.

The credit for creating a film such as *Rashomon* usually goes to the director (in this case, Kurosawa), although an army of people—actors, camerapersons, musicians, makeup artists, financial backers, and so forth—are also involved. In the 1960s and 1970s, many artists—some of them famous as painters or sculptors—took up filmmaking. Unlike commercial films, theirs were low-budget projects filmed with a hand-held camera and without the help of professionals; the filmmaker served as producer, director, cameraperson, and sometimes, actor. Although few of these films—sometimes called *underground* films—made an impact on the general public, they did leave a legacy. Mainly, they challenged the conventions of commercial films—including even those influenced by Kurosawa—and explored the relationship between art and reality.

Video

Because of recent breakthroughs in electronic technology, many artists who used film are now turning to television, or *video*. Unlike film, video produces moving images by electronic means rather than by mechanical and chemical means. A video camera is a tube with a lens in the front and a photosensitive electronic plate in the back that converts light reflected from a subject into electric signals. The signals are transmitted through the air or carried by cable to a television receiver—basically, a tube with a screen in the front that reads the signals and converts them back to an image of the original scene. Television signals can also be stored on magnetic tape and played back at any time. Earlier, video cameras and recording equipment were too awkward and expensive for individual artists. Now, small *camcorders* (Figure 4-28)—hand-held units with camera and recorder combined—are readily available, inexpensive, easy to operate, and capable of producing images as good as those in com-

4-28

mercial television. Thus, compared to film, video has distinct advantages: tape is cheaper than film, and the artist can play a videotape back immediately on a camcorder instead of waiting for a film to be processed in a laboratory, threaded through a projector, and viewed in a darkened room.

There are basically two venues for the public viewing of video art: in an art gallery or on public television. In a gallery, video is often incorporated into sculptures so that viewers may appreciate video images in the context of some permanent object or installation. On public television, where it is broadcast like any other television program, video usually takes the form of a series of short, five-to ten-minute segments in a half-hour program. Tapes of video art are also available for rent or sale at special outlets around the country.

Nam June Paik, who began working with video in the 1950s, long before the camcorder, has emphasized the sculptural possibilities of the medium (Figure 4-29). He has also developed his own technology of manipulating video imagery electronically to create novel visual effects. Other video artists prefer to experiment with the stereotypes of television's conventions and to tell stories that differ from the usual characters and plots of Hollywood.

One of the most intriguing presentations of video was staged by the organizers of an event called *Video Drive-In:* the projection of videotapes and television clips on an 18-by-24 foot screen before thousands of young people sitting under the stars in Chicago's Grant Park (Figure 4-30). The theme of the program, *Science of Fiction/The Fiction of Science,* was designed to parody popular culture

4-29 Nam June Paik, *Family of Robots: Baby*, 1986. Thirteen television sets, half-inch VHS player, and half-inch thirty-minute tape *(Heart Channel for Robot)*, 52½″ × 38″ × 13¼″. Courtesy Carl Solway Gallery, Cincinnati.

through juxtaposing video art and recycled footage of television commercials. Adding their own unique dimensions to this experience were the Chicago skyline and the nostalgia of drive-in movies.

Computer Art

Of all the media, computer art is the newest, the most "high-tech," and the most rapidly changing. As an acknowledged medium in the fine arts, its status is a little like that of video around 20 years ago: a few recognized artists have been invited to experiment with computer-generated art, but it tends to be ignored by art critics and arts magazines, and no artist of the stature of Nam June Paik has as yet

4-30 *Video Drive-In, Grant Park, Chicago, September, 1981.*

emerged. The most significant discoveries in computer-generated imagery (computer *graphics*) remain those by scientists and engineers in industry or government. And the most exciting computer images—the breathtaking views of company trademarks rotating and zooming through space—are produced for commercial television.

The basic components of a computer system consist of a device for input (such as a keyboard for entering numbers or letters), a *central processing unit* or CPU, and a video monitor for displaying the processed information. The CPU, a board with electrical circuits and transistors, is the heart of the system. The basic unit of information is a *bit,* or *binary* digit (0 or 1, like an off or on switch). A string of binary numbers (or configuration of off and on switches) comprises a *pixel.* A pixel can be translated into a dot with specified x–y coordinates on a video screen. Of course, dots can be extended into lines, and lines into images.

The most available computer technology for artists not skilled in mathematics is that of the personal computer. At the present time this technology is limited to primarily two-dimensional imaging, that is, designs or pictures lacking in any high degree of illusionistic depth. The components of a personal computer are the

same as those stated above except that, for art purposes, the user draws lines with a light pen on a *digitizing tablet* instead of entering information on a keyboard. Recently, many different kinds of "paint systems" have become available for colorizing images. Lillian Schwartz, who has collaborated with computer scientists in order to expand the potential of computer images, is one of the most active artists in the field. Her brilliantly-colored *After Picasso* (Figure 4-31) demonstrates the possibilities of using the hardware and software of one of the more sophisticated of these small-scale systems. Notice how Schwartz was able to achieve, in addition to flowing colors and lines, some convex and concave effects—particularly in parts of the face on the right.

However, to create a convincing illusion of a three-dimensional world—be it realistic or fantastic—requires expensive equipment capable of processing enormous amounts of information, and programs written by people with degrees in physics or mathematics. To create animation—the illusion of objects rotating and moving through space—requires even more capacity and expertise. So far, only government, industries, and universities can afford such state

4-31 Lillian Schwartz, *Beyond Picasso*, 1986. Cibachrome print, 50″ × 67⅞″. Copyright 1989 Computer Creations Corporations.

4 32 Yoichiro Kawaguchi, *Ocean*, 1986. Frame from film.

of the art systems, and only those artists having access to those agencies can use them. One of those artists is Yoichiro Kawaguchi who, unlike the vast majority of his colleagues, was specifically trained in computer graphics. To create his astonishing simulations of underwater life inspired by diving trips in the East China Sea (Figure 4-32), Kawaguchi writes his own programs. Every aspect of solid-object simulation—foreshortening, shading, texture, reflection, and so forth—requires a separate program, and every program consists of long columns of calculations. Kawaguchi's experience suggests that future artists may have to be as handy with algorithms as they are now with charcoal.

MIXED MEDIA

Mixed media, as the term suggests, involves the use of one or more media in a single work of art. Artists of the past have not always been puritanical about the distinctions between media. Some, for

example, have been known to embellish the shading in a pencil drawing with a little bit of ink wash, or colorize a black-and-white woodcut with dashes of watercolor. Many contemporary artists, especially those working with three-dimensional media, go far beyond such mere tampering and have made careers out of mixed-media inventions, sometimes using materials in very incongruous ways (Chapter 5). We have already seen at least one example of mixed media in Paik's video sculpture.

The number of possible mixed-media combinations—even in the two-dimensional realm—is infinite. But there is a specific kind called *collage*, namely, the pasting of fragments of paper, photographs, newsclippings, cloth, and other odds and ends to a flat surface. In addition, strokes of paint, charcoal smears, or anything, as long as it is basically flat, may be combined with the above. Although its history goes back to around World War I, collage has become popular with many artists in recent years. Romare Bearden, who is especially noted for his work in this medium, pieces together fragments of found images from photographs and other pictures. His ideas are drawn from the broad spectrum of black life in America—city and rural, North and South, old and young—and his found images include facial features, fragments of clothing,

4-33 Romare Bearden, *Pittsburgh Memory*, 1964. Collage, 9¼″ × 11¾″. Collection of Gladys and Russell Williams, New York.

parts of buildings, and even bits of African masks. In his hands, these originally unrelated fragments magically combine to create a new whole (Figure 4-33). Although the visual patterns are interesting, it is the capacity to generate mental associations that gives Bearden's multiple images their unusual strength.

SUMMARY

The variety of art reviewed in this chapter covers quite a range: in technology, from a stick of charcoal to a camcorder or super computer; in color, from a black-and-white woodcut to a multi-color lithograph; in longevity, from a fresco to a flickering image on a video screen; in context, from the mysterious interior of Rome's Santa Maria Maggiore to the open space of a summer night in Chicago's Grant Park.

But this represents only half of the total range: the two-dimensional half. The next chapter will cover the three-dimensional half.

CHAPTER 5 THREE-DIMENSIONAL MEDIA

T HE AMOUNT OF VARIETY in three-dimensional art is at least as great as it is in two-dimensional art. Much of this variety is due to the modern movement and its liberalizing effects on the concept of art, and much of it is the byproduct of technological advances in metals, plastics, and fabrication.

Besides having an extra dimension, a three-dimensional work differs from a two-dimensional one in that it provides a different shape (or silhouette) each time it is viewed from a different vantage point. The amount of difference from vantage point to vantage point depends on whether the piece is *in-the-round*—an independent, freestanding (or free-hanging) object capable of being viewed from all points of the compass—or in *relief*—a work in which the forms protrude from a background.

CARVING

Gianlorenzo Bernini's life-sized in-the-round sculpture of David (Figure 5-1), showing the hero as he is about to pivot and hurl the stone at Goliath, is carved out of a single block of marble. The use of *carving* to make images is as old as human culture itself. Sometimes referred to as the subtractive process, carving calls for removing material from a block of wood or stone with a knife, gouge, or chisel. Carving requires that the artist have a well-defined idea of how the piece is to look before he or she begins working. Bernini probably began by making a small model in clay and then having the shape roughly cut in the marble block by an assistant. Further cutting and refinements, using progressively finer tools, were probably executed by the artist. Unlike oil painting, carving in stone permits little room for changes and in-process modifications. The mental anxiety and the physical exertion of chipping away at an obstinate block no doubt discourage many artists from working in

5-1　Gianlorenzo Bernini, *David,* 1623. Marble, life-size.
Galleria Borghese, Rome.

this medium. Judging from his productivity, it appears that Bernini
was rarely discouraged; indeed, looking at individual works one
gets the impression that marble carving was, for him, easy. Few
other sculptors of stone have been able to imbue their works with
such a degree of realism. Bernini so carefully articulated and re-
fined the textures of the flesh, hair, and cloth that one can easily

forget that this figure was carved from stone. But the most innovative aspect of the work is its suggestion of movement. *David* is not a static form that merely represents a Biblical figure, but a fascinating study in potential motion and energy. David's slender body is caught in the very act of hurling the sling; its position, balance, and violent twisting compel the viewer to move almost entirely around the sculpture to understand it.

In Chapter 2 we saw two twentieth-century examples of carving—*The Kiss* (Figure 2-23), a stone carving by Brancusi, and *Pendour* (Figure 2-25), a wood carving by Hempworth. To these artists, the realistic depiction of figures in motion was not a high priority. Brancusi limited the shape of his piece to that of a single cube-like block to represent metaphorically the cleaving of two lovers; Hepworth carved an elegant abstract form to call attention to the texture of finished wood as well as to the relationship between concave and convex in the form itself.

MODELING

Not all sculptural methods are as difficult as carving, and not all materials are as hard as stone. *Modeling*—sometimes called the additive process—involves forming three-dimensional shapes out of a pliable material such as clay or wax. These materials can be manipulated with simple tools such as wooden paddles and knives or even with the hands. The art of modeling was used by Paleolithic artists as long ago as 10,000 B.C. In later periods, sculptors like Bernini used it for the same purpose that painters use drawing—to make preparatory "sketches" for their finished works. The disadvantage of the medium, of course, is that figures made in clay or wax are not permanent and therefore not satisfactory for finished works.

Clay, however, can be changed into a relatively hard material called *ceramic* by baking it at a high temperature in a special oven called a *kiln,* a process that probably goes back to the discovery of fire. One such object is the Japanese horse (Figure 2-34) discussed in Chapter 2. As opposed to being formed by pinching and pulling the clay—as are most modeled sculptures—this figure was created mostly out of thin slabs of clay rolled into cylinders and assembled while still damp. It was then allowed to dry thoroughly before being fired.

CASTING

Both clay and wax can be copied in more durable materials by a technique called *casting.* Although casting can be done in several ways, the basic steps are as follows: the artist covers the original

form with plaster, which hardens and becomes a mold when it is removed. The inside of the mold is a negative shape that corresponds to the positive shape of the original. Into this cavity a substance such as molten metal, cement, or polyester is poured or pressed. After the filler hardens, the mold is removed.

The *cire perdue* or *lost wax* process, used for bronze casting, consists of applying a layer of wax of the same thickness desired for the metal (no more than three-eighths of an inch) to the inside of a mold. The wax-coated cavity is then filled with a plaster core and the whole mold is baked. The wax melts and runs out, leaving a thin space for the molten bronze, which hardens into a lightweight, hollow cast. When and by whom this method was first discovered is a matter of speculation. We do know that bronze casting was borrowed by the Greeks from the Egyptians, and that it was also used by cultures in Asia and Africa.

The little statue in Figure 5-2, an example of in-the-round casting, was made sometime between the tenth and twelfth century in an African kingdom centered in Ife (western Nigeria). Whether the method of hollow-bronze casting had spread to this area from

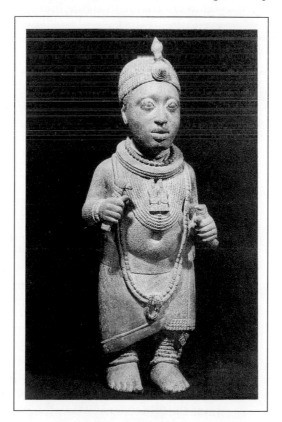

5-2 Ife king figure, Yoruba, tenth to twelfth centuries A.D. Bronze, 18½″ high. Ife Museum, Nigeria.

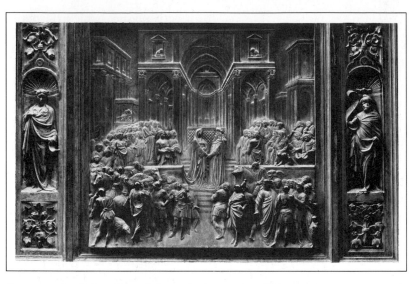

5-3 Lorenzo Ghiberti, *The Meeting of Solomon and the Queen of Sheba*, detail of the Gates of Paradise door, Baptistry, Florence, c. 1435. Gilt bronze, 31¼″ × 31¼″.

Egypt or had developed there independently is not known; regardless, the quality of the casting is excellent. Ife artists used the technique effectively to create lifelike portraits of their king, in which even the textures and smallest of details were given careful attention.

The fifteenth century Italian artist, Lorenzo Ghiberti, used bronze casting to make a series of reliefs for the doors of the Baptistry of the Cathedral of Florence, known as the Gates of Paradise. A close look at one of the reliefs, *The Meeting of Solomon and the Queen of Sheba* (Figure 5-3), reveals that the greatest relief is in the lower portion where some figures are almost in the round, while the upper third—the most distant part of the scene—is very flat. In the flat part, Ghiberti employed one-point perspective to help suggest the depth of the background.

Today, some artists cast in bronze, but many prefer to cast in other materials. We have already seen an example of a concrete casting—Picasso's *Bust of Sylvette* (Figure 2-22)—in Chapter 2. Even more common than concrete is vinyl or polyester resin. A versatile medium (far less costly than bronze casting), polyester resin is a heavy, syrupy liquid before it is hardened by the addition of other materials. It is extremely durable when reinforced with flexible sheets of fiberglass. John de Andrea casts with this and other plastics in molds made directly from bodies. After they have been painted with oils, the images are incredibly accurate likenesses of the actual person—right down to goosebumps (Figure 5-4). Look carefully at the male figure in Figure 5-4; it is not de Andrea you see, but his self-portrait. The Ife artist, who gave life to bronze, and even Bernini, who could make marble look like flesh, would have

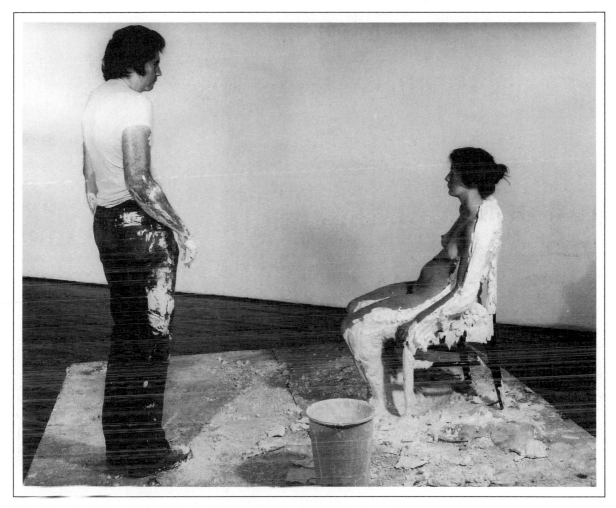

5-4 John de Andrea, *Clothed Artist and Model,* 1976. Cast vinyl, polychromed in oil, life-size cast.

been impressed. De Andrea, an exception to the general rule of modern sculptors who emphasize abstract forms, takes advantage of new technologies and materials to focus once again on the old problem of verisimilitude.

WELDING/METAL SCULPTURE

Long before de Andrea began to make his realistic sculptures in polyester, other sculptors had experimented daringly with new technologies. In the late 1920s, Julio González pioneered the use of *welding,* the joining of pieces of metal by heat, as an art technique.

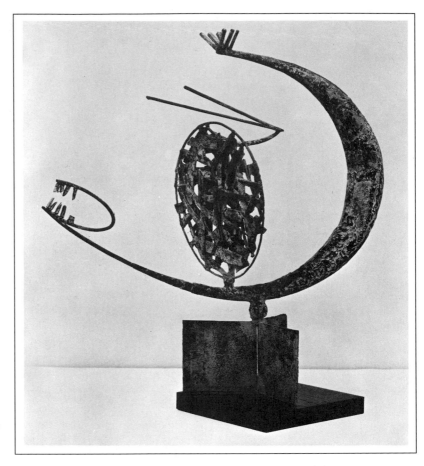

5-5 Julio González, *Head,* 1935?
Wrought iron, welded, 17¾″ × 15¼″.
The Museum of Modern Art,
New York. Purchase.

At the time this represented a radical break from what were considered the appropriate media for sculpture. González made crude constructions of scrap iron, rods, and nails. The textures, shapes, and spaces of a work like his *Head* (Figure 5-5) are stated in a completely modern sculptural language. The piece is not built up from a lump of clay or cut down from a mass of stone, but pieced together around empty space—an early example of what is known as *open sculpture.* Another excellent example of this method (and also an example of open sculpture) is Hunt's *Drawing in Space, No. 1* (Figure 2-24).

Both González' and Hunt's pieces are small enough to be in a museum or even a living room. But many metal sculptures, like Louise Nevelson's *Dawn Shadows* (Figure 5-6), are permanently installed outdoors. In the last 25 years metal sculptures have blossomed in public spaces all over the world. Located in plazas, lobbies, courtyards, or wherever their visual impact is most effective,

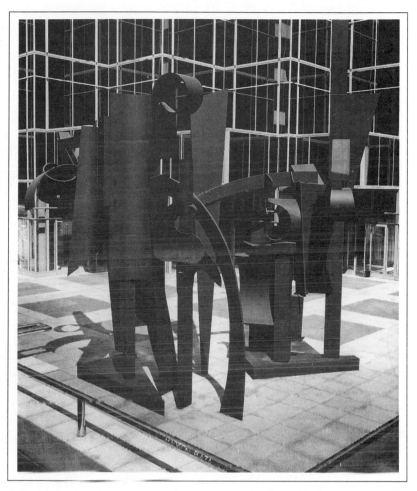

5-6 Louise Nevelson, *Dawn Shadows*, 1982. Steel painted black, approx. 30′ high. Madison Plaza, Chicago. Commissioned by Lee Miglin and J. Paul Beitler, Chicago. Photo courtesy the Pure Gallery.

these abstract open forms—whether welded, riveted, or both—have become the hallmarks of corporations and government institutions.

CONSTRUCTION

Open sculptures do not have to be made from metal. Naum Gabo used a two-piece plastic frame and nylon thread to put together *Linear Construction* (Figure 5-7). Entirely removed from traditional sculpture's attachment to human or animal forms, constructions

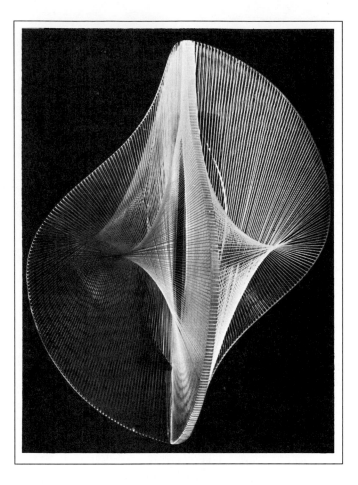

5-7 Naum Gabo, *Linear Construction,*
1950. Plastic and nylon, 15″ high.
Private collection.

such as Gabo's reflect the preoccupation of many mid-twentieth
century artists with abstract shapes, lines, and spaces. Gabo, who
had been trained as an engineer and mathematician, was attracted
to the beauty of the forms of analytic geometry. In the early 1920s
he began to translate these forms into open sculptures made from
lightweight materials. One of his later works, *Linear Construction* is a
keen blend of art and mathematics as well as a gently curving,
transparent image.

KINETIC SCULPTURE

Sculpture's possibilities have also been expanded to include move-
ment. *Kinetic sculpture* is the name applied to those works that—
through motors, wind, or other energy sources—escape the static

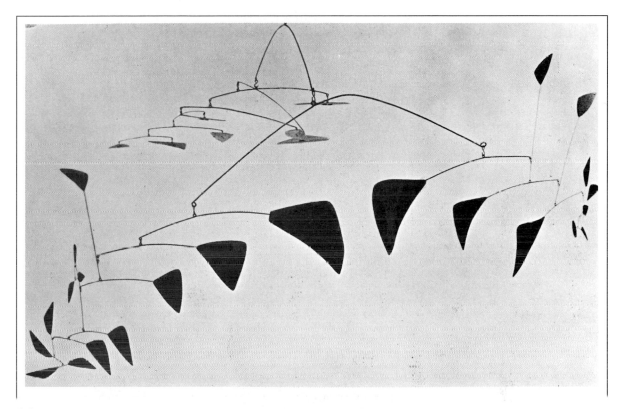

5-8 Alexander Calder, *Sumac*, 1961. Sheet metal, metal rods, wire, 49¾" × 94".
Courtesy Perls Galleries, New York.

state of ordinary sculpture. But even though kineticism was in large part inspired by machines, the first really successful works of this kind were not motorized at all. Alexander Calder's hanging *mobiles* (Figure 5-8) depend on a system of precise balances to make their metal vanes respond to movements of the air. The drifting and dipping of the abstract color shapes continually transform the appearance of the sculpture. Motorized kinetic sculpture was revived in the late fifties. But for all the technological means it makes available to sculptors today, it has still not produced any series of outstanding works. Oddly enough, the most interesting of the artists in this area is one whose whimsical vision of the machine is anything but scientific. Jean Tinguely's sculptures are constructed of odds and ends, and have nothing of the polished discipline and sense of purpose of the machine. His most symbolic construction was the huge *Homage to New York*, the ultimate purpose of which was to destroy itself—which it did—with fire, noise, a fitting degree of

5-9 Jean Tinguely, *Homage to New York*, 1960. Kinetic assemblage of machinery, fireworks, piano in the sculpture garden of The Museum of Modern Art, New York.

confusion, and the applause of New Yorkers, in the garden of that city's Museum of Modern Art (Figure 5-9).

MIXED MEDIA

Jean Tinguely's *Homage to New York* could as easily be included in the category of *mixed media* as in kinetic sculpture, for the term mixed media covers those works that use disparate, often incongruous, methods and materials. Typically, the term is identified with just present-day art, because so much of it, like that by Pfaff (Figure 3-14), Bearden (Figure 4-34), and Tinguely, consists of these exuberant conglomerations. But many artists in previous centuries were inspired to mix their media, sometimes in equally exuberant ways.

Bernini's statue of David (Figure 5-1), unsullied as it is by the application of paint or any other material, would satisfy purists who disparage the mixing of media. But his *Ecstacy of St. Theresa*, a project combining architecture, sculpture, and painting (Figure 5-10), would probably infuriate them. The angel (seen stabbing St. Theresa with a fire-tipped dart), St. Theresa, and the clouds supporting them are carved out of white marble; the rays of the sun overhead are of gilt bronze; the architectural niche is made of different colors of marble; on the ceiling above are both sculpted and painted an-

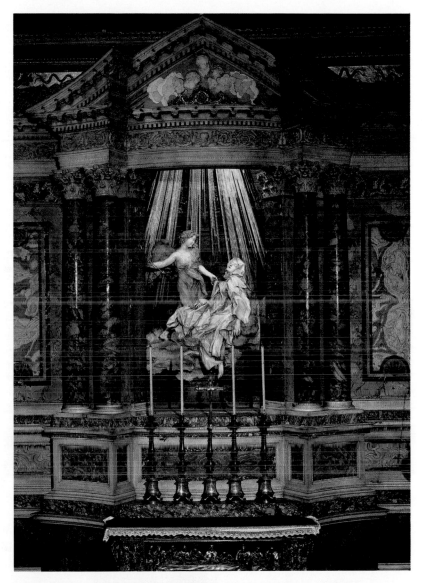

5-10 Gianlorenzo Bernini, interior of the Cornaro Chapel, 1645–52.
Santa Maria della Vittoria, Rome.

gels and painted clouds. The whole ensemble is enlivened by real
light that pours down from a hidden window and illuminates the
angels, clouds, bronze rays, and the scene of ecstacy itself. Bernini,
in this attempt to literally create a divine vision, used skill, imagina-
tion, and whatever material was available. He produced a remark-
able piece of religious theater; by today's standards and terminol-
ogy, it is also an outstanding example of environmental art.

Assemblage

Assemblage, the three-dimensional counterpart of collage (Chapter 4), is a twentieth-century invention and a particular category of mixed media. Typically, an assemblage employs fairly substantial three-dimensional things—for example, found objects such as remnants of furniture, appliances, plaster casts, even stuffed animals. As the name implies, this art calls for assembling these things with glue, nails, rivets, or any other means. There is no limit to the kinds of things eligible for incorporation in an assemblage or the ways they can be combined. Many assemblage makers tend to use eccentric materials or found objects as abstract forms, treating them as indifferently as individual brush strokes. But some use the objects for what they are, capitalizing on their capacity when placed in new or alien contexts to stimulate the viewer's imagination.

Colo's assemblages, though employing just a few everyday objects, often prompt unpleasant associations. His *Artifact for Keeping*

5-11 Colo, *Artifact for Keeping Secrets,* 1977. Mixed media, 17″ high. El Museo del Barrio, New York.

Secrets (Figure 5-11) both attracts and repels: the small chrome-plated cash box and knife blade are as clean and polished as merchandise in a discount jewelry store. But combined as they are with the knife blade pointing threateningly upward, these alien objects create ambiguous and disturbing connotations of money, sex, and violence.

Some of Lenore Tawney's assemblages employ unusual materials such as thousands of linen threads hanging from a ceiling as if poured through a sieve. Others employ everyday objects such as the chair in *In Utero* (Figure 5-12). The works of both artists are

5-12 Lenore Tawney, *In Utero*, 1985. Mixed media, 48″ high.

ambiguous, if not enigmatic. But whereas Colo's is hard, metallic, and threatening, Tawney's is soft, organic, and vulnerable. Colo's hints at the mysterious danger of some unknown or hidden evil, while Tawney's chair enclosed in mosquito netting suggests the mystery of on-going birth and renewal.

ENVIRONMENT

Environment, a relatively new term in art, was created to describe experiments that began in the late 1950s and 1960s that attempted to literally bring the spectator into the work. Environmental works (sometimes called *installations*) are not just hung on a wall or placed on a pedestal; they surround the viewer on all, or nearly all, sides. The term may be new, but the concept of surrounding the viewer is not. Today's experiments in this allegedly new medium have precedents in such traditional areas as theater, landscaping, architecture, and even, as mentioned earlier, Bernini's multi-media project in a small chapel.

One of the best examples of these precedents is the interior of a Gothic church or cathedral. Like an enormous open sculpture, a Gothic interior is a complex orchestration of aisles, columns, piers, pointed arches, ceiling vaults, and windows. The outer walls, especially the areas below the ceiling vaults, are decorated with windows of stained glass that transform the sunlight (Figure 5-13). The rays of intense color, whether seen directly through the glass or indirectly as they pierce the dark interior, are a significant part of the experience of being inside the cathedral.

To make stained glass, color must be added (by introducing certain minerals) when the glass is in a molten stage. Pressed into sheets and allowed to cool, the glass is then cut into smaller pieces according to a previously prepared design. Details such as facial features are usually painted on with oxides and made permanent by firing in a kiln. The fragments are then joined together with lead strips by a technique called *leading.*

The environmental art of Dan Flavin in our own day is related to that of the windows of a Gothic church, although Flavin uses colored fluorescent light fixtures rather than stained glass (Figure 5-14). The nature of the room in which the work is displayed obviously plays a crucial role in the appearance of the work. As the color reflects off the room's surfaces, it is affected by such factors as the size and shape of the room and the color and texture of the walls—as well as by the other light. Flavin was not the first artist to have used real rather than reflected light—but none had ever tried to actually make it the very *substance* of a work.

5-13　Bath Abbey window.

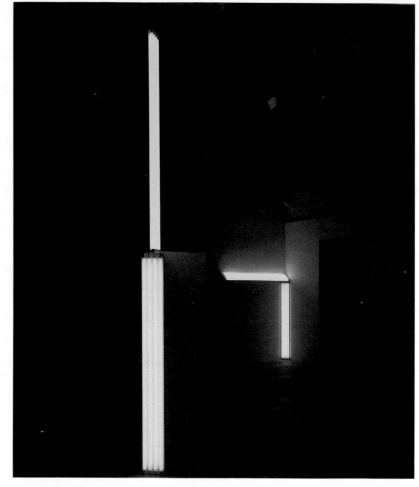

5-14 Dan Flavin, *Untitled (fondly to Margo),* edition of 3, 1986. 8′ yellow/pink flourescent lights, 2 fixtures, 192″ × 8′⅜″ × 8′⅜″. Courtesy of Margo Leavin Gallery, Los Angeles. Photograph, Douglas M. Parker Studio, Los Angeles.

Dan Flavin, *Untitled (fondly to Margo),* edition of 3, 1986. 8′ yellow/pink flourescent lights, 2 fixtures, 104″ × 96″ × 8′⅜″. Courtesy of Margo Leavin Gallery, Los Angeles. Photograph, Douglas M. Parker Studio, Los Angeles.

Merzbau

A major precedent for much twentieth-century environmental art was the *Merzbau,* a name given by the German artist Kurt Schwitters to a series of interior spaces he altered by installing constructions made of all sorts of odds and ends. The first of these, begun in 1924 in the artist's home in Hanover, was an assemblage of rusty tin cans, newspaper and pieces of broken furniture. He called it *Cathedral of Erotic Misery* and filled it with secret panels that hid other objects or tiny scenes that reflected his own erotic misery and that of his time. Eventually, however, he replaced the chaotic collection of junk with abstract forms made of wood. Although the later crea-

5-15 Kurt Schwitters, *Merzbau*, 1924–37 (destroyed). Mixed media. Photo Sprengel Museum Hannover.

tion may not have been as richly suggestive as the earlier one, it did focus more attention on the spaces and their importance in an environment (Figure 5-15). Clearly, Schwitter's project anticipated Pfaff's *3D* (Figure 3-14).

Happenings

The *Happening*, which began as something like a cross between a temporary Merzbau and improvisational theater, attracted a number of painters and sculptors in the early sixties. The first use of the term *Happening* appears to have been in a 1959 article by Allan Kaprow, in which he included a brief script for a related series of events called *18 Happenings in 6 Parts*. He later produced a version of this work (Figure 5-16) in a New York gallery, which he outfitted with plastic partitions, Christmas lights, slide projectors, tape recorders, and assemblages of junk. "Performers" spoke doubletalk, read poetry, played musical instruments, painted on the walls, squeezed orange juice, and executed other similar acts. The gallery

5-16 Allan Kaprow, *18 Happenings in 6 Parts*, 1959.

patrons required instructions on how to move through this potpourri, becoming in a sense performers themselves—a role that was developed in Kaprow's future works.

Happenings differ from theater in a number of important ways, although these are becoming more difficult to distinguish because of the influence that such works have had on experimental theater. The spectator-participant is involved in a work that may take place anywhere, indoors or out, and is surrounded by it rather than viewing it on a picturelike stage. Sight and hearing are not the only senses addressed. There are no actors separated from the audience by fictitious roles. Usually there is no plot and no focused structuring of sequence. Instead, there is a series of separate, often overlapping, sometimes unrelated events. Despite the apparent randomness, however, many Happenings are carefully scripted and rehearsed—though unpredictable occurrences are accepted as integral parts of the total experience.

Earth Art

For some artists a canvas, a room, or even an entire building is not enough space—they set about rearranging the landscape itself. Michael Heizer, one of the principal figures of the Earth Art move-

ment, did a number of pieces in the desert. His *Double Negative* (Figure 5-17) is an enormous rectilinear gash in the earth at the edge of a canyon, a sculpture that consists of both real and imaginary space (in which the canyon eats away the earth it is cut from)— a geometric shape constructed by a human being contrasted with an organic one created by nature. Although the work may appear no more complex than any other hole in the ground, it inspires many observations. Among these are the facts that the use of a negative form makes the space itself the work and that the immense scale allows for radically different perceptions of the form of the work depending on the vantage point—including that of someone in an airplane. Another important point is that this work is far more vulnerable to the erosions of time and weather, so that it will disappear in a relatively short time. A hundred years from now all that will remain are the photographs that document it.

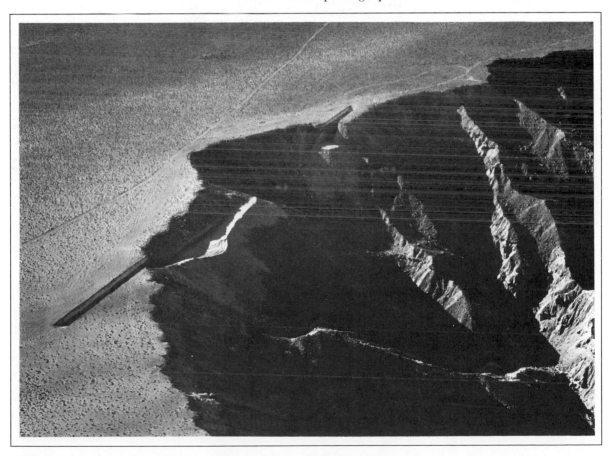

5-17 Michael Heizer, *Double Negative*, 1969–70. Two-hundred-thousand-ton displacement in rhyolite and sandstone, 50′ × 1500′ × 30′. Collection Virginia Dwan.

Tableau Vivants

Sandy Skoglund's environments, unlike those reviewed so far, can be likened to elaborate *tableau vivants*—scenes with actors posing silently. Her projects seem intended to tell a story—although the contents of the story is always a mystery. Skoglund begins with a drab environment—a slum apartment, or a low-rent office—furnished with real furniture and real actors (usually, older or depressed-looking people) and makes the environment even more drab by painting everything, including the actors' clothes, in a monochrome. To this she adds a fantastic element—meticulously sculpted and painted in either a matching or contrasting color—such as the blue leaves in *A Breeze at Work* (Figure 5-18). Finally, she photographs it.

Apropos much recent art, Skoglund's work defies classification. Is it photography? Not unlike Sherman (Figure 4-25), she contrives a scene, then shoots it with a camera. Is it an environment? Like

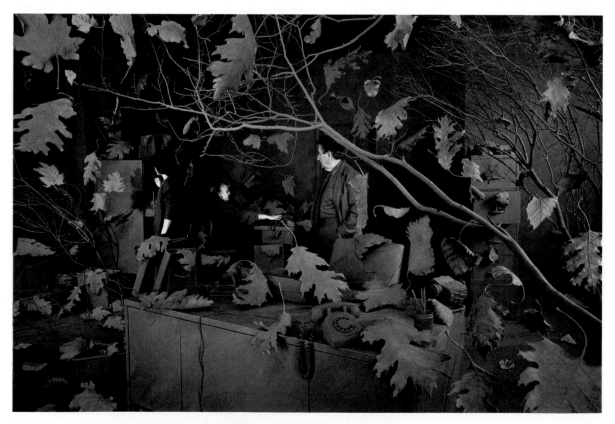

5-18 Sandy Skoglund, Installation view of *A Breeze at Work*, 1987. Mixed Media.
Courtesy Fay Gold Gallery, Atlanta, Georgia. © Sandy Skoglund, 1987.

Bernini, she is bent on creating believable visions, or, perhaps, hallucinations. To compound the mystery of her work, her photographs tend to resemble paintings more than photographs. At first glance, the leaves, the furniture, and even the frozen people in *A Breeze at Work* appear to have been rendered in tempera or gouache.

CRAFT ART

Craft art, or *crafts,* refers to the handmade production of useful objects, such as pottery, glass, metalware, clothing, and jewelry. Historically, these and other daily necessities were made by hand until the early 1800s—the advent of the industrial revolution—when the production of these things began to be taken over by machines. The benefits of machine production, at least with regard to its ability to bestow life with an abundance of material possessions, are undeniable. But to many people, mechanization is a mixed blessing; along with abundance it has also bestowed uniformity and dullness. Most of all, people miss the creativity and the intuitive sense of humanity that is imparted to an object that was made by hand, especially by the hand of a superb craftsperson.

The negative effects of machine production were first publicized in England, particularly by William Morris (English writer, designer, and social reformer) who, in the late 1800s, started the Arts and Crafts movement. Morris' goal was to revive the tradition of making objects by hand, and to restore the dignity of creative manual activity. Morris' ideas, which easily took root in the United States because of its own crafts heritage and affinity for handmade products, inspired Americans to form crafts organizations and exhibits, and to offer crafts in some colleges. Crafts gained momentum at the end of World War II when returning soldiers—many of whom elected to enroll in crafts courses—flooded American campuses. The American university, like a medieval monastery or guild, provided studio space, training, and employment (as teachers or artists-in-residence) for craftspersons. Today, even the smallest college art department offers at least one of the crafts disciplines.

University patronage has not ceased, and, more importantly, the market for crafts has increased dramatically over the last two decades, causing a sort of crafts boom. Today, instead of making objects to please a teacher or to get a job in a university, a craftsperson is more likely to make objects to sell through dealers, cooperatives, and crafts fairs. Because of a healthy economy, more discretionary income, a desire to invest in collectables, and the recent popularity of nostalgia items, Americans have discovered the crafts.

Although crafts have achieved status in both academia and the marketplace, craftspersons are concerned about the image of their field in the art world (a concern, incidentally, that goes back to the Renaissance). There are many symptoms of this: crafts' lack of representation in the prestigious art museums, the use of the term "minor arts" to refer to the crafts in art history texts, and their lack of visibility in major arts magazines. Even the field itself is divided about its image: some craftspersons reject the label "artist"; others with the same training are offended if people do *not* call them artists.

The history of crafts, then, should be kept in mind as we review the major media of the crafts: ceramics, glass, metals and jewelry, and fibers.

Ceramics

Ceramics—the art of making objects out of baked clay—is probably the most popular, best known, and most versatile of the crafts media. In the commercial world, ceramic material is used in every-

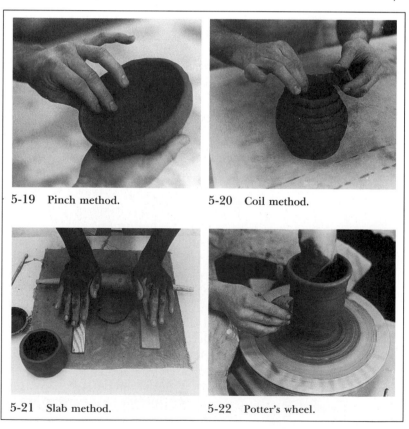

5-19 Pinch method.

5-20 Coil method.

5-21 Slab method.

5-22 Potter's wheel.

thing from the space industry to plumbing. In the past it was used to make toys, oil lamps, and funeral urns, as well as all kinds of pottery. Often the knowledge of an extinct culture is derived only through the study of its pottery remains (called *shards*).

Handbuilt pottery is made in several ways: cups and small bowls can be formed by progressively pinching the shape from a fist-sized ball (Figure 5-19); larger forms such as jugs, pitchers, vases, and jars by winding clay coils (Figure 5-20); and cylinders or square shapes by cutting and joining slabs of clay (Figure 5-21). All of the above, except the square shapes, can be made more uniformly and quickly with the aid of a potter's wheel (Figure 5-22). First introduced around 3,000 B.C., and used by cultures in Africa, Asia, and Europe, the potter's wheel—although it is essentially a manual type of technology—enabled the mass production of pottery in the ancient world.

Aside from the way it is formed, a pot is affected by the type of clay from which it is made. Earthenware (terra cotta), a low-fire clay, is coarse and porous; stoneware, a high-fire clay, is less coarse, but nevertheless robust; porcelain, a high-fire clay (consisting of a high proportion of a special clay called *kaolin*), is nonporous, naturally white, and quite refined compared to stoneware and earthenware. Porcelain was invented by the Chinese (perhaps as early as the ninth century) long before it was even known in Europe. The magnificent porcelain vase in Figure 5-23 is a good example of the

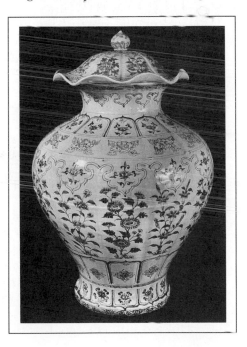

5-23 Covered vase, excavated at Peking, late Yüan or early Ming dynasty, late fourteenth century. White porcelain with underglaze decoration, 26½″ high. The exhibition of archeological finds of the People's Republic of China.

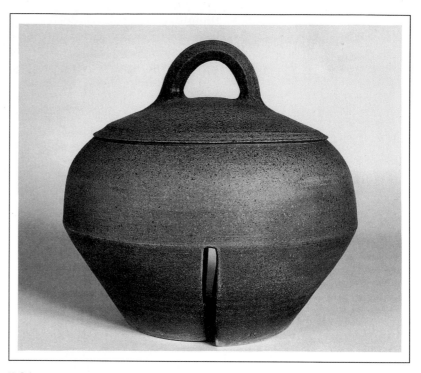

5-24 Karen Karnes, *Covered Vessel*, 1986. Stoneware, thrown, wood-fired, 13 × 13″ diameter.

kind of ceramic vessel that European potters tried to imitate—mostly without success—in the sixteenth and seventeenth centuries. Europeans were unable to produce their own porcelain until the eighteenth century.

The concerns of eighteenth century potters were quite different from those of today's ceramic artists. Now, the concerns often revolve around the identity of ceramic art itself, particularly the issue of function versus nonfunction: should a ceramic piece serve a practical purpose? Does it have to be a vessel? Does it even have to look like ceramic?

Karen Karnes' *Covered Vessel* (Figure 5-24) is an excellent example of modern functional pottery: it is rational, restrained, and elegant. Its round shape and proportions celebrate its existence as a pot—in this case, a covered jar. Even the tall legs—its least traditional aspect—are integrated in such a way that they continue the contour of a classical pottery form. Appropriately, the somber surface—brown-black in color and matte in texture—reflects the restraint of the form, and also serves as a visual metaphor of the earth, pottery's origins.

Howard Kottler's *Face Vase* (Figure 5-25) represents the other

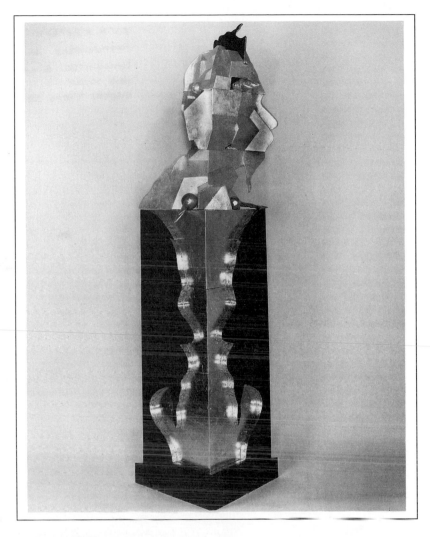

5-25 Howard Kottler, *Face Vase*, 1985. Earthenware with simulated gold leaf and paint, 83″ × 26″ × 18″.

side of the modern ceramic coin: irreverence, mockery, and paradox. It is nonfunctional. Its boxy shape topped by a knobby clump defies, rather than proclaims, traditional form. Its flamboyant colors—tacky, glossy gold set against jet black—mock the expectation that a ceramic piece "wear its humility on its surface." The title, *Face Vase*, refers to a classic illustration of the figure-ground principle in which a viewer sees either two mirror-image faces or a vase, and to Kottler's burlesque of this illustration (two faces with goatees) on the lower part of the work. The face aspect, including the goatee, is echoed in the top of the work as an abstract sculpture. The title is also a pun on questions raised by the piece itself. Is it a vase? Is it a portrait? Is it craft? Is it art? Is it a joke?

Glass

Glass art shares with ceramics many characteristics: the use of high temperatures in its manufacture, its vessel tradition, even its substance, which is hard and nonresilient. Glass was discovered by the Egyptians around 3,000 B.C., about the time that the potter's wheel emerged. The first objects were beads and solid shapes; glass vessels, made by wrapping layers of glass around a sand mold, did not appear until around 1500 B.C. The invention of the blow pipe between 200 and 100 B.C. enabled artisans to make hollow vessels on a mass-production basis.

For centuries, glass objects had been made almost exclusively in large furnaces with teams of workers. As a pursuit for the individual artist, it was virtually a lost art until Harvey Littleton (Figure 5-26), a potter, began in the late 1950s to melt glass in a stoneware bowl in a ceramic kiln. With the help of a few potters and glass technicians, Littleton developed a technology for producing glass in the private studio. By 1963, he had established the first hot

5-26 Harvey K. Littleton at work in his studio forming a hot gather prior to stretching and developing the form.

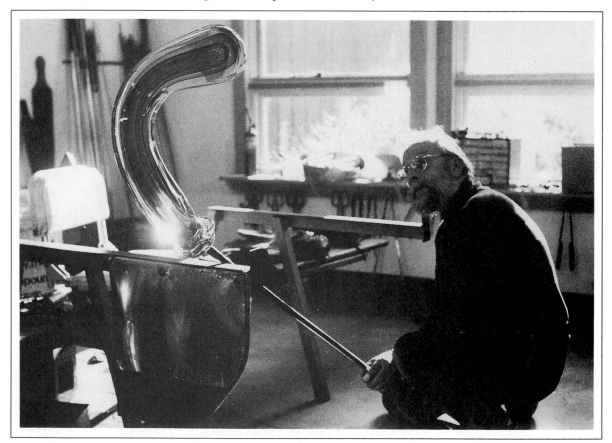

glass program in a university (University of Wisconsin), and was training others. By 1970, over sixty schools offered glass programs.

There are three kinds of glass production: *hot glass* in which a piece is blown or cast; *cold glass* in which it is cut, ground, etched, sandblasted, and/or polished; and *warm glass* in which a piece is heated over a flame or in a furnace until pliant enough to bend or fuse.

Despite its youth, glass is a recognized medium, and has already developed its own traditions. Issues confronting today's glass artists—function versus expression, vessels versus sculptures, seriousness versus mockery, the limits of experimentation, and so forth—are similar to those confronting ceramic artists.

Joel Myers freely experiments with glass surfaces, but is conservative when it comes to glass forms. From fragments of opaque colored glass that he makes himself, Myers chooses some to fuse to a blown form with a hand torch. He follows this with a variety of cold working techniques, including grinding, sandblasting, and etching. The final result, as in one of his *Contiguous Fragment Series* (Figure 5-27), is a composition in glass that takes advantage of the medium's capacity for varieties of transparency, translucency, opacity, color, and texture. Although his work exemplifies the possibilities of variety, and is more colorful than Karne's *Covered Vessel*, it nevertheless shares with the latter the same sense of formality.

Amy Roberts, who is fond of mixing glass with other materials, pursues an aesthetic agenda very different from Myers'. In *Voyage*

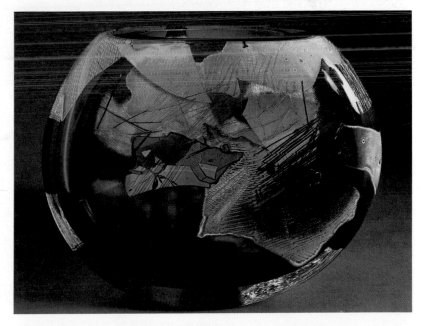

5-27 Joel Myers, *Contiguous Fragment Series*, 1987. Glass, blown, cut, sandblasted, acid etched, 12″ × 16″. Courtesy of Heller Gallery, N.Y.C.

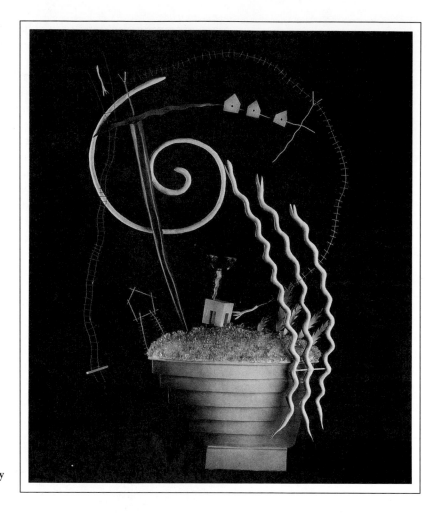

5-28 Amy Roberts, *Voyage into the Flatlands*, 1986. Mixed Media, 66″ × 52″ × 18″. Courtesy Joan Robey Gallery, Denver, CO.

into the Flatlands (Figure 5-28)—a combination of glass, wood, paint, and metal elements, many of which are fragile and precariously joined—Roberts does more than just experiment with form, she takes risks with the concept of glass art itself. She also takes risks with subject matter, in this case, a bizarre world in various shades of electric pink containing a boat, a mast, a spiral sail, a house, a wineglass, flags, ropes, and snakes. Though perhaps not as sardonic as Kottler's *Face Vase,* Roberts' free-wheeling concoction is just as irreverent.

Metals and Jewelry

The impulse to possess precious objects and to adorn the body is as old as humanity. To early cultures, such things as shells, bones, stones, seeds, and animal hairs were precious items. When people

learned to mine and smelt ores these things were replaced by metals, principally, gold—the most sought after metal throughout time for making precious objects.

Metal is formed by such methods as casting, annealing (heating to make it malleable), bending it over steel stakes or into depressions, cutting, soldering, and electroforming (depositing metal on a conducting mold by electrolysis). Surface treatments include piercing, engraving, etching, enameling, and anodizing (making an oxide film electrochemically so the metal will absorb dyes).

Contemporary metalsmiths and jewelers, like potters and glass artists, contend with the issue of functional versus nonfunctional. For the metalsmith who prefers to make expressive objects, the issue of scale arises: where does metal *work* end and metal *sculpture* begin? How important is the quality of intimacy to the concept of metalwork? For the jeweler, the functional issue raises the question of wearability: does a piece have to be wearable in order to be considered jewelry? Further, does it have to be made of precious metals and gems in order to be considered jewelry?

Tina Fung-Holder's *Neckpiece, Val5/385* (Figure 5-29), was created out of crocheted cotton yarn, safety pins, and glass beads.

5-29 Tina Fung-Holder, *Neckpiece, Val5/385*, 1985. Crocheted cotton yarn, safety pins, glass beads, 14″ × 12½″. Courtesy of the artist.

With these resources, Fung-Holder was able to manipulate shape, color, and texture to create an attractive necklace—indeed a piece of jewelry that, like a family hand-me-down, is all the more appealing because of its humble origins.

The appeal of Chunghi Choo's electroformed, silverplated *Fleur* (Figure 5-30) is the opposite of Fung-Holders'. The form is literally flamboyant (flame-like). The sleek sheen of its impersonal high-tech surface differs markedly from the earthy textures in *Neckpiece, 2 Val5/385.* Choo's piece is also reminiscent of *Art Nouveau,* a turn-of-the-century style that featured serpentine lines and

5-30 Chunghi Choo, "*Fleur,*" 1986. Silver-plated copper, electroformed, 19″ × 13½″ × 19¼″.

languid curves. *Fleur* is therefore a curious, but nevertheless successful, combination of past and future: an appropriation of a historical style joined with state-of-the-art methods of forming.

Fiber

Fiber refers to any substance that can be separated into threads or threadlike structures for spinning, weaving, braiding, and so forth. Historically, fibers were formed from animal or plant tissues (wool and cotton), but today many fibers—such as rayon, nylon, acrylic, and polyester—are synthesized chemically. The variety of fiber art may even exceed that of the other crafts media: for example, wall hangings, rugs, needlework, quilts, baskets, dolls, handmade paper, wearables, and fiber sculptures.

When fiber art is mentioned, many people think of loom weaving, and this is perhaps the principal construction method in the medium. Basically, weaving consists of crossing one thread (*weft*) over and under alternate (*warp*) threads that are stretched on the loom. Loom weaving, however, is only one of several methods; others, which include such things as plaiting, braiding, crocheting, macrame, knotting, and knitting, are generally classified under "interlacing." Often, the colors and textures are provided by the threads themselves, while the patterning of these elements is determined by the system of weaving or interlacing. But surface decoration is also available. Limited only by the skill and imagination of the artist, this can be done with various kinds of needlework, applique, dyeing, batik, painting, blockprinting, silkscreening, litho, and even photochemical methods.

Fiber artists, like other craftspersons, are divided over the role of functionalism. Some, like Lenore Tawney, whose *In Utero* (Figure 5-12) was reviewed earlier, incorporate fiber materials into the creation of novel assemblages. Others stay with the more traditional forms. However one traditional fiber form—the wall hangings—is in league with abstract painting.

A quilt—two layers of cloth with filling in between—is a type of wall hanging as well as an old American folk art that is experiencing a revival. During the colonial period and early days of the republic, when houses were drafty and blankets were scarce, Americans needed quilts to keep warm. But quilts were also admired for their beauty, and many Americans joined quilting bees to compete with one another in creating ever more beautiful quilts. Except in rural areas quilting bees died out in the twentieth century. But during the bicentennial celebrations of the mid 1970s, thousands of old quilts were retrieved and displayed in museums throughout the country, a phenomenon that inspired painters and fiber artists to

5-31 Michael James, *Rhythm/Color: The Concord Cotillion*, 1985.
Cotton silk, 100″ × 100″. ©Michael James, 1985.

try making their own quilts. Some of these, like Michael James'
Rhythm/Color: The Concord Cotillion (Figure 5-31) are as dazzling as
any modern abstract painting. By sewing together nearly 150 sec-
tions, each consisting either of diagonal stripes or of checkerboard
designs, James created a larger system of interwoven diagonal
bands and waves. Though the colors are actually opaque, the effect,
in places, is that of translucent overlapping planes, as if this work
were a Cubist painting (Chapter 13) instead of a quilt.

SUMMARY

The complexity of today's art seems to be unlimited. In the latter
half of the twentieth century the definitions of media and the
boundaries between them, which once seemed so secure, have been
challenged and overrun by new technologies and by experimental

artists bent on combining media, old or new. Such new media as photography and video as well as such hybrids as the collage, assemblage, and environment have gained respectability and must be considered part of art. The traditional limitations concerning the materials of art have also been challenged. Just as one can no longer say that art is limited to painting and sculpture, one can no longer say that sculpture is limited to marble, wood, or bronze; any substance is likely to be suitable, even water and air. Finally, the concepts of the art object, of the craft object, and of the relationship between art and craft have been challenged. Performances, environments, the use of perishable materials, and nonfunctional craft objects have raised fundamental questions pertaining not only to the concepts of art and craft but also to their relationship to the public and to posterity.

The lack of solid definitions and media boundaries introduces an element of unpredictability, if not chaos, but this is the inevitable price of freedom. The advantage of this uncertainty is that it allows artists to expand the possibilities of their work and viewers to enlarge their own experiences.

CHAPTER

6

ARCHITECTURAL MEDIA

A S YOU DISCOVERED in Chapter 5, craft objects no longer have to be functional. However, such a departure from tradition has not as yet occurred in architecture. Architectural objects continue to be utilitarian, that is, places for people to live, work, and congregate. This is not to say that buildings cannot also be symbolic, ceremonial, aesthetic, or even provocative, but such is never their only purpose. Because of their utility and their intimate involvement in everyday human affairs, architectural objects—more than art or crafts objects—are closely affected by the values, needs, and technologies of the society they serve.

In this chapter we will be studying architecture from two perspectives: principles of construction and levels of architecture. The first has to do with the methods and materials, both traditional and modern; the second has to do with the ways in which we experience architecture in our daily lives.

PRINCIPLES OF CONSTRUCTION

As we saw in the previous chapters, the form of an artwork is affected very much by its medium. Similarly, the form of a building is affected by the principles of construction used to create it. Although there is an almost infinite variety of architectural forms, there are relatively few principles of construction underlying those forms.

Post and Lintel

6-1 Post and lintel.

The simplest and most ancient method of spanning a space is the *post and lintel,* in which horizontal lintels—often called beams—are supported by vertical posts or walls (Figure 6-1). This method has been used with a variety of materials throughout the world.

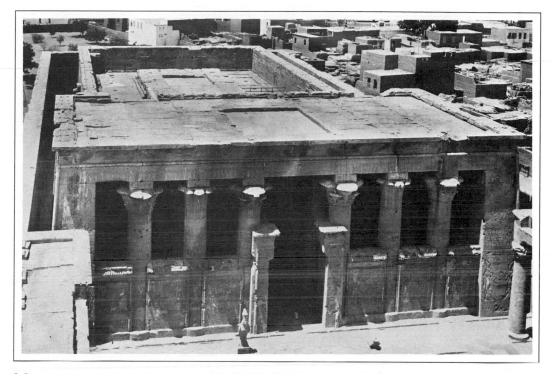

6-2 Temple of Horus, Edfu, Egypt, 237–212 B.C.

The oldest buildings still in existence are *masonry:* made of stone or bricks. The hall of an Egyptian temple dedicated to the god Horus employs a post-and-lintel system of carved stone (Figure 6-2). The masonry roof is carried by heavy beams that in turn are supported by massive posts (columns) and walls. The interior is dark and appropriate for its original function as a sanctuary. But this is also due to the limitation of stone as a building material. It is heavy and lacks the necessary tensile strength (the ability to withstand stress) for spanning large distances. Thus much of the floor space in a masonry building like the Temple of Horus is taken up by thick posts or walls needed to support the short, heavy lintels.

The Parthenon (Figure 6-3)—perhaps the most famous ancient temple of all—is located on a dramatic hill (the Acropolis) above the city of Athens. Dedicated to the goddess Athena, it embodies the aesthetic and philosophical ideals of the fifth-century B.C. Greeks. Like the Temple of Horus, it employs a masonry post-and-lintel system; however, in the Parthenon stone lintels are limited to spanning only the outside rows of columns and the inner rows of the porches. The ceiling (which no longer exists) was supported by wooden beams. Because wood is both lighter and

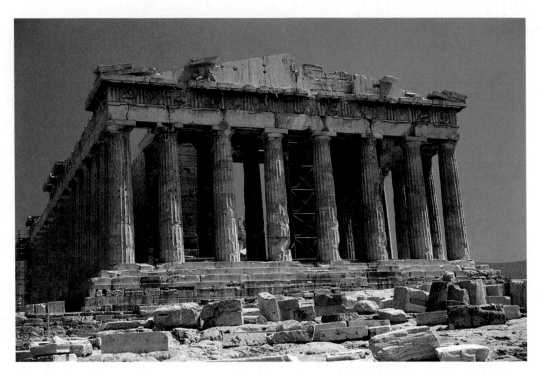

6-3 The Parthenon, Acropolis, Athens, 448–432 B.C.

stronger in tensile strength than stone, the inside of the Parthenon—though not spacious—was not crowded with a forest of heavy columns. On the other hand, wood is not permanent; it either burns or rots. All of the wood in the Parthenon, like that of other Greek temples, has disappeared. Consequently, the dilemma of post-and-lintel construction: Wood is perishable, masonry is cumbersome.

Corbeled Arch

6-4 Corbeled arch.

The *corbeled arch* (Figure 6-4)—a method of spanning an opening by laying rows of stones in such a way that each row projects inward until they meet at the top—was developed in many parts of the ancient world. The Maya Indians, who occupied what is now the Yucatan peninsula (Mexico) and parts of Central America, employed the corbeled arch to create openings in their huge limestone structures (Figure 6-5). Unlike post and lintel, this method allows builders to use small stones, a necessary advantage in places where longer blocks of stone are unavailable. On the other hand, the cor-

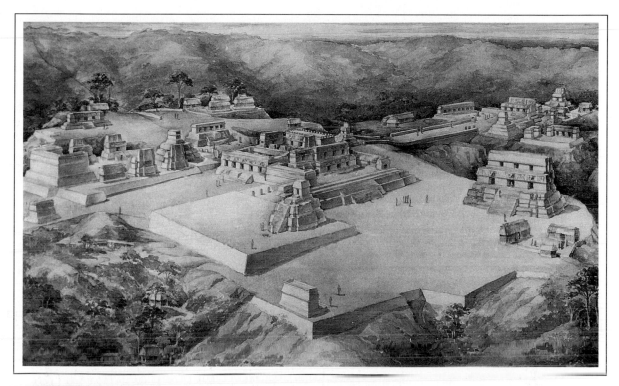

6-5 Temple group, Maya, Uaxactun, Mexico. Reconstruction drawing by
T. Proskouriakoff as of c. A.D. 700.

beled arch is unable to span more than 15 feet. Rooms in Maya
buildings therefore were very narrow and very dark. Of all the
masonry methods, the corbeled arch is probably the least efficient—
that is, it provides very little space per pound of material.

Arch

The *arch* (sometimes called "true" arch to distinguish it from the
corbeled arch) is the most efficient and versatile of the methods of
construction using only masonry. With the arch the problem of
masonry's lack of tensile strength is overcome by the use of small
stones, but unlike a corbeled arch, a true arch consists of wedge-
shape stones arranged in a curve (Figure 6-6). Because of their
shape, the blocks press against one another rather than falling—
the force of gravity being diverted outward as well as downward.
During construction, the stones are supported by a temporary

6-6 Arch.

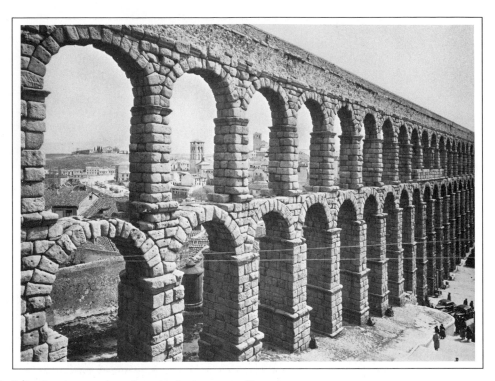

6-7 Roman aqueduct, Segovia, Spain, c. A.D. 10.

6-8 Barrel vault.

6-9 Cross vault.

wooden framework—or centering—until the last stone, the "key-stone," is in place. The remains of a Roman aqueduct in Segovia, Spain (Figure 6-7) is an excellent example of arch construction. An aqueduct is actually a series of arches supporting a large trough through which water could flow for a great distance.

Although a single arch might afford some protection from rain, an aqueduct is not designed to provide shelter. A *barrel vault* (Figure 6-8), which is an extended arch, is the simplest form of shelter using the arch principle. Because of the downward and outward pressure of a solid masonry ceiling, a barrel vault requires heavy walls for support along its entire length. The *cross vault* (Figure 6-9) formed by two intersecting barrel vaults, is an improvement because the support is focused at just four points, permitting openings on all four sides.

The Roman Colosseum (Figure 6-10) employs every variation of the arch system except the dome. Three levels of arcades (repeated arches) form the outside wall. On the inside, barrel-vaulted ramps lead to the arena, and cross-vaulted corridors circle the entire stadium on all levels (Figure 6-11). In addition to covering the ramps and corridors, these vaults comprised the superstructure for the stadium itself, which at one time seated 50,000 people. It

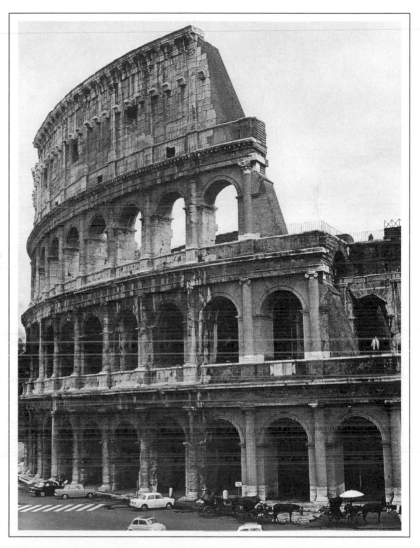

6-10 Colosseum, Rome, c. 70–82 A.D.

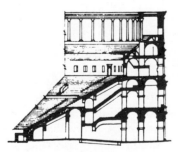

6-11 Sectional diagram of the Colosseum

should be pointed out that many of the Colosseum vaults are concrete rather than stone. Roman concrete consisted of a mortar of lime, sand, and volcanic dust reinforced with an aggregate of small stones. This mixture was then poured into molds corresponding to the shape required by construction; when the mixture hardened, the molds were removed. Concrete, like stone, is a type of masonry. Without the reinforcement of steel rods (as in modern ferroconcrete construction), it also lacks tensile strength. Therefore, to span a space and not crack, concrete must be cast in curved configurations such as arches, barrel vaults, and cross vaults.

6-12 Dome.

The *dome* (Figure 6-12), also a curved configuration, is simply a radial form of the arch. Just a few blocks north of the Colosseum stands the Pantheon (Figure 6-13)—a large dome-covered temple, and another example of Roman ingenuity. The Pantheon's dome, which held the record for being the largest dome in the world for 13 centuries, is a solid concrete shell. Its diameter of 144 feet is impressive even by modern standards; the top, which is crowned by a round opening (called an *oculus*), is 144 feet off the floor (thus completing the diameter of a circle in the vertical dimension). In places, the cylindrical wall (or drum) supporting the dome is 23 feet thick. On clear days the sun, streaming through the oculus, the only opening in the entire building, is reflected on the Pantheon's inner surfaces as a bright circle that moves with the speed of the rotation of the earth. Because it was converted to a Christian church in the seventh century, the Pantheon was spared the dismantling suffered by other Roman buildings that were literally used as quarries to provide stones for Christian churches.

Although the technology of concrete died with the Romans, arch systems of construction lived on; indeed they were used extensively up through the nineteenth century. Throughout this history, it was the Gothic builders of the twelfth through sixteenth centuries who exploited the arch more than anyone else.

One of the major contributions of Gothic builders was the *pointed arch,* which proved far more versatile than the round arch in

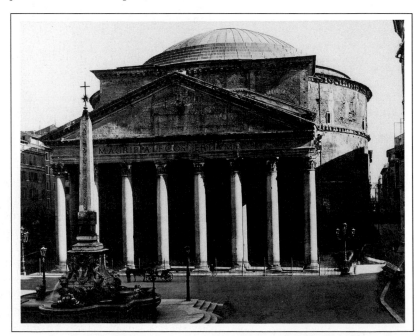

6-13 The Pantheon, A.D. 118–25.

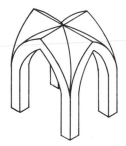

6-14 Pointed arch cross vault.

building vaults (Figure 6-14). A round arch is a semicircle; its height is strictly governed by its width. A pointed arch, which is more like a triangle, allows the ratio of width to height to vary simply by changing the angle of the arch. This in turn allows intersecting vaults of different widths to have the same height—an advantage that was very important to the Gothic builders. The sharper angle of the pointed arch also serves to divert the force of gravity more directly toward the ground, thereby requiring less reinforcement in the form of heavy walls and bracing on the sides.

In the discussion of environmental art in Chapter 5 a Gothic building was likened to an enormous open sculpture. Much of this open effect is due to the use of pointed arches and pointed cross vaults, as illustrated by the interior of Chartres Cathedral (Figure 6-15), a building full of light and space, even though it is constructed entirely of masonry. This effect is further facilitated by still

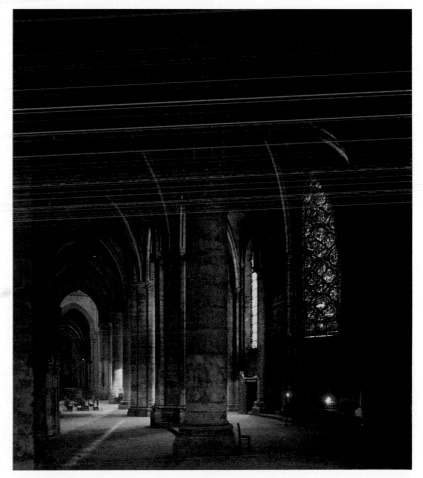

6-15 Chartres Cathedral, view of nave and crossing, begun 1194.

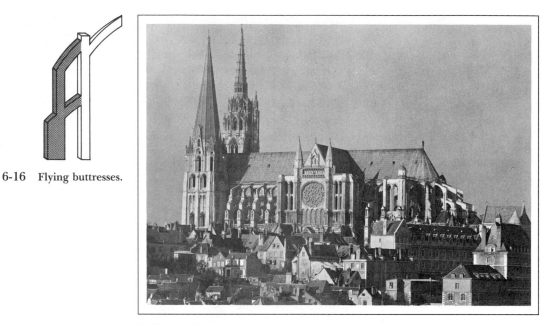

6-16 Flying buttresses.

6-17 Chartres Cathedral, France, twelfth through sixteenth centuries.

another contribution of the Gothic builders, the *flying buttress* (Figure 6-16), a half-arch on a pier outside the church that braces the wall where it intersects with a ceiling vault, thereby absorbing the outward pressure of the vault. A whole system of these vanelike flying buttresses can be seen grouped along the outside of Chartres Cathedral (Figure 6-17).

Between the fall of the Roman Empire and the beginning of the Renaissance (early 1400s), domes had been built in eastern Europe and Asia minor, but none were as large as the Pantheon dome. Meanwhile, only a few unimposing dome structures had been built in western Europe. Therefore, when the large pointed dome (Figure 6-18) on the Cathedral of Florence—the first of its kind—was dedicated in 1436, an architectural landmark was born. One hundred forty feet in diameter and 300 feet high (351 feet to the top of the "lantern"), the Florence dome is an impressive sight today; think how it must have appeared to the people at the dedication. Designed by Filippo Brunelleschi, it is a radical solution to the problem of spanning such a huge space without resorting to extra thick supporting walls or buttressing. Because a pointed dome, like a pointed arch, directs the force of gravity downward rather than outward, it is more stable than a round dome. Brunelleschi's design served as the basic model for domed buildings thereafter—including, among others, our nation's capitol.

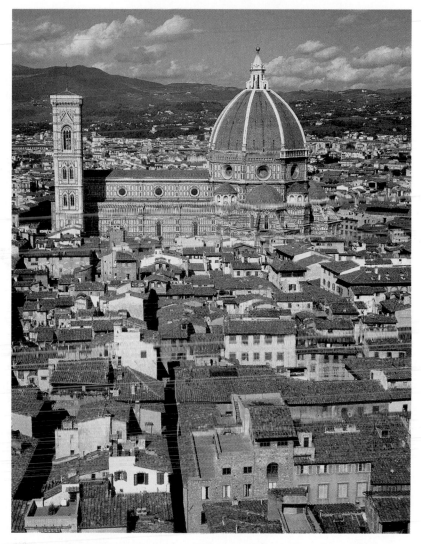

6-18 The Cathedral of Florence, 1296–1436. Dome (1420–36) by Filippo Brunelleschi.

Frame

Although post-and-lintel and arch systems continued to be used into the nineteenth century, they were challenged by new technologies brought about by the needs of the Industrial Revolution. In the 1830s the wooden *balloon frame* was developed to answer the demand for a rapid means of building houses—to keep pace with the growth of Chicago and other settlements of a rapidly developing

America. Two-by-four boards were nailed together to form a lightweight framework to support the exterior siding and interior walls. This method of construction coincided with the improvement of sawmill machinery and the mass production of nails. Today it is called wood-frame construction, and is so commonplace that we have difficulty appreciating its once-revolutionary importance. Prior to the balloon frame, wooden buildings in America were either log cabins or post-and-lintel constructions—the spaces between the posts filled with such materials as stone, bricks, plaster, or earth. On the other hand, the balloon frame was not only lighter in weight, it also capitalized on the standardization of parts to speed construction. Two-by-four boards and machine-produced nails could be converted to a building in two weeks by two people who were handy with saw and hammer.

In 1851, a vast building called the Crystal Palace was erected in London. A single structure of iron and glass that allowed the light of day to flood the interior, it was the site of the Great Exhibition, a world's fair that featured industrial and agricultural products from many countries. Despite its size—a ground plan of over 800,000 square feet—the Crystal Palace was built in less than six months. To accomplish such an engineering feat, its designer, Joseph Paxton, designed structural units that could be partly prefabricated. Planned around the largest standard sheet of glass (at that time only four feet square), the wood and iron members were manufactured in Birmingham and fitted together into a framework on the site in London (Figure 6-19).

Although it was a remarkable tour de force—both as a technical accomplishment and as a spectacular sight—the Crystal Palace was not considered architecture by the architects of the time. They thought of it as a functional structure built for a particular job and suited for rapid construction (and perhaps equally rapid dismantling)—a kind of super circus tent. But the main reason it was not considered architecture was that it was made of iron and glass. Other iron buildings of the nineteenth century had more permanent uses—railroad stations, warehouses, factories—but they too were looked on merely as functional "sheds." To be considered architecture, a building had to use solid stone, not a lightweight framework of iron posts and girders bolted together. Few observers had the foresight to realize that the Crystal Palace would inspire radical changes in architecture. Its principle of construction—a metal framework that freed the walls of their load-carrying function—eventually came to be the basis of twentieth-century public and commercial building.

The revolution launched by the Crystal Palace spread to America in the last two decades of the nineteenth century when a colony

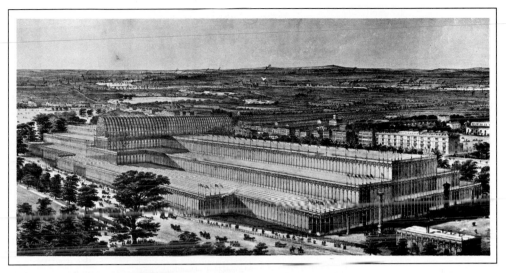

6-19 Joseph Paxton, Crystal Palace, London, 1851. Nearly 2000′ long.

of high buildings began to rise over Chicago's downtown district. These first *skyscrapers* were born of new industrial technologies, including that of steel-frame construction—an outgrowth of the Crystal Palace's iron framework—and the elevator. They were also the result of a growing need for office space in a commercial hub where real-estate costs were extremely high. It was a case of simple economics: use the free space—the sky instead of the costly space on the ground. The principle of construction was the same as that of the balloon frame: a skeletal framework—this time iron and steel rather than wood—constructed prior to the walls. Of the many architects of the "Chicago School," the most outstanding was Louis Sullivan. His buildings, more than the others, are seen today as architectural masterpieces. A simple, unpretentious solid, his Guaranty Building in Buffalo exemplifies the world of business as well as metal-frame technology (Figure 6-20). The vertical lines between the windows have been stressed by means of continuous bands of relief decorations designed by Sullivan himself.

The Buffalo building, like other skyscrapers, was covered with outer walls of masonry. Even though the practical need for masonry construction no longer existed, there seems to have been a psychological need to make a building appear heavy and solid in spite of its metal structure. Indeed, Sullivan's designs fell out of favor in the early twentieth century because they did not resemble masonry buildings enough. After World War I, downtown buildings were often made to resemble Renaissance palaces or Gothic cathedrals—sometimes even with phony flying buttresses, such as

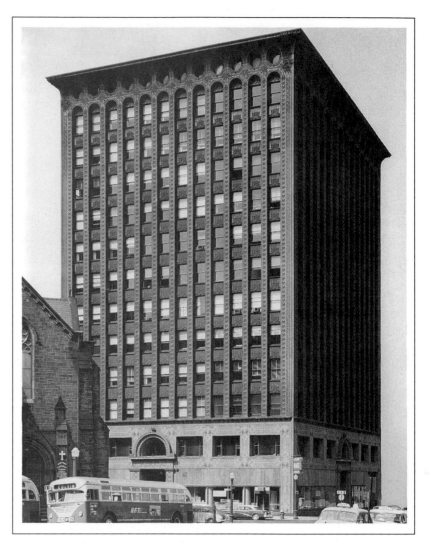

6-20 Louis Sullivan, Guaranty Building, Buffalo, 1894.

those near the top of the Chicago Tribune tower (Figure 6-21). The result of a prize-winning design submitted by the architects Raymond Hood and John Meade Howells, the Tribune tower was completed in 1925.

It was not until the early 1950s that architects began to design buildings that were frankly steel frame, covered only with a skin of glass and metal (or "curtain wall"). The freedom to create such architecture was inspired in large part by the work of Ludwig Mies van der Rohe. The latter was director of the Bauhaus, a famous German design school, but in 1933 when the Nazis came into power, the school closed, and Mies fled to Chicago. There, he took over the architectural department of the Illinois Institute of Tech-

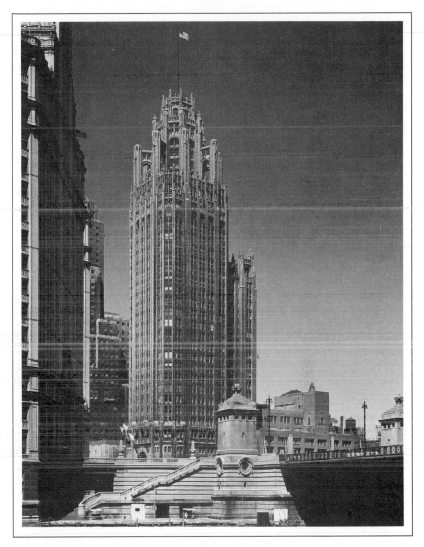

6-21 Raymond Hood and John Meade Howells, Tribune Tower, North Michigan Avenue at the River (north bank), 1925.

nology that he used as a base for continuing his architectural practice and spreading his ideas. More than any other architect, Mies is identified with a style of architecture that is completely devoid of ornament or superfluous detail. His famous motto, "less is more," aptly summarized his style and doctrine of design. The Seagram building in New York (Figure 6-22), made in collaboration with Philip Johnson, epitomizes the style as much as any of Mies' buildings. Except for a raised level at the bottom and a four-story cap at the top, the Seagram is a relentlessly simple, bronze-and-glass

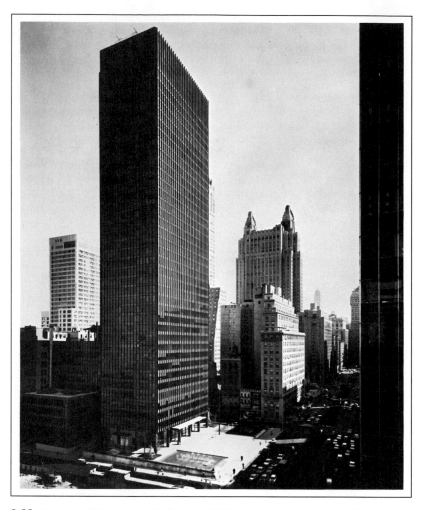

6-22 Ludwig Mies van der Rohe and Philip Johnson, Seagram Building, New York, 1956–58. Photo by Ezra Stoller © Esta.

monolith. This kind of style has had a large following among designers of commercial and government buildings. Now, more than three decades later, both architects and the public have become satiated with "less is more."

Though it is certainly not an imitation of the Seagram Building, the Centre Pompidou in Paris (Figure 6-23) by Richard Rogers and Renzo Piano is just as devoid of extraneous ornament. Challenged to create an ideal area for the display of art, the architects came up with an original solution: turning the building inside-out. While uninterrupted space is on the inside, all of the workings—ducts, pipes, ventilators, escalators, and so forth—are on the out-

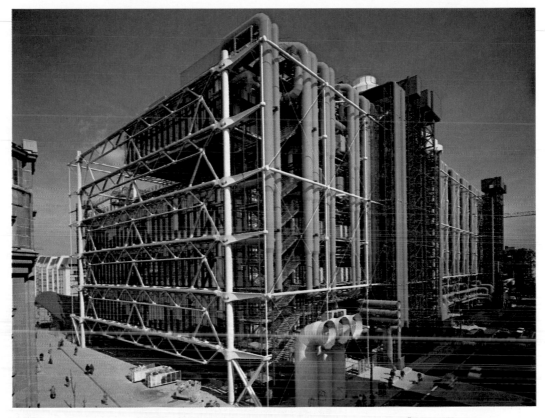

6-23 Richard Rogers and Renzo Piano, Georges Pompidou National Center of art and culture (the Beaubourg), Paris, 1977.

side, creating the impression of an oil refinery. However riotous these utilities may appear, they are entirely essential to the function of the Centre. Rogers and Piano's masterpiece is both the ultimate expression of metal frame and a parody of it.

Ferroconcrete

The technology of concrete was resurrected in the nineteenth century with the invention of portland cement (made by burning and grinding a mixture of limestone and shale). Since then concrete has become increasingly popular as a construction material. Unlike steel construction, which lends itself to the geometry of right angles and flat surfaces, concrete, which is poured into molds, can assume almost any shape. Still, like its Roman predecessor, modern concrete is a form of masonry, and by itself is weak in tensile strength.

However, this handicap can be overcome by imbedding stretched steel rods or cables in the concrete, a combination called *ferroconcrete* or *reinforced concrete*. The dual advantage of plasticity and strength makes ferroconcrete an extremely versatile medium with its own unique qualities.

Charles Éduoard Jeanneret, a Swiss architect who called himself Le Corbusier, is of the same generation as Mies van der Rohe, and like his German–American counterpart, has exerted a tremendous influence on late twentieth-century architecture. Compare Unité d'Habitation, Le Corbusier's high-rise apartments in Marseilles (Figure 6-24) with the Seagram Building. Instead of steel columns, Unité is supported by massive concrete piers; instead of being on the same plane as the wall, its windows are deeply recessed; instead of bronze and glass, it flaunts a surface of unadorned concrete that still bears the impressions of the casting forms. Unlike the Seagram, Unité is rustic and sculpturesque, thereby providing an architectural alternative to the glass box.

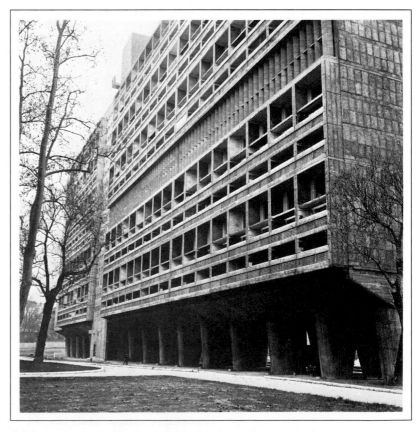

6-24 Le Corbusier, Unité d'Habitation, Marseilles, 1947–52.

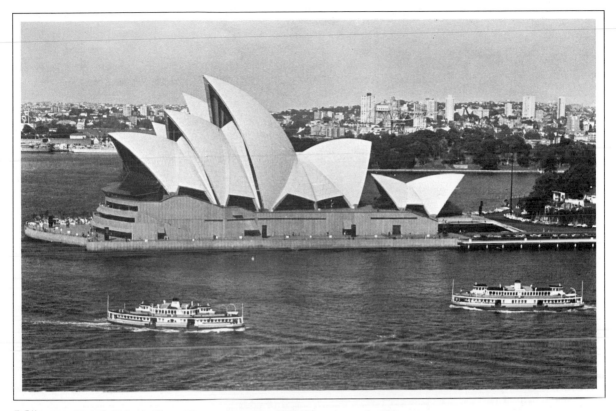

6-25 Jörn Utzon, Sydney Opera House, Australia, 1959–72.

The curving concrete vaults of the Sydney Opera House designed by Jörn Utzon are even more sculpturesque (Figure 6-25). Looking at the building, one is reminded of gull wings, swelling sails, or breaking waves, all of which are appropriate to the site—a peninsula jutting into the middle of Sydney's harbor. The repetition and varied axes of the vaults impart a sense of movement; the scale (the highest shell is nearly 200 feet) and unique design of the vaults provide drama. The Sydney Opera House is not only a striking landmark for approaching ships, but also the most familiar architectural symbol of Sydney.

Geodesic Dome

Buckminster Fuller, American engineer and visionary, invented the *geodesic dome*, which uses a method of assembly similar to that of Paxton's Crystal Palace, but involves a principle of construction related to that of the Pantheon. Rather than a grid system, as with a

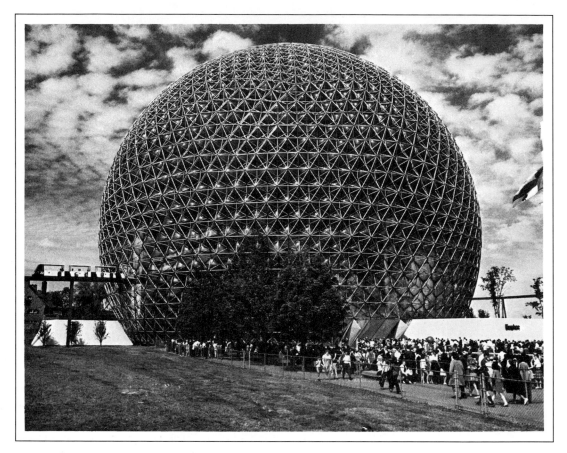

6-26 Buckminster Fuller, United States Pavilion, EXPO 67, Montreal, 1967.

wood or metal frame, the geodesic dome employs a system of hexagonal pyramids constructed of triangles; the repetition of the pyramid module eventually forms a spherical enclosure. The dome of the United States Pavilion at EXPO 67 in Montreal (Figure 6-26) employs an additional supporting system of triangles that bridges the apexes of all the pyramids. Each side of the triangle is part of a line that encircles the dome's surface. The pavilion is slightly higher than the Sydney Opera House, yet its weight is only a fraction of the weight of that building—for it was constructed of nothing more complicated than steel pipes and panels of transparent acrylic. Fuller's dome seems unlimited in its capacity for interior space, possibly capable of spans even several miles wide. It may well be the most rapid and efficient construction method presently available. It remains to be seen whether or not the geodesic shell will play as significant a role in answering future social needs as the balloon and steel frames have in the past and do in the present.

LEVELS OF ARCHITECTURE

We now consider some of the ways in which architecture affects the spaces in which we live. The twin considerations of *lived space* and *architectural space* help define this topic. Lived space refers to that which we physically occupy, move through, use for various purposes, and in which we encounter and interact with objects and other people. But we also interpret this space with our minds and feelings. Architectural space consists of the solids, openings, places, and paths that shape lived space.

An architectural writer, Christian Norberg-Schulz, identified different levels of what he called *existential space*. Three of these levels—landscape, urban, and house—are convenient divisions with which to classify and review some varieties of lived space and their counterparts in architectural space.

Landscape Level

The scale of space at the landscape level might be likened to that which we can see in a landscape painting or in the view from a tall building or a low-flying plane. At this level the relationship between community and site can be examined effectively.

Historically, major settlements such as San Francisco were developed on sites where favorable natural features existed, especially waterways. Because of the large bay, the fine harbor, and its location on the west coast of a developing nation, early San Francisco had the potential of becoming an international city. With a little help from historical events—such as the 1849 gold rush—the great city has lived up to the promise of its location. In addition, the Bay Area enjoys the natural endowments of rich and fertile land in a setting of sea water and foothills. It has the double blessing of harbors for trade and varied topography that provides an aesthetic identity of its own.

San Francisco's builders have both contributed to and detracted from the natural beauty. The Golden Gate Bridge, which is the visual keynote of the area, and the historic waterfront and cable cars contribute to San Francisco's image. However, the regularity of the streets—unrelated to the natural contours of the hills—and the tall buildings threaten to obscure some of the very qualities that give San Francisco its unique landscape identity.

Landscape in a modern city undergoes its most visible transformation in the city's spiritual center, the commercial district. There the man-made monuments—office buildings, hotels, restaurants, department stores, elevated freeways, and bridges—give the city its

metropolitan identity. In ancient times, the spiritual center was marked instead by architecture intended for religious purposes.

Probably the most venerated city landscape in the world is the Acropolis of Athens (Figure 6-27). Crowned by the Parthenon, this hilltop was the spiritual focus of the Athenian world—the showplace of their artistic glory and the rallying point for their civic and religious ceremonies. With the aid of famous artisans from all over Greece, a great construction effort during the time of Pericles (fifth-century B.C.) transformed the Acropolis into a sacred marble city overlooking the *agora,* or marketplace, of the city below. The hierarchy of sacred and profane was therefore confirmed by landscape elevation. The landscape's potential was further utilized in the city's ceremonies: Processions starting in the agora wound their way up the rocky slopes, through the majestic gate of the Propylaea, and onto the exalted plateau of the Acropolis. One of the major legacies of Greek art and architecture is the concept of the heroic, and the heroic qualities of the gateways and temples on the Acropolis can best be understood in the context of their heroic landscape setting.

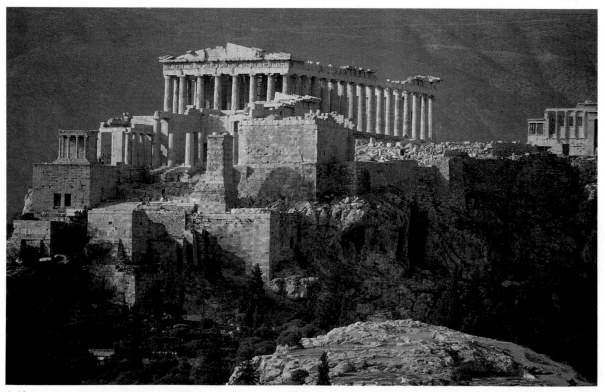

6-27 View of the Acropolis, Athens.

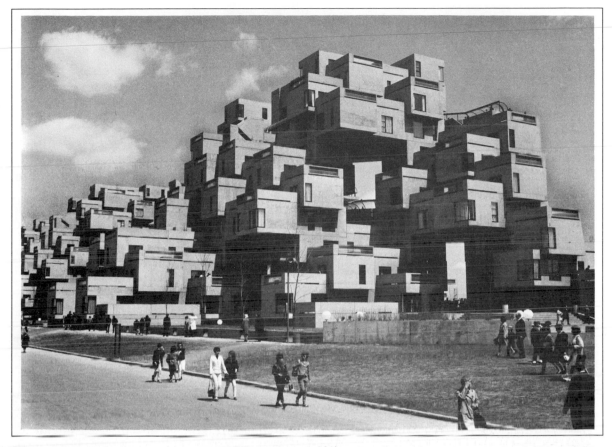

6-28 Safdie, David, Barott, and Boulva; Habitat, Montreal, 1967.

Less dramatic but equally important is the role of landscape in residential living, where attention is given to the selection of sites for family homes and to how the structures can be accommodated to the land. Unfortunately, the sites of many American homes—especially those in nonhilly areas—lack variety. The general criteria for developing new subdivisions consist of laying out a grid of asphalt roads, clearing the trees, and leveling each lot.

Habitat (Figure 6-28), a fascinating grouping of apartments designed by architect Moshe Safdie for EXPO 67, may be an answer to the monotony found so often in suburban developments. It provides variety of level and direction even though it is built on a flat site. An even greater variety of levels, directions, spaces, and textures is afforded by a Dogon village in Africa (Figure 6-29). This richness is due to the fact that the architecture—mostly houses and granaries—is organically related to the natural shapes and contours of the hillside.

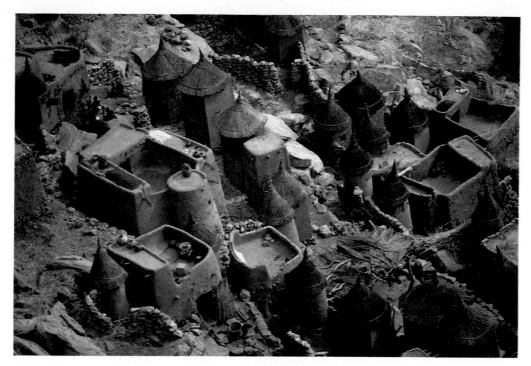

6-29 Dogon village, Mali, West Africa.

Urban Level

The ways in which architecture accommodates social interaction are the focus at the urban level. The physical elements of space that define our urban world are determined by a complex network of history, beliefs, customs, and available technology.

Village and Town Bandiagara, capital of the Dogon people, is not far from the legendary city of Timbuktu in Mali. It has become, along with other settlements of the Dogon people, an object of absorbing interest to sociologists and architects.

The hand-built architecture of the Dogon has the sensuous qualities of sculpture. The design of the homes and the community is determined by symbol and tradition rather than geometry. A house is built in the configuration of a human being: the entrance representing the vulva, the cooking area the lungs, and the kitchen itself the head. The proportions are based on the sexual symbols of 3 (male genitals) and 4 (female labia) multiplied by 2; thus a house is always 6 by 8 paces (Figure 6-30). This anthropomorphic symbolism is extended to the village. Individual family complexes are grouped to form various parts of the total village—which represents a body lying in a north-south direction.

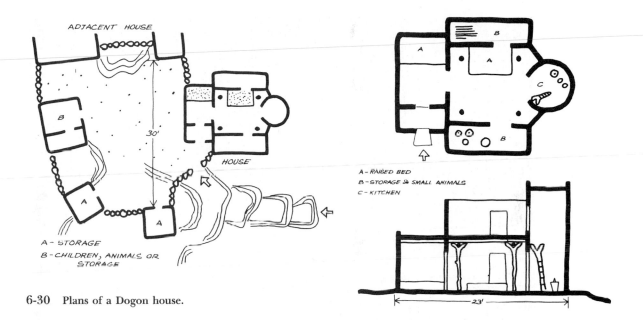

A - STORAGE
B - CHILDREN, ANIMALS, OR
STORAGE

6-30 Plans of a Dogon house.

A - RAISED BED
B - STORAGE & SMALL ANIMALS
C - KITCHEN

The symbolic interlocking of house parts, groups of houses, and village parts reflects a reciprocal interlocking in the social structure. Families of a village are linked by a complex patrilineal system based on marriage customs and a system of individual and collective ownership. Each person is linked emotionally to a network of houses, which in turn is linked both socially and symbolically to the village.

City Planning Perhaps the unity and togetherness of a Dogon community can only be provided in a small village of a preliterate society. The larger towns and cities of literate societies cannot always depend on inherited symbols and traditions to furnish the order needed to conduct their daily business.

The name most associated with city planning of ancient times is Hippodamus of Miletus, who allegedly introduced the gridiron scheme to the cities of Greece and Asia Minor in the fifth century B.C. (Figure 6-31). Regardless of his actual role in planning cities, the use of parallel streets intersecting at right angles in later Hellenistic and Roman communities came to be known as the Hippodamic system. Such a system not only facilitated the flow of commerce that was essential to Greek cities; it also provided order and regularity, in contrast to the chaos of older cities whose streets were determined by the dictates of custom—old footpaths and ceremonial parade routes—rather than by people's needs.

Modern city planning is intended to satisfy the same needs; however, the enemy of order and regularity is not the pattern of

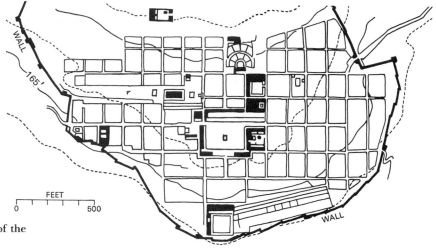

6-31 Simplified ground plan of the city of Priene, Greece.

the streets but the crowded living conditions and their attendant social problems.

Ebenezer Howard, considered the earliest city planner of the modern era, was not enthusiastic about modern cities. Disliking what he saw, heard, and smelled in late-nineteenth-century London, Howard proposed to halt the city's growth and surround it with smaller cities combining the "best of town and country." His "garden cities" would be encircled by agriculture. Industry, schools, and housing would be grouped in planned preserves, with culture and commerce at their centers (Figure 6-32). In essence, his proposal was anti-city in both its rationale and intended effects. It motivated people to think about the problems of urban living and consider decentralization—thinning out the population of the city and spreading it across the land—as the best way to solve those problems. The concept was advanced by two men who were probably the most influential architects of the twentieth century. Both became engrossed with their own conceptions of urban living—each of which in some way reflected Howard's garden cities.

Frank Lloyd Wright, like Howard, was no lover of cities. "To look at the plan of a great city," he said, "is to look at something like the cross-section of a fibrous tumor." Wright held this attitude despite (perhaps because of) the fact that he had learned his trade in Chicago under Louis Sullivan. A dramatic and forceful person, he promoted decentralization, equating centralization (symbolized by the evil skyscraper) with antidemocracy, the antichrist, and the gravestone of capitalism. He included the automobile as an essential element of his utopian plan, believing that the private citizen with a car, like a bird freed from a cage, could "go where he may

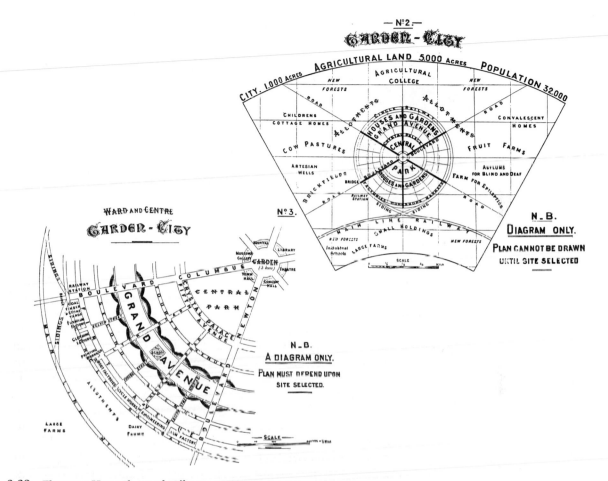

6-32 Ebenezer Howard, two details from the *Garden City* proposal, 1898.

enjoy all that the centralized City ever gave him, plus the security, freedom, and beauty of the Good ground. . . ."

Le Corbusier was as enthusiastic about the city as Wright was opposed to it. Yet Le Corbusier did not appreciate cities in their present state, which he perceived as "bulging with human detritus, with the hordes of people who came to them to try their luck, did not succeed, and are now all huddled together in crowded slums." The *Ideal City* proposal (actually twelve years earlier than Wright's plan) consisted of wide avenues that crisscrossed to form large city blocks—the Hippodamic system on a grand scale (Figure 6-33). Many of these superblocks were to be topped with skyscraper towers—for residential or professional purposes—surrounded by large parks. Although it appalled disciples of the garden city concept, it was in fact a garden city in a different form—a "vertical garden city," in Le Corbusier's own words. Although his scheme called for twelve thousand inhabitants to an acre, high-rise quarters

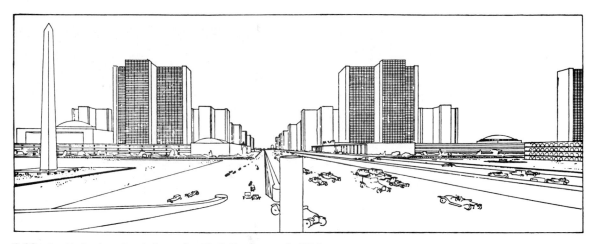

6-33 Le Corbusier, sketch from the *Ideal City* proposal, 1922.

would occupy only five percent of the surface. His ambitious idea, unlike Wright's, made extensive use of the skyscraper—but like Wright's, made ample provision for automobile thoroughfares and parking.

Le Corbusier's later versions of his *Ideal City* plan for the reconstructions of Paris and Moscow were never accepted, but his dream city has had immense influence on American city planners. The clarity, simplicity, and glamorous visibility of Le Corbusier's drawing-board city has, directly or indirectly, captured the imagination of architects, zoning officials, mayors, and even university regents.

Today many urbanologists are questioning the value of these developments that reflect the thinking of famous city planners. The solutions of Howard, Le Corbusier, and Wright are no longer viewed as answers to our problems. The vertical solution of centralizing people in high-rise housing often produces bleak skyscrapers surrounded by parking lots. Or worse, it destroys old neighborhoods, usually with catastrophic socioeconomic results. The horizontal solution of dispersing the population, aimed at helping families fulfill their dreams of green grass and clean air, regularly turns into expensive and inconvenient strips of housing neatly laid out with roads that go nowhere and end nowhere. The enthusiasm of both Le Corbusier and Wright for the automobile seems especially misplaced. "Our fast car," Le Corbusier exclaimed, "takes the special elevated motor track between the majestic skyscrapers." Today, however, our automobile-clogged urban and suburban streets are looked upon more as a disease of modern life than as a panacea. *Planning for Pedestrians* If social interaction is to take place at the urban level, cities must also provide for pedestrians.

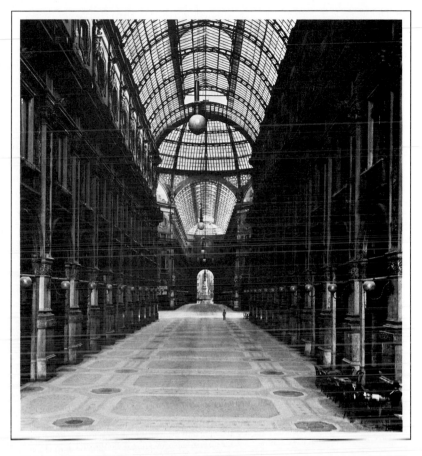

6-34 The Galleria of Vittorio
Emanuele, Milan, 1865–67.

Italy is a country famous for its public walkways, from winding
medieval streets to dramatic squares like the Capitoline Hill (Figure
2-35). Even there the Galleria of Milan is unequalled in its own way
(Figure 6-34). It is a covered street housing numerous shops and a
permanent gallery of industrial products in one of the richest com-
mercial cities of Europe (of all the Italian cities, the one most like an
American city). But the Galleria is more than a shopping center; its
arcades contain bars, cafes, restaurants, and its marble streets are
for dining and leisure as well as business. It is a square for informal
seminars and a promenade for strolling—a place where artists and
members of the entertainment world can mix with everyday peo-
ple. Add a few pickpockets and tourists, and the mixture is com-
plete. But most of all the Galleria is a focal point for the citizens of
Milan.

Precedents for the Galleria go back to Imperial Rome. Little
remains today of Trajan's Forum—a large square formed by colon-
nades on three sides and an immense covered building called a

basilica on the fourth—except parts of the large market on the east side of the square. But it was once an important center of the capital. In addition to being a place for shopping and leisure, like the Galleria, the forum was a combination civic center, financial exchange, sacred area, and sculpture gallery. Lawsuits were tried in the basilica or in an open-air court where crowds of listeners could admire the legal eloquence.

Surprisingly, the automobile is responsible for a creation that could be considered a revival of the Forum of Trajan and a rival to the Galleria. Americans, who often feel compelled to drive a car even to mail a letter, are now encouraged to stroll during shopping because of a commercial solution to the parking problem in downtown areas of the city. Obviously serving fewer functions than a forum, an American shopping center is, nevertheless, a unified complex of retail stores, eating places, and malls for strolling;

6-35 Hulen Mall, Fort Worth, Texas, 1978.

larger centers frequently have movie theaters, skating rinks, and sculpture courts. With its glass roof, open-frame space, exposed trusses and ducts, and escalators, Hulen Mall in Fort Worth, Texas (Figure 6-35) resembles a combination of the Crystal Palace and the Centre Pompidou turned right-side in. Mix all this with mezzanines, atriums, balconies, overpasses, a fountain, a profusion of plants and flowers, and year-around climate control. Attractions like these in Hulen Mall and shopping centers all over the country were obviously intended to inspire people to shop—and at first that was about all. However, now that their newness has worn off, malls are beginning to be used for additional purposes: arts and crafts exhibits, music concerts, health fairs, fashion shows, children's theater, charity events, and even jogging. Hulen Mall, for its part, has been described as "a people place, humming with activity. It's a shopping center, a flea market, a picnic ground, and a civic center all in one."[1] More significantly, teenagers and senior citizens use malls as informal meeting places. Perhaps someday shopping malls will serve as many functions as Trajan's forum did.

Meanwhile, the open square is experiencing a revival in the downtowns of many cities, large and small. Prohibiting traffic for two or three blocks converts a street running through a major commercial area into a pedestrian mall. Such a practice provides more opportunities for human contact as well as some architectural variety. Also, refurbishing old stores, restaurants, and theaters—and perhaps adding some new ones along with a parking ramp—may draw some customers away from the shopping centers.

Paley Park, a "vest-pocket park" in New York City, was created from empty space between buildings just off Fifth Avenue (Figure 6-36). It was not necessarily intended to attract trade, but it certainly provides some relief from an unbroken urban environment. And it is a popular place with office workers in the area, who go there at lunchtime to talk, eat, and relax.

House Level

The urban level is characterized by public places where people gather and paths where people move about. Private spaces within the urban environment are classified as the *house level*. The essence of the house level is interior space, intimately proportioned by and related to the human being. It is a center of personal activity, a place someone goes to or comes from—and most important—a

[1] Editors of *Interiors* Magazine. *The Interiors Book of Shops & Restaurants*. N.Y.: Watson-Guptill, 1981, p. 126.

6-36 Paley Park, New York, 1967.

place in which a man, woman, or child establishes a feeling of personal identity.

Single-family Dwelling The formal directness and material economy of Japanese art has long been an influence on some of the modern art in the West. Western interest in Eastern art has been especially visible in the area of domestic architecture.

The basic ordering unit for a Japanese house is the *tatami,* a tightly woven rice-straw mat that is spread on the floor. Conveying the size and function of Japanese rooms, the meaning of these six-by-three-foot mats has so penetrated the Japanese language that the phrase "four-and-a-half-mat novel" (suggesting an intimate

nine-by-nine-foot-square room for a man and woman) is a familiar slang expression for a romantic book.

Japanese rooms, which serve different functions depending on the occasion, do not correspond to rooms in American homes (Figure 6-37). For one thing, the nature and arrangement of rooms is profoundly affected by the Japanese custom of removing one's shoes before entering the house proper. The combined entrance hall (1) and anteroom (2) used for this purpose has thus become a

garden design for residence of 20 tsubo = 66.1 sq.m = 720 sq.ft. with tea-hut

mizusawa komuten-cg

scale 1:100.

6-37 Plan of a Japanese house.

very important space, which in the smallest of houses may consist of ten percent of the entire floor area. The act of taking leave of the outside world by removing one's shoes symbolizes the first stage of shedding the indifference and estrangement of the outside and assuming the peace and harmony of the inside. The second stage of integration with the inner environment comes in the adjoining anteroom. It is here that the husband and wife greet each other after work, and here that the host and guest meet and bow. Now one is ready for full integration into the house. The anteroom is usually adjacent to all of the other rooms; however, a guest would be directed into the reception room (3). Roughly equivalent to an American living room, it is the most important space in a Japanese house (averaging at least eight mats in size). Containing a revered and ornamental alcove called a *tokonoma*—a sort of private-home sanctuary—and bordered by a broad veranda that leads to a lovingly cultivated garden, this room is the spiritual core of the house.

Among the admired aspects of Japanese architecture are the outdoor-indoor relationships (Figure 6-38) and the concept of con-

6-38 Old Samurai's House, Miyagiken, Japan.

tinuous or "flowing" space. A small garden, even under the limited conditions of city living, is considered a minimum requirement, one linked visually and psychologically to the interior by a veranda. In addition to the continuity between exterior and interior, movable partitions and the modular coordination of rooms lend to the Japanese house a sense of uninterrupted flow between interior spaces.

Yet wholesale application of Japanese principles of architecture to Western architecture would be superficial. The differences in life-style related to the custom of entering the home have already been mentioned; basic occidental attitudes toward physical comfort and hygiene require an assortment of furnishings that would suffocate a Japanese interior. Even more fundamental are the traditional differences in personal philosophy that always operate as underlying premises in domestic architecture. A Japanese interior, with its small scale and thin walls, is not conducive to the expression of individual personality.

Frank Lloyd Wright successfully assimilated into his early homes some elements of architecture that could be attributed to Japanese inspiration (Figure 6-39). The long horizontal lines, made longer by extended eaves and overhanging balconies, and the indoor–outdoor continuity evoked by the verandas and the many windows, are signatures of the Prairie Style he began to develop in the first decade of this century. But the drama, the scale, and the sense of solid luxury are strictly American in spirit—although beyond the pocketbook of the average American. The prairie house

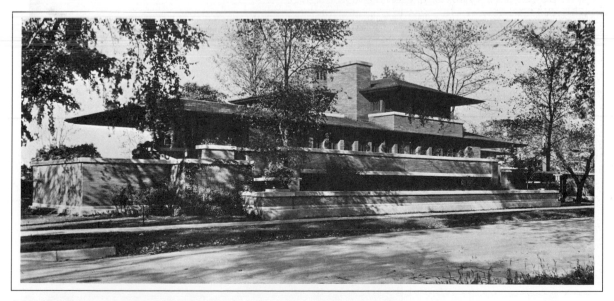

6-39 Frank Lloyd Wright, Robie House, Chicago, 1909.

has left its mark (and thus a Japanese touch) on every suburban ranch house with its familiar overhanging eaves, picture window, and relatively open floor plan.

Concentrated-family Dwelling Increasingly, the single-family dwelling is too expensive for most Americans, let alone for people in other parts of the world. Further, if the 15,000 square foot lot that the typical middle-class home rests on is multiplied to keep up with a population that increases by two percent every year, the whole country would soon be suburbanized. Clearly, there is a need for forms of concentrated living that will permit large numbers of people to occupy relatively small surface areas.

High-rise projects like Chicago's Marina city (Figure 6-40) represent one approach to the problem. These tall, ferroconcrete structures, located along the marina and within walking distance of shopping and work, are comfortable and convenient for the upper-middle-class people living there. Even the parking problem has been solved by turning over 18 floors to the residents' automobiles.

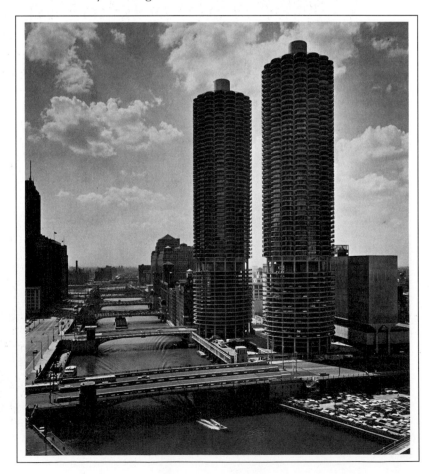

6-40 Bertrand Goldberg, Marina City, Chicago, 1964.

But for average or poor families, especially those with children, high-rise projects are not comfortable and convenient. The dream of a vertical garden city can become the nightmare of a vertical slum. The Pruitt-Igo project in St. Louis, built in the 1960s with the best of intentions for providing housing for low-income families, has the dubious distinction of being the first famous project to be ordered demolished. Among the reasons for its failure was the fact that outdoor play areas were too small, unsupervised, and relatively inaccessible to the children. Hallways and elevators soon became the play areas—eventually the targets of vandalism—leading to the complete disruption of family living. Today, with high-rise projects being the sites of rampant graffiti, drugs, rapes, kidnapping, and all sorts of crime, the Pruitt-Igo experience seems mild. Since then, so many high-rises with sound structures have been demolished that it is no longer news.

The high-rise apartment is not the only type of high-density housing available. An alternative consists of individual units linked together, each unit having a patio—if not its own ground space. Called "urban low-rise group housing," this scheme is a solution that is attracting architects and urban planners today. Yet this type of housing is not new. It existed in the Western Hemisphere before the time of European settlers and long before land started to become scarce. The Anasazi Indians of the Southwest, for example, began living in concentrated settlements as early as the first century A.D. The Cliff Palace in Mesa Verde National Park (Figure 6-11)

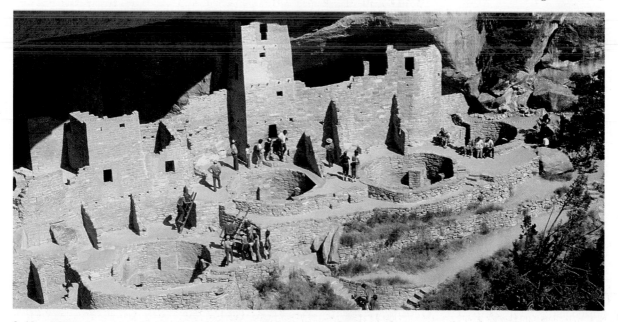

6-41 Cliff Palace, Mesa Verde National Park, Colorado, c. A.D. 1100.

was a multi-storied, masonry-walled community containing over 200 dwelling rooms. In Africa, the Dogon style of living resembles that of low-rise group housing (Figure 6-29). Although each house is separate, the complete unit of house, plot of ground, and granary bins is connected with those surrounding it.

The experimental apartment complex Habitat, which succeeds in looking like a hillside town without the benefit of a real hill, is a contemporary example of high-density group housing (Figure 6-28). The nearly identical modular units were ingeniously designed so they could be attached to each other in enough different ways to lend a degree of individuality to each unit and prevent the entire complex from looking monotonous. (The lack of central hallways and elevator shafts, however, makes garbage disposal and access to the apartments difficult.) In Europe, where lack of space is more of a problem than in America, there are already many interesting but less radical examples of new apartment complexes. Terraced, staggered, linked, and patioed—they retain many of the advantages of detached single-family dwellings and the attractive

6-42　Low-rise housing units, Bern, Switzerland.

qualities of garden-house life (Figure 6-42). Surprisingly, low-rise urban housing was found to be almost as economical as high-rise housing, both with regard to site requirements and to cost of construction. Further, it was found that concentrated living, if effectively designed, can contribute to the quality of life rather than detract from it.

SUMMARY

The first part of this chapter surveys certain basic principles of architectural construction, while providing one or two examples for each. Variations of the arch principle were used in constructing much of the world's public buildings for centuries, and with that method people were able to make buildings as different as the Colosseum and Chartres Cathedral. A few new methods, developed within the last 150 years, provide architects considerably more freedom. Using metal frame or ferroconcrete, they have been able to make structures as unique as the Centre Pompidou and the Sydney Opera House. Yet, though today's architecture takes a variety of forms, it is not as free as today's art and crafts. To erect a roof over people's heads, architects— no matter how experimental they may be—cannot afford to ignore certain laws of nature and the practical matters of function, materials, and technological expertise.

The second part of the chapter reviews the architectural environment from the perspectives of three different levels. Some of the examples in this review, such as the Athenian Acropolis, qualify as distinguished architectural monuments; others, like the pocket park, are unpretentious pieces of people's daily surroundings. All of them exist as examples of humankind's constant and unceasing alteration of the physical environment. It is an enterprise that satisfies practical needs and, sometimes, gives pleasure and inspiration.

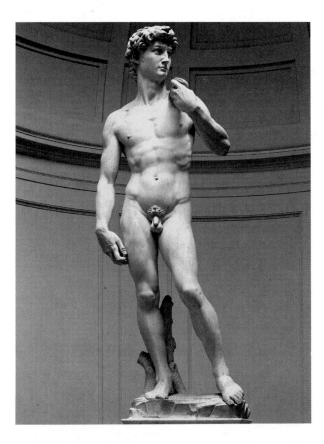

Artists who work with images use them as writers use words—to interpret the human experience of the time and place in which they live. In primitive societies, in which groups of people share a common history and set of beliefs, their conceptions of the world are reflected not only in their art, but in their ceremonies, their ritual objects, and in the ways they build and decorate their houses. In a society such as contemporary America, in which religious, regional, class, and ethnic differences divide the population, such a degree of unity is impossible; the pluralism of beliefs and values is reflected in the pluralism of its artistic expressions, as well as its diverse lifestyles. ¶Nevertheless, certain themes seem to persist in the artistic expressions of all periods and cultures, whether they be primitive or modern, simple or complex. These themes address basic questions such as: What is the nature of the world? Where did we come from? What is our place in the world? ¶Part Two looks at certain themes and their artistic interpretations across times and cultures. Chapter 7 examines the ways different societies express nature in their art and the implications of these expressions for the ways in which these societies relate to nature. Chapter 8 explains the pervasiveness of the nude in Western art and sheds light on attitudes toward sexuality across time; Chapter 8 also reviews examples of the erotic art of a non-Western culture. Chapter 9 compares and contrasts the theological views of four major religions—Judaism, Bud-

dhism, Islam, and Christianity—as well as uses of imagery to express transcendent meanings. Chapter 10 looks at the multi-faceted American experience—the changing ways a nation views itself as revealed by its art. Thus, Part Two is an artistic journey through time and space.

CHAPTER 7 IMAGES OF NATURE

A LMOST EVERY ENGLISHMAN," art historian Sir Kenneth Clark once said, "if asked what he meant by 'beauty,' would begin to describe a landscape. . . . " The same might be said of a Japanese, or an American, or, in fact, almost any citizen of a modern society. To the average person, the art of painting is often identified with the landscape—despite the fact that today only a minority of artists make landscape paintings.

This popular conception of art is reinforced by the endless number of inexpensive and tawdry reproductions of landscape paintings sold for the decoration of American living rooms. Perhaps the proliferation of these images in our culture has cheapened them and reduced them to little more than trivial ornament. If this is so, it obscures the fact that landscape painting is a sophisticated product of art and human consciousness. It is the result of a long artistic evolution linked to a history of changing human attitudes toward the natural environment. The varieties of attitudes toward nature and how these have been expressed in art (not only in terms of landscape) are the subject of this chapter.

ICE-AGE PAINTING

Animals appear to have been the very first subject matter of art. As far as we know, the earliest image makers were Ice-Age hunters that lived more than 12,000 years ago in western Europe, not far from the melting ice of the last major glaciation. Members of a Paleolithic (Old Stone Age) culture, they did not farm but eked out an existence by gathering food from wild plants and hunting wild animals that furnished food, furs, hides, bones, and ivory. On the walls of subterranean caves they left an amazing artistic record of

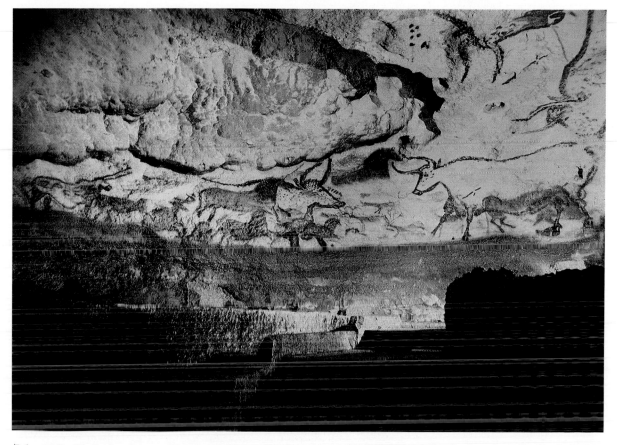

7-1 *Hall of Bulls*, Lascaux, c. 15,000–10,000 B.C. Dordogne, France.

these animals. Ever since the discovery of this art about a century ago, observers have been impressed by the evidence it provides of an extraordinary level of artistic observation and image-forming ability.

Although some of the species painted in caves near Lascaux in southern France no longer exist, the artists made their images so vivid that we have no trouble recognizing them as various types of grazing animals—bison, wooly rhinos, mammoths, horses, bears, and giant elk (Figure 7-1). The outlines and proportions seem to have been based on fairly accurate observations of the profiles of real beasts.

We can only guess at what the artists used for paints and brushes. They may have mixed pigments of red ocher and manganese with animal fat, and then used reeds or animal tails for transferring this mixture to the caves. There is also reason to believe that hunter-artists painting at other sites used blowpipes to spread the

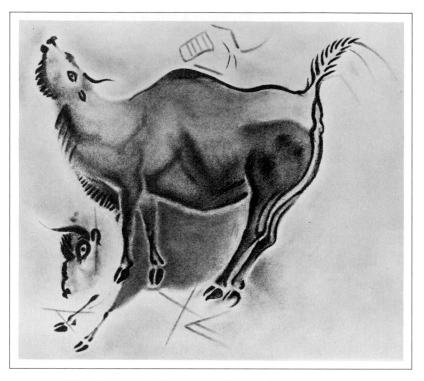

7-2 Bellowing bison and fragments of another galloping bison, Altamira, c. 15,000–10,000 B.C. Altamira, Spain.

mixture. The images in the caves of Font-de-Gaume and Altamira (Figure 7-2) are even more three-dimensional than those of Lascaux, primarily because of a chiaroscuro effect—not unlike that in a modern picture made with an airbrush—that brings out the bulky qualities of the animals.

Not all subjects were treated with as much sophistication as the animals. Representations of people are mostly stick figures; the rare references to landscape features such as rocks, plants, and streams are more like schematic symbols than images. Likewise, the arrangements of the animals (with or without other images) reveal none of the sophisticated methods—overlapping, vertical placement, variations in size, and linear perspective—now employed by artists to suggest spatial depth. Indeed, few of the arrangements seem determined by any identifiable logic. Randomly placed—sometimes overlapping but usually unrelated to one another in size or narrative—the images are, in this respect, reminiscent of modern graffiti. The impressive realism of Ice-Age art is confined almost entirely to the portrayal of individual animals.

But if we consider the kind of lighting (or lack of it) that was available in these caves, we can speculate that prehistoric people probably could not have viewed more than one painting at a time anyway. Imagine what it must have been like to see one of these

beasts leap into view as a torch was waved in front of it. This intriguing mental image leads us to question what an animal picture meant to these hunters; what was the purpose and content of this art? To address such a question requires research and no small amount of imagination. Some conjectures can be ruled out. The fact that many of the murals are in inaccessible, poorly ventilated enclosures refutes the notion that these caves were used as art galleries or dwellings. The fact that many of the images show the marks—real or painted—of weapons suggests that the pictures did not serve purely aesthetic purposes.

The best guess is that the awkward locations served as privileged sanctuaries for religious rites and that the images of beasts served magical purposes. Animals, which the Ice-Age hunters depended on for survival, must have been at the center of their beliefs and superstitions.

Image-making similar to that of the Ice-Age peoples have been found in some modern African societies. And totemism, a belief that animals are ancestrally or spiritually related to human beings, has continued to thrive in many places in the world. The mythologies of preliterate peoples are filled with stories of humans turning into animals and vice versa. Accordingly, it seems likely that Ice-Age societies probably also believed in some form of totemism.

In such societies, distinctions were not made between the natural world and the spiritual world. Since Ice-Age life was totally bound to animals, art depicting animals must have had awesome significance. Its magic was not only important for ensuring success in the hunt but was part of the very structure of belief and social continuity. In a sense these paintings were not images but real spirits, occupying the same magical stage as the hunter-dancers.

EGYPTIAN TOMB ART

Human beings—and the dead rather than the living—were represented in most Egyptian art, because one of the principal uses of paintings was the decoration of tombs. Here, too, art had a magic function. The image served to provide a home for the spirit of the deceased, especially if the mummified remains should deteriorate. The tomb of Ti, located at Saqqara, provides an excellent example of this custom. Ti, who lived around 2400 B.C., was an important bureaucrat, the overseer of the pyramids and the Sahura temple. Consequently, his remains were privileged to reside in a *mastaba* (a small, flat-topped tomb) in a special burial ground for deceased officials.

One of Ti's earthly privileges was that of fishing and hunting in the marshes of the Nile. Because Egypt was an agricultural society,

fishing and hunting were sports—not means of survival. In order to continue these sports in the hereafter, Ti commissioned a relief mural depicting hunting and fishing (Figure 7-3). Along with his own image, magical images for servants, boats, animals, and plants were also necessary. Other painted reliefs in his mastaba illustrate the many needs of his rich estate in eternity: workers polish his statues, cooks and bakers prepare his food, craftsmen build boats for his favorite sport, and peasants harvest his grain and care for his cattle.

In order to guarantee that an image would be an adequate home for a soul, the Egyptian artist was compelled to follow certain rules. Ti's body, for example—which seems pinned in an upright position to the corrugated thicket of reeds—has its head, legs, and feet shown in profile while one eye and the trunk of the body are shown frontally. This formula (sometimes called *fractional representation*) was applied to almost all human figures, whatever their activity. Had the artist shown the back rather than the front of the nobleman's head, or one of his arms hidden behind his body, or his feet hidden inside the boat, then he would have tragically omitted some of Ti's anatomy, and according to the rules of magic Ti himself would have been without a face, two arms, or two feet. The artistic solution was to provide the most adequate and characteristic full view, not only of Ti but of the people and creatures that were to serve him forever.

The same type of thinking that considered anatomy a sum of the parts was applied to the organization of the picture. Although various elements of nature, people, and animals are logically connected (to an extent never achieved in Ice-Age art), they are not at all integrated in the realistic sense that we customarily associate with landscape art. Divided into tidy zones, the relief clearly spells out the proper neighborhood of each figure. The aquatic animals are relegated to their own environment, symbolized by neat rows of vertical ripples. The scarcely broken line on top of the water is the baseline for the boats. Overhead is another clear zone of fowl and smaller animals among the papyrus tops. Little if any overlapping is permitted, even where there are swarms of animals.

In the rigid structuring of this mural we can also perceive the symptoms of a highly organized civilization that was physically and emotionally dependent on the Nile. Although the river and its banks provided much of what they needed to live—fish and game, papyrus to write on, clay for pottery—the vital and abiding resource was the annual overflowing of the Nile that irrigated and enriched the fertile valley with silt. All Egyptian agriculture, hence Egyptian survival, depended on this event. So regular was the flooding—between July 19 and 21 at Heliopolis (now Cairo)—that

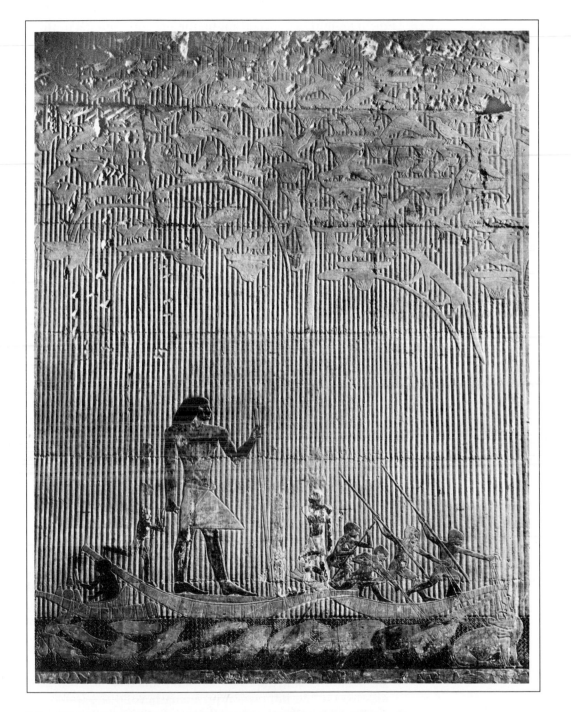

7-3 *Hippopotamus Hunt*, tomb of Ti, Saqqara, c. 2500 B.C. Painted limestone relief, approx. 48″ high.

the river imposed it rhythms on the life and thinking of the people. Thus the dependable fluctuations of the Nile, sanctified in Egypt's mythology as well as its law, helped produce what was perhaps the most rigid and stable society ever seen on this planet. This conservatism was exemplified by Egypt's art—an art that changed very little over a period of three thousand years.

ROMAN WALL PAINTING

It is believed that Greek landscape painting grew out of Greek theater sets, the word "scenery" coming from the Greek word for "stage." Yet we can only guess about the origin and development of Greek landscape art from pottery painting or from written sources, because almost no Greek painting survives. We can, however, obtain a secondhand reflection of the later forms of this art from Roman frescoes and mosaics, which frequently were imitations of Greek works. Indeed, Greek artists were sometimes imported to Italy to decorate the walls of wealthy Romans' homes.

In a painting on a wall of a Pompeii villa (Figure 7-4), we see a few trees and buildings on a gentle hillside, a quietly romantic setting for strollers and a modest herd of goats. This view of nature, as well as the feeling it inspires, represents an enormous leap from Egyptian art. The separate figures and objects are lighted by the sun; some even cast shadows. The temples and the bases of monuments, unlike the Egyptian boats in Figure 7-3, expose two of their sides instead of one (although their oblique angles do not create a consistent perspective). The people and animals are not restricted to their profile views but are free to stand or relax in any natural position. Everything—trees, architecture, creatures, and the ground on which they rest—is integrated into a single visual event. A pervasive light blends the elements by de-emphasizing edges and boundaries. But this integration is also achieved by some of the logic and controls of optical space. We interpret an Egyptian picture vertically or horizontally, like a floor plan, but we can view the Roman picture—because of overlapping, relative sizes, and other visual cues—in much the same way as we see real objects in space.

The Romans, fascinated by the illusionistic potential of a more realistic form of painting, decorated their walls with numerous false architectural features such as columns, lintels, arches, and gables perhaps to tease their guests into seeing nonexistent courtyards and temples. Landscapes were often framed by false window moldings to give the impression of seeing beyond the wall.

Paradoxically, the mental attitude that allows one to view an illusion as a surrogate of a real scene is the product of a more

7-4 Wall painting transferred to panel, from the Villa of Agrippa Postumus, late first century B.C. Portion shown approx. 26″ high. Museo Nazionale, Naples.

scientific approach to reality. The awakening of the intellect that began with the Greeks—to which the Romans were heirs—introduced scientific explanations not shared by other ancient cultures. Eventually this more objective attitude drove totemism out of nature. Image-making, liberated from taboos and its primitive magical function, was free to be used to represent natural appearances. But hand in hand with science and the art of appearances

came an attitude of detachment, if not estrangement, from nature. No longer a part of nature, Greeks and Romans, especially those living in the cities, had become *observers* looking at nature from the sidelines. The primitive hunters and the Egyptians were so much a part of nature that they were incapable of viewing it with either scientific or artistic detachment.

On holidays the traffic of our freeways, jammed with cars and campers, is headed mostly away from the city. The perception of nature as being not only beautiful but a place to escape to is, in our day, taken for granted. Roman citizens, especially those who could afford wall paintings, seemed to have held a similar view. They, too, were urban dwellers, enjoying public services—water, sewage, paved roads, markets, courthouses, theaters, and public baths— that were remarkable for a preindustrial society. But despite the amenities, city dwelling then, as now, must have inflicted some psychological pressure. The idea of "opening up the wall" to imaginary porticoes and parks was probably intended to satisfy a need to be in closer contact with nature—even if it was a fictitious nature.

CHINESE LANDSCAPE PAINTING

To the Chinese of the Sung Dynasty (960–1279), landscape art was more than a stage prop. Nature itself was the protagonist of a drama in which humans were minor actors. In Chapter 3 we saw an example of a Sung landscape by Tung Yuan (Figure 3-12) in which the people were dwarfed by the vastness of the land. *Clearing Autumn Skies over Mountains and Valleys* by Kuo Hsi (Figure 7-5), in which the only indication of human life—a strolling philosopher in the lower left—is barely discernable, evokes a similar sense of vastness. This effect is due not to a system of one-point perspective but to the artist's skillful use of ink washes with which he suggested mountains, forests, and shrouds of mist. In places he used areas of empty paper to hint at the deepest layers of a mist. A wash cannot be forced; the artist must "go with the flow," since the watery medium runs, spreads, and sinks into the pores of the paper. The working process of this kind of art is analogous to the Oriental attitude of respect for and cooperation with nature. By contrast, oil painting, the popular medium in the West, is always under the control of the artist and thus is analogous to the Judeo-Christian attitude of dominion over nature.

However, *Clearing Autumn Skies over Mountains and Valleys* is more than just a collection of amorphous mists. Its ink washes are structured by a system of lines and details. The feeling of distance and space indicated by the washes is enhanced by placing the small

7 5 Kuo Hsi, Makimono, *Clearing Autumn Skies over Mountains and Valleys* (detail), twelfth century. Ink and light color, 81⅜" × 10¼". Courtesy of the Freer Gallery of Art, Smithsonian Institution, Washington, D.C.

figure at the bottom of the picture. (The sensation of potentially falling into the scene is due perhaps to this "plunging" perspective.) Lines also complement the tonal areas in defining the craggy mountains and the textures of foliage and rocks.

In addition to aiding the illusion of depth in the picture, the lines are also responsible for rhythmic, abstract patterns. Artistic use of line was a tradition in ancient China where handwriting (*calligraphy*), like painting, is looked on as a fine art. Chinese artists receive extensive training in calligraphy, and Chinese painting was nurtured by the freedom and fluency of Chinese script and by the cults that refined the art of calligraphy over the centuries.

Rather than directly copying a section of nature, Chinese artists gathered impressions while walking. They absorbed the subject matter from many angles, in the process savoring it and mentally translating it into forms for trees, water, and mountains learned earlier from their masters. Everything was stored in the memory, to be released later during an act of creativity. Like a stage performer, the artist felt the need for mental preparation before the act. According to documents of the time, some Chinese artists depended on wine for this creative release. Kuo Hsi (Figure 7-5) relied on a private ritual that was described by his son.

Whenever he began to paint he opened all the windows, cleared his desk, burned incense on the right and left, washed his hands, and cleansed his ink-stone; and by doing so his spirit was calmed and his thought composed. Not until then did he begin to paint.

The absorption and filtering of reality before transferring it to paper was an artistic habit founded on a philosophy of life. The goal of the Chinese artist was to reveal the essentials of nature rather than to record its outward appearance. The twelfth-century Confucian philosopher Chu Hsi compared the ultimate knowing of anything to the act of peeling an orange: An artist who merely imitated outer appearances was one who stopped at the peel. Educated artists, like the philosophers who meditated on religion and philosophical subjects until these became engraved on their inner consciousness, studied nature from all angles until they could internalize its universal character. Central to this philosophy of art was *Ch'i*—life force or energy. A pantheistic concept of divinity—as opposed to belief in a personal God—*Ch'i* was the source of creativity in both nature and art. The extent to which a painting or poem revealed *Ch'i* was the touchstone of its aesthetic value.

Ideas connecting nature and human beings run deep in Chinese thought. By the time of the Sung painters, a cult of nature had arisen from elements of all three of China's religions (Buddhism, Confucianism, and Taoism). Both Taoism and Ch'an Buddhism—the sect to which most painters and intellectuals belonged—involved the search for an escape from reality, an escape that took the form of a withdrawal to nature. This was motivated by more than purely religious insights and metaphysical speculation, since at that time China was being divided by internal upheavals and barbarian attacks on its borders. Artists, however, received salaries from the government or rich patrons and were insulated from the mainstream of Chinese living, free to fulfill their need for withdrawal. Their art was not shared with the average Chinese but was circulated among a cultural and economic elite. Love of nature, it seems, was a privilege of the wealthy.

CHRISTIAN MANUSCRIPTS

At the time Tung Yuan, Kuo Hsi, and other Sung painters were glorifying nature, Christian artists in Europe were glorifying the gospels. Unlike the Chinese, to whom the divine was manifest in the forces of nature, Christians worshiped a personal God, separate from nature, who presented Himself through Christ. *Christ's Entry into Jerusalem* from the *Gospel Book of Otto III* (Figure 7-6), a typical example of biblical illustration during A.D. 1000, serves to show the limited way in which nature was represented and also how far Eu-

7-6 *Christ's Entry into Jerusalem* from the *Gospel Book of Otto III*, c. 1000. Bayerische Staatsbibliothek, Munich.

ropean art had turned away from Greco-Roman realism. Christian artists, reflecting a total commitment to the spiritual world of Christianity, were too busy communicating the message of salvation to have time for nature. Also, nature, as an extension of the human body, was basically sinful—a vale of sorrows and temptations through which Christians must painfully make their way in order to enter paradise. Not that nature was entirely excluded in art. Gospel texts were often decorated with images of animals, but the latter

served as emblems for beings or ideas other than themselves. An ox, a lion, and an eagle, for example, symbolized the Evangelists Luke, Mark, and John. Nature was used in medieval Christian art for symbolic or ornamental purposes.

In the thirteenth century, the later part of the Middle Ages, there occurred some moderation of the Christian aversion to na-

7-7 Taddeo di Bartolo, *St. Francis' Sermon to the Birds*, 1403. Niedersachsische Landesmuseum, Hanover.

ture. Much of this was due to the life and teachings of St. Francis of Assisi, shown in his famous "Sermon to the Birds" by the early fifteenth-century artist Taddeo di Bartolo (Figure 7-7). A humble and compassionate man (the founder of the Franciscan Order) Francis saw nature and all its creatures as gifts of God. Still, his teachings did not have the effect of stimulating artists to paint landscapes or of entirely redeeming nature in the eyes of the faithful. An anecdote about mountains illustrates Europeans' continuing reservations about nature, and the great difference between Chinese and Christian attitudes. The Alps, so attractive to tourists today, were not considered a fit subject for human attention, even in the fourteenth century. Petrarch, a famous scholar, talked his brother into accompanying him on a climb of Mt. Ventoux. In those days, climbing a mountain for aesthetic reasons was almost unheard of. But when they reached the top, Petrarch read a passage from Saint Augustine that made him feel guilty about enjoying himself and forgetting the needs of his immortal soul. "I turned my inward eye upon myself," he says, "and from that time not a syllable fell from my lips until we reached the bottom again."

LEONARDO

Five hundred years after Kuo Hsi's *Clearing Autumn Skies over Mountains and Valleys* and the *Gospel Book of Otto III*, and 300 years after St. Francis, a Florentine artist named Leonardo da Vinci painted the portrait of the young wife of Francesco del Giocondo (Figure 7-8). Since then, she has become the most famous woman in the Western world; her legendary smile has fascinated every generation. The fact that it was possible to make such a portrait in 1503 shows the vast distance that European art and intellectual life had come. The intellectual interest of Europeans was shifting—as suggested by the expression on Mona Lisa's face—away from the mysteries of the Church and beginning to focus on the mysteries in themselves. Humanism, a system of thought based on the interests and concerns of people, had become pervasive in Renaissance Italy. Even before Leonardo, during the early 1400s, artists had experimented with the problems of expressing the human spirit in more secular terms. The people's interest had turned from the heavens to the earth—in keeping with a Renaissance marked by a revival of scholarly and scientific investigation. For example, it was during this time that Florentine artists (among them, Leonardo himself) developed the principles of linear perspective. It is the form of the landscape behind Mona Lisa, as well as its newly discovered human meanings, to which we must now turn our attention.

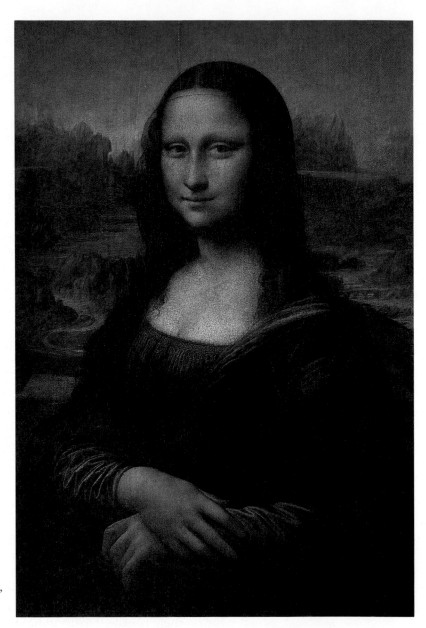

7-8 Leonardo da Vinci, *Mona Lisa*, 1503–05. Oil on panel, 30″ × 21″. Louvre, Paris.

As might be expected from Petrarch's experience, the Europeans' historical lack of rapport with the land appears to have made it difficult at first for their artists to incorporate land features into their pictures. Early attempts, especially with mountains such as those in Taddeo's painting, were naive or fantastic (not unlike the papier mâché concepts of moon scenery that appeared in movies before the days of space travel). Even the tool of one-point perspec-

7-9 Leonardo da Vinci, detail of the upper-right background of the *Mona Lisa*.

tive, which worked well for representing the shape of a building or room interior, was relatively useless for forests and streams. Renaissance artists before Leonardo also seemed to have a difficult time fitting their people into continuous landscapes. Either the people were the wrong size or the foreground was discontinuous with the background—or both.

Leonardo, a scientist as well as an artist, was more observant and less committed to abstract formulas in his approach to landscape than were his contemporaries. He solved the problem of harmonizing the subject with the background by placing the young woman on a high ledge overlooking a landscape (Figure 7-9). The hills and valleys, roads and riverbeds, crags and sky, form a single

organic environment, held together by a pervasive atmosphere. (Leonardo perfected his own aerial perspective, which he called *sfumato*—a smoky ambience created by softening the edges of all the figures and objects.) Leonardo filled the pages of his notebooks with studies of everything from human anatomy to the movements of water. But his art was informed by emotion as well as scientific observation. It is no accident that the geological forms behind Mona Lisa seem to throb like a living organism. Leonardo believed that a life force, not unlike that of the Sung concept of Ch'i, flows through all things of the earth. Yet also lurking in Leonardo's mountains and valleys there is a forbidding quality not found in Chinese art. Nature, as he once observed in his notebooks, "often sends forth pestilential vapours and plagues upon the great multiplications and congregations of animals, and especially upon mankind." Some of the chill of medieval art survived the Renaissance thaw and lingered in Leonardo's landscapes.

CONSTABLE

The shaded pond, trees, and distant meadows in the nineteenth-century English painting *The Hay Wain* by John Constable (Figure 7-10) are radiant with peace, serenity and optimism. Long before Constable, European artists had mastered virtually all the principles—linear and aerial perspective, gradient of textures, cast shadows, and so forth—associated with creating an optical illusion of nature. Indeed, his countrysides are indebted to seventeenth-century art, in particular Dutch paintings of low horizons, scudding clouds, and moving shadows. But even though he was a thorough student of the techniques of other artists, Constable was also a keen observer of nature itself. His dedication resulted in his extending the vocabulary of outdoor art to one of its finest manifestations in the Western world. His particular contribution was that of capturing the transient phenomena of nature's "dews, breezes, bloom and freshness" by means of broken color—touches of relatively bright color and flecks of pure white, often applied with a palette knife. Such effects are not simply a matter of facile painting technique. Constable's fresh vision was a result of both his closeness to nature and continual experimentation with the oil medium. His belief that painting should be pursued as an inquiry into the laws of nature is reminiscent of Leonardo da Vinci's attitude. And as was the case with Leonardo, Constable's reliance on observation was enhanced by a reverent passion for his subject.

Nature worship swept Europe in the early nineteenth century. On the Continent, the writings of Jean-Jacques Rousseau had chal-

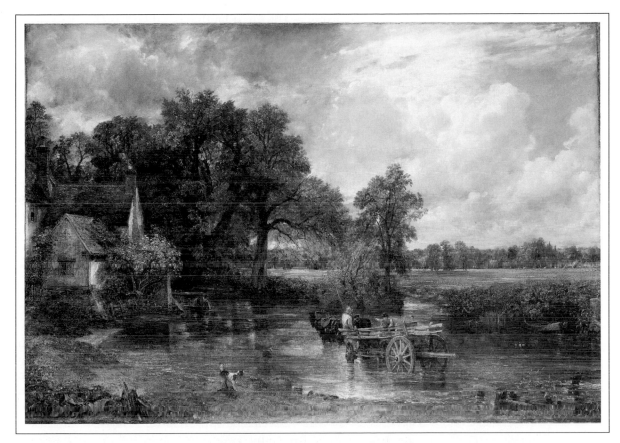

7-10 John Constable, *The Hay Wain*, 1821. Oil on canvas, 51¼″ × 73″. Reproduced by courtesy of the Trustees, The National Gallery, London.

lenged the hearts and minds of Europeans by upholding the virtues of primitive simplicity over the vices of civilization. In England, the Romantic poetry of Wordsworth (read by Constable) extolled the spiritual revelations of nature in even its most humble aspects. Literature and art reflected an intellectual revolution that seemed to be steering Europe toward an outlook like that of eleventh-century China—the common ground being a mystical feeling for nature. (One symptom of this shared state of mind was the mutual affinity in China and nineteenth-century England for large informal gardens.) Constable's temperament and personal religious views coincided perfectly with this cultural movement. The natural universe, in which the philosophers of the time believed the highest moral feelings were revealed, was considered to be the handiwork of God. And this handiwork extended to every last thing—mill dams, willows, old rotten planks, shiny posts—that Constable revered in the

English countryside. His finest landscapes, like *The Hay Wain,* were painted in the East Anglian countryside around the river Stour where he grew up.

Ironically, the works of Constable—the artist who most successfully expressed the moral, philosophical, and visual ideals of the people of England at that time—were more popular in France than in his own land. English artistic tastes, which favored a more finished-looking and idealized product, had not as yet caught up with English spiritual values. But in France *The Hay Wain* received a prize in the Salon of 1824, and was to profoundly influence many French artists—whose work in turn influenced the Impressionists. But Constable's greatest legacy was to a broad movement in the arts known as *Romanticism.* Much Romantic painting was given to

7-11 Joseph Mallard William Turner, *Snowstorm, Avalanche and Innundation in the Val d'Aosta,* 1837. Photograph © 1990, The Art Institute of Chicago. All Rights Reserved.

extremes: it either wallowed in sentimental depictions of rustic life or soared into operatic visions of catastrophic nature as in *Snowstorm, Avalanche and Innundation in the Val d'Aosta* (Figure 7-11) by Constable's contemporary J. M. W. Turner. But Constable, because of both his artistic honesty and profound respect for nature, resisted the temptation to theatricalize nature as other artists of his generation tended to do.

THE HUDSON RIVER SCHOOL

Although nature worship did not infect Americans as early as it did Europeans, when it did, it became perhaps more potent in the New World than in the Old. Soon after the opening of the Erie Canal (1825), when the American wilderness became an object of curiosity and pride, a new national mood linked to the land began to emerge. From then on the land in all its variety and vastness captivated the national imagination. It became the symbol of America's ambitions and, as such, fueled the doctrine of territorial expansion known as "manifest destiny."

Among those who helped to facilitate and shape this obsession was a group of New England essayists and poets known as the *Transcendentalists:* Ralph Waldo Emerson, Amos Bronson Alcott, and Henry David Thoreau, among others. Their writing, a curious amalgam of pantheism and Yankee pragmatism, was the American equivalent of European Romanticism. Like Rousseau and Wordsworth, they rhapsodized about nature and the divine. For Emerson, a former Puritan minister and acknowledged spokesman for the group, an encounter with nature could be profoundly religious: "Standing on the bare ground—my head bathed by the blithe air . . . the currents of the Universal Being circulate through me; I am part and parcel of God." The American writers, however, focused not on the mill dams and rotten posts of Constable's farm country, but on the primitive, undefiled American wilderness—the new Garden of Eden.

This focus was shared by Thomas Cole, an artist who expressed in paint what the Transcendental poets expressed in words. In his *The Oxbow* (Figure 7-12; an actual site seen from the top of Mount Holyoke in Massachusetts) a gnarled, lightning-blasted tree on a wedge of hill in the left foreground is set against a spacious view on the right, where we see a great bend in the Connecticut river. The leading edge of the storm coming from the left tends to continue the line of the hillside in an arc that goes off the canvas, further dividing the picture between the left and right, and between dark

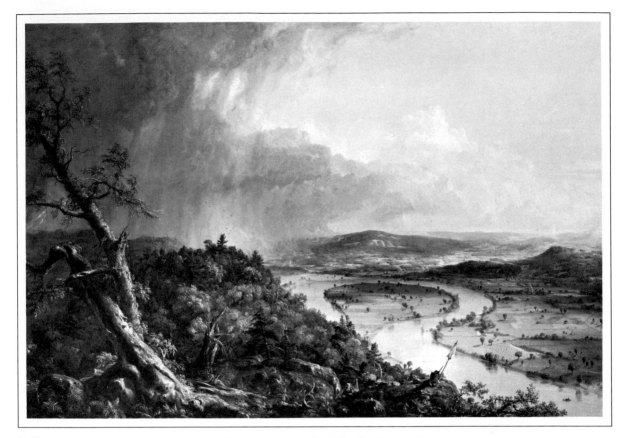

7-12 Thomas Cole, *The Oxbow*, 1846. Oil on canvas, 51½″ × 76″. The Metropolitan
Museum of Art, New York (gift of Mrs. Russell Sage, 1908).

and light. It is the dramatic recreation of the lighting that accompanies a summer storm, when some parts of the land are darkened and others remain bathed in light—an alternation that Cole repeated in the highlights on the tree and the cloud shadows of the distant hills. The drama unfolding in the atmosphere adds to the quality of wildness that Cole admired, and that he further emphasized by the unruly underbrush on the hill and the sense of unencumbered distance beyond.

This kind of landscape suited the new American sensibility and fostered the American version of Romantic painting. Cole enjoyed a following of east-coast artists who came to be known as the *Hudson River School* (because they often drew their subjects from the vicinity of the Hudson River and the Catskill Mountains). Like Cole, they were European trained and applied their skills to making heroic images of the natural environment, but not always of the wooded hills of New York. Albert Bierstadt, who made oil sketches

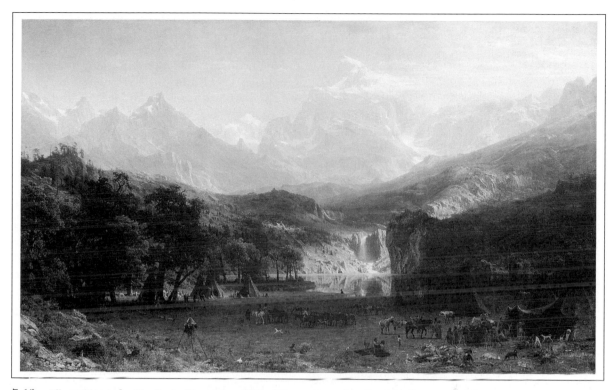

7-13 Albert Bierstadt, *The Rocky Mountains*, 1863. Oil on canvas, 73¼″ × 120¾″.
The Metropolitan Museum of Art, New York, Rogers Fund, 1907.

while accompanying the Lander expedition that mapped the wagon route to the Pacific, returned to paint theatrical scenes of a then unfamiliar environment (Figure 7-13). Such paintings were the icons of manifest destiny. Frederic Edwin Church, who traveled to North and South America, to North Africa, and even to the frozen Labrador coast, looked for Gardens of Eden far beyond the shores of the United States.

THE IMPRESSIONIST LANDSCAPE

In post Civil-War America, the Garden of Eden increasingly succumbed to the axe, the mill, and the railroad; manifest destiny was losing its hold on people; idealism was giving way to rampant materialism. The innocence of early nineteenth-century America, the age of presidents Jefferson and Jackson, went up in the smoke of the Civil War and the industrial revolution. Thus, the popularity of the Hudson-River type of landscape declined. Bierstadt, for example, who had enjoyed enormous popular and financial success in

the 1860s and early 1870s, had met with indifference and financial ruin by the 1880s.

In Europe, the decline of the Romantic landscape occurred much earlier. Although Europeans had not experienced a war at mid-century as traumatic as the American Civil War, they were more deeply affected than Americans by the changes and social disruptions of the new industry. By mid-century, Realism, a movement in art and literature committed to the depiction of ordinary experience (often with a socialist agenda), replaced Romanticism. In painting, the change had less to do with style than with the choice and treatment of subject matter. Realists, who accused the Romantics of trafficking in sentimentality and melodrama, professed to represent things as they were—warts and all.

By the 1870s, when Bierstadt was still popular in America, a new art movement called Impressionism was already underway in France. Although related to Realism, Impressionism is distinguished by its own method and style: painting a scene on the site using small strokes of bright color. The use of broken color was a legacy of Constable's, but Impressionist works are typically brighter and more carefree. Indeed, because of their freshness and vivacity, Impressionist landscape paintings are today the most widely known and appreciated works of art ever produced. More could be said about the style of Impressionism and its role in art history, but in this chapter we are interested in how it manifests certain attitudes about nature and people's place in nature.

In Camille Pissarro's *The Banks of the Oise, Pontoise* (Figure 7-14) we see trees and a few strollers on the left, and a river on the right leading to Pontoise, a picturesque town linked to Paris by a railroad. (The country estates of Paris business men are supposedly concealed behind the trees on the left.) The casual, freely-executed style—typical of Impressionism—is consistent with the leisurely feeling Pissarro's painting evokes. Unlike the Hudson River painters, Pissarro makes no effort to dramatize or moralize about God and nature. He accepts with equanimity the works of God and the works of man, even including factories, a railroad bridge, and a smokestack in the center of the picture. *The Banks of the Oise, Pontoise* may share with Constable's *The Hay Wain* the depiction of humble, mundane things; however, it does not proclaim, even implicitly, that rural life is more noble than city life. Indeed, the countryside is an extension of city life, to be enjoyed on a weekend by anyone—anyone, that is, who can afford the price of a round-trip ticket. It is also a world without idealism, romanticism, religious connotations, or even social consciousness. Impressionist paintings are popular today not only because of their colors but because they

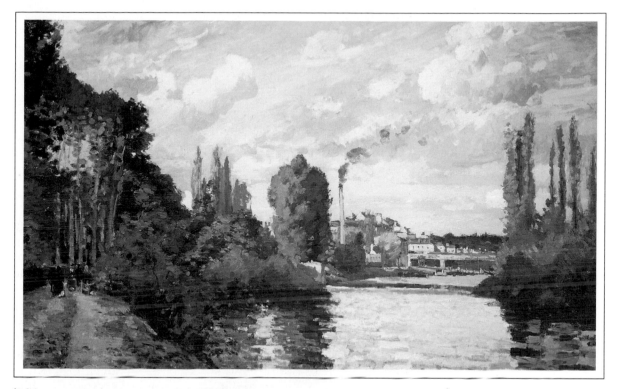

7-14 Camille Pissarro, Banks of the Oise, Pontoise *Bords de l'eau à Pontoise*, 1872. 21½″ × 35¾″. Los Angeles County Museum of Art. Lucille Ellis Simon Collection.

prompt us to relive what we perceive to be a blithe lifestyle in nineteenth-century France—a lifestyle that many Americans, young and old, admire and identify with.

THE EXPRESSIONIST LANDSCAPE

By the early twentieth century, landscape art, along with many other art traditions, was overwhelmed by the Modern Art movement. Nature continued to be a viable subject at times, but even when it was, it was subordinated to the concerns of Modernism— for example, a piece of nature might be used simply as a motif for exploring abstract harmonies. Still, for a few artists, particularly some of those in the United States and Canada, nature was a principal theme in their art. To these artists, the North American landscape continued to be a source of inspiration. Like their Hudson River predecessors, their attachment to nature was very emotional and often mystical. But unlike the nineteenth-century painters,

7-15 Emily Carr, *Forest, British Columbia*, c. 1931–1932. Collection of the Vancouver Art Gallery: Emily Carr Trust, 42.3.9 Cat. 28

their work was not linked to any great spiritual movement such as Transcendentalism, or to any vital national theme such as manifest destiny. In addition, their feelings about nature were so intensely personal and expressed in such individualistic styles that their art was not nearly as accessible to the public as Hudson River art was.

In some respects Cole's *The Oxbow*, despite its realism, has more

in common with *Forest, British Columbia* (Figure 7-15), a semi-abstract work by Emily Carr, than it has with Pissarro's casual scene. Both Cole's and Carr's are views of wilderness nature; both are dramatic, suggesting seen and unseen forces at work; the artists of both were devout nature lovers. But in other respects their paintings are very different. Cole's painting, which is based on an actual site, is true to the basic optical facts of that site—although for dramatic effect Cole emphasized certain details, distorted others, and probably made up the atmospheric conditions. Carr's work, on the other hand, is probably not based on a particular site, as her version of nature depends less on visual experience than on emotion. The optical facts, such as they are, are decidedly secondary to the abstract form—in this case consisting of flowing shapes, brooding colors, and thick paint. This type of art is often referred to as *expressionistic.*

The fact that *The Oxbow* appears open and airy, whereas Carr's work appears enclosed and dark, is significant, and not merely an accident of subject matter choice. *The Oxbow*, painted during a time of American optimism, represents the early days of our country's westward expansion. *Forest, British Columbia*, painted nearly a century later, represents literally the other end of that expansion and the closing of the North American frontier. It is also a metaphor for the loneliness and despair of an artist whose work was only belatedly accepted by her Canadian countrymen.

REGIONALISM

The Great Depression of the 1930s imposed a toll not only on the national economy but also on art. Typically in times of crises, people long for a renewed sense of continuity and the reassurance of what they perceive to be the roots of their national heritage. To Americans, the land seemed to be a potent symbol of this quest. Answering this spiritual need and supplying the demand for images of the land was *Regionalism,* an American school of art that was basically realistic in style and populist in content.

Regionalism was so-called because many of the artists drew their subject matter from the region in which they lived—often the American Middle West. Grant Wood, one of the best known Regionalists, hailed from Iowa. Wood sometimes represented Iowa farmers and townspeople as heroic, sometimes as narrow-minded Philistines. But he always portrayed the land, his most abiding interest, as heroic. *Spring Turning* (Figure 7-16), a breathtaking view of spring plowing, shares with Cole's *The Oxbow* the same sense of

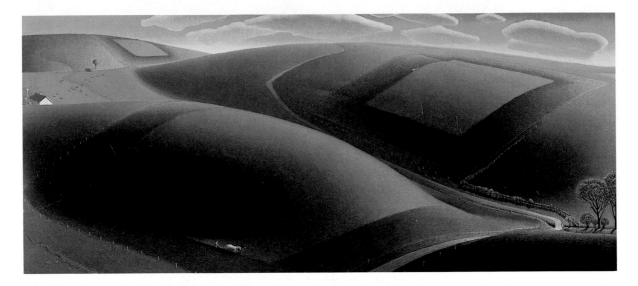

7-16 Grant Wood, *Spring Turning,* 1936. Oil on masonite panel, 18⅛″ × 40″. Private Collection, Courtesy of James Maroney, New York.

expansive optimism. Unlike primeval Connecticut or the British Columbian rain forest, this is land that was cleared of trees and wild grass, but even so, it has not lost its primal character. As Wood describes it: "the naked earth in its massive contours, asserts itself through anything that is laid upon it." Regionalism is often viewed as a reaction to Modernism, a perception fostered by not only writers but by many of the Regionalist artists themselves. Whereas early Modernism pioneered expressionistic and abstract styles, Regionalism was seen as simply a return to realism. Nevertheless, the style of *Spring Turning,* like those of a number of Regionalist works, reflects some influence from its rival Modernism, especially the latter's emphasis on strong formal design. In this respect it is not so very different from Carr's painting of a forest.

NATURE IN LATE TWENTIETH-CENTURY ART

By the late 1940s, the cultural climate in America had changed again. Having emerged in triumph from the crises of both the Great Depression and World War II, America assumed a leadership role in the community of nations. In the wake of a war that was seen by many as a struggle between free societies and totalitarian societies motivated by nationalism, nationalism itself—along with Amer-

ica's previous isolationism—went out of style. Thus Regionalism, a provincial and nationalistic kind of art, was no longer appropriate.

Taking the place of Regionalism was Abstract Expressionism, a new kind of art distinguished by large canvasses of freely-painted abstract forms. You may recall Hans Hofmann's *Rhapsody* (Figure 3-2), which was discussed at length in Chapter 3. This style of painting so dominated the thinking and values of the art world of the 1950s that landscape art (and almost any other kind of art) was completely overshadowed. Although landscapes did not disappear from American art, they certainly did not receive the attention that they enjoyed during the days of Regionalism. Interestingly, landscape meanings were sometimes attributed to the large canvasses of the new style. Writers often referred to them as "visionary," "sublime," "transcendent," and so forth—the same adjectives used to describe Hudson River paintings. Some were even said to evoke a sense of place, as reminders of America's roots in the land.

Since the 1950s, nature itself has acquired a new significance. The issue this time is not merely a matter of maintaining the land in its original primordial state, but that of saving it from destruction. Words such as "ecology," "acid rain," "biodegradable," and "toxic emission," unheard of before the mid 1960s, are now part of everyone's vocabulary. Nature is once again in the forefront of the world's attention.

In addition, enormous changes have occurred in art since the 1950s. Abstract Expressionism was dethroned as the single reigning style and joined by a plurality of styles and media—some of which were reviewed in Chapters 4 and 5. Among the new media is Earth Art; recall Michael Heizer's *Double Negative* (Figure 5-17) reviewed in Chapter 5. It is difficult to say if Heizer and others who practice this art are responding to environmental concerns and intend their projects to call attention to these concerns. Whatever the intent, Earth Art is the newest kind of image of nature.

Recently, there has been a revival of landscape painting—perhaps a conscious or unconscious response to the new interest in the environment. New landscapes come in a variety of styles, but most of them—even some of the most realistic ones—have in common the fact that their color harmonies and compositional strategies show the influences of abstract painting. A good example is *Illinois Flatscape #30* (Figure 7-17) by Harold Gregor. An invention of the artist, a flatscape is an aerial view of the countryside based on a photo taken from a chartered plane. Although the buildings, roads, and fields are rendered realistically, the colors are abstract, and many of the lines and textures have been simplified to bring out their pattern qualities. Thus a flatscape is somewhere between an abstract painting and a traditional landscape. The tension that

7-17 Harold Gregor, *Illinois Flatscape #35*, 1987. Oil and acrylic on canvas,
60″ × 82″. Tibor de Nagy Gallery.

exists between abstract design and image is what makes the picture
so fascinating. The parallels between this kind of painting and Im-
pressionism are suggestive. Like an Impressionist work, a flatscape
satisfies the viewer's appetite for both beautiful color and a reassur-
ing image. It is also a portrait of nature as seen through the eyes of
the urban spectator—in this case, from the twentieth-century van-
tage of an airplane—as if to remind Illinois residents that harmony
exists beyond the beltways of their cities and suburbs.

SUMMARY

Images of nature differ greatly across cultures and periods of time,
and are reflections of humankind's various relationships to nature.
Of all the cultures reviewed in this chapter only medieval Christian-

ity was reluctant to make images of nature, indicative perhaps of the Judeo-Christian doctrine of dominion over nature and the fact that nature was to be endured, not enjoyed.

It has been theorized that people in urban societies such as ours long to be in closer contact with nature. This yearning can be satisfied in a physical way by strolling in the country, camping out, and so forth, or in a vicarious way by viewing images of nature. In any case, an image of nature is a great carrier of meaning, whether as a talisman, an icon of belief, a symbol of national striving, a vehicle for expressing an emotional state, or simply as an image of consolation.

THE NUDE IN WESTERN ART

T HE NUDE HAS BEEN A pervasive subject in Western art for centuries. Even in this century, when the modern movement dominated most of the agenda in art, the nude has persisted, and recently has experienced somewhat of a revival. Meanwhile, drawing nude models (known as "life drawing") in art schools has never ceased to be a basic part of the curriculum. Just as it has been for centuries, skill in drawing the nude will probably always be considered a touchstone of artistic ability.

Significantly, the West is the only culture, past or present, in which nudity in art has been a sustained tradition. The basic values of our culture are founded in Judeo-Christianity and the Bible. Yet, neither the New Testament nor the Old Testament (with the possible exception of the Song of Solomon) rejoices in the naked body; instead, nudity is usually identified with humiliation, sin, or lust. In view of this, the existence of a nude tradition would seem at the very least to be paradoxical.

This chapter, which overviews the development of the nude tradition in Western art starting with the Greeks, will shed light on the reasons for this seeming paradox. Looking at men and women separately, we will explore not only some of the reasons for the nude's longevity, but also some of the ways in which it has been used to express ideas, and how the aesthetic object has played a major role in creating a set of standards for the sexual object. Then we will consider images of men and women together using an example that is not from the Western tradition.

MEN

In contemporary American culture, physical beauty is usually associated more with the female body than with the male body. But to

the ancient Greeks, male beauty was just as compelling as female beauty—if not more so. From the seventh century to the fifth century B.C.—known as the *Archaic* period—sculptors created nude images of men, not women.

The Greeks

Statues of males were often associated with the cult of Apollo, god of youthful, manly beauty—but they were also associated with athletic sports, particularly the Olympic games. As early as the Archaic period young noblemen competed in those events in the nude. Whereas to us nakedness, the "natural" state of humans, is often thought to be a trait of primitive peoples, to the Greeks—who by this time were emerging as an important Mediterranean civilization—it was a sign of their superiority, a trait setting them apart from the surrounding "barbarians." The nude became an expression of the essentially human concern in Greek philosophy and religion.

Archaic sculptures of nudes (Figure 8-1)—usually tributes to either Apollo or to athletes in their prime (known as *Kouroi*)—display a vigor and self-confidence typical both of young athletes and of a young culture. To the Greeks, these statues personified physical beauty and self-discipline, and a balance between body and spirit. To us, however, these statues have a marked stiffness, despite their display of vitality in other respects. This stiffness is a legacy of Egyptian sculpture (Figure 8-2). Like their two-dimensional imagery (recall the tomb picture in Figure 7-3), Egyptian statuary was governed by strict rules that did not allow the artists a variety of poses. In Egyptian art, the lack of movement seems appropriate, emphasizing its monumentality and royalty; in Greek statuary, however, it is worn somewhat awkwardly.

Unlike the Egyptians and the other ancient peoples, the Greeks evolved their cultural forms. Throughout the Archaic period they changed the style of the nude image—gradually but perceptibly—away from stiffness and toward naturalism. By the early part of the fifth century, the Greeks embarked on an era of extraordinary progress in philosophy and the arts called the *Classical* period c. 480–323 B.C. ("Classical," spelled with a capital "C" should be distinguished from "classical," spelled with a lowercase "c," which refers to the culture of both Greece and Rome). The aesthetic instinct that had given Archaic Kouroi statues their human alertness gave Classical statues a hitherto unknown realism, exemplified by the 480 B.C. Kritios Boy (Figure 8-3). Sir Kenneth Clark, who has

8-1 *Kouros*, c. 615–600 B.C. Marble, 7'2" high. Metropolitan Museum of Art, New York (Fletcher Fund, 1932).

8-2 *Pair statue of Mycerinus and Queen*, from Giza Dynasty IV, 2599–1571 B.C. Slate Schist, 54½". Harvard-M.F.A. Expedition. Courtesy, Museum of Fine Arts, Boston.

made an important contribution to the subject with his book *The Nude: A Study of Ideal Form,* says of this statue:

> Here for the first time we feel passionate pleasure in the human body . . . for the delicate eagerness with which the sculptor's eye has followed every muscle or watched the skin stretch and relax as it passes over a bone could not have been achieved without a heightened sensuality.

During this period Greek artists developed models of male beauty in bronze and stone that gave tangible form to Greek concepts of humanism and idealism. Just as the spirit of humanism was to motivate Leonardo and Renaissance scholars 1500 years later (Chapter 7), humanism stimulated Greek philosophers to seek answers to questions about the workings of the world and human nature through observation and rational deduction. Humanism

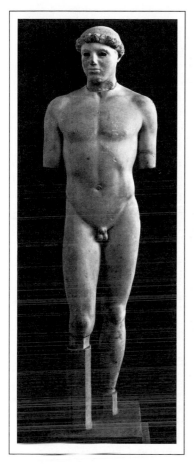

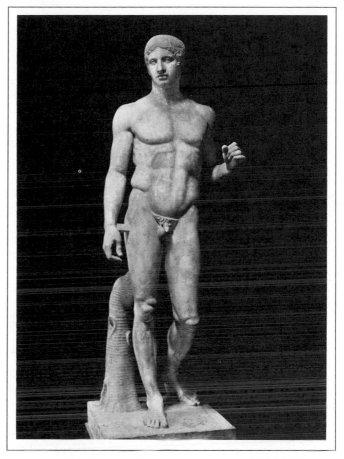

8-3 *Kritios Boy,* c. 480 B.C.
Marble, approx. 34″ high.
Acropolis Museum, Athens.

8-4 Polyclitus, *Doryphoros (Spear Carrier),* original c. 450 B.C.
Roman copy, marble, 6′6″ high. Museo Nazionale, Naples.

was reflected in art by the increased realism of the human body.
Greek idealism is best understood from the writings of Plato, a
prominent fourth-century philosopher, who theorized an ideal
world outside of time and space in which there were not only the
eternal "verities" of Truth, Beauty, and Goodness but the ideal
forms for everything—including the bodies of people. To Plato,
this ideal world was more "real" than the world on earth, the latter
being a mere imitation of the former. Idealism was reflected in art
by the beauty and supposedly perfect proportions of the statues,
qualities that were also built into Classical architecture such as the
Parthenon (Figure 6-3).

By mid-century the famous sculptor, Polyclitus, had created the
SpearCarrier, known to us today only through marble copies by
Roman artists (Figure 8-4). Because our perceptions have been

conditioned by photography, movies, television, and even realistic statuary in public parks, we may not be overly impressed by its realism or the significance of its contribution to the art of representing the human body. But if we compare it with the Archaic example, we quickly see how far Greek artists had progressed in articulating the structure, proportions, and movement of the body. Unlike the seventh-century Kouros—whose individual parts seemed to have been pieced together—the fifth-century *Spear Carrier* is an organic, indivisible unit. Perhaps the single most significant aspect is the manner in which he is standing. His slight step, placing the majority of his weight on one foot, was as important to Western art as the first step taken by the first astronaut on the moon's surface was to space science. The position of the feet and the effect it has on the posture and the character of the body is a moon's distance away from the rigidly symmetrical stance of earlier works. The slant of the shoulders (downward slightly to the figure's right), countered by an opposite slant to the hips, is achieved by the figure's weight being centered over the right foot. This is known as *weight shift,* a convention for representing the human body that is still found in every life-drawing class. In real life it is a natural way to stand or walk.

Polyclitus, as if anticipating Plato's writings, developed a canon of proportions and movements for the ideal male body that were used by all other sculptors of this period. In addition to the canon, the other signs of Classical sculpture can be seen in *Spear Carrier's* passive, expressionless face and the simplification of the planes of his chest, thorax, pelvic girdle, and even of his kneecaps. Thus the naturalism of this art was tempered by the Classical passion for perfection.

In late *Post-Classical* art, this idealism often gave way to a sense of elegance as reflected in the late fourth-century *Apollo Belvedere,* also a Roman copy (Figure 8-5). The latter does not exhibit the same rigor—the effect of a controlling, committed intellect—that Classical work does. In other Post-Classical statues, extreme realism or dramatic displays of human expression took the place of idealism. This lack of commitment to a doctrine of idealism in art was a symptom of a corresponding sophistication and lack of philosophical unity in late Greek society.

The Romans, the heirs and the assimilators of Greek culture, added little to the male nude—apparently content with reiterations and variations of the themes already perfected by the Greeks. Believing that it enhanced their divinity, Roman rulers had their portrait heads placed on top of ideal nude bodies. Despite this decline in its earlier significance, the practice of sculpting male nudes continued until medieval times.

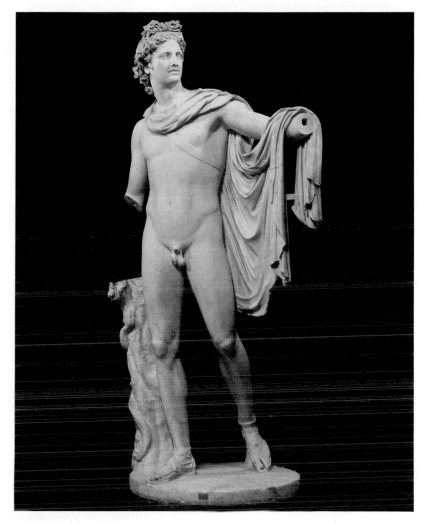

8-5 *Apollo Belvedere*, original c. 330 B.C. Roman copy, marble, 7'4" high. Vatican Museum, Rome. Scala, New York, NY.

After the Roman world was overturned by the new order of Christianity, images of nudes fell into disfavor for approximately a thousand years. Except for the story of Adam and Eve, Christian theology of the Middle Ages had little interest in nudity, and then only as a way to exemplify the sins of the body rather than its virtues. Many pagan statues were destroyed during this period.

The Italian Renaissance

In the fifteenth century, the artists of the Renaissance rediscovered Greek and Roman sculpture, and once again the naked body appeared in art. Like the Archaic artists, Renaissance artists focused on the male nude—at least at first. Antonio Pollaiuolo, one of the

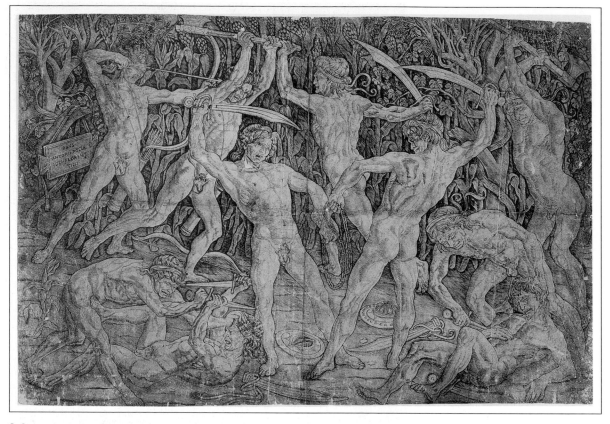

8-6 Antonio Pollaiuolo, *Battle of Naked Men*, c. 1465. Engraving, approx. 15″ × 23″. The Metropolitan Museum of Art, New York. Bequest of Joseph Pulitzer, 1917).

early masters of the subject whose engraving of ten naked men in pitched battle (Figure 8-6) displays male anatomy from every point of view, seemed bent on describing each and every muscle group as it would appear in tension beneath the skin. The artist's motive in choosing a battle scene was not realism—since Renaissance mercenaries were no more prone to fight in the nude than today's soldiers—but a pretext to test and to flaunt his drawing skill. Giorgio Vasari, early writer on art, said that Pollaiuolo's treatment of the nude was "more modern than any of the masters who preceded him," and his work was widely influential. To our eyes, however, Pollaiuolo's treatment seems rather forced and awkward. Indeed, his enthusiasm for showing all the muscles tends to make his warriors, their energetic struggle notwithstanding, almost as stiff as Archaic statues.

By the early sixteenth century the male nude shed this stiffness, and, like its Classical predecessor, reached a new height. But when applied to the heroic figures of the Old and New Testaments instead of the gods of Mt. Olympus, it underwent a transformation.

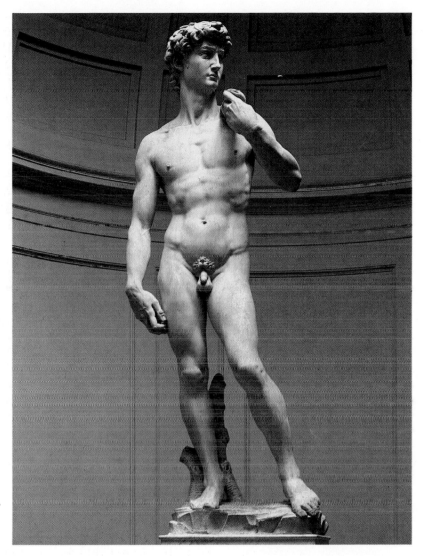

8-7 Michelangelo, *David*, 1501-04.
Marble, approx. 18′ high, including
base. Galleria dell'Accademia,
Florence.

Michelangelo, the greatest artist of the time, frequently in-
cluded male nudes in his sculptures and murals, and probably con-
tributed more to the development of the male image than any artist
since Polyclitus. Considering the human body divine, he made im-
ages of it that added a new and vital dimension to masculine beauty
in art. But beauty alone is only a part of the total content of his
sculpture. He carved his monumental *David* (Figure 8-7) for the
city of Florence in the early years of the sixteenth century—about
the same time that Leonardo, another Florentine, was painting
Mona Lisa (Figure 7-8). The sculptor shows the young hero in the
moments before battle, his head turned toward the approaching

Goliath. We can certainly see something of the *Spear Carrier* in the stance and proportions of the *David*, for Michelangelo was an enthusiastic student of the antique statues that could be found everywhere in Italy. But after looking at the defiant head held in place by a column of muscle, our eyes move down across a torso that barely conceals a storm of tensions underneath the surface—tensions that are vividly revealed even in the right hand of the statue, which is poised to act quickly. We see that although Michelangelo's treatment of the *David* may have been influenced by the *Spear Carrier*, its intensity belongs to a world very different from the classical calm of the older sculpture.

Artists of the Renaissance, including Michelangelo, often dealt with subjects from Greek and Roman mythology as well as from Christianity. But even when creating images of gods and heroes, they did not attempt to idealize physical beauty so much as to emphasize the strength and energy of these muscular and active figures. To Renaissance artists, the naked male was a powerful and novel subject—one that let them breathe new life into religious and mythological themes while showing new masculine ideals.

After the Renaissance, interest in the male nude declined, although the female nude—as we shall see in the following section—became very popular. Not that the male nude was discontinued; it remained an established but not vital artistic tradition. And for specific subjects—battle scenes, crucifixions, and episodes from classical myths—it was still appropriate (though not essential). As an end in itself—whether exemplifying beauty, power, or energy—male nudity no longer captured many artists' imaginations. As a symbol, it usually alluded to the glory of the classical past—glory that was becoming more of an empty memory, if not a fantasy, in an increasingly modern age.

The Late Nineteenth Century

The nude male images by the French sculptor Auguste Rodin are among the most successful ones made since the Renaissance. Perhaps this is because Rodin's images rarely referred to the classical past. His *Age of Bronze* (Figure 8-8) brings to mind Michelangelo's *David;* both seem to have a reserve of energy waiting to be released. But while the *David's* firm, aggressive posture announces the violence the young man is about to commit, the tentative posture of the Rodin youth does not clearly indicate what action is contemplated. The youth seems to be taking a step, clutching his head with one hand and gesturing vaguely with the other. Apparently Rodin himself was unsure of the theme, for he originally called the work *The Vanquished.* However, despite this lack of clear intention, the sculpture's rising, striving movement is suggestive. Physically, it

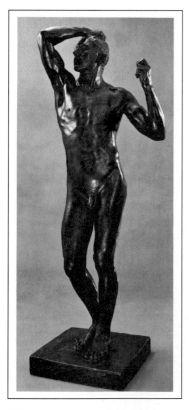

8-8 Auguste Rodin, *The Age of Bronze,* c. 1876–77. Bronze, 5'11" high. The Minneapolis Institute of Arts. John R. Van Derlip Fund.

expresses the restless energy that seethes beneath the surface of every living thing; psychologically, it expresses the restless emotions of human beings' spiritual longing.

Art Today

Although in Rodin's time the idealized figure was still able to convey abstract ideas, it was soon to fall from favor altogether. The modern art movement was already underway, and by the early 1900s interest in the nude male—along with landscapes and other traditional subject matter—was replaced by a preoccupation with abstract forms and color. Only very recently has the male nude begun to reappear as a subject of any importance. And the reasons for this do not seem related entirely to aesthetics, for some of the artists who paint nude males today are women, many of them identified with the growing feminist movement.

Sylvia Sleigh's paintings of naked men are provocative even in an age that thinks of itself as sexually liberated. Not only are her subjects nude, but the view is usually frontal and the pose casual—reflecting a candor about the male body that has been almost nonexistent in art outside of life-drawing classes. Because most people are not accustomed to this, a painting like *Walter Finley Seated Nude* (Figure 8-9) seems brash, if not a little shocking. But Sleigh's purpose—like that of the Greek artist who made the *Kritios Boy* (Figure

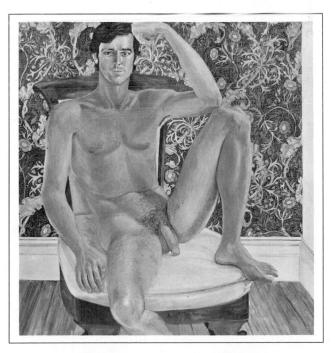

8-9 Sylvia Sleigh, *Walter Finley Seated Nude,* 1976. Oil on canvas, 56″ × 52″. Collection Dennis Adrian, Chicago.

8-3)—was probably to emphasize the beauty of the male subject, which is supplemented by the ornately flowered wallpaper of the background as well as reflected in his relaxed, self-confident pose. Most of Sleigh's models are young men with an abundance of health, good looks, and body hair, which she has called "natural embroidery."

WOMEN

Women may have been the earliest subject matter in art. Small carvings of women, some predating the paintings at Lascaux (Figure 7-1), have been discovered at various prehistoric sites. Because these figures often emphasize the parts of the female that involve child-bearing, experts think they were intended as fertility images. But interesting as these items may be for their insights into prehistoric culture and art, they are isolated examples of female nudity. Again, it was the Greeks who were responsible for making a sustained tradition of this subject, but not until after they had developed the art of making the male nude.

The Greeks

Living in a nation in which images of the naked female body constantly appear on the newsstands and in the movies while images of male nudity are still somewhat rare, we may have difficulty understanding attitudes in Greece before the fourth century B.C.—a time in which sculptures of young women were usually clothed while those of Apollos and young athletes were almost always naked.

Even in the fifth century B.C., after the long tradition of nude Kouroi and when Greek artists like Polyclitus were refining their Classical masterpieces of nude athletes, statues of women were normally clothed in a loose-fitting—often revealing—garment called a chiton. Women, of course, were considered sexually attractive. Apparently, however, the idea of expressing female attractiveness through nude images was not condoned. By the fourth century, though, statues of naked women were beginning to be made for the sake of experiencing their ideal nudity. Appropriately, this ideal developed around the cult of Aphrodite, the love goddess, and her Roman equivalent, Venus. Statues of these and other nude figures of women became increasingly popular in the Greek (and Roman) world.

The first significant Aphrodite statue was created by the fourth-century Greek Master Praxiteles for the people on the island

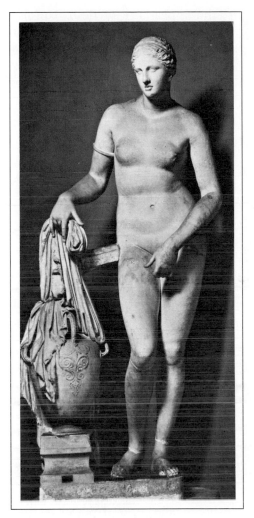

8-10 After Praxiteles, *Cnidian Aphrodite*, original c. 330 B.C. Roman copy, marble. Vatican Museum, Rome.

of Cnidos (Figure 8-10). By this time the challenges of representing the human body had been overcome by sculpting male nudes. But the posture of weight-shift, Polyclitus' legacy, takes on a voluptuous character when applied to the female body. The curve of her left hip, as well as the smaller curve below her armpit, is much fuller and more pronounced—its smooth line less broken by bone and muscle. The S shape of the female body, often called sinuous, becomes a familiar symbol of desire. Praxiteles was well suited to sculpt Aphrodite; even his statues of men have a sinuous quality, together with a delicate modeling of the surface that almost gives

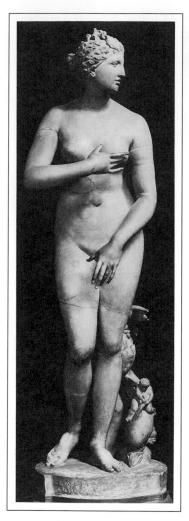

8-11 Venus de Medici, early third century B.C. Roman copy, marble, 5'½" high. Galleria degli Uffizi, Florence.

the appearance of flesh. Unfortunately, Praxiteles' Aphrodite is known to us only through Roman copies.

There are no records describing fully either Polyclitus' canon or Praxiteles' canon for the female, but we do know one detail: the same unit of measurement was used for the distance between the breasts, the distance from the breasts to the navel, and the distance from the navel to the division between the legs. While these proportions varied little in the Post-Classical period, the content of female statues tended to be erotic, as seen in the almost coquettish gesture of a second century B.C. Aphrodite (known to us through a Roman copy called the Venus de Medici, Figure 8-11). Images of naked females soon superseded in popularity those of naked males.

The Middle Ages

The basic formula established by Praxiteles was scarcely varied in any major way through the rest of the Greek and Roman periods. And just as was the case with nude images of men, the Christian world prior to the Renaissance professed little interest in naked women except in instances in which there was a need to symbolize fleshly lusts. In one culture the body had been a focus of religious veneration; in the other it was, at times, considered antireligious. However, in the twelfth and thirteenth centuries, at the height of medieval civilization, women began to play a more important role in courtly life and were celebrated in the arts and letters. The age of chivalry flowered and the veneration of the Virgin Mary appeared in the Church. The worship of the Virgin helped to offset the notion of Eve the Temptress that had dominated thinking during the earlier years of the Middle Ages. And Mary had her earthly counterpart in the medieval lady of the court, who achieved a position of honor and even of power in the masculine world of knighthood and the Crusades. Images of women, whether those of the royal courts or the Virgin Mary, were of course depicted fully clothed. Yet their femininity was not completely hidden; witness the seductive S-curve posture present in *The Virgin of Paris* as she holds the baby Jesus (Figure 8-12). Furthermore, her clothes and general appearance were probably based on those of the chic ladies of the court. But aside from her indubitable femininity and the apparently accidental similarity between her pose and that of the *Aphrodite,* the two women are quite different. *Aphrodite* is a goddess of beauty whose nudity implies an acceptance of the human body. *The Virgin of Paris* is a spiritual figure whose beauty exemplifies a beatitude transcending the earthly body. This beatitude is reflected by the tranquility of her face and the impression of lightness of her

body (despite the fact that she is made of stone). Even the way she holds the baby seems to defy gravity.

The Italian Renaissance

As the feudal system of the Middle Ages gave way to another form of society based on city-states, the influence of the Church was weakened and artists began to work instead for the wealthy noblemen who held political power. Men like Lorenzo de' Medici of Florence cultivated the study of the past, inspiring a new interest in the myths, poetry, and sculpture of the Greeks. And with this, inevitably, there came an admiration for the Greek and Roman portrayals of the nude. But it was not an easy matter for the artists of the fifteenth century to bridge the gap between the goddess of love and the Christian Virgin. A medieval attitude toward the image of the naked female persisted even when images of naked men had come to be sanctioned as symbols or as representations of biblical heroes—like Michelangelo's *David*.

Thus, most artists concentrated on images of men—clothed or nude—to represent or symbolize the burgeoning middle-class society of traders. Femininity, once again, was out of style; a surprising amount of the art of the period, whether dealing with religious subjects or the nobility, seems to have stressed the attributes of masculinity. With little to go on in terms of precedent for painting the female nude within a classical theme, Sandro Botticelli created one of the most enduring versions of Venus Aphrodite in art history (Figure 8-13). Initially inspired by an Italian poet, Botticelli's version of the love goddess's birth harks back over 20 centuries to the original hymn to Aphrodite by the early Greek poet Homer:

> where the moist breath of Zephyros blowing
> Out of the west bore her over the surge of the loud-roaring deep
> In soft foam. The gold-filleted Hours
> Welcomed her gladly and clothed her in ambrosial garments . . .
> And around her delicate throat and silvery breasts
> Hung necklaces inlaid with gold, . . . *

Venus's pose was probably based on that of the Venus de Medici (Figure 8-11), which at the time was in the possession of the Medici family. Botticelli created an image of a nubile woman who is both desirable and dignified. To this extent his achievement is true to the spirit of Greek female nudity but is not especially Greek in other respects. None of the figures, including Venus, is standing

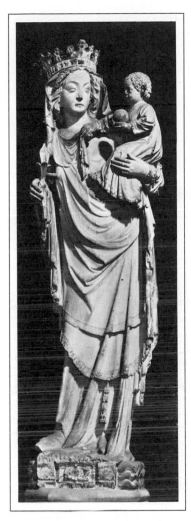

8-12 *The Virgin of Paris*, early fourteenth century. Cathedral of Notre Dame, Paris.

*Reprinted from *The Homeric Hymns, A Verse Translation* by Thelma Sargent. By permission of W. W. Norton & Company, Inc. Copyright © 1973 by W. W. Norton & Company Inc.

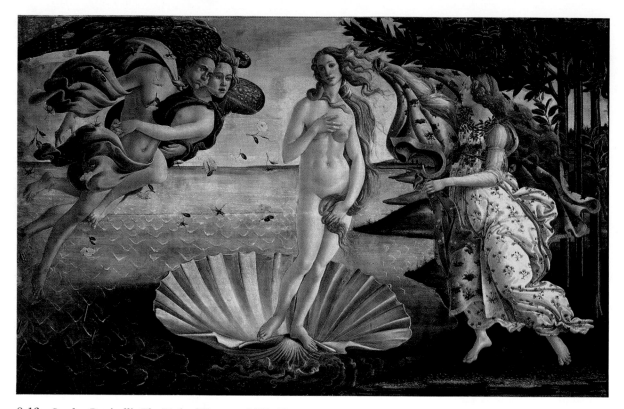

8-13 Sandro Botticelli, *The Birth of Venus*, c. 1480. Tempera on canvas, 5'8" × 9'1". Galleria degli Uffizi, Florence.

solidly on the ground (or the shell). Even allowing for allegorical license and the need to illustrate the fantasy of someone being born out of the sea, Botticelli's Venus is more like the lightweight figures of angels and virgins that inhabit medieval Christian art than the solidly physical types of the classical marbles. The delicately ornate details of waves, leaves, and strands of hair are repeated in the decorative treatment of the billowing drapery. Except for the nudity, the picture could almost be a medieval tapestry.

There is nothing medieval about the nudes of the Venetian artist, Tiziano Vecelli (known as Titian). Painted nearly 60 years after Botticelli's *Birth of Venus*, Titian's *Venus of Urbino* (Figure 8-14) is, without reservation, a goddess of love. She reclines languidly in full display on a couch shared by a small dog while servants work in another room of what appears to be an opulent Venetian villa. Her facial expression together with her passive posture signifies she is available for pleasure—an aspect echoed in the luxury of her surroundings. By this work Titian established a convention of female nudity that was to endure for centuries. Versions of this pose and

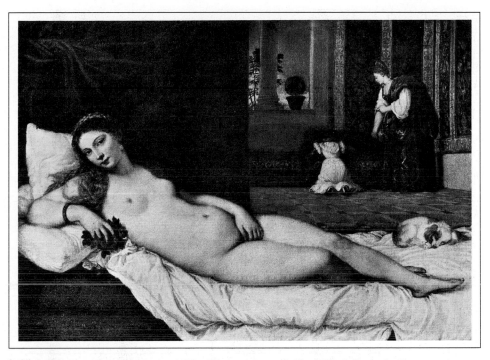

8-14 Titian, *Venus of Urbino*, c. 1538. Oil on canvas, 17¼″ × 65″. Galleria degli Uffizi, Florence.

ambience were to be repeated in countless works, both good and bad. Titian also became the leader of a school of painting centered in Venice known for its practice of using the paint medium more directly. He and his colleagues omitted the step of first outlining a picture in tempera, preferring to use oil paint from the start—a pursuit that resulted in paintings rich in color and surface textures. (See Chapter 4.) Compared to the *Venus of Urbino*, Botticelli's *Birth of Venus* appears rather "lean," not only in the shape of the central figure but in all the shapes, the colors, and even its atmosphere.

The Seventeenth Century

The paintings of Peter Paul Rubens of Flanders (Belgium) owe much to the pioneering work of Titian and his school. Like Venetian paintings, they are imbued with sensuous colors and textures, and soft forms that blend with their surroundings. Further, Rubens' nude women, like Titian's goddess, seem uninhibited about their nakedness—lacking the medieval reserve that still lingers in Botticelli's Venus. By the seventeenth century—the *Baroque* period of art—painters had become skillful in rendering pictorial effects,

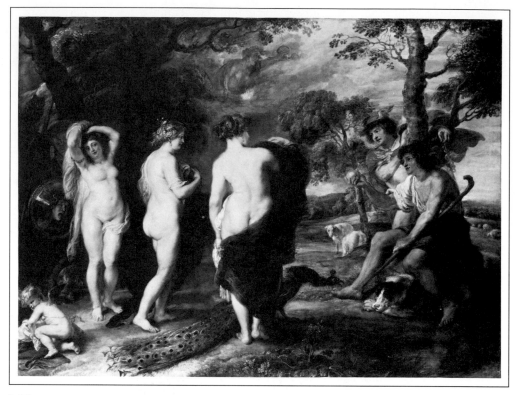

8-15 Peter Paul Rubens, *The Judgment of Paris*, c. 1636. Oil on canvas,
57″ × 75″. Reproduced by courtesy of the Trustees, the National Gallery, London.

and Rubens was first among equals. In his *The Judgement of Paris* (Figure 8-15)—a Greek story of a beauty contest between the goddesses Athena, Aphrodite, and Hera—the spatial organization is more complex than that in either a Titian or a Botticelli painting. The nudes are also more energetic and vital—this despite the fact that they appear to be heavier.

The generous dimensions of Rubens' women raise interesting questions about the effects of historical versus local influences on what artists depict. Are Rubens' nudes a reflection of the tastes of a period or an expression of some northern European preference for hearty and healthy women? Or, indeed, are these wondrous women an expression of the artist's personal tastes? (The central nude, Aphrodite, is a portrait of his wife.) Such questions have often been asked but never satisfactorily answered. So many factors affect the work of any artist that we can only offer a partial answer— that art is always created through a filter of experiences both personal and cultural. In this particular case it would certainly be inaccurate to claim that the artist's preferences were determined by

where he lived—for Rubens, an aristocrat, was also a successful statesman who held ambassadorial posts and painted in many of the courts of Europe. And there is no doubt that his trio of naked women were intended to be just as desirable as Botticelli's slim and (by more contemporary standards) appealing goddess.

Neoclassicism

Painted about a century and an half after *The Judgment of Paris*, Marie Guillemine Benoist's *Portrait of a Negress* (Figure 8-16) presents a view of womanhood radically different from Rubens'. The

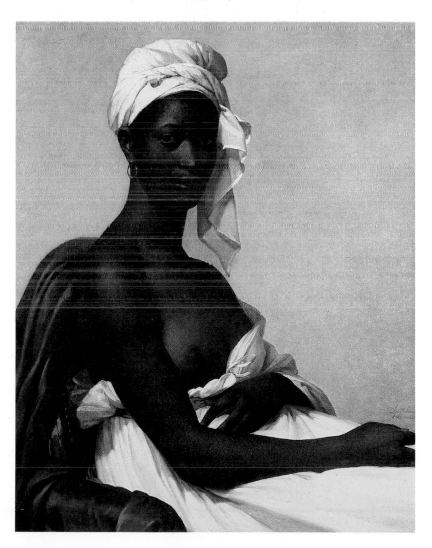

8-16 Marie Guillemine Benoist, *Portrait of a Negress*, 1800. Oil on canvas, 31¾″ × 25¾″. Louvre, Paris.

late 1700s and early 1800s witnessed the emergence of Neoclassicism, a movement in the arts marked by a renewed interest in the simplicity and restraint associated with classical art. (This movement was a reaction to the exuberance and exaggeration of art styles that were in many ways a product of Rubens' legacy.) While Benoist's portrait—because of its simple composition and clarity of line and texture—clearly reflects the sensibility of Neoclassicism, it is not nearly as cold and stereotyped as many Neoclassical works tend to be.

According to some observers, paintings of nude females reflect a male point of view. English critic John Berger went so far as to say, "Women are depicted in a quite different way from men—not because the feminine is different from the masculine—but because the 'ideal' spectator is always assumed to be male and the image of the woman is designed to flatter him." If this is true, Benoist's portrait seems to be an exception. In addition to presenting her sitter's sensitive face, long neck, full breasts, and elegant hands, she has emphasized the subject's tenderness and quiet dignity. Benoist captured something of the woman's personality that transcends the anonymity of a sex object.

Victorian Images

Nude images continued to appear in art, managing to survive even the nineteenth-century Victorian period when public antipathy toward the body was at a peak—when the sight of an ankle was considered provocative and the use of the word "leg" was held to be indecent. Oddly enough, the art of the time was full of sexually titillating displays of Turkish harems, Roman slave markets, and decadent orgies. So long as the nudes in a work were sufficiently classical and the subject matter could be interpreted as intended to teach historical or moral lessons, the most voyeuristic scene was guaranteed public approval. The works of French artist William Bouguereau, one of the most popular painters of the late nineteenth century, vividly illustrate this paradox. Although an "official" painter who enjoyed the benefits of public patronage, his treatments of classical themes—like *The Birth of Venus* (Figure 8-17)—amount to little more than lavish displays of female flesh. In this respect he was the equal of Rubens. However, unlike the seventeenth-century master, Bouguereau suppressed all evidence of painted surface to achieve a slick realism to rival that of the camera. It was as if the artist had photographed a group of actors in a *tableau vivant*. The illusion of optical reality and the provocative posturing of the figures, especially that of Venus, simply magnify the aspect of exhibitionism. To grasp how far Western painting and

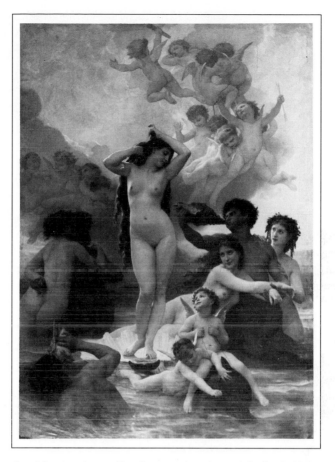

8-17 Guillaume-Adolphe Bouguereau, *The Birth of Venus,* c. 1879. Present location unknown.

the Venus theme had come over a period of 400 years, compare Bouguereau's version of *The Birth of Venus* with Botticelli's.

An exception to the hypocrisy of nineteenth-century art was the work of Édouard Manet. Refusing to disguise his nudes as goddesses or to make any pretensions about history or morality, Manet painted real women in real surroundings, as in his *Olympia* (Figure 8-18). Both the art critics and public were scandalized by this painting when it was shown in the Paris Salon of 1865. Ironically, Manet had borrowed the pose and composition from Titian's *Venus of Urbino* (Figure 8-14), a very acceptable and by then archetypal version of the Venus tradition. However, Manet's critics were not impressed by that fact—even if they had indeed been aware of it. They correctly perceived that the figure in the picture was not an idol from myth but a contemporary young woman, a perception based not only on the presence of the black maid but also on what the naked figure was wearing—a choker necklace, bracelet, and slippers—rather than on what she was not wearing. This meant,

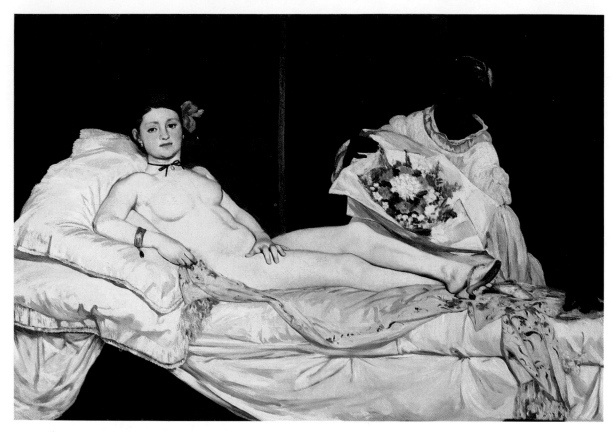

8-18 Édouard Manet, *Olympia*, 1863. Oil on canvas, 51¼″ × 74¾″. Louvre, Paris.

given her blatant nakedness, that she was at best a woman of easy virtue, at worst, a prostitute. Further, instead of looking demurely at the viewer, she had the audacity to look him directly in the eye without a hint of modesty. Manet's own audacity for painting such a picture was rewarded with scorn and ridicule, and thereafter he was branded as the *enfant térrible* of the French art world. Today, *Olympia* is considered as much a masterpiece of early modernism as Titian's *Venus of Urbino* is of the sixteenth century.

The Twentieth Century

Like male nudity, female nudity declined in the twentieth century. As the modern movement gained momentum, paintings like Bouguereau's symbolized all that was bad about established art—not only because of their falsity but also because of their commitment to pictorial realism. The traditional practice of vividly illustrating a subject, nude or otherwise, was considerably downgraded and classical themes lost whatever credibility they continued to

have during the nineteenth century in an increasingly scientific and materialistic world.

Yet Venus, of a sort, persisted as a subject matter during the early years of the twentieth century as artists sought solutions to new artistic problems. No longer an end in herself, she became a means to other ends, such as exploring new strategies of composition or expressing personal feelings. Henri Matisse, for example, flattened her out and turned her into just another compositional element (Figure 8-19). The issue here is obviously not to extol the body beautiful nor to arouse the sexual imagination, but to present an original and harmonious array of pattern and color. Any subject

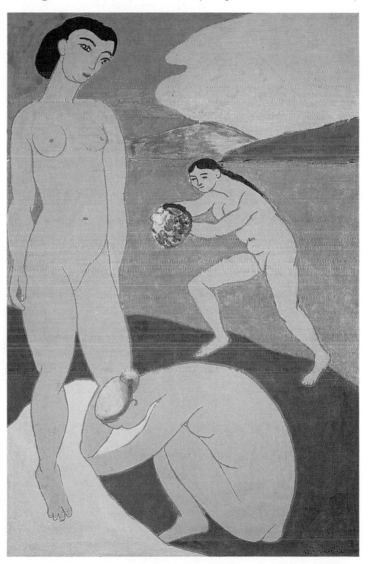

8-19 Henri Matisse, *Le Luxe, II,* 1907–08. **Distemper on canvas, 82½″ × 54¾″. Statens Museum for Kunst, Copenhagen (Rumps Collection).** ©Les Héritiers Matisse, M. Claude Duthuit, 61, Quai de la tournelle, 75oo5, Paris.

matter—a still life, flowers, wallpaper—could have accomplished the same end.

A half century later Venus emerged again in an even more contrary way. The paintings of Willem de Kooning are prime examples of Abstract Expressionism. But lurking in some of his paintings are vague images of women [similar in spirit to the image in Dubuffet's *Tree of Fluids* (Figure 2-32) painted about the same time]. For example, in *Woman I* (Figure 8-20), one of de Kooning's Woman series, are signs of a face, breasts, and lap, along with flesh tones and pastel shades. All of this is incongruously enfolded into the turmoil of de Kooning's typically aggressive brushwork—the painterly equivalent of a primal scream. Beyond the fact that they

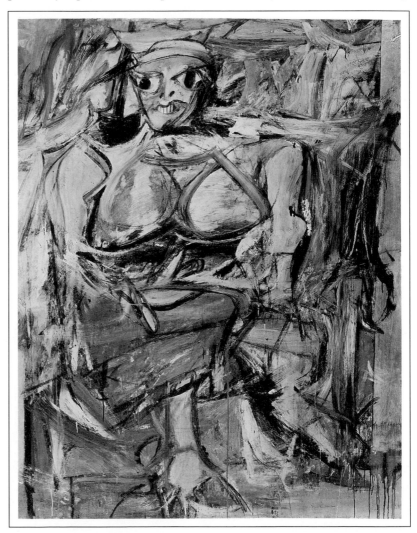

8-20 Willem de Kooning, *Woman I*, 1950–52. Approx. 76″ × 58″. Museum of Modern Art, New York (purchase).

are obviously unsettling, de Kooning's Woman paintings defy easy interpretation. Most people agree that they refer not to any particular woman but to Woman—as a larger than life abstraction, as an idea with mythical dimensions. But is she Woman as: earth mother, sex symbol, witch, or some private conundrum of de Kooning's?

As unpleasant as *Woman I* may seem, an even more disturbing body of work on the subject of women appeared in the 1960s. Rather than using an abstract idiom, artists such as Andy Warhol and Tom Wesselmann borrowed their styles from the vocabulary of comic strips and advertising. With cold indifference—and equally cold insight—they created satirical versions of the modern Venus. Warhol took the ideal woman off her pedestal and put her on the supermarket shelf, as interchangeable as a line of soup cans or any other marketable commodity (Figure 8-21). The judgment implied

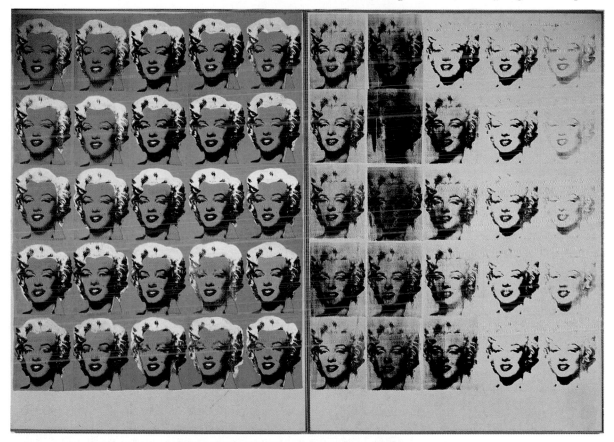

8-21 Andy Warhol, *Marilyn Monroe Diptych*, 1962. Oil on canvas, 6'10" × 9'6". Collection Mr. and Mrs. Burton Tremaine, Meriden, Connecticut. Photo courtesy of Leo Castelli Gallery, New York. Copyright 1990 the estate and foundation of Andy Warhol/ARS N.Y.

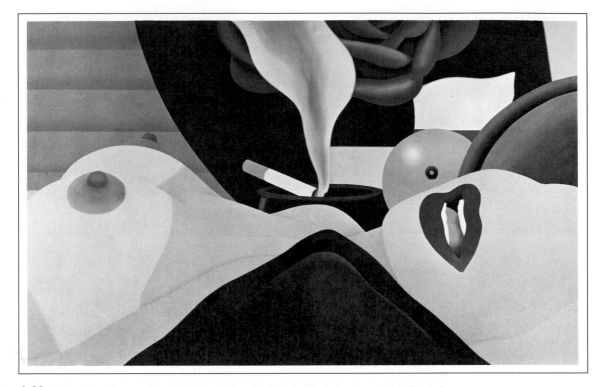

8-22 Tom Wesselmann, *Great American Nude No. 99*, 1968. Oil on canvas, 60″ × 81″.
Courtesy Sidney Janis Gallery, New York.

in this act—not only about the status of women but about the dehumanization that occurs in a mass-media, mass-production world—is far more devastating than the violence in de Kooning's brushstrokes. Wesselmann's long series of Great American Nudes—set in collage environments of sexual symbols and products that advertising has made "essential" to life—comments on this from another viewpoint, emphasizing the blandness of a Venus whose only features are sexual (Figure 8-22).

Yet it is largely among the cliché images of popular culture that the traditional concept of Venus survives. Born Aphrodite and arriving naked from the sea, she quickly usurped the stage-center of artistic nudity from Apollo. And when her role in art was compromised by the abstract emphasis of twentieth-century painting, she was reborn from the sea of mass media and arrived naked in the centerfold of *Playboy* magazine, enacting the fantasies of the American male. Although realistic painting and sculpture have lately returned to prominence in the galleries, sexuality is no longer as marked or as myopic as it once was. Artists, reflecting a new attitude toward women, have abandoned the sex object in favor of the

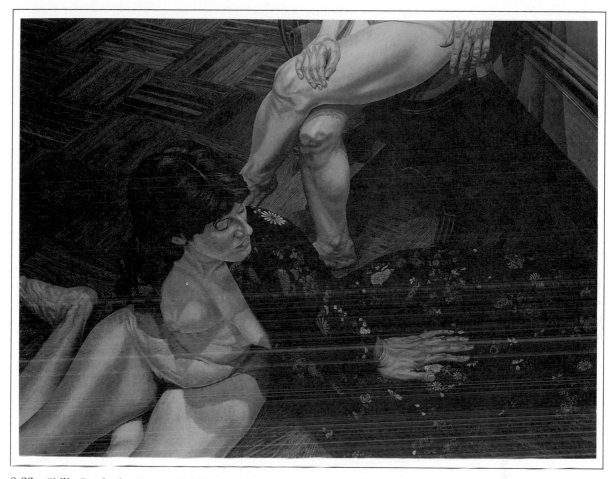

8-23 Philip Pearlstein, *Two Models, One Seated on Floor in Kimono*, 1980. (Detail)
Oil on canvas, 72″ × 96″. Courtesy Frumkin/Adams Gallery, New York.

art object; nudity, when it is portrayed, is often dealt with in a
matter-of-fact way—as in the case of John de Andrea's sculptures
of women (Figure 5-4), Sylvia Sleigh's portraits of naked men, or
the paintings of Philip Pearlstein.

Since the 1960s, Pearlstein has specialized almost exclusively in
the nude, male or female, particularly in the sharp-focused kind of
treatment of it as seen in *Two Models, One Seated on Floor in Kimono*
(Figure 8-23). His approach to the subject, thus, is at the opposite
end of the aesthetic spectrum from de Kooning's, not only because
of its realism but also because of its finished surfaces, devoid of any
trace of expressionistic brushwork. Although a Pearlstein painting
is devoid of expressionism it is not devoid of other qualities that can
be related to abstract painting. The even-handed lighting, the

uninflected colors, and the literal treatment of texture and detail in which no part is accented tends paradoxically to flatten the composition. This together with the radical cropping of the figures and the tilted perspective emphasizes the painting's decorative elements. Like a new landscape, a Pearlstein work manifests the influences of abstractionism, and like a Gregor flatscape (Figure 7-17) elicits a tension between realism and abstract pattern. This tension is reflected in the ambivalence of Pearlstein's nudes: that is, the ambivalence between being sex objects and art objects. Their explicit nakedness, transcribed in such a detached and thorough manner, tends to showcase their gender and to depersonalize them at the same time. Perhaps this is why Pearlstein's paintings have been described as "coldly erotic."

MAN AND WOMAN

To merely show how artists have represented men and women separately would be literally incomplete. The union of a man and woman is, after all, the fulfillment of the promise implied by their separateness. The balance of this chapter will complete the theme by surveying a few examples that deal with the relationship between men and women.

Indian Temple Art

One of the most noteworthy—and unusual—depictions of the male-female relationship is found in the Khajuraho temples of northwest India, which were constructed in the tenth century A.D. by a people called the Chandels. The major temple of the group is so covered with relief sculptures and other carvings (Figure 8-24) that from a distance it resembles a coral deposit more than a building. Sculptures of gods and goddesses, saints and mortals, decorate the niches and bands around the turrets, some carved in high relief, others fully round—and nearly all engaged in one form or another of sexual activity. The majority of the figures are *apsaras*, heavenly courtesan-nymphs, who occur either singly or in conjunction with a male figure, and who may in fact be representations of the *devadasis*—women who served as attendants to the temple's deity and as public dancers and musicians. Many of the figures represented actual princes and their wives and courtesans, a fact that calls to mind a parallel with Europe of the same period: the Royal Portals of Chartres Cathedral in France, so called because the Old Testament figures carved alongside the doors represented the kings and queens of France (Figure 8-25). But the comparison only serves to demonstrate the vivid difference in outlook between the

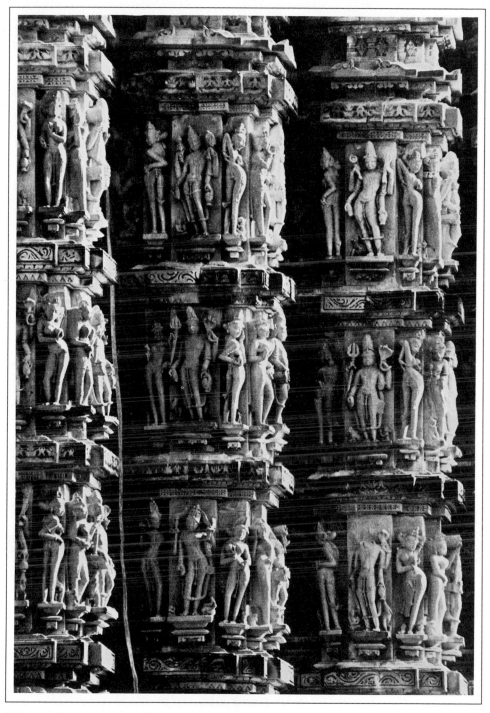

8-24 Walls of the Kandarya Mahadeva Temple.

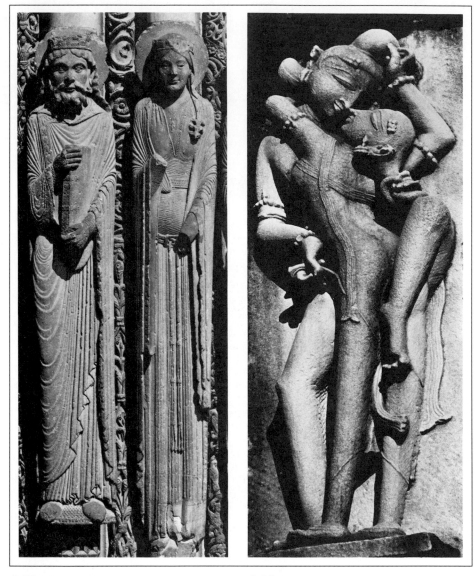

8-25 Detail of the Royal Portals, Chartres Cathedral, twelfth century.

8-26 Detail of the Kandarya Mahadeva Temple, tenth–eleventh centuries.

two faiths. The stiff, formal figures on the cathedral were clearly intended to de-emphasize the body; the sensuous creatures that populate the temple were sculpted with greatly exaggerated sexual attributes. Their postures and gestures elicit a sense of movement, and the jewelry and flimsy scarves that cling to their bodies accentuate the eroticism of their acts (Figure 8-26).

Unlike most of the artists of the Western tradition, these Indian sculptors did not use live models. Instead, they based their work on earlier sculptures and evolved their conventions for representing the human body by relying more on their religious and sexual views than on their observations of anatomy. Much of the imagery was inspired by literary sources—such as the myth of the creation of woman in which Twashtri, the Divine Artificer, took the roundness of the moon, the clinging of tendrils, the trembling of grass, the glances of deer, and many other qualities and compounded them to make woman. Accordingly, the young maidens tend to be adorned with breasts that resemble wine-palm fruit. Both men and women have supple bodies seemingly devoid of bone and muscle. They have volume without weight, and their movements defy the mechanics of real bodies. Theirs is a liberated, rhythmic anatomy that evokes the feelings of erotic love.

The open celebration of sexuality was completely in keeping with the beliefs of Hinduism, a major theme of which is the life-giving energies: the male female principle. At times the female aspect, often personified by Shakti, is emphasized; at other times it is the male aspect, Siva, that is stressed. But the principle of wholeness always prevails, necessitating the union of male and female. In certain rites, sexual intercourse itself is considered a divine act whereby the participants become like Siva and Shakti, or god and goddess.

Chagall

The expression of love between the sexes is as strong in the work of the twentieth-century painter Marc Chagall as it is in the Kandarya sculptures, but it is expressed in a strictly monogamous context. Chagall and his wife Bella first met in their small home town in Russia when he was about 22. At the time she was studying in Moscow he was studying art, without much success, in St. Petersburg. They fell in love immediately. But marriage between the two was delayed when Marc left in 1910 to continue his studies in Paris, then the art capital of the world. In a short time he became a successful artist. The natural naiveté of his style appealed to the progressive critics and dealers of Paris who, at the time, were interested in nontraditional approaches.

Despite his phenomenal success he had not forgotten Bella, and in 1914 returned to Russia to marry her. Although both families objected, especially hers, the two were married in 1915. Chagall painted several works on the subject of love shortly before and after his marriage. In *Double Portrait with Wineglass* (Figure 8-27), the fantasy come true is revealed by Marc, intoxicated with happiness,

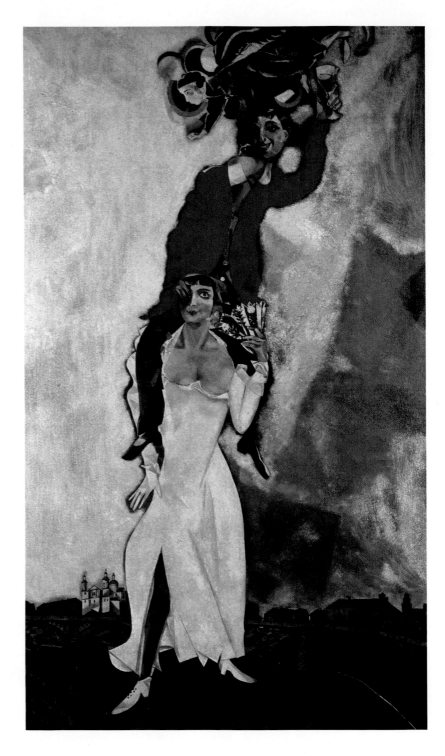

8-27 Marc Chagall, *Double Portrait with Wineglass*, 1917–18. Oil on canvas, 7'7¾" × 4'5½". Musée National d'Art Moderne, Paris, © 1990 ARS, N.Y./ A.D.A.G.P.

sitting on the shoulders of his wife—with their newborn child hovering angel-like over both. Below them lies a quaint Russian village, perhaps Vitebsk, near their hometown. Logic and the forces of gravity are overcome by their private happiness. Floating figures are common in Chagall's works; here they symbolize the flight of lovers—the buoyancy of the human spirit in marital bliss.

Chagall's art is an extension of his private world, a world that freely unites the real with the unreal and the present with the past. In many ways it is similar, both in form and content, to the sculptures of Kandarya Mahadeva. But Chagall's art reflects his dedication to the love of a single person, and to the physical and spiritual celebration found in a genuine monogamous union.

Kokoschka

A contemporary of Chagall, Oskar Kokoschka, painted *The Tempest* (Figure 8-28) in 1914, at almost the same time as *Double Portrait with Wineglass*. Like Chagall's painting, it is a young man's artistic response to a personal experience with love. When we look at the

8-28 Oskar Kokoschka, *The Tempest*, 1914. Oil on canvas, 71¼″ × 87″. Oeffentliche Kunstsammlung Basel Kunstmuseum.

painting, several other parallels suggest themselves: for example, the pair of lovers in *The Tempest* also seems to be floating. In fact, the German title is *Die Windsbraut*—literally "the bride of the wind"—which would be an apt name for Bella, whose figure floats in so many of Chagall's works. Like the earlier Chagall painting, *The Tempest* is a double portrait of the artist and a particular woman.

Kokoschka's three-year love affair with Alma Mahler—daughter of an artist, widow of a celebrated composer, and one of the most beautiful women in Vienna—nearly destroyed him. The dual trauma of passionate romance and high society was too much for Kokoschka; love, hate, ecstasy, fear—above all, disillusionment—were combined in the relationship timely ended by World War I. Kokoschka's poetry during the period refers to the turmoil—like the color and forms in his painting—that threatened to devour his identity and creativity.

Kokoschka's *The Tempest*, like Chagall's *Double Portrait with Wineglass*, is a reflection of the artist's relationship to another woman. The Chagall is buoyant with joy, the lovers seem as free of gravity as a kite in an April breeze, and their love for each other is without even a hint of reservation. The Kokoschka, on the other hand, is heavy and turbid like a gathering of clouds before a storm; the man's face has the glazed expression of one who is distracted; the love between the two is, at best, ambivalent—more desperate than happy, more restless than satisfied.

The work of Eric Fischl, although different from *The Tempest* in many respects, shares its spirit of discontent. Typically, a Fischl scenario involves middle-aged men and women, sometimes accom-

8-29 Eric Fischl, *Noon Watch,* 1983. Oil on canvas, 65″ × 100″. Courtesy Mary Boone Gallery, New York.

panied with children, relaxing or engaging in recreative activity in a backyard, at poolside, or at the beach, as in *Noon Watch* (Figure 8-29). The style, which is neither as expressionistic as Kokoschka's nor as tightly painted as Pearlstein's, can be perhaps described as loose realism. Thus a Fischl picture consists of ordinary life painted in a traditional manner—except that everyone in the picture is naked. The condition of nakedness is exploited for all its psychological and symbolic potential. Unlike a Pearlstein composition, which is so elegantly designed and fastidiously painted that it tends to distance the viewer, a Fischl composition is as awkwardly informal as the people themselves. This, together with Fischl's tendency to use a low eye level, tends to draw the viewer into the scene; the viewer becomes a voyeur who not only spies on the people's nakedness but shares in their embarrassment. The middle-class pursuit of pleasure, which so often becomes a desperate means to conceal the anxieties of boredom and unfulfilled desire, is now unmasked and disrobed.

SUMMARY

Of all the subject matter available to the artist, perhaps none has proved more universally and consistently appealing than the human body. Whether as an ideal form or as the portrait of a particular person, it has been viewed and treated differently by the artists of every age. Simply looking at the way in which a naked body was represented can tell us as much about an age as all the objects, clothing, and other things recorded in the work. Style and content tell us whether the people of a given time believed that a man should be athletic or elegant, or whether a woman was considered a piece of decorative property or an object of worship. The relationship between the sexes is often expressed indirectly in these works, but it has less frequently been the subject matter of art. To be sure, a hidden trove of sexually explicit works produced by artists great and small does exist, yet these works are rarely meant to be more than stimulating or amusing. Only in rare cases—such as the Indian temple carvings—has the sexual relationship been treated in a religious way. Western art, needless to say, has had little of this. In the twentieth century, however, it has become more possible for artists like Chagall, Kokoschka, and Fischl to come to terms with the sexual, as well as the emotional, ties between men and women—and to express their infinite variety in a variety of ways.

CHAPTER 9 IMAGES OF FAITH

L OOKING AT THE HISTORY OF ART, one would have to agree that the overwhelming majority is religious. Non-religious (secular) art is decidedly in the minority, flourishing only in the West and only in recent times (the late nineteenth and twentieth centuries). In just about all other times and places, art has been produced for various kinds of religious purposes—sacramental, devotional, ritualistic, or instructional—and thus has been tied in one way or another to belief. Moreover, the most ambitious and inspired art projects of all time were created in the name of religion.

Yet, the relationship between art and religion has not always been a harmonious one, even during those times when a particular culture's religious devotion was at a peak. The clash between art and religion usually occurred over the issue of *anthropomorphic* imagery—that is, the use of human figures to represent gods or the divine. In some cases, the idea of graphically representing a deity was considered at best futile, at worst, blasphemous. In other cases it was feared that the faithful would revere a statue or picture more than the entity that the image was supposed to represent (a practice known as *idolatry*).

In several of the world's religions, the making of anthropomorphic images—especially those of their most venerated deities—has been avoided or prohibited at one time or another. In the second of the Ten Commandments the banning of such imagery is explicit: "You shall not make for yourself a graven image, or any likeness of anything that is in heaven above, or that is in the earth beneath, or that is in the water under the earth" (Exodus 20:4). For the ancient Jews, this prohibition was comprehensive and seemingly permanent. Likewise, early Christians, because of their Jewish roots, refused to celebrate their faith in artistic images. Around the third

century they shed their reluctance and began to decorate the walls of their churches and their underground cemeteries (catacombs) with illustrations of the Bible. The Christians of the Byzantine Empire (headquartered in Constantinople—now Istanbul, Turkey) banned religious art for over 100 years (730–843). Following the Reformation, many Protestant Christians were opposed to any form of religious art, although they did not ban it. Islam, which shares with Judaism and early Christianity the concept of idolatry, imposed the most severe ban of all by forbidding both symbols and images in their religion and even forbidding representations of the human figure in any context. (To this day art students in Saudi Arabia are forbidden to draw the human figure—clothed or nude.)

Despite such prohibitions, the production of religious art has flourished throughout most of human history. Religions opposed to imagery either ignored their own prohibitions or expressed the religious impulse in other ways. Islam, for example, which had the strictest ban, has left the world with a rich legacy of religious architecture and architectural decoration.

The majority of this chapter reviews examples of religious art in some of the major faiths of the world—specifically, Judaism, Islam, Buddhism, and Christianity. Each of these ancient and geographically diverse faiths has, over time, experienced numerous, and sometimes enormous, transformations in its cultural styles. The illustrations in this chapter, therefore, are not intended to be wholly representative of either the art or the theologies of these religions. The chapter concludes with an examination of religious expressions in the modern world.

JUDAISM

Because of foreign invaders and conquerors, the ancient Jews, a tiny culture occupying a narrow strip of land at the eastern end of the Mediterranean, left no significant monuments of art or architecture. However, they did employ art in their religious practices and sometimes even took exception to their own second commandment.

Judaism is inseparable from the history of the Jews themselves—originally, semitic nomads who first settled in Palestine (roughly the same geography as modern Israel) around 2200 B.C. Surrounded by powerful neighbors—Egypt in the west and the aggressive city-states of Mesopotamia (a region comprising modern Iraq) in the east—the tiny nation of Jews endured more than its share of disasters: enslavement by Egypt, social unrest and political division within its own territory, the destruction (twice) of its principal temple and capital city, and exile and dispersion of its people (a condition that still exists wherein Jewish people are located outside of

Israel in the *Diaspora*, literally "dispersed" around the world). Throughout this tortured history the Jews took consolation in their faith and the fact that they were the "chosen people" of God (or Yahweh) who had made a covenant with them through Abraham, their first patriarch, and later through Moses, the hero who had led them out of Egyptian captivity and who received the Ten Commandments. In addition to chronicling this history, the Old Testament unfolds a developing concept of *monotheism,* belief in one God, as opposed to the rampant *polytheism* that existed throughout the rest of the ancient world.

The Old Testament points out that the prophets also assailed idolatry. Jeremiah, for example, reproaches the Jews in page after page for worshiping idols. But despite the controversy over imagery, the Old-Testament Jews *did* engage in religious art. That little of it survived is due not to Jewish injunctions but to Babylonian, and later, Roman destruction. To learn of this art, we must go to the source that contains these injunctions: the Old Testament. In Exodus 25:18–20 we find God instructing Moses to decorate the lid of the ark of the convenant—the box intended to hold His Commandments—with, among other things, golden cherubim (guardian angels with widespread wings). To house the ark, the best craftsmen in the land are hired to design a tabernacle. We learn that Solomon's Temple (described in 1 Kings 7 and 2 Chronicles 3) was overlaid throughout with gold and furnished with, among other things, sculptures of cherubim, oxen, lions, palm trees, pomegranates, and flowers. Significantly, the biblical writers pass no judgment on this extravagance. Although the Second Temple, built after the fall of Babylon and the return of the Jewish exiles, is not described in such detail (Ezra 6), there is every reason to believe it too was lavishly furnished.

The issue of idolatry, however, was never completely suppressed. Herod—the king of the Jewish nation when Jesus was born—alarmed and alienated a scholarly sect known as the Pharisees when he had a golden eagle placed over the Temple. But the Pharisees notwithstanding, Jews of the post Old-Testament period adorned their religious buildings with figurative art—a fact supported by archaeological evidence.

Synagogue at Dura Europos

In the 1930s, diggers discovered the remains of synagogues decorated with numerous illustrations of humans and animals. The most impressive of these is a third-century synagogue in a Roman frontier town called Dura Europos (now in eastern Syria). The walls of the synagogue are covered with frescoes (Figure 9-1) bringing to

9-1　Synagogue from Dura Europos, view of north-west corner, c. A.D. 250.
National Museum, Damascus.

life various biblical stories—the Exodus from Egypt, the arc of the covenant, the tabernacle, Moses at various stages of his life, David, Solomon, and so forth. Although Yahweh is not represented, His power is symbolized in numerous places by a truncated hand appearing from the clouds. Lacking a well established tradition of pictorial art, the Jewish artists borrowed motifs from other traditions. The costumes, for example, are Near-Eastern, except for the pallium or toga—the classical garb of a philosopher or teacher—worn by Moses. The tabernacle is represented as a small Greek temple. Likewise, the painting style is basically Near-Eastern, but with a smattering of Greco-Roman touches. For the most part, the people are flatly painted, frontal, and repeated with little variation of shape or movement. The spatial organization is primarily two-dimensional, not unlike that of an Egyptian mural (Chapter 7). Scattered here and there, however, are a foreshortened altar, some overlapping, a foreshortened ox, a touch of chiaroscuro, a hint of linear perspective, and a cast shadow. Whatever their shortcomings in consistency, to the Jews in Dura Europos these pictures were no doubt easy-to-read, vivid evocations of the Holy Scriptures.

Christian paintings have also been discovered in Dura Europos. Although badly damaged, they are intact enough to reveal that their style is similar to that of the synagogue murals. (Many early

Christians, especially in that part of the world, were of course baptized Jews.) Thus the art of Dura Europos not only gives us clues to Jewish art and religious life of the time, but to the art and spiritual climate in general during the third century when the Roman Empire was experiencing turmoil and the old Greco-Roman gods were soon to fade away.

The relationship between Judaism and art has been an ambivalent one. While officially condemned, art was used liberally during both the biblical and post-biblical eras. Jews could not ignore the fact that sculptures and decorations, such as those in the tabernacle and the two Temples, brought emotion to religious observance, and that the buildings themselves became symbols of the faith and rallying points for Jews. In the post-biblical era they discovered the potential of pictures, such as those in the synagogue, to both instruct and enrich faith.

BUDDHISM

While the Jews were captives in Babylonia, Sakyamuni, the founder of Buddhism was born in northern India (550 B.C.). The major religion of India was then Hinduism, the oldest living faith in the world. In the *Upanishads,* the sacred writings of this immensely complex religion, there emerges a set of beliefs about the soul and the journey of life that is fundamental to both Hinduism and Buddhism. Like both Plato and the medieval Christians, the ancient Indians regarded the physical world as transient. But where Western thinkers—classical, Christian, or Jewish—accepted the notion of the individuality of the human soul, the writers of the Upanishads did not. To them a personal soul was in a continual state of flux, possessing only a tenuous continuity as it passed through life. More importantly it was part and parcel of a larger soul, the Soul of the World. This view led Indian thinkers to formulate the most salient doctrine of their belief system: *samsara,* or reincarnation, the passage of the ego after death into another body—human or animal.

At age 35, Sakyamuni had a vision in which he saw the endless succession of birth and death. From this experience, he determined that all evil and suffering were caused by desire, and desire started with birth. To end suffering, one must break the cycle of birth, death, and rebirth, and thus escape from samsara. After seven years of meditation, he preached his insights at Sarnath, became known as the Buddha (the enlightened one), and developed a large following.

According to legend, after Sakyamuni died his remains were divided up and housed in several burial mounds called *stupas.* Al-

though originally intended just for burial, stupas evolved into pilgrimage shrines. The earliest shrines were simple domes, the circular plan symbolizing the cycle of life while the dome served as a perfect metaphor of the simplicity and serenity of the Buddha. Relief carvings of plants, animals, attendants, worshiping hosts, and so forth adorned some of these shrines, but the Buddha was represented only by his symbols—his footprints, his stupa, a lotus flower, the bodhi tree. The appearance around 100 A.D. of images of the Buddha are believed to have come about because of Greek influence in the wake of Alexander the Great's conquests.

The Stupa at Borobudur

Rising from a Java plane is one of Buddhism's most imposing structures: the stupa at Borobudur (Figure 9-2). The shrine is really a rounded hill, terraced and clothed in masonry. Of its nine levels, the base (which is mostly underground) and first four levels are rectangular, the next three are circular and support 72 miniature bell-shaped stupas, and the top level consists of a single stupa, the climax of the whole monument. Like the plan of earlier stupas, Borobudur's is radial and oriented to the four points of the compass. Thus its plan becomes a sort of cosmic diagram, or *mandala*, and its terraced shape, a model of the World Mountain.

9-2 Stupa at Borobudur, Java

The sculpture program, consisting of both relief and in-the-round images, was designed to parallel in a symbolic way the physical ascent to the summit: a spiritual journey through increasingly higher planes of consciousness, leading eventually to *nirvana* (the state of eternal bliss and the goal of all Buddhists). The walls of the rectangular terraces are filled with relief sculptures stretching for miles. Those on the base (which is mostly covered) depict people caught in the grip of desire, the endless hell of birth, death, and rebirth (samsara) that Sakyamuni warned about. The second level depicts the legendary life of the sage from his pre-existence to his first sermon at Sarnath. Figure 9-3 shows Sakyamuni's disciples giving him a ceremonial bath prior to the sermon as he sits in a lotus pond. The next three levels illustrate a variety of Sakyamuni's teachings, or *sutras* (threads). These lead to the sixth level, the first of the three circular levels that contain the miniature stupas (Figure 9-4). The transition from the fifth to the sixth level is dramatic, almost like entering paradise. Not only does one ascend into a higher and more open ambience, one also advances from the square to the circle—the geometrical shape that best describes the seamless experience of infinity. The stages of enlightenment are unfolded symbolically and aesthetically as a pilgrim progresses from the bottom level to the central stupa at the top.

There are no relief carvings on the three circular levels; instead

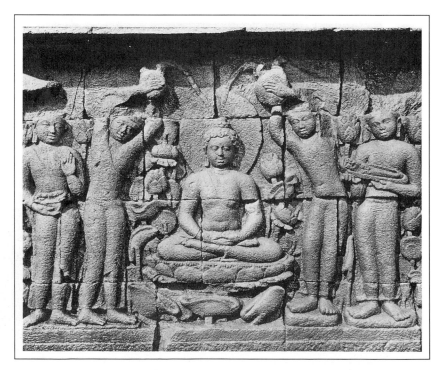

9-3 The Buddha Bathing before His First Sermon. Relief on the interior wall of the 1st gallery of the Borobudur, Java (detail), approx. 750–800. Stone, originally with a finish, height approx. 100 cm.

72 seated Buddhas are located in each of the 72 miniature stupas. Fortunately we can examine the one that is exposed in full view in Figure 9-4. Like the domed stupa, the seated Buddha image—developed earlier in India—had by this time become an archetype. The ones at Borobudur are considered among the finest in the entire Buddhist world.

Perhaps the first thing that comes to mind is the similarity between the Buddha sculpture and the erotic figures on the tenth-century Hindu temple in Khajuraho (Figures 8-24 and 8-26). Both have supple bodies covered with smooth envelopes of skin; both seem to have volume without weight, as though they had been inflated instead of carved; both are young and sensuous. But the Buddhist piece represents an ideal. His proportions, like those of

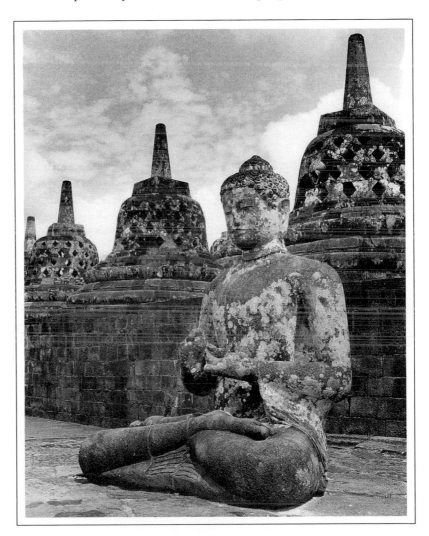

9-4 Vairocana Buddha. Borobudur, Java.

Doryphoros (Spear Carrier) (Figure 8-4), were based on a canon, but obviously a very different canon—one that does not have a counterpart in the anatomy of a real human. The Buddhist texts, which list no less than 32 major and 80 minor features for a Buddha statue, apparently used a metaphorical system for prompting the shapes of his anatomy: His eyes are equated with lotus buds, the curls of his hair with snail shells, his broad shoulders with the head of an elephant, his torso with the body of lion, and his legs with a gazelle's legs, and so forth. Special distinctions include his topknot (for enlightenment and wisdom), a small protuberance (*urna*) between the eyes (through which emanates the light of wisdom), the distended ear lobes, the classic yoga position of the legs, the wheels of knowledge inscribed on the souls of his feet, and finally the stylized hand gestures, or *mudras*, which convey different meanings (in Figure 9-4, the gesture of teaching).

Whether or not the Borobudur Buddha incorporates all of the prescribed features, there is no doubt that its bodily attitude and facial expression convey the utter tranquility of one withdrawn from the distractions of this world. As such it becomes a model of human perfection. Like the Buddha himself who took leave of earthly life to enter the final state of nirvana, and thus reconcile the paradoxical natures of life and transcendence, his stone image seeks to be a mirror of the Eternal.

ISLAM

Islam, the youngest of the living faiths, refers to the Moslem religion and to all the nations—from Morocco to Bangladesh and beyond—where that religion predominates. Like Buddhism, Islam is closely associated with the life and teachings of one person.

In A.D. 570—over 1100 years after the birth of Sakyamuni and some 1800 years after Moses received the Ten Commandments—Mohammed (the Prophet) was born in Mecca, a trading post on the west coast of Arabia. Pre-Islamic Arab culture, like that of the Jews before Abraham, was nomadic, superstitious, and idol worshiping. Young Mohammed never learned to read and write, but he was studious enough to absorb the ideas of monotheism—probably from contacts with the small Jewish and Christian communities in Mecca—and eventually he dictated one of the most important books in the world. Like Buddha, he had a vision—in this case the angel Gabriel revealed to him that he was the messenger of Allah (God). When he tried to spread this message to the polytheistic Meccans, however, he was met with hostility and was forced to flee to Medina. The year of his flight (A.D. 622) is the first year of the Moslem calendar.

In Medina, Mohammed acquired a following, returned to Mecca in triumph, and proceeded to convert the rest of Arabia, proclaiming Mecca as the Holy City of Islam. After Mohammed's death, his followers converted the peoples of the Middle East, North Africa, and Spain in a lightning series of conquests. The new faith was, and still is, centered around the *Koran*, the Moslems' sacred book. Unlike the Old Testament, it is God's (Allah's) revelation to one man as recorded by his disciples and followers. Like the Jewish scriptures, however, it professes monotheism, and recognizes the Jewish prophets. Moreover, it recognizes Jesus—but as a prophet rather than the son of God—and Mohammed as the last of the prophets. Although the Koran itself does not preach against idolatry, the *hadith* literature—a collection of sayings and anecdotes from Mohammed's life—does. Mohammed's purpose was to put an end to Arab idolatry and superstition. There are no mysterious rites, and no formal priesthood. The *mosque*, the Moslem place of worship—a courtyard surrounded by a wall and facing the direction of Mecca (the *qibla*)—is as simple and direct as the faith it serves (Figure 9-5). The wall on the qibla side is identified by a

9-5 Courtyard and porticos of the Great Umayyad Mosque, taken from the south-east corner. Damascus.

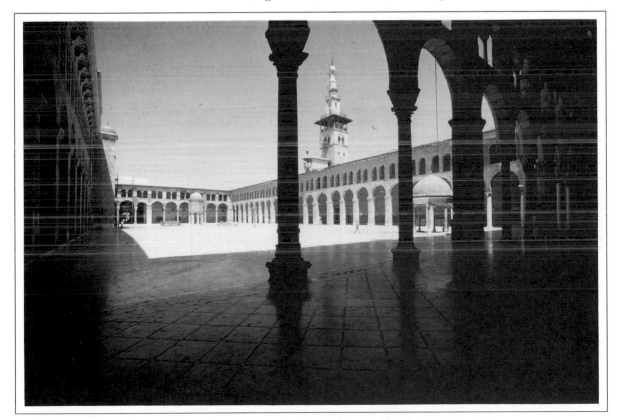

mihrab, a niche or small sanctuary. Opposite the quibla wall is a *minaret,* or prayer tower, from which the *muezzin* (crier) called the faithful to prayer.

The Great Mosque of Cordova

You may recall the graceful dome (Figure 3-7) over the mihrab of the Great Mosque of Cordova. One of the most imposing monuments of liturgical architecture, the Cordovan mosque was begun in 785 during the height of Islamic civilization (around the time that the stupa at Borobudur was begun). A member of the Ommayad dynasty who had established himself as independent ruler of Spain intended it to provide an alternative to Mecca as a point of pilgrimage. Designed on a plan 570 feet by 425 feet, the original structure contained 110 arcades. The caliph's successors continued adding arcades until, by the tenth century, it contained 400 arcades (850 columns) creating 36 east–west aisles and 17 north–south aisles (Figure 9-6). These statistics, in addition to indicating the physical dimensions of the mosque, reveal the Islamic fondness of repetition and, thus, something of the principles of Islamic art.

The walls of a mosque, unlike those of a Jewish synagogue, a Buddhist stupa, or a Christian cathedral, are completely void of figurative art of any kind. This fact relates to the Islamic prohibition against imagery (among the rare exceptions to this rule are "Persian miniatures," a type of story-book illustration). Aside from the ban itself, explanations given for this void invoke such arguments as the fear of idolatry, the influence of Judaism, even the alleged lack of artistic skills on the part of a nomadic culture. According to Islamic scholar, Lois Ibsen Al Faruqi, these explanations are essentially negative and fail to account for the fact that Islamic art, an original language of forms, was, no less than the Islamic faith, a breakthrough in human culture: "This breakthrough in the arts was too important, too novel, too creative to be a mere conformation to condemning injunctions, to the fear of idolatry, outside influences, or jealousy."

Faruqi asserts that the function of liturgical art is to communicate "a reality that reaches beyond the natural world." But what kind of art is able to communicate this reality? The Moslem answer was abstract art, but not one comprising a system of abstract symbols such as mandalas, stars, crosses, and so forth. Although some Islamic configurations lend themselves to such interpretations— for example, the radial dome in Figure 3-7, like a mandala, symbolizing the universe—this was not the intention. Islamic art consists of "infinite pattern" that evokes, through the sheer power of its

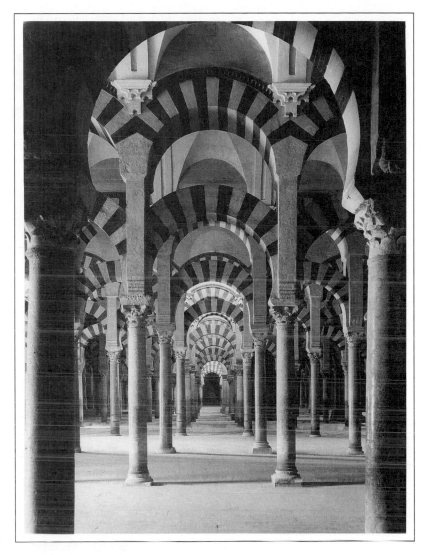

9-6 View of the interior of the
Great Mosque of Cordova, Spain.

internal organization, an intuition of transcendence. One of its principles is that of dividing the visual field into ever smaller, repetitive units. An example of this is the prolific arcade system of the Mosque of Cordova (Figure 9-6). A series of double arches that spring from thin columns like palm-fronds, the arcades draw the eye inexorably to the qibla. On the other hand, the limits of space are nullified by the forest of arcades—an experience of space without end. This, together with the endless repetition and lack of a focal point, gives the sensation of arcades continuing beyond the limits of the visual field—or an experience of infinity.

A Persian Carpet

Another principle consists of the Moslem fancy for creating intricate combinations and interlacings. The patterning on the Cordova dome is one case in point. Another is a sixteenth-century carpet (Figure 9-7) from Persia (modern Iran). Persian carpets were

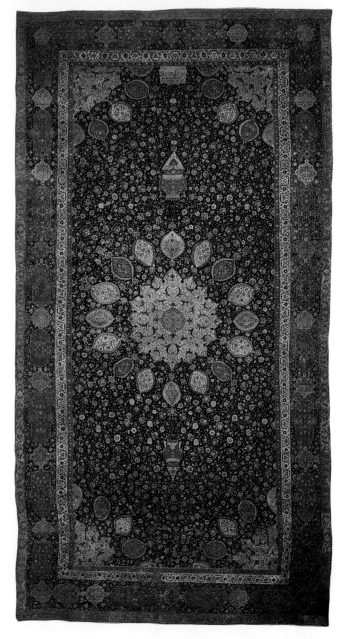

9-7 Carpet from the tomb mosque of Shah Tahmasp at Ardebil, Iran, 1540. Approx 34′½″ by 17′½″. Victoria and Albert Museum.

highly valued long before the time of Mohammed, but after the arrival of Islam their matchless artistry was often put to the service of furnishing mosques as prayer rugs or wall hangings. Woven for a tomb-mosque, the carpet in Figure 9-7 displays a central medallion surrounded by a plethora of tiny stems, leaves, and flowers in colors of crimson and gold set against a blue field. It contains neither text nor symbols of the faith. But attempting to deconstruct the labyrinthian detail, and the interlacing and endless permutations of motifs could lead one to have an actual religious experience. As Faruqi explains: "These combinations are to be supplied by the viewer as he continues the pattern for as long as his imagination can support him. When the point of collapse is reached, the Muslim viewer can only exclaim, 'Allahu Akbar!' ('God is the greatest!')."

CHRISTIANITY

Like Sakyamuni and Mohammed, Jesus lived in this world—interacting with people, debating with religious authorities, giving sermons, teaching by parables, and developing a following of disciples. However, the circumstances of His death were dramatically different from those of the other religious founders. Christians believe Jesus is the Son of God and that when He was executed, He rose from the dead, promising to return. The story of his redemptive death and resurrection—commemorated both in the celebration of Holy Communion (when Christians share in the mystery of the resurrection) and in the annual celebration of Easter—lies at the heart of the Christian faith.

Conditions in the Mediterranean world at the time of Jesus' death were quite favorable for the spread of Christianity. The safety of foreign travel provided by the *Pax Romana* (the "peace of Rome" imposed by the Roman emperor) enabled the Evangelists, particularly St. Paul, to make their journeys in relative safety. Wherever they went, they were assured of audiences in the synagogues of the Diaspora, while the Greek language allowed them to preach their message in a common tongue. Finally, the old pagan gods and goddesses were losing their hold on people's imaginations. Despite persecution by Roman authorities, Christianity had gained such a foothold in the Empire by the fourth century that the Emperor Constantine himself was converted. Not long after that, Christianity became the official religion of Rome.

During the early part of the Middle Ages the Germanic peoples of western Europe were converted through the missionary efforts of monks—almost the only literate people of the time, as well as the conservators of what little remained of civilized culture after the

Fall of Rome. Medieval Christianity reached its apogee in the twelfth, thirteenth, and fourteenth centuries, a period of artistic development marked by great cathedrals (Figure 6-15 and Figure 6-17), stained glass (Figure 5-13), sculpture (Figure 8-12 and Figure 8-25), and painting (Figure 4-1 and Figure 4-2).

Unlike their Jewish brethren, Christians during most of this history were rarely constrained by the Second Commandment. Indeed, art and Christianity were inextricably connected—Christian faith supplying the subject matter and inspiration; Christian artists providing the talents that they believed were gifts of God. No better examples of this connection exist than in the works of Michelangelo and Rembrandt—the two artists to be reviewed in this section. Michelangelo's paintings in the Sistine Chapel were made in the early sixteenth century (the century of the Persian carpet); Rembrandt's were made in the seventeenth century. Not long after Michelangelo had completed the Sistine Ceiling, Martin Luther, a German monk, challenged the doctrines of the Church, an act that ignited the Reformation—a rebellion against Catholicism that eventually led to the establishment of separate Protestant churches. Catholics responded with a Counter-Reformation, a movement aimed both at reforming their own church and at hardening its doctrines against the Protestants. By Rembrandt's time, Christianity in western Europe was divided between Catholics and Protestants.

Catholics stressed the authority of the Church, a hierarchical institution centralized under the leadership of a pope in Rome. *Salvation,* the goal of eternal life and redemption from sin, was a journey of faith aided by the observance of a series of rites called *sacraments.* Protestants, on the other hand, stressed the authority of the Bible. To them, salvation was accomplished not by the intercession of a priest but by a personal confession of faith as revealed in the Gospel. The differences between the works of Michelangelo and those of Rembrandt represent this contrast. Michelangelo's bigger-than-life projects, located as they are in the Sistine Chapel in the Vatican, the headquarters of Catholicism, not only express the glory of Almighty God but also exemplify the power and splendor of the Catholic Church, especially as it flourished during the Renaissance. Rembrandt's works, through their emphasis on Biblical subjects and, particularly, their earthy treatment of those subjects, reflect the Protestant doctrine of "the priesthood of all believers."

Michelangelo (1475–1564)

Michelangelo Buonarroti's youth was spent in Florence, Italy, at a time when that city was at the peak of its glory as an artistic and

intellectual center of Renaissance Europe. It was there that the famous circle of gifted writers and artists gathered around Lorenzo "The Magnificent," the greatest patron of all the Medicis and the ruler of Florence at the time.

In the Medici Gardens Michelangelo trained as a sculptor amidst Lorenzo's famous collection of classical statues. The 15-year-old apprentice also had the opportunity to listen to and interact with some of the humanist scholars and poets of Lorenzo's circle. It was because of their influence that he himself became a lover of classical scholarship and an enthusiastic follower of *Neoplatonism*—a synthesis of Greek and Christian beliefs which was a major intellectual movement in Renaissance Italy.

Michelangelo's development was also influenced by the sermons of Savonarola, the fiery Dominican monk who denounced the culture of humanist scholars and predicted that the sins of the Florentines would be avenged in a holocaust. His denunciations spared no one, not even Lorenzo or the Roman pope. Thus, a contrasting side of the young Michelangelo was cultivated: a medieval sense of sin and the fear of divine retribution.

In 1505, shortly after completing the sculpture of the Old-Testament hero, *David* (Figure 8-7), Michelangelo was summoned to Rome by the ambitious and powerful Pope Julius II to sculpt a grandiose tomb. Soon after the artist started work on the project, the pope lost interest in it and instead began to pressure him to paint a fresco on the immense ceiling of the Sistine Chapel. After protesting that he was a sculptor and not a painter, Michelangelo reluctantly accepted the commission in 1508 and began what was to be his greatest enterprise.

The work required four years. Atop a scaffold some 65 feet above the floor, Michelangelo painted a fresco of more than 700 square yards (Figure 9-8). Just the painting itself was an awesome technical feat, but the concept and the scope of the ideas are equally awesome. Using the Old-Testament book of Genesis as his basic source and the human figure as his principal means of expression, he constructed a complex interpretation of the Judeo–Christian Creation liberally infused with classical motifs. Like the stupa at Borobudur, the Sistine Ceiling is a visual compendium of theology that progresses physically and symbolically from lower to higher.

The lowest zone consists of the eight *lunettes* (triangular shapes just above the chapel's arched windows) containing the kings and queens of the biblical Jews, the ordinary mortals who were the ancestors of Christ. The larger lunettes at the corners contain events from the Old Testament that are believed to have foreshadowed Christ's crucifixion. The next zone contains the most monumental

9-8 Michelangelo, ceiling of the
Sistine Chapel, 1508–12.

figures in the mural, each sitting within a shallow niche between the
lunettes. Twelve in all, they consist of, alternately, biblical prophets
and pagan sibyls (Greek prophetesses). These, in Michelangelo's
version of prophecy, are the clairvoyant mortals who predicted the
coming of Christ. Above them running along the crown of the ceil-
ing are the nine scenes of Genesis, beginning with the Creation and
ending with the drama of the Flood. Finally, there are *putti* (cupids)
appearing as relief carvings on the pedestals that flank the proph-
ets' and sibyl's niches; *genii* (guardian spirits) as the shadowy figures
behind each of the prophets and sibyls; and naked youths (slaves),

each restlessly perched on a pedestal at one of the four corners of a creation scene. Although Greek in their nudity, the roles they play in this work are similar to those of Christian angels.

In all of the Creation scenes, Michelangelo was bold enough to portray God Himself. In the *Creation of the Sun and Moon* (Figure 9-9), the second of the Genesis scenes, He appears twice: on the right where, accompanied by heavenly assistants, He seems to be directing the project, and on the left, flying off, perhaps, to separate the water and earth. Both figures are clothed in loose-fitting gowns that whirl around a muscular athletic body—similar to a

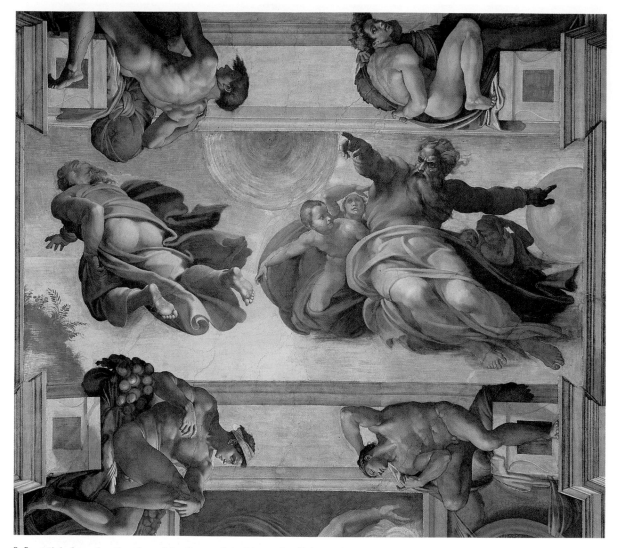

9-9 Michelangelo, *Creation of the Sun and the Moon*, detail from the Sistine Chapel ceiling, 1508–12. Fresco, approx. 9′2″ × 18′8″.

pagan god. But the face of the one on the right does not have the distant stare of a Greek statue, the classical calm that we expect of a Greek god. Instead it has the fierce look—full of holiness and wrath—of Yahweh, the Jewish God.

Jesus is nowhere to be seen in this mural, not because the artist had any compunctions about making his image, but because he wished to illustrate the promise of Redemption embedded in the Old Testament. Therefore, although Christ's image is absent, his first coming is represented symbolically in many ways.

Perhaps the most impressive aspect of the Sistine Chapel ceiling is the sense of order that Michelangelo managed to impose on it. Few works in the history of Western art can compare with it in scope. Over 300 figures populate the space and are drawn to several different scales. Worlds are being created and destroyed. Christian, Jewish, and Neoplatonic themes intermingle. Yet the artist has managed to contain it all by using every bit of the inconveniently parceled space to further his ends—dividing it up into an arrangement of rectangular and triangular spaces that harmonizes these many components. The mural's visual balance is paralleled in its thematic balance: the pagan love of beauty opposed by the Christian emphasis on the life of the spirit, and the fear of divine retribution opposed by the hope of Christ's redemption. This balance reflects the tense combination of medieval Christianity and Renaissance humanism in Michelangelo's background. Although his preferred medium was sculpture, he produced what many believe to be the greatest single painting in the Western world.

Twenty years later Michelangelo was prevailed upon by one of Julius' successors, Clement VII (one of the Medici popes), to decorate the altar wall of the same chapel. By now the artist was nearly 60 and, in addition to the trials of aging, he was depressed by the deterioration of the world around him. The foundations of the Catholic Church were being threatened by the Reformation; Rome, the seat of the Church, had been sacked seven years earlier by Spanish and German soldiers; and the Medicis had been forced to leave Florence, only to return as tyrants who eradicated its freedoms. Meanwhile, Michelangelo had involved himself in far too many projects. He was harassed from all sides by those who had commissioned him—including the executors for Pope Julius II, who were still trying to get him to finish the tomb. It would appear that Michelangelo's mounting frustrations were released in all their fury in his mural on the Altar Wall.

Rather than Christ the Redeemer, as promised in the Sistine Ceiling, Michelangelo gave us instead Christ the Avenger in *The Last Judgment* (Figure 9-10)—a chronicle of his Second Coming based on readings from Revelation, I Corinthians, and Dante's *Inferno*. Rather than a vision of human beings as a divine creation, there is a dark and pessimistic view of them as being virtually incapable of achieving grace. The saved are not easily distinguished from the damned, for neither group looks happy or possesses the physical beauty that characterizes the creatures on the ceiling. Once again the human body is naked—and even larger and more muscular than before—but this time its proportions are freakish, its movements are ungainly. Their lamentable appearance is part and parcel of their predicament. Starting in the upper center a titanic Jesus

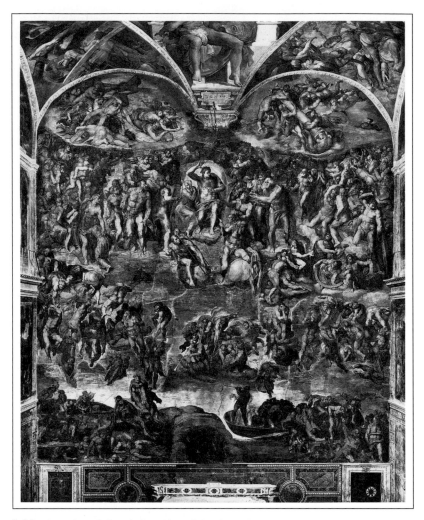

9-10 Interior of the Sistine Chapel. Vatican, Rome.

is seen denouncing the world. Below him angels blow trumpets to start the process of judgment. The dead are wrested from their graves in the lower left to be lifted before Christ. Pathetic souls gather around the angry Jesus, who decides who is to remain with him and who is to be dragged struggling into hell (lower right) where devils and figures from Greek mythology await.

Reflecting the content of *The Last Judgment,* the composition is a tumult of unevenly distributed clumps of flesh arching around the central figure of Christ. When we compare this with the ceiling— with its balance of figures and spaces and its rectangular, ordered composition we become aware not only of the vast difference be-

tween the two works but of the lengths to which Michelangelo had gone in breaking with the values of his earlier art. In the final analysis of content, Michelangelo's *The Last Judgment* was as much a prophecy of the agonies of religious conflict as it was of the Second Coming.

Rembrandt (1606–1669)

In the early seventeenth century a small union of predominately Protestant cities in the northern counties of the Netherlands broke away from Spanish control to establish the independent Dutch Republic. Dutch art at the time that Rembrandt came of age was almost completely outside the seventeenth-century mainstream. There were, basically, two artistic alternatives in Holland. One, called the Italian school (because the artists studied in Italy or were influenced by those who did), was partial to historical or mythological subjects filled with posturing, idealized bodies, and impressive settings. Its roots went back to the High Renaissance (and the works of Michelangelo) and its principal counterpart internationally was the Baroque art of the Catholic countries of Europe, a style magnificently exemplified by the paintings of Flemish painter Rubens (Figure 3-4). The other was the emerging, and increasingly influential, Dutch school, which favored the portrayal of everyday life in the form of household objects and ordinary people (subject matter that is commonly referred to as *genre*) exemplified by the work of Dutch artist de Hooch (Figure 3-6).

Unlike the seventeenth-century Catholic Church which reveled in religious art, the Dutch Reform Church opposed it. Their beliefs and views were founded on those of John Calvin, the Geneva reformer who believed that the arts had no place in the church; to depict the Divine according to Calvin was to humanize it and thus to degrade it. As a consequence of his legacy, the production of art with religious subjects almost ceased in the Dutch Republic. But with secular subjects, the situation was different. The demand on the part of the well-to-do bankers, merchants, and burghers for portraiture and genre themes was so great that painting flourished in the little republic during the seventeenth-century as never before. In such a religious and economic climate, Rembrandt was, in some ways, an outsider. Unlike most of his fellow artists, he persisted in making religious pictures; he produced over 800 religious works—although for a period of time he was highly reputed for his portraits and mythological subjects. Unlike Baroque painters, Rembrandt filled his religious pictures with ordinary people treated with the simplicity and realism characteristic of genre art.

9-11 Rembrandt van Rijn, *The Presentation of Jesus in the Temple*, 1631. Panel, 23¾″ × 18¾″. The Hague, Mauritshuis.

Some believe Rembrandt's interest in the Bible was inspired by his mother. If so, it was strengthened and given some artistic direction by his teacher, Pieter Lastman, who also liked to do biblical subjects. Whatever the reasons, Rembrandt created a great many paintings, prints, and drawings that could be thought of as biblical illustrations. Unlike either the projects of Michelangelo or the stupa at Borobudur, Rembrandt's art does not deal with discourses on theological themes (such as the Creation, the Last Judgment, or Nirvana), nor does it feature super-human beings in an abstract

world. Instead it is populated with ordinary people in a recognizable world. In keeping with the principles of Protestantism, Rembrandt believed in the sanctity of the Bible, and that each person, guided by the Holy Spirit, must interpret it according to his or her own conscience. However, he apparently did not accept Calvin's dour concept of predestined hell for the majority of people. Instead the emphasis in Rembrandt's art is on a personal relationship between God and the lives of human beings through the agency of a loving Jesus Christ.

Presentation in the Temple (Figure 9-11), made when the artist was around 25, is typical of his earlier work. The story is about Simeon who, having God's promise that he would see the Messiah before his death, was led to the temple where Mary and Joseph had delivered Jesus for presentation. Taking the infant in his arms, the old man intones some of the most beautiful lines in the New Testament: "Lord, now lettest thou thy servant depart in peace, according to thy word: For mine eyes have seen thy salvation" (Luke 2:29–30). Simeon, Mary, and the child are isolated by a beam of light that pierces the vast, grottolike temple. The majesty of the robed figure on the left (who may be either Anna, the prophetess, or a high priest) is balanced by the humility and naturalness of the rest of the people in the central group. Of these, the most expressive is the bearded Simeon who, out of profound gratitude for God's grace, pours forth his thanks. Because of certain operatic effects—the strong light–dark contrasts, the grand setting—Rembrandt's treatment in this early work is reminiscent of mainstream Baroque art. But unlike a Rubens, in which the drama depends on the use of heroic figures with theatrical gestures, a Rembrandt invokes drama by means of believable figures performing in a scenario created out of the artist's fertile imagination.

Rembrandt worked on *Christ Healing the Sick* (Figure 9-12) off and on from 1639 to 1649—the decade that spanned the middle of his career. This etching demonstrates his ability to reveal human character and motives even more than the painting of the *Presentation*. Known also as *The Hundred-Guilder Print* (because of the price it allegedly fetched at an auction) the etching melds together a number of stories from Matthew. To Jesus's left is the crowd of sick that he healed after crossing the river Jordan (Matthew 19:1, 2; Figure 9-13). To his immediate right is Peter seen restraining a mother from bringing her child to Jesus for his blessing. But Jesus says "Suffer little children, and forbid them not, to come unto me" (Matthew 19:14) as he counteracts Peter's gesture. Behind Peter is the rich young man, slumped to the ground and troubled over his unwillingness to "go and sell what thou hast, and give to the poor"

9-12 Rembrandt van Rijn, *Christ Healing the Sick*, c. 1649. Etching and drypoint and burin 11″ × 15½″. The Art Institute of Chicago (gift of J. Lionberger Davis, 1965. 848) Photograph © 1990. All Rights Reserved.

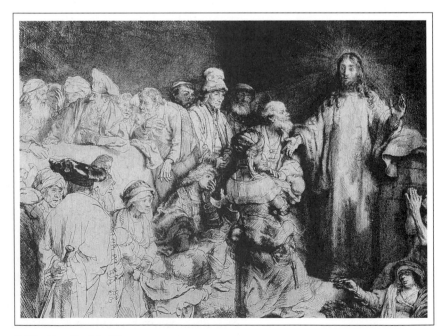

9-13 Detail of 9–12

(Matthew 19:21). Above the young man and to the far left, one can see the Pharisees—who challenged Jesus with theological questions even as he ministered to the sick—visiting among themselves (Matthew 19:3–9). Finally, on the far right is a camel coming through a door—perhaps a reference to "It is easier for a camel to go through the eye of a needle, than for a rich man to enter the Kingdom of God" (Matthew 19:24). Despite the variety of people and the variety of their actions—pleading, mocking, or simply observing—each figure is completely believable, fitting comfortably within the physical and psychological space of the scene. Perhaps the best indications of Rembrandt's skill in creating plausible people and movement are seen in the details: note the hands, the eyes, the expressions on the faces of those in the shadows or on the edge of the crowd.

The vividness of the people, important as this is, is only one of Rembrandt's tools for telling a story. The other, as we saw in the painting, is his use of chiaroscuro—in this case, all the more remarkable because of the difficulty to produce tones in an etching. (Notice the complicated web of hatched and cross-hatched lines radiating from the head of Jesus.) Softer and less focused than they are in the painting, the lights and shadows in the etching are not deployed for theatrical effect. Instead Rembrandt has manipulated them in such a way that they suggest the numinous quality of a Divine experience. As in other Rembrandt works the light seems to emanate from the people, rather than reflect off of them. This is especially true of the central figure of Christ who, like the statue of a seated Buddha, is intended to show that the Divine is a source of light.

RELIGIOUS ART IN A SECULAR WORLD

Pictures of God, Jesus, and Old Testament heroes are rare in today's art. Such subject matter, however, is not completely absent and, even when it is absent in a particular work, the work in question could still be considered religious.

The Hudson-River landscapes reviewed in Chapter 7 are good examples of traditional-style works that express religious values even though their subjects are not religious. Piety in the nineteenth century had found an aesthetic outlet in nature as poets and painters captured the religious imagination of a then predominately Protestant America. In a sense, landscape art had displaced the use of biblical figures—such as we saw in the Sistine Ceiling—to embody a Christian world view.

When Realism, and later, Impressionism, deposed Romanticism (Chapter 7), the validity of the landscape as a vehicle for expressing piety lost credibility—along with sentimentality and the celebration of feeling in general. While originally Protestantism had deprived Christianity of traditional subject matter, Realism had deprived it of the possibility of spiritual transport through romantic sentiment.

The Modern movement, the most significant recent revolution in arts and culture, soon deposed Realism and Impressionism, and the crisis between art and religion deepened. On the artistic front, religion was threatened by artists' obsession with radical change; on other cultural fronts, religion was threatened by secularism in general. In 1880 German philosopher Friedrick Nietsche proclaimed that God was dead, and by the early twentieth century, that prognosis seemed to be true in art. But not everyone accepts this dour analysis with regard to religious art. Some authorities maintain that it has not only survived, but that it has played a more important role than ever in a secular world. Their definitions of "religion" and "art," however, differ somewhat from what we have seen up to now.

Piet Mondrian and Wassily Kandinsky, two of the most important leaders in abstract painting in the early twentieth century, saw their art as a means of spiritual revival. A member of the Dutch Theosophical Society, as well as a leading figure in geometric abstraction (Figure 9–14), Mondrian expressed his beliefs in journal articles and pamphlets. Kandinsky, a leader of the German Expressionists (Chapter 13), wrote an influential book—*On the Spiritual in Art*—in which he proclaimed the new art to be in the forefront of a "spiritual revolution." While the paintings of Mondrian and Kandinsky differ in important respects, both are abstract. Likewise, while their religious views are different in some ways, both are basically mystical and outside the mainstream of Judeo-Christian belief.

Meanwhile, among the ranks of both Christian and Jewish theologians are those who believe that art, now more than ever, is needed to fill a spiritual vacuum. In this regard, they support the aims of modern artists, but frame their arguments in different terms than those of Mondrian or Kandinsky. Paul Tillich, who is probably best known for his thoughts on the topic, believes that all art "points to a self-interpretation of man, thus answering the question of the ultimate meaning of life." Tillich explains that good art—that is, art that confronts the human situation honestly and courageously—is religious regardless of its subject. As a case in point: Wesselmann's *Great American Nude, No. 99* (Figure 8-22), although sardonic and irreverent, nevertheless discloses the

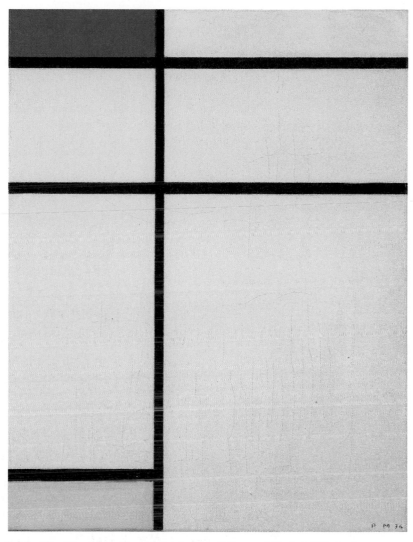

9-14 Piet Mondrian, *Composition in Blue, Yellow and Black*, 1936. Approx
17″ × 13″. Kunst Museum, Basel, Switzerland. (Emmanuel Hoffman Foundation)

dehumanization of women in a consumer society. To Tillich,
Wesselmann's painting would be religious, whereas a slick portrait
of Jesus may not be. Langdon Gilkey agrees with Tillich, but goes
further in claiming that the experience of art as an end in itself has
redemptive value: " . . . art thus stops the heedless flow of time in
an enhanced moment . . . a moment of intense seeing and of par-
ticipation in what is seen, then . . . the transcendent appears
through art, and art and religion approach one another."

So far we have discussed examples in which a case was made for transcendence existing in traditional-style art without a religious subject; abstract painting intended to generate mystical experience; modern-style painting with a non-religious subject but with a content that is authentically expressive of the human condition; and any art that enhances and enriches experience. (Also mentioned was a case for transcendence *not* existing in a traditional work with a religious subject.) The only category not discussed is that of modern works in which traditional religious content is intended.

Early Modern Examples

Although religious subjects were not popular with the majority of early modern artists, there were exceptions. Chagall, for example, created a number of overtly religious subjects. *Moses* (Figure 9-15) (a tapestry made for Israel's parliament) shows an angel from the thundering mountain giving the Commandments to Moses, who

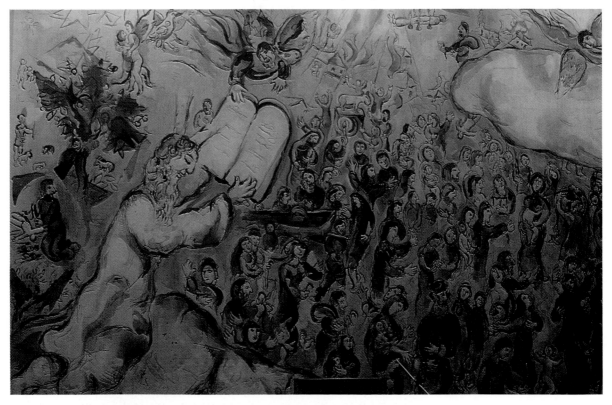

9-15 Marc Chagall, *'Exodus' tapestry*, 1964. Tapestry, 15'7" × 29'8". The Knesset. Jerusalem. Executed at the Gobelins Works, Paris by Mme. Bourbonneaux and assistants.

exhorts the Israelites to "Fear not" (Exodus 20:20). Like the artists in Dura Europos, Chagall was a Diaspora Jew. He was in exile even from his native Russia and family of Hasidic Jews. As with many of Chagall's works, it can be said that this one reflects a nostalgia for a lost homeland. Other exceptions among early modern artists were Emil Nolde and Georges Roualt. Nolde who, like Kandinsky, was an active member of the German Expressionists, painted such subjects as *The Last Supper* and *Doubting Thomas*. His loosely-structured, painterly style—not unlike that of Kokoschka (Figure 8-28), but more grotesque—posed religious content in terms of subjective, sometimes violent, emotional states. Roualt, perhaps best known for his consistent use of religious subjects, made paintings with such titles as *Head of Christ*, *Clown*, *Christ Mocked by Soldiers*, and *King Herod*. Like Nolde's, these are often grotesque, but more structured, typically with the figures outlined in ropy black lines, reminiscent of the leading in Gothic windows (Figure 6-15).

Newman and Twitchell

In the 1950s and early 1960s, Barnett Newman did a series of paintings on the *Stations of the Cross* (Figure 9-16)—supposedly commemorating the stages of Jesus' sufferings. But more than just Christianity may be at work here. Newman was a member of a generation of American post-war abstract painters who made a cult of artistic creativity. The source of this creativity, they asserted, was in the depths of one's personal being. Thus the making of art—*true* art—was both a confessional and a creative act. Artists, like priests or shamans, were closely attuned to this religious–creative source. Newman explains:

> What is the *raison d'etre*, what is the explanation of the seemingly insane drive of man to be painter and poet if it is not an act of defiance against man's fall and an assertion that he return to the Adam of the Garden of Eden? For the artists are the first men.

Newman's enormous canvases are divided vertically by one or more bands set in an expansive sea of bright color. Optically, the color tends to dominate the viewer's visual space; symbolically, it could refer to the vast expanse and loneliness of the universe. The narrow lines of color that activate the surrounding field are in turn dependent on that field for their existence. Some writers have suggested that Newman's art symbolizes the situation of man in the world. Others avoid symbolic interpretation and proclaim that the religious meaning in Newman's work, like that in Islamic art, is to be derived from directly experiencing its visual properties.

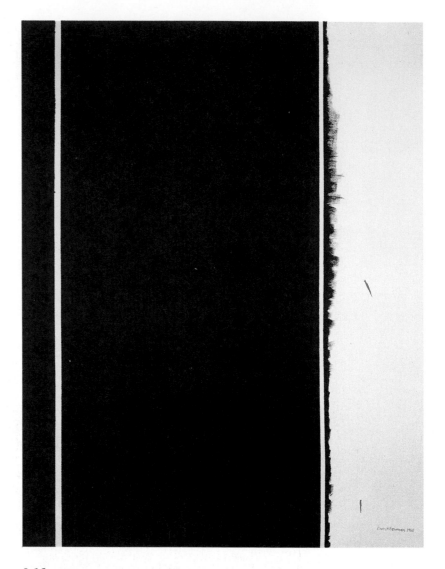

9-16 Barnett Newman, *Twelfth Station*, 1965. Acrylic on raw canvas, 78″ × 60″.
From the series *The Stations of the Cross: Lema Sabachtham*. National Gallery
of Art, Washington, Robert and Jane Meyerhoff Collection.

In the work of both Chagall and Newman, religious content is
couched in a modernist artistic language. Such is not the case with
the contemporary artist, Kent Twitchell. Twitchell's projects consist
of enormous outdoor murals painted on the sides of buildings and
freeways throughout Los Angeles. They are unusual because of
their locations, scale (from two to five stories high), photo-realistic
style, and subjects: movie stars, artist friends, depictions of Jesus,

and other religious references. What is perhaps most unusual is that Twitchell, an art-world maverick, is receiving recognition from the art press as well as the popular press.

One would expect the art world, that guardian of high culture and seriousness, to be embarrassed by the sensationalism of Twitchell's projects. Most of all, mindful of popular bookstore depictions of religious figures, one would expect the guardians of taste to be turned off by Twitchell's blatantly realistic paintings of Jesus. No doubt, there are critics who do object to Twitchell's work. However, the art world is much more open-minded than it was in the 1960s and 1970s, to say nothing of Newman's time. Realism, as we have already seen, has returned to favor; the art world is much more pluralistic; culture seems to be entering a "post-modern" phase (a subject that will be treated in some detail in Chapter 14).

The most subtle—and also most mysterious—of Twitchell's images are those, like *7th Street Altarpiece* (Figure 9-17), in which the

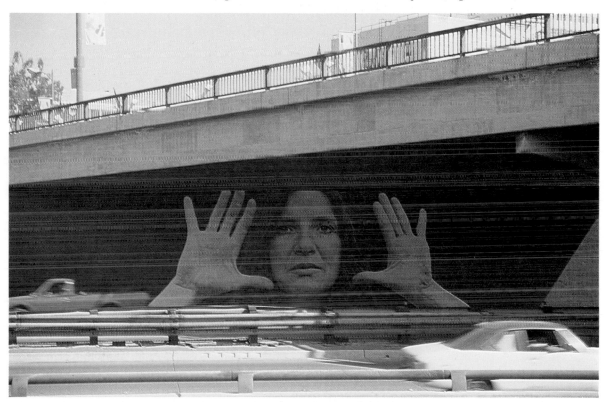

9-17 Kent Twitchell, *7th Street Altarpiece,* 1983–84. Underpass of the Harbor Freeway, Downtown Los Angeles.

Gazing across 15 lanes of freeway this woman was painted in Downtown Los Angeles as part of the 1984 Olympic Arts Festival.

sacred and secular are held in tension. Filling the space of a Los Angeles underpass is the enormous face of a woman (artist-friend Lisa Albuquerque) with fixed gaze and framed by her outstretched palms. As in a medieval altarpiece (Figure 4-5), the sense of religious presence is intensified by the frontality and symmetry of the image as well as by the woman's gesture. Beyond these means, however, Twitchell has invested the image with a certain degree of intimacy that makes it even more compelling. While the woman is perhaps Mary (either the mother of Jesus or Magdalene), she is also, clearly, a woman that we could see in a store, office, classroom, or bar. This melding of past and present, and sacred and profane, brings to the forefront of our consciousness the sense of *immanence*— the doctrine of God's presence everywhere and at all times. As Twitchell explains: "If Jesus were walking on earth today, that little troubled barrio around the liquor store is where he'd spend some time." And that is also where we would find not only Mary, but one of Twitchell's murals.

SUMMARY

Among the similarities between Judaism, Islam, and Christianity are the stories of the Old Testament, the doctrines of monotheism, idolatry, prophecy, repentance, judgment, heaven, and hell, and the observances of prayer, sabbath, feast days, and many more. All three have claims on the city of Jerusalem: in addition to being the ancient capitol of Judaism and the place where Jesus was crucified, it is the third holy city of Islam (behind Mecca and Medina). There are also similarities between Buddhism, Islam, and Christianity. Sakyamuni, Mohammed, and Jesus performed their ministries in this world. Their lives and teachings were written not by the men themselves but by their followers. Both Buddhism and Christianity grew out of older religions (Hinduism and Judaism). Both have struggled with the paradox of their founders being simultaneously God and man. Both share stories of their founder's virgin birth and of their being tempted by the devil (Mara and Satan).

Just as there are parallels between the religions, there are parallels between their art. The role of imagery involves depicting stories of their scriptures. In this regard, a Borobudur relief resembles a Dura Europos mural, an etching or painting by Rembrandt, and a painting by Chagall. As an ambitious project that summarizes the major themes of the faith, the Borobudur shrine has much in common with the Sistine Chapel. Twitchell's realism, use of local

models, and combining of secular and sacred was anticipated by Rembrandt's paintings and etchings. Finally, the Persian carpet and the abstract painting by Newman, although different in many respects, share their absolute abstinence of imagery.

The art of all the faiths is a record of humanity's attempt, in one way or another, to express or to evoke the experience of a transcendent reality.

CHAPTER
10

IMAGES OF AMERICA

A RT IS A REFLECTION of the society that produces it; it is affected by a particular geography, climate, historical background and set of attitudes. This chapter concerns a relatively young art—American art—that expresses an acute awareness of place and people. Perhaps because most Americans at one time or another in their family histories came from someplace else, they seem to be uniquely conscious about where they are and who they are in America.

Like the American people, American art was, and still is to some extent, an immigrant. Its ambivalent and subordinate relationship to European art was a dominant theme in its development up until the mid-twentieth century. Since then American art has been on at least equal terms with its European neighbor. Recently, it has been affected by African, Native American, and Latin American influences. Thus, a search for a specific American artistic identity, whether in form or content, is probably a futile quest in such a pluralistic culture. The following examples reflect this many-sided interpretation of the American experience.

THE EARLY REPUBLIC

Throughout the greater part of the nineteenth century, the growth of American civilization paralleled the settlement of its land and westward expansion. As we saw in Chapter 7, American poets and painters played a significant role in articulating American dreams by creating both a cult of nature and a myth of manifest destiny. However, woven into this obsession with the land were other issues. After the election of Andrew Jackson in 1828, the economy began to move from the Jeffersonian ideal of small farms and villages to one of urban centers and factories; old class distinctions became

blurred because of economic growth and a new egalitarianism inspired by Jackson himself; and the territories and states west of the Appalachians increasingly became a force in American politics and social outlook. In addition to these issues were the nagging but often repressed concerns of human rights and race, particularly with regard to slavery in the South and to the treatment of Indians in the West.

Against this background, Americans attempted to stake out a distinct cultural identity. Although certain that their country was unique among nations, offering unparalleled freedom of opportunity, Americans were uncertain about the parameters of their new culture: to what extent should the arts look to Europe for the touchstones of cultural taste? To what extent should they be guided by popular taste in a free democracy?

As we saw in Chapter 7, the landscape art introduced by Thomas Cole, the first painting tradition of epic proportions in the United States, was rooted in European art. Cole and each of his Hudson River colleagues had both studied and traveled in Europe. But not all good landscape painting was by Hudson River artists.

Duncanson

The paintings of Robert S. Duncanson were similar to those of the Hudson River School in both form and content. But unlike the members of that school, Duncanson was not from the east coast, was largely self-taught, and had not traveled to Europe before starting his career. In addition, he was black. Born in New York state of a free black mother and a Scottish-Canadian father, Duncanson spent most of his adult life in Cincinnati, Ohio. By mid-century Cincinatti's booming prosperity made it the rival of eastern cities and a major regional art center. But it also shared antebellum tendencies with the pre-Civil War South, and thus was involved in the issues of slavery and the rights of free black citizens. Duncanson's patrons were abolitionists; his art, however, does not reflect a personal involvement in the slavery issue.

Typical of his work is *Blue Hole, Flood Waters, Little Miami River* (Figure 10-1), a romanticized description of a wilderness oasis not far from Cincinnati. Duncanson's devotion to nature and artistic abilities are demonstrated in the keenly observed details of rocks, foliage, and clouds. The profusion of detail, however, does not overwhelm the picture's unity or obscure its mood. The basic compositional scheme is that of four triangular shapes—the sky, the lagoon, and the right and left tree masses—all pointing toward the center, located at the far side of the lagoon. On the near side are a

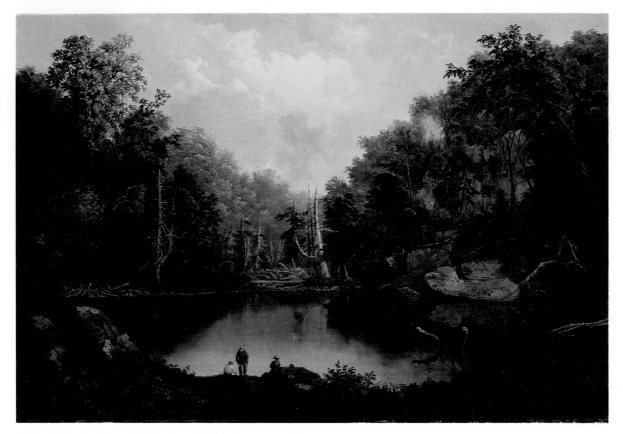

10-1 Robert S. Duncanson, *Blue Hole, Flood Waters, Little Miami River*, 1851.
Oil on canvas, 29¼″ × 42¼″. The Cincinnati Art Museum (gift of Norbert Heermann).

few shaded figures that establish the scale of the scene and contrast with the brightly illuminated water—the major focus of the painting. Unlike Hudson River artists who seemed bent on drama and describing nature in the most exaggerated, heroic terms, Duncanson strove to present a quiet paradise in which humanity and nature coexist in peace.

Bingham

The quiet mood of Duncanson's work is shared by that of George Caleb Bingham, but with an added dash of whimsy. Bingham, who grew up in the frontier state of Missouri, decided to take up art after meeting a frontier portrait painter. He studied briefly in the East, where he learned how to make monumental figures. But rather than remain there to learn more about painting in the grand manner, he returned to Missouri and adapted his skill with the

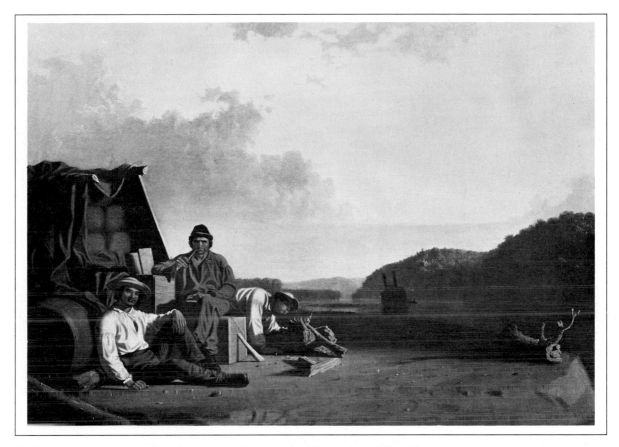

10-2 George Caleb Bingham, *Watching the Cargo,* 1849. Oil on canvas, 26″ × 36″.
State Historical Society of Missouri, Columbia.

figure to represent the scruffy trappers and raftsmen who became his favorite subjects. Bingham's interpretation of the Mississippi River, the setting for many of those subjects, and the dividing line between the East and West, played a part in creating the legend of America.

Watching the Cargo (Figure 10-2) shows three rivermen relaxing on a mudbank of the Mississippi while their barge is stranded on a sandbar in the shadows behind them; a sunlit piece of driftwood, to the right of the men, returns our attention to the foreground and provides some visual balance. The lazy late-afternoon atmosphere, accented by long shadows, expresses a peacefulness more like Duncanson's painting than Cole's (Figure 7-12). But because of the emphasis on the earthy people, together with their work-a-day belongings and a faint suggestion of humor, this painting is not nearly as lofty in sentiment as either Duncanson's or Cole's.

Watching the Cargo is a good example of American genre art. In Bingham's era, genre artists were well known for recording America's village and country life in terms of the anecdote—some event considered amusing or sentimental—and Bingham showed a definite preference for the anecdotal. However, some of his paintings, like *Watching the Cargo,* transcend mere recording and remind Americans of the timeless qualities of their land.

Landscape and genre art flourished in the decades preceding the Civil War, a time of optimism when the adventures of industrialization and westward expansion were just getting underway. The spirit of the times is reflected in the works of Cole, Duncanson, and Bingham, in which portraits of the land not only proclaim the virtues of nature but also serve as metaphors of freedom and opportunity.

AFTER THE CIVIL WAR

In the period after the Civil War, the industrial and territorial expansion set in motion earlier became more pronounced than ever. And in the process, immense fortunes were made as tycoons fought for control of the railroads and the new industries like petroleum and meat-packing. Although the late nineteenth century in America was an age of rampant materialism, the new wealth also demanded culture—or at least the display of it. Culture to the new-rich Americans meant Europe. It was axiomatic that quality would be sought overseas rather than at home, and American millionaires competed with one another to acquire European art and associate themselves with the art of the Old World. Needless to say, it was a depressing period for America's artists—many of whom gave up on their own country and settled in Europe.

Sargent

One American artist, John Singer Sargent, enjoyed the best of both the Old and the New Worlds. Like so many nineteenth-century American artists, he had studied in Europe. He had acquired a broad, fluid painting style in a Parisian studio at the age of 18, and a few years later traveled to Spain to learn about shadows and luminosity from the works of Velázquez. Equally at home in Europe and America, his reputation was international and "European" enough to make him popular in his own land. A good eye, a deft brush, and a taste for elegance were the ideal requirements for a portrait painter of the time. Sargent was in demand by fashionable people during the period Mark Twain called the Gilded Age.

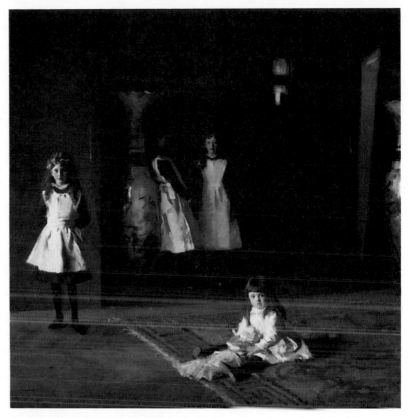

10-3 John Singer Sargent, *The Daughters of Edward D. Boit*, 1882. Oil on canvas, 87″ × 87″. Courtesy of Museum of Fine Arts, Boston (gift of Mary Louisa Boit, Florence D. Boit, Jane Hubbard Boit, and Julia Overing Boit, in memory of their father, Edward Darling Boit.

One of Sargent's best paintings, *The Daughters of Edward D. Boit* (Figure 10-3), is of four girls who appear to have momentarily dropped whatever they were doing to pose for the viewer. The signs of nineteenth-century gentility are seen everywhere: in their scrubbed faces, their crisp clothes, the spacious interior, and the furnishings of the room—especially the pair of large oriental vases. Sargent made the scene seem quite casual, not only by his facile painting style and unerring sense of draftsmanship, but also by boldly placing one girl off to the left. Yet if we look closely, we see that he offset her weight in the composition by the pull of several things on the right, including the edge of the vase and the light coming from the deep space on the room behind the girls. The shadowy atmosphere that flows around every figure softens their forms and makes the light seem all the more luminous. It is a scene

of refinement and grace that skillfully uses some of the stylistic advances of European art without taking the risks; it is also a glamorous art that celebrates the life-style of the wealthy class.

Homer

Winslow Homer's art describes the life-style of the ordinary Americans of the time. Homer began his artistic career as a freelance illustrator for picture magazines, an experience that probably developed his ability to observe contemporary subjects and re-create their moods as well as their appearances. Although he had spent some months in Paris and may have seen the work of the young Impressionists—whose directness of approach and emotional detachment were compatible with his own tendencies—Homer was largely self-taught.

Compare the plain, well-lighted interior of *The Country School* (Figure 10-4) with the softly-shadowed interior of the Boit mansion. The walls display little more than the patina of wear, their plainness accentuated by the expanse of unvarnished floorboards in the foreground. About the only similarity between Homer's schoolchildren and the Boit children is the naturalness of their appearance and actions. Otherwise the people and setting of *The Country School* are as ordinary and humble as a school lunch.

10-4 Winslow Homer, *The Country School*, 1871. Oil on canvas, 21⅜" × 38⅜". The St. Louis Art Museum. Museum purchase.

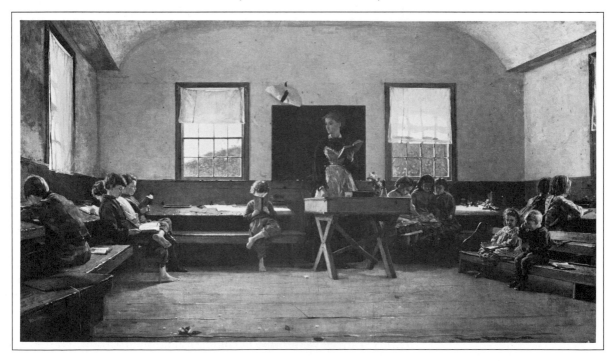

If we sense any nostalgia in Homer's work, it is not because of the artist's treatment of the subject—which lacks any trace of sentimentality—but because of our own conceptions (or misconceptions) about an America that existed a century ago. In its day, the apparent lack of charm in this and others of Homer's paintings troubled his critics. Henry James, who was familiar with European art, once commented that Homer "cares not a jot for such fantastic hair-splitting as the distinction between beauty and ugliness" and complained about "his barren plank fences . . . freckled, straight-haired Yankee urchins . . . flatbreasted maidens . . . " Yet to the general public, it was the simple factualism and the lack of high-flown subjects that made Homer's pictures appealing. Apparently the American people sensed that he portrayed them honestly from *their* point of view.

Tanner

Just as Homer painted the rural whites of his generation, Henry Ossawa Tanner portrayed rural blacks—a subject that was usually treated with condescension or ridicule. Tanner was one of the few artists, black or white, to deal frankly and sympathetically with the subject—as demonstrated in his poignant *The Banjo Lesson* (Figure 10-5). Ironically this painting was made in Paris (although it was based on drawings Tanner had made in North Carolina).

Born in Pittsburgh, Tanner's father was a minister (later a bishop) of the African Methodist Church and his mother a former slave. After serving several parishes, the elder Tanner moved his family to Philadelphia. Young Tanner was admitted to Philadelphia's Pennsylvania Academy of Fine Arts where he studied under the distinguished Thomas Eakins, but because of mistreatment from the students he left the school at the end of two years. After a decade of trying to make a living as an artist in Philadelphia, North Carolina, and Atlanta, he sailed to Paris. There he found acceptance both as an artist and as a black. And it was there that he crystallized his style and found his content.

The Banjo Lesson reveals the freer brushwork that Tanner acquired while studying at a private studio in Paris, but the modeling of the figures and the strong lighting are legacies of his experience with Eakins. The lighting not only contributes to the quiet mood but outlines the forms of the two figures, especially the way the old man tenderly supports the boy in his lap and teaches him to play the banjo. Like the late Rembrandt, who also portrayed personal devotion in the context of humble family relationships, Tanner was able to evoke a sense of grace by means of a few understated gestures. Tanner went on to become an acclaimed artist in France, and

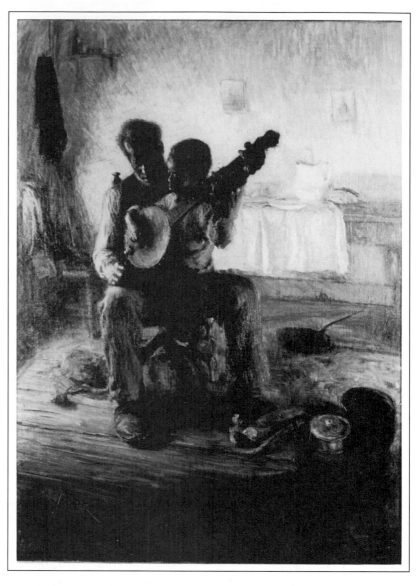

10-5 Henry Ossawa Tanner, *The Banjo Lesson,* 1893. Oil on canvas, 49″ × 35½″. Hampton University Museum.

one of the few Americans ever to exhibit and win prizes in the Paris Salon (France's major annual art exhibition).

Russell

Of all the Indians, the Plains Indians were, and still are, the most legendary. It was they who hunted buffalo, fought the white settlers, defeated General Custer, and stimulated the imaginations of generations of people. Despite the stereotypes, most Indians were

not hunters but peasant-villagers; furthermore, the Plains culture did not even exist before the arrival of the Europeans who brought with them the horse and rifle. The myth built around the Plains Indians—part of the larger myth of the Old West—is due in large part to the work of late nineteenth- and early twentieth-century illustrators like Charles M. Russell.

Most of Russell's paintings were products of memory—the artist's memory of his own and other people's experiences in the Montana Territory where he had lived after migrating there as a youth. He was seventeen and on his first cattle drive when he witnessed the scene in *The Toll Collectors* (Figure 10-6). After crossing the Yellowstone River, Russell and his colleagues encountered members of the Crow Reservation who demanded a dollar a head for the privilege of sending cattle through their land. It must have made an impression on the young Russell; the artist retained this experience for over thirty years before painting it. But *The Toll Collectors* is more than an account of a single incident; it is also an image of epic

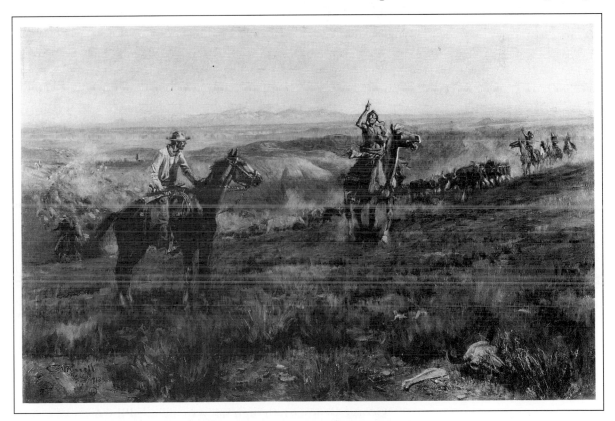

10-6 Charles M. Russell, *The Toll Collectors*, 1913. Oil on canvas, 24″ × 36″. Montana Historical Society, Helena Mackay Collection.

conflict between two cultures. In this conflict the Indians play an ambivalent role: as the hated obstacles to manifest destiny and as heroic "noble savages."

Russell spent an entire winter with the Blackfoot Indian tribe with whom he developed a respect that lasted the rest of his life. He paid tribute to them by depicting their exploits more than those of whites, a practice that no doubt contributed to the noble-savage image mentioned earlier. Although Russell was much closer to the scene than Hollywood, most of his portrayals of the Old West, like those of the movies, are reconstructions—the early shaping of the myth that, with the distancing effect of time, focuses less and less on the reality and more and more on the collective dream.

CITY IMAGES IN THE EARLY TWENTIETH CENTURY

The story of the great westward movement and the myth of the Old West tends to dominate people's thinking about America in the late 1800s, crowding out another story that is even more important— the growth of American cities and the steady migration of people from rural to urban areas. By 1890, five urban areas had populations of one million or more, and 30 percent of all Americans were city dwellers. The modern city, furthermore, was responsible for a new social phenomenon—the inner-city slum. In a preindustrial city, the elite lived in the center while the poor lived on the unprotected fringes; in a postindustrial city, the elite fled to the relative cleanliness of the edges, leaving the center to the poor.

The Ash Can School

In the first decades of the twentieth century a group of eight artists (called "the Eight") began to observe and depict the life of the inner city. Most of them had begun their careers as illustrators for city newspapers, a fact that probably accounts both for their interest in this subject and for their style, which sometimes tended toward caricature—similar to editorial cartoons. Impressed by the throbbing street life of the city, they portrayed slum tenements, "cliff dwellers," grubby storefronts, broken fences, clotheslines—scenes that were not only provocative but considered unfit for art. As a consequence of their subject matter, not their style, some members of the Eight (in particular, Robert Henri, George Luks, and John Sloan) came to be known as the *Ash Can School.*

George Bellows, although not a member of the original group, was closely associated with the Ash Can School. Also a former newspaper illustrator, Bellows' style was even more exaggerated than

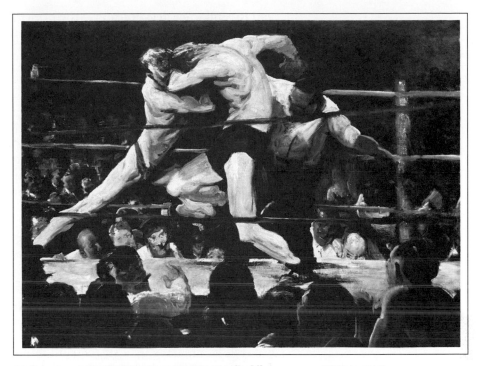

10-7　George Bellows, *Stag at Sharkey's,* 1907. Oil on canvas, 36¼" × 48¼".
The Cleveland Museum of Art, the Hinman B. Hurlbut Collection 1133.22.

that of his Ash Can colleagues. In *Stag at Sharkey's* (Figure 10-7), he
used long, fluid strokes to render the bodies and forceful move-
ments of the boxers. And, somewhat in the manner of Sargent, he
emphasized the central figures by highlighting them against a
shadowy background, in this case, the poorly lighted, smoke-filled
inside of a sports arena. The overstated postures of the fighters
approach caricature, and the ugly audience of cigar-chomping fans
surrounding the ring would probably make the spectators at a
Roman circus seem genial by comparison. Bellows made several
pictures of boxing; his attraction to this subject suggests that he felt
that machismo was an important aspect of the American experi-
ence, and, therefore, of its art.

Like Bellows, the Ash-Can artists exaggerated the human fig-
ure at times; however, their styles were essentially conservative—
especially when compared to the early modern styles that were flar-
ing up in Europe. In the final analysis, their originality lay in their
subject matter; prior to them, few artists on either side of the Atlan-
tic had dealt with the theme of the urban poor. Still, the people in
Bellows' paintings are not too different from the working-class
Americans celebrated by Bingham at mid century, and by Homer

and Russell a few decades later—the principal difference being that Bellows' people live in the city instead of the country.

Early Modernists

After World War I some American painters moved in the direction of abstraction. This was partly due to the influence of styles that had begun to develop in Europe, for an ever larger number of expatriate American painters and writers worked there, and the lines of communication between these artists and those living in this country, principally New York, were beginning to have an effect. Other forms of abstraction developed independently, in large part inspired, it appears, by a strong desire to find a fresh way to approach American subject matter.

While the Ash Can artists in New York were concentrating on the sociological aspects of the city, a group of artists in Milan, Italy were extolling its technological aspects—the towering buildings and swift transportation that were becoming part of urban living. Calling themselves *Futurists*, they preferred "a roaring motorcar, which looks as though running on shrapnel . . . " to a classical statue. They expressed their euphoria over the new city by a modern style of breaking up a subject and rebuilding it into a system of planes and surfaces that in itself evoked movement and excitement.

Stella

Joseph Stella brought the Italian style to New York. An Italian American, Stella met the Futurists while visiting Italy. The faceted forms in *Skyscrapers* (Figure 10-8) are reminiscent of those in Futurists paintings, but perhaps more recognizable. Despite the abstraction, we can still make out familiar features of the city—skyscraper towers, bridges, cables, and smokestacks. Although less specific, other features are suggestive of the city, such as the radiating lines that could be searchlight beams and the numerous hollows that might represent the city's many cavernous alleyways and subway tunnels. We can almost hear the noise of buses and cabs and the wails of sirens. To many people these things spell confusion and chaos; the very thought of the city inspires indigestion and frayed nerves. But to Stella it was all poetry—a kaleidoscopic harmony of exciting impressions. His extravagant statements reflected the vision of his paintings: "The steel had leaped to hyperbolic altitudes and expanded to vast latitudes . . . " His faith in the man-made world was equal to that of the Futurists', and comparable to a Hudson River painter's faith in the natural world; he intended his art to "affirm and exalt the joyful daring endeavor of the American civilization."

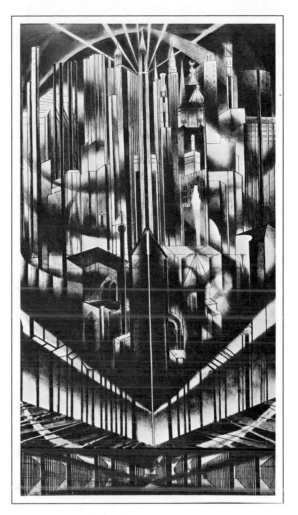

10-8 Joseph Stella, *The Voice of the City of New York Interpreted: the Skyscrapers,* 1920–22. Oil on canvas, 54″ × 99¾″. Collection of the Newark Museum, Purchase 1937, Felix Fuld Bequest.

O'Keeffe

Georgia O'Keeffe, considered one of the most important modern artists in America, did not transpose a style from Europe as did Stella and others. After learning to paint in a conservative manner at one school and to manipulate the principles of abstract design at another, she tried doing some teaching and painting on her own. But one day she took stock of her work, saw that it had been influenced by others, and destroyed all of it. She vowed thereafter to please just herself. Eventually her new work came to the attention of Alfred Stieglitz, a New York photographer and the only American dealer in modern art at the time (1916). Although O'Keeffe flourished under the patronage of Stieglitz (whom she later married), she remained her own artist to the end.

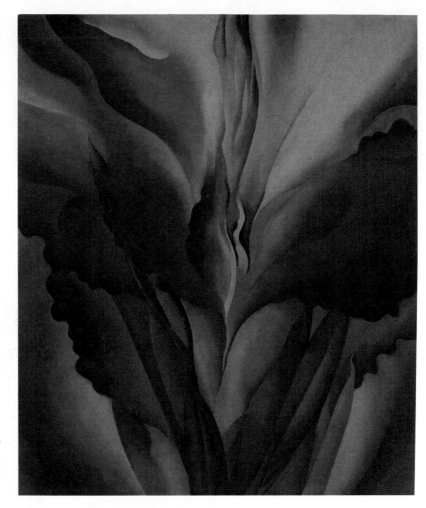

10-9 Georgia O'Keeffe, *Red Canna*, c. 1924. Oil on canvas mounted on masonite, 36″ × 29⅞″. University of Arizona Museum of Art (gift of Oliver Jones).

O'Keeffe's style typically involved reducing a motif to its formal essence in the context of a bold design, while at the same time retaining a link to the optical world. This approach made it possible for her to create powerful and evocative paintings out of subjects as banal as flowers. By taking a single blossom and enlarging it until the shapes filled an entire canvas, she turned the sensual curves and colors into an almost erotic display (Figure 10-9). She continues to be best known for her paintings of nature, including not only the flowers but also the desert around Taos, New Mexico (where she later made her home) whose austere, pristine landscape lends itself to her style. But earlier, O'Keeffe made some striking paintings of the city. *City Night* (Figure 10-10), a scene of skyscraper monoliths seen from street level, demonstrates the artist's ability to combine image and strong design. Her practice of simplifying a

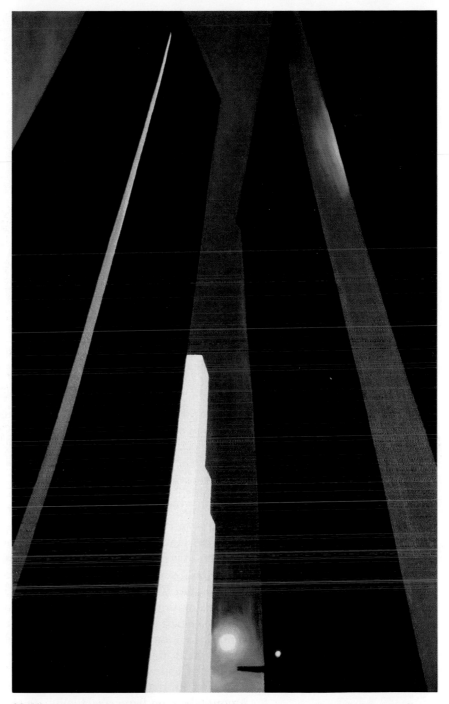

10-10 Georgia O'Keeffe, *City Night*, 1926. Oil on canvas, 48″ × 30″. Minneapolis Institute of Arts. Courtesy Georgia O'Keeffe Estate.

form and enlarging it to monopolize the space of the canvas not only brings out the abstract qualities of her subject, but in this case invokes its awesome scale. Impressively bold and direct, *City Night* is an even more potent symbol of urban optimism than Stella's *Skyscrapers*.

CRITICAL VIEWS

Not all the artists who worked in the period between the two world wars shared the Modernists' enthusiasm for abstraction or their optimism about the modern city. During the 1920s and 1930s many artists began to stress American subject matter in more traditional styles. Regionalists like Grant Wood (Figure 7-16) turned to an idealized version of rural America that praised the virtues of the simple life. Others focused instead on the problems of urban life, such as unemployment, the decay of neighborhoods, and the growing demoralization of the average citizen.

Hopper

Edward Hopper had more than a casual knowledge of the work of the Ash Can School, having studied with Robert Henri—a leading teacher of the time—who was to become one of the more important members of the group. Because he had spent some time in Europe at the beginning of the century, Hopper also had some knowledge of the newer trends. But he remained an original artist who rejected both the excesses of the Parisian avant-garde and the Ash Can artists' tendency to sentimentalize their subjects. Hopper's America, epitomized in *House by the Railroad* (Figure 10-11), is not vital and lusty like Bellows', but cold and relatively cheerless.

Hopper was a skillful pictorial composer, not because of his mastery of the principles of design, but because he possessed an uncanny ability to select the most telling details and arrange them in such a way as to evoke a great amount of content. In *House by the Railroad*, just enough detail is used not only to describe a Victorian-style house in a forlorn environment, but also to proclaim something about modern life. The cold light reflecting off the left surfaces of the house and its complementary shadows clarify the house's volumes but also help to emphasize its leaden starkness. Like everything in a Hopper painting, this house seems to have both physical and emotional weight. The railroad track and its roadbed brutally amputate the bottom of the house, while the empty sky completes the feeling of physical and spiritual emptiness. Hopper seems to suggest that the alienation of neighbor-

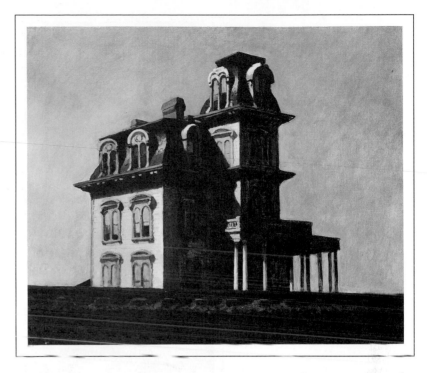

10-11 Edward Hopper, *House by the Railroad*, 1925. Oil on canvas, 24″ × 29″. Collection, The Museum of Modern Art, New York (given anonymously).

hoods (and the people in them) is brought about by railroads, empty lots, thoroughfares, or any number of things to which declining areas of the city are susceptible. In this forbidding context, human occupation is suggested only by the randomness of the window shades. As Hopper's biographer Lloyd Goodrich pointed out, "Seldom has an inanimate object expressed such penetrating melancholy as *House by the Railroad.*"

Lawrence

Tombstones (Figure 10-12) by Jacob Lawrence makes a much more explicit criticism of America. If we were to regard Hopper as a painter of the dream that failed, Lawrence would have to be the painter of the dream that never began. His social comments, made all the keener by his knife-edged, brightly-colored images, indict American society for its racism. *Tombstones* records a group of people in front of an apartment building that houses a tombstone shop on its ground floor. The people are of all ages, from an infant in a mother's arms to an old man climbing the steps. The collection of tombstones, like a small cemetery, not only suggests the end of a life cycle (implied in this range of ages) but also perhaps the eventual death of the neighborhood.

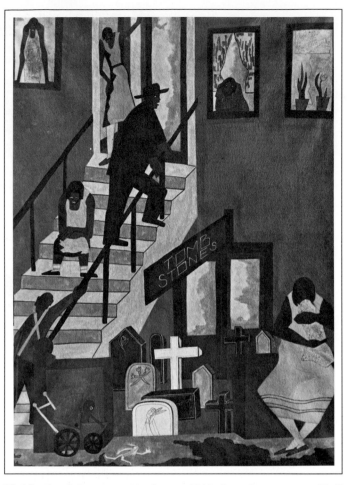

10-12 Jacob Lawrence, *Tombstones*, 1942. Gouache on paper, 28¾″ × 20½″.
Collection of the Whitney Museum of American Art, New York. Purchase, 43.14.

The simplified, schematic character of Lawrence's forms led art
historian David Driskell to identify his work as "neo-primitive." But
this does not mean that Lawrence, who studied art in New York and
worked in the Federal Arts Project, was not a sophisticated artist.
On the contrary, he intentionally borrowed the characteristics of
African-American folk art and of comic strips in order to endow his
own art with a greater directness. Other critics have related his
bold patterns and flat, bright colors to similar tendencies in African
art and modern European art. But Lawrence's images and compo-
sitions are individual, and his work has a definite message about the
life of a particular group of people. It is realistic art, not in the
optical sense of being true to appearances but in the sense of seiz-
ing, by means of exaggeration and caricature, the essence of what

life is like under dehumanizing circumstances. As Driskell said of Lawrence, "His work is tough, urbane, unsentimental."

POST WORLD-WAR II

By the early 1950s, *Regionalism* was discredited and *Modernism* was back in—only this time American artists did not play second-fiddle to Europe. Their own style, *Abstract Expressionism* (Chapter 7)—the first home-grown American style—impressed the European art world, and the influence began to flow in that direction. Still, despite its American roots, the new style did not necessarily celebrate American life. For one thing, Abstract Expressionists, along with the critical establishment that supported them, disparaged realistic styles; and it is obviously difficult for any art that eschews realism to refer to the familiar world. Further, these artists tended to hold American culture, particularly its popular aspects, in contempt. Thus if the Abstract Expressionists made references at all to the American experience, these references were as abstract as the style itself.

Andrew Wyeth

Despite the fact that realistic styles were out of fashion in the 1950s, some realistic painters, in particular Andrew Wyeth, were able to receive attention. The son of N. C. Wyeth, a celebrated illustrator, Wyeth has focused an entire career on the landscape and people of two small rural areas in the Northeast: Chadds Ford, Pennsylvania and Cushing, Maine. *Christina's World* (Figure 10-13) was the first painting to bring him fame; since then he has continued to be very popular with the American public.

As with many of his paintings, Wyeth used one of his neighbors—in this case Christina Olson, a disabled woman—to model for *Christina's World*. In the foreground Christina struggles awkwardly, separated from the farmhouses on the crest of the hill by a broad stretch of grassy slope. Like Hopper, Wyeth is able to evoke a depth of feeling from the sparest of compositions; each detail—the contour of the hill, the buildings and their locations, the narrow segment of sky, as well as the figure—assumes significance. The buildings symbolize either the past or an unattainable goal, the hillside is a metaphor of hope and yearning, and the woman in her pathetic struggle stands for all of us. Wyeth's work has obvious ties to the content of the Regionalists: to Hopper's work because of its pathos, and to Grant Wood's work because of its reverence for rural life.

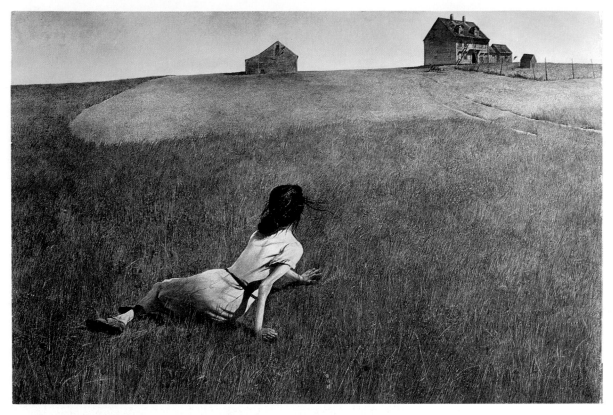

10-13 Andrew Wyeth, *Christina's World*, 1948. Tempera on gesso panel, 32¼″ × 47¾″. Collection, the Museum of Modern Art, New York. Purchase.

Art critics have tended to deprecate Wyeth because of his style—which was seen as regressive, if not a betrayal of Modernism—and his content—which was seen as mawkish. Even now that the issue of abstraction versus realism is past, Wyeth's credibility in the art world is still problematic. Even his supporters, those who acknowledge his evocative power, feel that his vision of America is too nostalgic—about an America that no longer exists and probably never did. Nevertheless, there is no question that a Wyeth painting often strikes a deep chord in the psyches of many Americans.

The California Dream

Generally, art made since the 1950s takes itself much less seriously than does the art of either Wyeth or the Abstract Expressionists. The next two examples by artists of a more recent generation differ from each other in form, content, and specific theme, but still have

a number of things in common. Both works employ recognizable imagery, while not entirely foresaking the legacies of abstractionism; both, in contrast to abstract painting, are closely connected to everyday life; both are playful and mildly ironic; and both are set in California; which—as everyone knows—is a state of mind as much as a state of the Union.

David Hockney was born in England and studied art there, but has lived in southern California for many years. Like many English-born members of the entertainment industry, Hockney matured his artistic and personal style in this country. He even maintains a "show-biz" persona, which he flaunts as much as his art, and is attracted to America and Americans.

Hockney's swimming pool, a central image in much of his art, has been represented by him in a variety of media: collage, lithography, photography, film, and finally, painting. The simple composition of *A Bigger Splash* (Figure 10-14), the result of reducing an

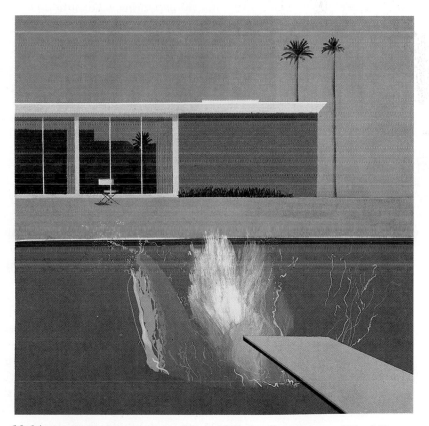

10-14 David Hockney, *A Bigger Splash*, 1967. Acrylic on canvas, 96″ × 96″.
© David Hockney, 1967.

image to its bare essentials, is clearly reminiscent of O'Keeffe's towers. But the precision finish of the edges, shapes, and colors goes beyond O'Keeffe's work. In this respect, the Hockney painting has much in common with advertising art. Except for the diving board, which thrusts diagonally into the scene from the lower right, all the lines, including even the slender trunks of the palms, are parallel to the edges of the canvas. All the shapes—except again, the diving board—can be read as flat planes. All the colors are flat, even that of the reflection on the patio doors, except for the splash itself.

Hockney's deadpan description of a swimming pool at high noon painted in Ektachrome colors is an obvious cliche of the "good life." As such, it is a bald celebration of California hedonism. However, through a combination of brilliant design, sumptuous color, and subtle understatement, Hockney elevates cliche to the plane of art, and thereby causes us to see the swimming pool image in a fresh way. Although ambiguous and marvelously understated, *A Bigger Splash* nevertheless manages to mock the same hedonism that it proclaims. Like much of his art, this piece is ambivalent, sophisticated, and playful all at the same time.

Compared to Hockney's spare imagery, Gilbert Sanchez Lujan's is a feast. *Cruising Turtle Island* (Figure 10-15), part of a series about the myths of the Southwest Indians, is a profusion of symbols and images. The ethnic mix of Lujan's art is a reflection of his own background. Of Mexican-Dutch and Hispanic ancestry, Lujan grew up in a multi-ethnic community near Los Angeles. The culture there, like southern California in general, was largely defined by the cult of the automobile; and Lujan developed a lasting obsession with customized cars (referred to by the artist as "culture vehicles.")

Such a vehicle can be seen in the foreground of *Cruising Turtle Island*. Hispanic youths use these cars for "cruising." An important part of the ritual is the decoration of the car. Painted on the side of Lujan's car are, among other things, the early-Mexican symbols of a jaguar and a rabbit, and an image of the indigenous Hispanic driver behind the wheel. The top is embellished with scroll motifs found in Meso-American temples (Figure 6-5). The car is cruising on a beltway around Turtle Island. In California Indian myth, the American continent was assumed to be a large turtle. This pre–Columbian theme is extended to the "dog city" on the island. There, one can see structures reminiscent of Meso-American pyramids and architectural representations of Kachinas (Pueblo spiritual entities). Mixed with these are signs of modern culture, such as a cluster of buildings on the left that could be the future of any number of commercial strips in the Southwest. Lujan explains that

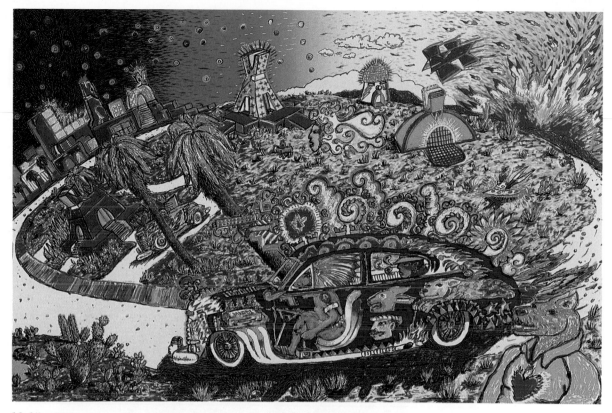

10-15 Gilbert Lujan, *Cruising Turtle Island*, 1986. ©Magu, 1986.

Cruising Turtle Island represents his dream of what California could be if Hispanic culture in the area were completely realized.

Scholder

In the nineteenth and early twentieth centuries a persistent issue in American art was whether to keep up with European advances or just concentrate on home-grown themes; in other words, should the emphasis be on the word *art* or the word *native*. While today this is a dead issue for most American artists it is not for artists like Fritz Scholder. Indeed, for Scholder, who is both a successful contemporary painter and part American Indian, the issue of art versus native is uppermost. Drawing his subjects from a variety of sources, Scholder is determined not to become known as an ethnic painter. But for a period of time he incorporated Indian themes into his work, particularly with reference to the Plains Indian, the one that

Russell painted earlier in the century (Figure 10-6). Believing that a contemporary treatment of this subject provides a truer statement of the Indian, Scholder gave the noble-savage image a sardonic twist. The figure in *Super Indian #2 (with ice-cream cone)* (Figure 10-16) is assertively large, boldly frontal, painted in a dark brooding brown, and surrounded by rich colors in a style reminiscent of Newman's (Figure 9-15). He stares at us from deep inside this image of himself. Like the people in the Hopper, the Wyeth, and even the Lawrence pictures, he is a tragic figure—but for different reasons. He is dressed in a ceremonial costume that identifies him

10-16 Fritz Scholder, *Super Indian #2 (with ice cream cone)*, 1971. Oil on canvas, 7′6″ × 5′. Collection Solomon Schechter Day School of Nassau County, New York.

with the folkways of an all but obliterated culture; yet he holds an ice cream cone, a folk object of the culture that overwhelmed his. Like the often-contradictory art and history of America, the painting mingles the past and present, pathos and humor, and radically different ways of life.

SUMMARY

One of the intriguing things about American art is that it has so often been torn between polar alternatives. Already mentioned was the constant disagreement over the issue of art versus native. Only after World War II did Americans catch up with and, shortly thereafter, surpass the masters of European art, thereby putting that issue to rest. But America's art has also been subject to other divisions, those that are typical of all art—the lyrical versus the dramatic; a love of nature set against a preference for the diversions of the city; the celebration of feeling versus a preference for objectivity; optimism versus pessimism; the beautiful versus the ugly; high culture versus low culture; and abstractionism versus realism.

PART THREE Historical Context

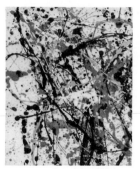

The first two parts of this book consider art's relationship to perception and to the expression of important themes. Part Three examines art as a phenomenon in itself, concentrating on the ways it exists in history. By looking at some of the major artworks of the past in their order of appearance, we can begin to discern a definite pattern—almost as if we were watching a time-lapse movie of a blossoming flower. This pattern is sometimes more revealing than the individual works themselves. Yet because art is a product of human behavior, the process of change and the directions it takes are neither predictable nor inevitable. ¶The first section in Chapter 11 looks at a theory that purports to explain the structure of change in art history. The rest of that chapter overviews developments in art from the Renaissance to the mid-nineteenth century in light of that theory. Chapters 12, 13, and 14 examine the art of the Modern period—that is, the long sequence of images and ideas that began around a hundred and fifty years ago. Modern art did not begin suddenly; it evolved almost imperceptibly before it gained momentum in the late-nineteenth century and then exploded in the twentieth. Underlying the movement were not only the attitudes and discoveries of many artists but also such things as the invention of photography and the great social upheavals that grew out of the rise of democratic forms of government. Conditions have changed greatly since the beginnings of the Modern period; so, of

course, has art. It is by studying these changes in their historical context that we are able to understand something of the how and why of not only the Modern period, but also of the Postmodern period—that is, the period we are in now, at the brink of the twenty-first century.

CHAPTER

11

THE SHAPE OF TIME

A PAINTING OR SCULPTURE exists in time as well as space—not the real time of music or poetry, but the abstract time of history. Each object of art can be thought of as an event that marks a specific point in time and offers some clue to understanding the character of that time. As you recall from Chapter 9, Michelangelo's *Last Judgment* (Figure 9-10) communicates something of the agony of the Reformation and Counter-Reformation struggles without making any direct reference to the politics of the period. Edward Hopper's *House by the Railroad* (Figure 10-11) expresses something of the melancholy and social isolation of twentieth-century life without containing a single human being.

Time also ages an object, art or otherwise. In this sense every object is a continual event, undergoing constant but not necessarily visible change. Finally, in a dynamic society like ours, the art object also undergoes a change in perception. What seemed to be stylish a few years ago now seems old-fashioned; what seemed outlandish now seems pleasing. New designs are created that surpass others and new ideas emerge to replace the old—a new context evolves that is sometimes alien to an old object or sometimes helps to make it more acceptable. Every new and different object forces us to see other things in a slightly different way; we might say it changes the appearance of those objects that came before.

PRIME OBJECTS

In 1934, a revolutionary car called the Chrysler Airflow (Figure 11-1) was exhibited for the first time. A critic wrote that it looked strange at first but that after a while " . . . you are quite likely to

11-1 The 1934 Chrysler Airflow.

come around to the viewpoint that these cars look right and that conventional cars look wrong."

The Chrysler Airflow

As it turned out, the Airflow sold badly; after three years of production, it was discontinued. The Airflow was not a bad car in the engineering sense; it had demonstrated remarkable capabilities in road tests. But apparently the buying public rejected it on the basis of its looks.

Before we discount the critic's prediction, we should look at the history of automotive design during and just following the appearance of the Airflow. A Chrysler project, the Plymouth (Figure 11-2) was typical of the year 1934. The rear seat was directly over the rear wheels and the engine was situated behind the front axle. Although showing some evidence of modern "sculptured" styling, its basic contours were still square—and the fenders, body panels, headlamps, and spare tires were separately attached. On the other hand in the Airflow the rear seat had been moved forward and the engine was placed over the front axle. An aerodynamic frame gave the car a unique shape, while the continuous body sheath gave it the appearance of a single organic unit. When we look at the automotive industry after 1934, we find that the Airflow's radical styling

11-2 The 1934 Plymouth.

11-3 *(above)* The 1936 Plymouth.
11-4 *(left)* The 1939 Plymouth.

was gradually incorporated into the design of other cars throughout the rest of the decade. Again, the Plymouth is typical. In the 1936 version (Figure 11-3), the rear seat and engine were moved forward; the slanted windshield and the aerodynamic body line resemble the 1934 Airflow more than they do the 1934 Plymouth. In the 1939 model (Figure 11-4), the headlamps and grill were finally blended into the body shape. Plymouth, along with other American cars, did maintain the long, straight hood and vertical front end— an accent that probably symbolized power to the American buyer. Despite this and a few other minor modifications, the entire automobile industry turned out projects that were essentially descendants of the 1934 Airflow.

The Shape of Time

Relative time and formal change are the subject of art historian George Kubler's book *The Shape of Time*, which provides a useful scheme for considering artworks and artifacts in their historical context. His system not only gives us some insight into why some

works are accorded more recognition than others but also explains the mechanisms of stylistic evolution.

The basic ingredient of Kubler's theory of change is a concept of relative time as opposed to absolute (calendar) time. In other words, saying that the Airflow came out in A.D. 1934 tells us very little by itself. What we need to know is when this car made its appearance in relation to other models of passenger cars. This leads us to Kubler's concept of *formal sequences:* "Every important work of art can be regarded both as a historical event and as a hard-won solution to some problem." A radical change in the shape of a significant art object (or an artifact such as a car) is usually a purposeful solution within a sequence of designs. The solution is related to those that came before and, if it is successful, will be connected with solutions that follow. Within a sequence of linked solutions there are *prime objects* and *replications.* Prime objects are successful major inventions; they affect certain traits of all the objects that follow them in such a way that these traits cannot be traced directly to any of the objects that came before them. Replications, on the other hand, are merely simple variations on the theme created by the previous prime objects. (In the case of mass-produced objects, a model may have thousands of identical "copies," but this is not what is meant by replications in this usage.) In Kubler's scheme, the Airflow deserves the label prime object; the Plymouths of the late 1930s were its replications. If we were to look at a large enough span of automobile history to discover the next prime object (or the one just prior to the Airflow), we might see an example of a formal sequence or series of design solutions that significantly modified the shape of the car.

Using Kubler's scheme, we can identify a number of prime objects and formal sequences in the previous pages of this text. The series of Greek sculptures of nude youths in Chapter 8 illustrates some of the steps taken by the Greeks during the Archaic and Classical periods in perfecting the human figure. The proportions of Polyclitus' *Spear Carrier* (Figure 8-4)—a prime object if ever there was one—served as the norm for figure sculpture throughout the Classical period, and even beyond. Centuries later the Romans paid tribute to it by making literal copies of it.

The development of Greek architecture, meanwhile, paralleled that of the nude. The diagram in Figure 11-5 describes the changes in the silhouette of the Doric column illustrating the refinement of its proportions during the Archaic and Classical periods. The final stage in this formal sequence (represented by the silhouette on the right) was the Parthenon (Figures 6-3 and 6-27), one of the most generative prime objects of all time. Not only did it spawn numerous replications in Classical Greece, but also in Rome, and later in

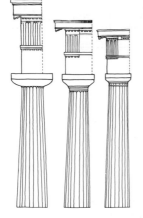

11-5 Changes in Doric-order proportions.

Europe and in North America. Think of how many commercial and government buildings there are—particularly in Washington D.C.—that flaunt classical columns.

The Roman Pantheon (Figure 6-13) was such a remarkable triumph of engineering for its time that it became a prime object that defied imitation for centuries. Brunelleschi's dome for the Florence Cathedral (Figure 6-18), another prime object and the first dome in the West, did not appear until 1300 years later. Chartres Cathedral (Figures 6-15 and 6-17), like the Parthenon and the Cathedral of Florence, is a symbol for an age—in this case the "Age of Faith"—served as the prototype for all High Gothic cathedrals in France, a style that was replicated in other countries.

Although other examples of prime objects in previous chapters could be cited, the rest of this chapter is devoted to examples not yet reviewed. They consist of works by artists recognized as major innovators who were active during a 450-year period of time (c. 1400–1850) from the Renaissance to the modern movement.

THE FIFTEENTH-CENTURY RENAISSANCE

Recall from discussions in Chapters 7, 8, and 9 that the Renaissance was an important watershed in the visual arts. Artists, especially those in Italy, began to break away from medieval styles and to look to classical models for many of their ideas. Several artists were especially influential. We will look at Donatello and Masaccio.

Donatello

Donatello (Donato di Niccolo Bardi), an outstanding Florentine sculptor in the early part of the century, was a friend of Brunelleschi, the designer of the dome of the Cathedral of Florence. As both men were interested in classical art, they traveled to Rome to study the ruins there: Brunelleschi would measure and draw such buildings as the Pantheon; Donatello must have done the same with classical statuary.

The results of Donatello's knowledge of classicism can be seen in his sculpture of *St. Mark* (Figure 11-6). Donatello did not imitate classical sculpture, but he did apply its lessons concerning human anatomy, proportions, and movement. Compared to *The Virgin of Paris* (Figure 8-12), a late medieval sculpture, the *St. Mark* is much more lifelike. Note especially the relationship between clothes and anatomy. The folds of Mark's gown are not stylized, nor do they fall in predictable, rhythmical lines; instead they sag and bunch according to the dictates of the body underneath. Indeed the gown ap-

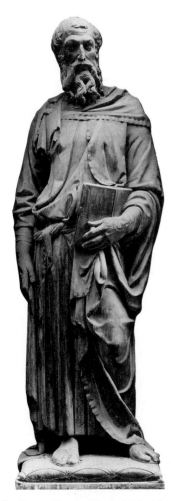

11-6 Donatello, *St. Mark*, 1411–13. Marble, approx. 7′9″ high. Or San Michelle, Florence.

pears as if the saint had not changed it since his last missionary journey. Like his clothes, his bearded face is not beautiful; rather, it expresses the aura of authority and realism that one would expect of the most plain-spoken of the four Evangelists. Donatello's *St. Mark* is a prime object of a new European sculpture, one that is informed by classicism, but expresses the values of Christianity. This new tradition was admirably expanded upon by Michelangelo's *David* (Figure 8-7).

If anything, the art of painting lagged behind that of sculpture in the early fifteenth century. In the previous century, Giotto had taken the first step in breaking away from the stereotypes of medieval art (Figures 4-2 and 4-3). Although artists in the fourteenth century continued to produce frescoes and altarpieces, none had pushed the limits of picture-making beyond the master's own innovations. For example, the pictures of Taddeo di Bartolo (Figure 7-7), made almost a hundred years later, are stylistically similar to those of Giotto. It was not until the career of Masaccio that the tradition of discovery and innovation started by Giotto would be continued.

Masaccio

The robust men in *The Tribute Money* (Figure 11-7) by Masaccio (Tommaso Guidi) are the painterly counterpart of Donatello's *St. Mark*. Painted on the wall of a Florentine chapel, this fresco is

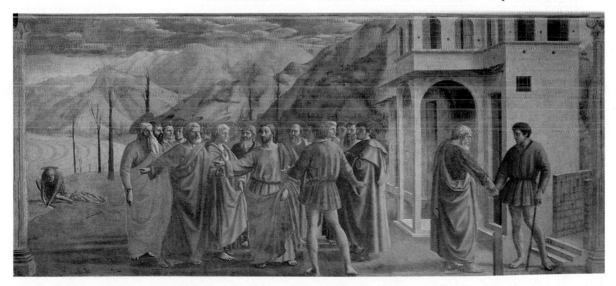

11-7 Masaccio, *The Tribute Money*. 1427. Fresco, 8′4″ × 19′8″. Brancacci Chapel, Santa Maria del Carmine, Florence.

one of a series on the subject of St. Peter. Here, Peter, the disciple to whom Christ is pointing, is being commanded to extract the tax money from the mouth of a fish, which he does on the far left, and then pays the tax collector on the right. Peter and the rest of the disciples have the bodies of Roman statues, and their togas, like St. Mark's robe, hang loosely from their sturdy frames in convincing ways. They are further defined by a chiaroscuro grounded in a consistent source of light from the right. Masaccio was one of the first artists to experiment with the newly developed system of one-point perspective (Chapter 2). In this work it determines the lines of the left side of the house behind Peter and the tax collector (the position of the vanishing point is directly behind the head of Christ). Meanwhile, a general impression of air and space, especially with regard to the hills behind the central group, is the result of an effective manipulation of both scale and aerial perspective. *The Tribute Money* and other frescos of Masaccio's were so admired by later generations of Renaissance artists that the little chapel harboring them became a virtual school of art. Thenceforth to the twentieth-century, painting was in the forefront of artistic developments.

THE HIGH RENAISSANCE

Leonardo

One admirer of Masaccio's frescos was Leonardo da Vinci. Active at the turn of the century, he was also one of the three luminaries of the *High Renaissance*—the period of time in the early sixteenth century when the developments of the fifteenth century were brought to fruition. The other luminaries were Michelangelo (Chapter 9) and Raphael (Figure 2-39).

As we saw in the examples of Donatello and Masaccio, early Renaissance artists strove for greater realism, but this was not the only impulse behind their efforts. They also strove for greater beauty and harmony. Evidence of this can be seen in their depictions of the human figure in which each figure—young or old—is endowed with a healthy, athletic physique (a legacy that ultimately dates to the work of Polyclitus). A problem arose, however, when fifteenth-century artists tried to incorporate several of these beautiful figures in a single scene: either movement was sacrificed to stability, or stability was sacrificed to movement. For example, the composition in Masaccio's *The Tribute Money* is stable but relatively static. The foreground of Ghiberti's *Meeting of Solomon and the Queen of Sheba* (Figure 5-3), however, is lively but confusing; the same is

true of Pollaiuolo's *Battle of Naked Men* (Figure 8-6). A major objective of Renaissance art was the reconciliation of movement and stability—a goal that seemed to have eluded artists throughout the century.

Leonardo's *The Last Supper* (Figure 11-8) was the first painting to solve this problem. Although completed in the fifteenth-century (1498), the mural is indeed a High Renaissance work. It is also one of a half a dozen or so of the most famous artworks in the world—despite the fact that it is becoming difficult to see. Applied to the wall of a Milan monastery with a paint invented by the artist himself, the picture began to peel off the wall during Leonardo's lifetime. Since then it has suffered still more abuses, even including some damage from World War II bombings.

In designing the *The Last Supper* Leonardo observed two major principles of stability: horizontality and symmetry. The horizontal format is reinforced by the long table and the men arrayed behind it, and the fact that both are parallel to the plane of the picture. The symmetry of the room and the table is echoed in the one-point perspective in which the lines terminate at a point in the exact center (directly behind Christ's head).

Christ, the geographical and psychological center of the picture, is further set off by the open window behind him and by his separation from the disciples. He has just stated, "One of you will betray me." The shock of his announcement ripples visibly through

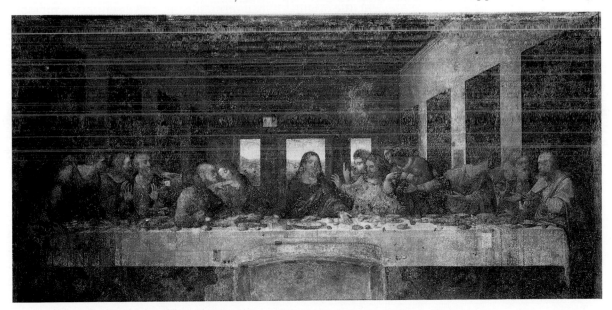

11-8 Leonardo Da Vinci, *The Last Supper*, 1495–98. Mural painting, 15′1″ × 28′10½″. Santa Maria delle Grazie, Milan.

the group as each asks, "Is it I?" Judas, who seems to be recoiling from the fact that it is he, is leaning back with one arm on the table to the left of Jesus. The animation of the men is tempered by their noble bearing and graceful gestures. Although each reacts differently—imparting variety to the scene—all of the disciples are in harmony, visually and psychologically, with one another.

A marvelous integration of not only movement and stability but also of subject matter and form, *The Last Supper* is to this day one of the world's most popular pictures. In its own day it helped to bridge the gap between the fifteenth and sixteenth centuries and to inaugurate the High Renaissance. Among the famous works of this period are Leonardo's own *Mona Lisa* (Figure 7-8), Michelangelo's *David* (Figure 8-7) and the monumental Sistine Ceiling (Figure 9-8), Titian's *Venus of Urbino* (Figure 8-14), and Raphael's *The School of Athens* (Figure 2-39). The latter, especially, is almost a summation of High Renaissance art: noble figures, stately movement, grand setting, and heroic scale.

MANNERISM

The High Renaissance, which lasted little more than 20 years, was a brief flowering. In the mid 1530s a different style emerged known as Mannerism. Both the art and the label itself are controversial. *Maniera,* the original Italian term, meaning over-emphasis on manual dexterity, came to signify virtuosity in the sixteenth century. The English word, mannerism—excessive use of some affected manner or style in art—is close to the meaning intended in the seventeenth-century by critics who tried to discredit what they deemed to be a perversion of High Renaissance principles. Today, the judgment of Mannerist art is more moderate; it is seen both as a reaction against the High Renaissance and as an important stage of development between that period and the Baroque.

Michelangelo, the most imposing of the High Renaissance artists, was also an important author of Mannerism. Recall the giant nudes and the crowded, tumultuous composition of his *The Last Judgment* (Figure 9-10) and how it contradicted his earlier work in the Sistine. Many younger artists, impressed with the mural's power, found those very things that defied High Renaissance principles—the unconventional figures, agitated movement, and irrational design—to be the most inspiring. As for Michelangelo himself, his change of style, as we observed, could have been due to his response to the troubled times, as well as to his personal mood. It is reasonable to assume that the upheavals of the Reformation and Counter Reformation (the Catholic reaction to the Reformation)

were also catalysts for the younger artists. But it is also reasonable to assume that as young artists they found the High Renaissance style too overpowering for them to work within. Thus to assert their independence and to stake out their own personal styles, they reacted against it.

Tintoretto

Tintoretto (Jacopo Robusti), the best known exponent of Mannerism from Venice, was no longer young when he painted his *The Last Supper* (Figure 11-9), and by 1594, when the painting was finished, the Mannerist style had been well established. Tintoretto's version of this famous subject is not only a good example of the style, it also contains many characteristics that anticipated seventeenth-century Baroque art. From Titian, his teacher, Tintoretto acquired his taste for rich textures and colors, and from Michelangelo, his aptitude for making muscular figures. But Counter Reformation fervor may have prompted his style as much as anything else. To express the

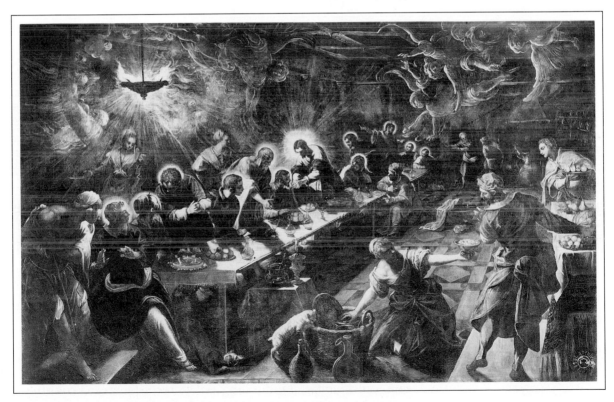

11-9 Tintoretto, *The Last Supper*, 1592–94. 12′ × 18′8″. S. Giorgio Maggiore, Venice.

emotionalism of that movement, Tintoretto felt it necessary to exaggerate perspective, movement, and light.

Contrast Tintoretto's *The Last Supper* with Leonardo's. The table thrusts diagonally, almost aggressively, into the picture. The vanishing point, instead of being in the center, is way off to the right. Christ (the one with the brightest halo) is in the center of the picture, but no longer dominant. To enliven the scene, Tintoretto has added servants, attendants, observers, and gossamer angels above the crowd. All of the characters, regardless of their roles, are feverishly active in a dark environment charged with flashes of brilliant light. Instead of balance, dignity, and focused action, Tintoretto gives us instability and energy. Instead of an understated drama about a last supper among men in which betrayal and tragedy are prophesied, he gives us the Holy Eucharist—the miracle of the bread and wine becoming the body and blood of Christ—as religious theater.

BAROQUE

Mannerism evolved into Baroque art, the dominant style of the seventeenth century. In general, this art has a reputation for being excessively ornate and pompous—qualities exemplified by the works of two famous Baroque artists, Bernini and Rubens. Recall Bernini's *Ecstacy of St. Theresa* (Figure 5-10) and Ruben's *Lion Hunt* (Figure 3-4). The style has been criticized because of its alleged lack of restraint and, therefore, has been compared unfavorably with High Renaissance art, but in fact it drew from that tradition, as well as from Mannerism. From the latter, Baroque inherited its penchant for energy; from the former, its sense of grandeur and dramatic unity. Modern writers, moreover, are quick to warn that Baroque art is not a homogenous style, that it can vary from a lusty battle scene by Rubens to a staid domestic scene by de Hooch (Figure 3-6). Some historians divide the style between "Catholic Baroque" and "Protestant Baroque," or between "aristocratic style" and "bourgeoise style." However, one feature that is shared by almost all Baroque art and which distinguishes it from either Mannerist or High Renaissance art is the intensity of its chiaroscuro.

Caravaggio

The life of Caravaggio (Michelangelo de Merisi)—a man of passion, quick temper, and a long police record—was as colorful as that of any artist. Were it not for the help of patrons who protected him from his enemies and the authorities, he might have been

killed or permanently imprisoned at a very young age. As it was, he survived to only age 36.

Caravaggio was loathe to obey the rules of propriety in both life and art. Not that he made bad art, but he refused to comply with the usual rhetoric of heroic figures and gestures. He sought to describe a biblical story, such as *The Conversion of St. Paul* (Figure 11-10), as realistically as possible. The overstated lighting and posturing in this work might strike us as being more melodramatic than realistic. It is similar in this respect to an early work by Rembrandt. But to Caravaggio's contemporaries, a picture of St. Paul in such an unceremonious position, exposed to the naked

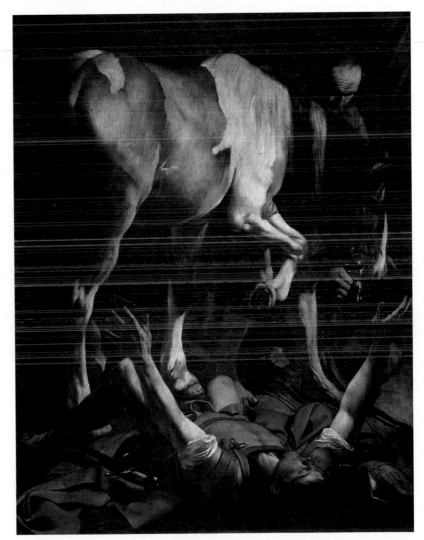

11-10 Caravaggio, *The Conversion of St. Paul*, c. 1601. Oil on canvas, approx. 90″ × 69″. Santa Maria del Popolo, Rome.

glare of a strong light, was too realistic, even vulgar. Not only that, by enlarging the figures and compressing the space, Caravaggio brought the viewer into the scene—a device made all the worse by the proximity of the least flattering part of a horse's anatomy. Unaccustomed to such lack of decorum, Caravaggio's critics felt that his interpretation mocked the famous apostle's conversion. Although the artist may have mocked conventions in art, he was not ridiculing St. Paul. Indeed his interpretation is almost a literal description of the verses in Acts: "and suddenly there shined round about him a light from heaven: And he fell to the earth" (Acts 9:2, 3). If anything, Caravaggio's approach to the subject is all the more pious because of its honesty and directness. Fortunately, some of Caravaggio's contemporaries understood this and recognized his genius.

Caravaggio's most important legacy was his sculpturesque realism achieved through the use of strong contrasts of light and dark. Of course the dark background and bright light in *The Conversion of St. Paul* are inherent in the subject, but Caravaggio used these in all his works, regardless of subject. Soon, thanks in large part to a woman artist by the name of Artemisia Gentileschi, other artists in Italy began to do the same, and then the practice spread to other countries, particularly to Spain and the Netherlands. The use of emphatic chiaroscuro became pervasive in much of Baroque art. We have seen evidence of this in Rubens' paintings (Figures 3-4 and 8-15) and especially in Rembrandt's painting of *Presentation in the Temple* (Figure 9-11).

Gentileschi

A generation later, the Italian public must have become more accustomed to unsparing realism—that is, if we may judge by a work based on a story from one of the apocryphal books of the Old Testament, *Judith Slaying Holofernes* (Figure 11-11) by Gentileschi. After gaining the confidence of Holofernes, a Babylonian general, Judith decapitates him in his sleep and thus rescues her fellow Israelites from a siege. In Gentileschi's interpretation it is an ugly struggle: the hapless general futilely trying to fend off the women, the maid awkwardly controlling the general, and Judith simultaneously committing the brutal act and recoiling from it. Like Caravaggio, Gentileschi used light and dark to describe the form and intensify the drama—although here, darkness is not a setting for a religious experience but a metaphor for intrigue and violence.

Like all women artists of the time, Gentileschi was an exception. Because of social conventions and guild rules, women were discouraged from entering art. But thanks to an artist father (Orazio) who was willing to train his daughter and even let her join him on mural

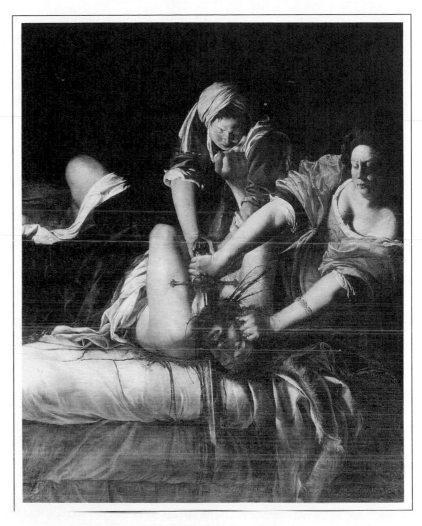

11-11 Artemisia Gentileschi, *Judith Slaying Holofernes*, c. 1620. Oil on canvas, 78⅓" × 64". Uffizi Gallery, Florence.

projects, she was able to overcome some of the enormous disadvantages women artists had to face. Her career extended to Florence, Rome, and Naples where she was able to attract wealthy patrons and good commissions. Because she was instrumental in transmitting the ideas of Caravaggio to those cities, she has been acclaimed as the first woman in the history of Western art to make a significant contribution to the art of her time.

Velázquez

Italy continued to produce many artists in the seventeenth century, but it was no longer the major country to do so or necessarily the most important source of art developments. Rubens, Rembrandt,

and de Hooch, for example, were based in the Netherlands. One of the most active nations in art was Spain—her most distinguished artist being Diego Velázquez, a man who lived about the same time as Rembrandt.

As court painter to King Philip IV, Velázquez made trips to Italy where he observed that country's art heritage and collected art for the king. Like many Spanish artists, he came under the spell of Caravaggio's hard-edged chiaroscuro, at least at first. But the painterly style of Titian and Tintoretto, whose work he saw in the royal collection, proved to be more influential in the long run. Thus, like Rembrandt in mid-career, Velázquez's brushwork loosened and his chiaroscuro softened. Further, like many Baroque artists, he was affected by the impulse of achieving ever higher standards of optical realism. By this time the techniques of chiaroscuro, foreshortening, and linear perspective had been so assimilated and refined that

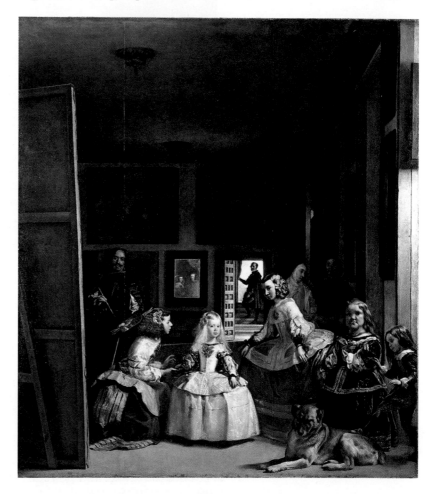

11-12 Diego Velázquez, *Las Meninas*, 1656. Canvas, 10′5″ × 9′. Museo del Prado, Madrid.

gifted artists like Caravaggio, Gentileschi, Rembrandt, and Velázquez could depict almost anything—in either the real or the spiritual worlds.

Las Meninas (The Maids of Honor, Figure 11-12) exemplifies Velázquez's extraordinary originality and abilities as a painter. Originally titled "The Family of Philip IV," it is a royal portrait—but, if so, where are the king and queen? The royal couple's daughter, the Infanta, is in the foreground being fawned over by the maids of honor. In the right foreground are the Infanta's "pets," a dog and two dwarfs; behind them, a governess and a friend; and standing in the doorway in the back, another official of the royal household. Presiding over the scene is Velázquez himself looking at the viewer or, perhaps, at his large canvas in the left foreground. Hanging on the rear wall are the king's paintings along with a mirror which contains—as you may have guessed—a reflection of the king and queen.

A rich experience visually and intellectually, *Las Meninas* lends itself to a variety of readings. Consider, for example, the different levels of reality on the rear wall—painted images, a mirror image, and a real person framed in a doorway; or the identification of the royal couple with the position of the viewer—as though we are sitting for Velázquez and the image in the mirror is our own reflection. Or perhaps this is a pun on the notion of art being a mirror of life. So supremely confident was Velázquez that he was able to produce a superb illusion of reality and make a commentary on illusionism at the same time. He also managed to combine self-portrait and group-portrait and to include all the members of the royal family and their retinue without compromising the naturalness of the scene or the dynamic qualities of the composition.

ROCOCO

The cultural center of gravity began to shift to France during the seventeenth century. This was due in part to the splendor of Louis XIV's court and to the French Academy, a training ground for artists and artisans established by Louis. But credit must also go to the English navy that ruled the sea lanes and leached power from countries like Holland and Spain. After Louis' death in the early eighteenth century, the French aristocracy was in the forefront of a change in art that paralleled a similar change in the mood and taste of the French court: from the heavy splendor of Louis to the frivolity of his successors.

The art of this period, labeled Rococo from the French word for a concoction of seashells, perfectly captures the new mood and expresses the values and pastimes of a pleasure-seeking aristocracy.

Sometimes called a decorator's style, Rococo was associated with the interiors of Paris townhouses, or *salons*, that featured delicate designs based on plant forms or little shells, and murals filled with garlands and cupids. Rococo grew out of Baroque art—not the somber and realistic Baroque of Caravaggio, Gentileschi, Rembrandt, and Velázquez, but the vivacious and fanciful Baroque of Rubens. Rococo subjects are mainly about people at play, whether fashionable ladies and gentlemen or pagan gods, described with sinuous lines, pastel shades, and shimmering textures—in which every substance seems to be made of silk.

Watteau

The most famous of the Rococo artists, Jean-Antoine Watteau was largely responsible for setting the tone of that art. But instead of conveying light-hearted (or as some would say, "light-headed") abandon as did his followers, Watteau betrayed a serious attitude

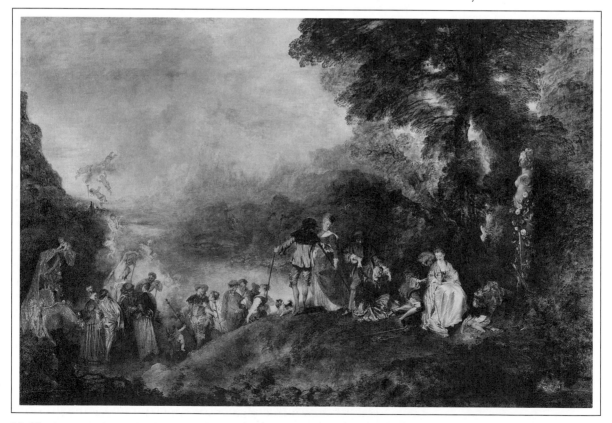

11-13 Jean Antoine Watteau, *A Pilgrimage to Cythera*, 1717. Oil on canvas. 51″ × 76″. Louvre, Paris.

about life and society. His subjects include myths, aristocratic pageants, or allegories that mingle myth and pageantry, such as *A Pilgrimmage to Cythera* (Figure 11-13). According to legend, Cythera was the island home of Venus where couples would go to make love. Watteau chose to show a group of love-pilgrims leaving the island. To the right of them stands a garlanded statue of the goddess of love herself. To the left at the bottom of the hill is a golden boat waiting to take them back to reality. In the distance, through the evening haze, is a faint view of snow-capped mountains. A pervasive mood of wistfulness, signified by the tall woman in the center who pauses to look back, is prompted by the soft colors as well as by the languid actions of the people. As art historian Michael Levey explains, "the picture is imbued with a poignant sense of the losing battle love fights against the reality of time."

Fragonard

In *The Swing* (Figure 11-14), Jean-Honoré Fragonard has also raised the issue of erotic love to the level of myth, but without Watteau's aura of melancholy. A young couple flirts in a sumptuous garden with the aid of an older man who has agreed to swing the woman suggestively over the head of the young man. The amorous theme, given the behavior of the people and the presence of statues of cupid, is unmistakable. But the sexual energy of the picture is due mainly to Fragonard's exceptional style: his silken textures, delectable colors, ecstatic lights and darks, and a design that organizes these elements into a unified and voluptuous image. Note the way in which the woman's swirling clothes are at the center of a riot of shimmering foliage; the whole picture seems almost to throb with expectation. Fragonard used the same tools as Tintoretto—rich colors, light, and movement—but to express sexual, rather than religious, passion.

Meanwhile, during the century of Watteau and Fragonard, social and intellectual currents were underway that would eventually rise up and destroy the power of the old nobility, and in its wake, the Rococo style. The segment of society made up of shopkeepers, bankers, traders, and professional people, known as the middle class, had grown dramatically. Their influence and power in the Dutch Republic during the seventeenth century (Chapter 9) was unique at the time, but also prophetic. In the eighteenth century, they had become strong enough in other countries to pose a serious threat to the old order, particularly in France.

The eighteenth century was also the time of the *Enlightenment*, a philosophical movement and point of view that enshrined rationalism. Isaac Newton (the seventeenth-century English physicist

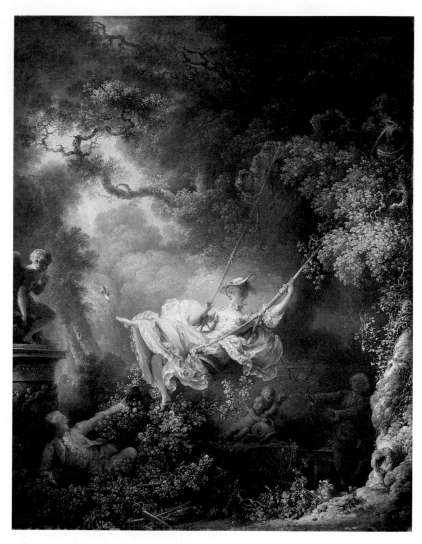

11-14 Jean-Honore Fragonard,
The Swing, 1766. Oil on canvas.
35″ × 32″. Reproduced by
permission of the Trustees of the
Wallace Collection. London.

who discovered the spectrum colors) had demonstrated that the universe is governed by universal laws. Enlightenment writers, such as the Frenchmen Voltaire and Denis Diderot, were impressed by the rationalism of Newton's universe, and felt that it could serve as a model for society. By means of satire and sharply-worded essays, they tried to instill in the minds of their readers the need for reason in religion, politics, and all human affairs. Although their writings were tremendously influential, they did not represent the sentiments of all Europeans. To devout Christians and religious leaders, Newton's mechanical universe raised disturbing questions about religious convictions. To the governing elites of Europe, the ideas of the Enlightenment, especially about human liberty, chal-

lenged their authority. Nevertheless, Enlightenment ideas greatly affected the social and intellectual climate of late eighteenth-century France.

NEOCLASSICISM

In this kind of climate, Rococo had few champions. The new middle class resented it as an art of the privileged class; conservative Catholics and Protestants objected to its immorality; Enlightenment philosophers condemned it as frivolous; and even its old patrons among the aristocracy began to disown it. Johann Joachim Winckelmann, a German art historian, said that Europe needed an art of "noble simplicity and calm grandeur" to replace Rococo.

David

The hopes of the public and Winckelmann were fulfilled in 1784 when Jacques Louis David unveiled his *The Oath of the Horatii* (Figure 11-15). Painted only 18 years after *The Swing*, David's picture could not be more different. Instead of fun-loving aristocrats, it features three Roman brothers swearing an oath to fight a death-duel with three Alban brothers. Off to the right are two sisters (one betrothed to one of the Albans) and an older woman, slumped in

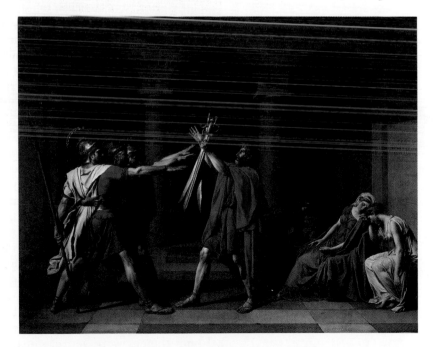

11-15 Jacques-Louis David, *Oath of the Horatti*, 1784. Oil on canvas, approx 14′ × 11′. Louvre, Paris.

despair. Instead of being set in a beautiful garden, David's scene is enacted in a severely simple Roman court. Instead of softness and nuance, it features bold lights and darks, primary colors, clearly defined forms, and a straight-forward design. *The Oath of the Horatii* is an intense, concentrated image of bravery and stoicism. It was also the first work of a new style that, like early Renaissance art 350 years earlier, found inspiration in the themes and principles of classical art. Indeed, this new art became known as Neoclassical. It was approved by intellectuals as an embodiment of seriousness and reason, and by the French middle classes as an allegory of honor and patriotism. It also became a symbol of the French revolution. David, who was personally active in the French revolution, eventually became Napoleon's court painter.

The spirit of Neoclassicism affected other aspects of culture. The classical music of David's contemporaries—Franz Joseph Haydn and Wolfgang Amadeus Mozart—fulfills the principle of noble simplicity and calm grandeur. Thomas Jefferson, who was an architect as well as a distinguished statesman, designed the University of Virginia in the Neoclassical style and stimulated the revival of classical architecture in America.

ROMANTICISM

Not long after Neoclassicism had become established, Romanticism took over. Although it was a reaction against the artistic and philosophical principles that had become associated with Neoclassicism, Romanticism was certainly not a call for returning to the tastes and values represented by Rococo art. The rise of this movement can be explained in part by the fact that the optimism of the Enlightenment was dashed by the atrocities of the French Revolution and the failures of the Napoleonic wars. Faith in reason went out of style and was replaced by renewed faith in God, and especially, by faith in emotion. It could be said that romantic writers and artists, unlike those of the Neoclassical era, trusted their hearts rather than their heads.

Recall that Romanticism was preoccupied with nature. Rousseau, Wordsworth, Constable, and Turner, among others, fostered a cult of nature in Europe, while their counterparts—the Transcendentalists and the Hudson River School painters—did the same in America. But nature worship was not the only preoccupation of Romantic artists. Such subjects as death, religion, nationalism, unrequited love, the long ago and far away, sex, violence, morbidity, and anything exotic—all of which were treated with high seriousness—served as grist for their artistic production. The only off-limit themes were genre, satire, and frivolity.

Delacroix

Of all the people involved in Romanticism, none was more representative of that movement than Eugené Delacroix. The leading Romantic painter in France, a major spokesman for the movement, the idol of Romantic poets and painters, a man of passion, Delacroix's tastes were more sanguinary even than those of other Romantics. To him nature was exemplified not by landscapes, but by wild animals, especially tigers. He disdained French culture, and favored the Bedouin society of Morocco—which he often visited— because he so admired the courage and ferocity of Arab warriors.

Delacroix's *The 28th July: Liberty Leading the People* (Figure 11-16) is neither set in the outdoors nor in an exotic culture, but is

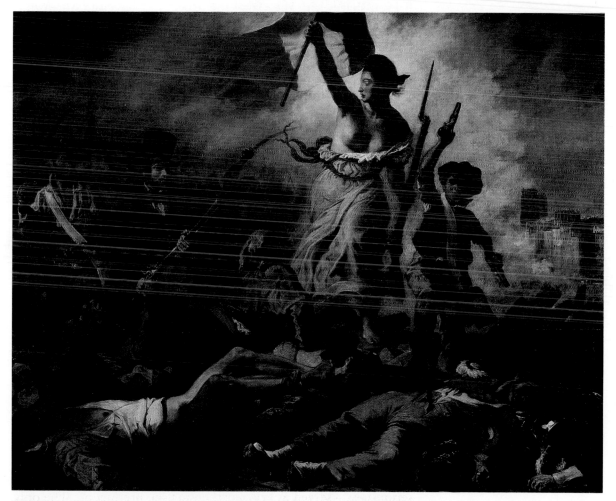

11-16 Eugené Delacroix, *The 28th July: Liberty leading the people*, 1830. Oil on canvas, 8′6″ × 10′7″. Louvre, Paris.

nevertheless violent and typically Delacroix. Commemorating an actual revolution (when the streets of Paris were barricaded for a brief time by workers, students, and intellectuals in July, 1830), the painting could stand for any revolution in the name of freedom. Waving the tricolor, Liberty leads a group of males intended to represent the spectrum of modern society: a workman brandishing a sword, a middle-class dandy carrying a rifle, and a boy flourishing pistols. Underfoot are the dead and suffering, perhaps intended to symbolize the high price of defending an ideal.

As icons of revolution, Delacroix's painting and David's painting are quite comparable. Both embody the values of courage, patriotism, and stoicism in terms of heroic figures and melodramatic actions. The fact that the Delacroix features a goddess signifies that it even shares with the David the aspect of classicism. Meanwhile their differences point up some of the generic differences between Neoclassicism and Romanticism. In the Delacroix the violence is no longer latent but actual. The people are no longer statuesque, but move freely. Except for the goddess, they are dressed in contemporary, non-military costume. Both the brushwork and the design in the Delacroix are much freer; the atmospheric effects of smoke and fire are typically Romantic. Finally, such an honest and forthright display of death and suffering—reminiscent of the dead and dying in Goya's *The Third of May* (Figure 3-3)—was virtually unheard of in art prior to Romanticism.

As we have seen, cultural styles occur in cycles, and the closer we get to the present, the shorter the cycles seem to become. By mid-century Romanticism began to give way to another idiom. The spirit of Romanticism had by no means ceased—Hudson River landscapes continued to be painted to the end of the Civil War; romantic music continued to be written to the end of the century—but a number of young painters in France and England rebelled against it in the name of Realism.

REALISM

The impulse to make images resembling things in the visible world has a long history—dating to the lifelike animals recorded on cave walls over 12,000 years ago (Chapter 7) or to the natural-looking, although idealized, men and women carved by the Greeks more than 2400 years ago (Chapter 8). While it should be clear that the imitation of the visible world has not been uppermost in all cultures and at all times—for example, ancient Egypt (Chapter 7), medieval Europe (Chapters 7 and 8), Hindu India (Chapter 8), Southeast Asia (Chapter 9), Islam (Chapter 9), and the twentieth-century

West—it was dominant in the West from the Renaissance to the middle of the nineteenth century, when it peaked.

In its strictest sense, nineteenth-century Realism demands more of a work of art than that of just imitating appearances. It also means, at least theoretically, a complete absence of interpretation on the part of the artist. Therefore it is easier to explain what a picture should *not* have, that is: *no* distortion of what the eye naturally sees; *no* obvious use of design principles or other devices to give a picture harmony, unity, or drama; *no* use of imaginary subject matter; and *no* glorifying or sentimentalizing of whatever subject matter is used.

Courbet

The acknowledged leader of the Realist movement was Gustave Courbet. Like Caravaggio almost 250 years earlier, Courbet was criticized for his lack of taste. His *Burial at Ornans* (Figure 11-17), a homely gathering of townspeople at a graveside, was considered too coarse even to be considered art. Courbet had taken the subject from ordinary life, and very humble life at that. Had he described the people as noble toilers of the soil, or cast the scene as an allegory of some universal truth, the public may have accepted it. Instead he portrayed them matter-of-factly, without flattery or condescension. Even his technique was criticized. Because much of the

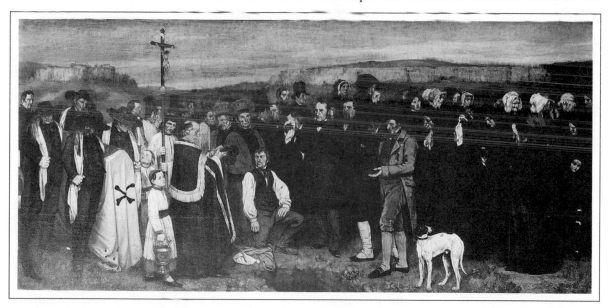

11-17 Gustave Courbet, *Burial at Ornans*, 1849. Oil on canvas, 10′3″ × 21′9″. Louvre, Paris.

painting was done with a palette knife rather than a brush, its surface is as coarse as the people. Moreover, to the public, the colors were uninspiring and, worse, the composition lacked the kind of hierarchy they were accustomed to. Unlike a David or a Delacroix, in which some figures are given more priority than others, everyone in Courbet's work—priest, mayor, grave digger, coffin bearer, mourner, dog—is treated the same. The center of interest, if any, is a hole in the ground.

To make matters worse, *Burial at Ornans* had political drawbacks as well as aesthetic ones. Having been completed in 1849, not long after the workers' revolution of 1848, it was criticized by conservatives for bringing politics into art. But by the same token it was praised by liberals. Courbet, who said "I am not only a socialist, but also a democrat and a republican, in a word, a partisan of revolution," had identified himself with liberal politics. Thus Realism had a political agenda, at least for awhile. But with time, the aversion to Realism softened and the fear of class uprising subsided. Courbet eventually enjoyed the recognition of the art establishment, and he reciprocated by making paintings to please, rather than offend, middle-class patrons. Meanwhile, Realism had found fertile soil in the United States where a practical-minded public appreciated such pictures as *The Berry Pickers* (Figure 4-7) and the *The Country School* (Figure 10-4) by Winslow Homer.

SUMMARY

This chapter examines the relationship between time and art, and provides a framework for explaining the evolution of artistic forms and the sensibilities behind those forms. Kubler's construct can be used to identify prime objects—innovative artworks that have affected the appearance of works that followed them. Likewise, the importance of a work of art can be evaluated with the scales of time; if a painting or sculpture has played a key role in art history, it achieves art-historical status—regardless of its appeal in other respects.

This chapter also overviews 450 years of art developments in the West. The Renaissance, which started in Italy, was a turning point in the art of the West. Renaissance ideas soon spread to the rest of Europe, and eventually Italy was no longer the principal source of artistic change. The most outstanding and innovative artists of the seventeenth century seemed to be either Netherlanders or Spaniards. By the eighteenth and nineteenth centuries, many nations could claim to have great artists, although by the mid-nineteenth century, France had become the new hot bed of change.

This chapter ends with Realism. Unquestionably, realism was a most important issue in Western art from the Renaissance to the mid-nineteenth century. Over that time, artists consistently improved their skills in making imitations of the visual world—although of course they were also concerned about such other issues as subject matter, composition, and adherence to classical principles. As we shall see in the next chapter, realism continued to be an important issue in the second half of the nineteenth century; however, it began to be treated in a way very contrary to that of the previous 450 years.

CHAPTER

12

THE MODERN MOVEMENT

I
N THE LATTER part of the nineteenth century a series of changes took place in French art that eventually developed into a major revolution in Western art—a revolution known as the Modern movement. This revolution was not initiated by a single dramatic event; in fact, the Modern movement was not even recognized as such until long after it began.

THE MODERN MOVEMENT REVOLUTION

The early stages of unrest in the art world were directed against the academic art of mid-century France, the kind of art shown in major exhibitions and that received prizes and praise from critics. Thomas Couture's *Romans of the Decadence* (Figure 12-1), an orgy depicted in a jaded realistic style and intended to make a moral point, is representative of this kind of art. Such a painting was surely out of touch with life and therefore ripe to be overthrown. But in the long run, the Modern movement did much more than just overturn academic painting. In time it succeeded in repealing one of the most fundamental premises of Western art since the Renaissance—the notion that realism, the imitation of appearances, was a necessary condition for a picture to be a work of art.

Realism—or the subversion of it—was not the only issue of the Modern movement. New possibilities in media and content were also investigated. But in the last part of the nineteenth century and the early part of the twentieth, progressive painters increasingly

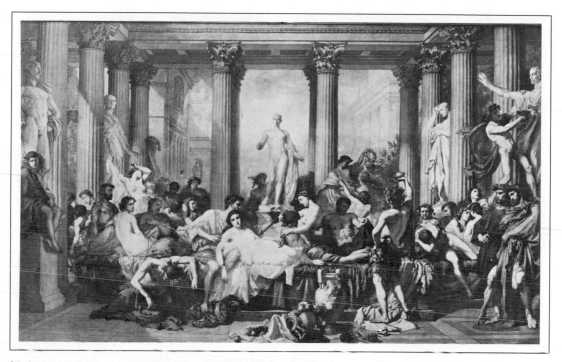

12-1 Thomas Couture, *Romans of the Decadence*, 1847. Oil on canvas, 15′1″ × 25′4″. Louvre, Paris.

moved away from the realistic treatment of subject matter toward an art in which abstract form became the main focus.

Manet

Manet's *Olympia* (Figure 8-18), a reclining nude depicted as a real woman instead of a goddess, was not the artist's first *success de scandale*. In 1863, the thirty-one-year-old artist submitted *Luncheon on the Grass* (Figure 12-2) to the Paris Salon. The principal annual art show of nineteenth-century France, the Salon was more than just a marketplace for works. It was the arena for establishing reputations and careers. To show in the Salon was a necessity; to receive a prize or favorable public recognition was extremely advantageous.

Manet's painting was turned down. But the Salon turned down so many works that year that the government was prevailed upon to open another section for a parallel exhibition of rejected works—called, appropriately, the *"Salon des Refuses."* There, Manet's work was in a position to be noticed—and it was. It received more attention than the works of either show, most of it negative. *Luncheon on the Grass* scandalized both the critics and the public.

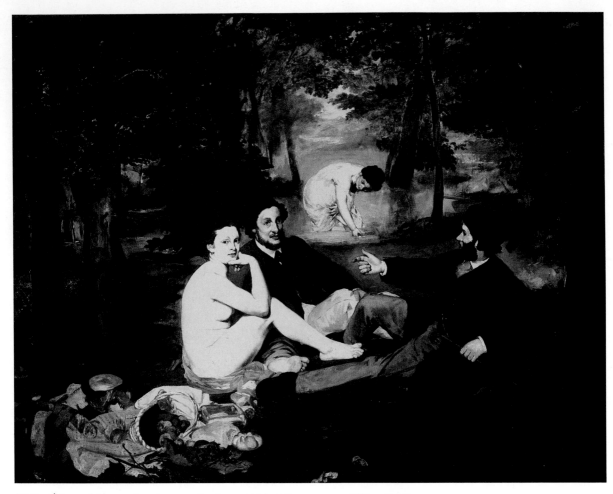

12-2 Édouard Manet, *Luncheon on the Grass*, 1863. Oil on canvas, 7'8" × 8'10".
Musée d'Orsay, Paris.

Today it is somewhat difficult to understand why this work caused such a fuss. Nudes in art, as we know, were quite acceptable, even common, in those days. *Luncheon on the Grass,* however, is neither a sermon on Roman decadence nor a classical fable. The figures are not Greek goddesses in a fairy-tale setting accompanied by Greek gods or singing troubadours, but two young women—one loosely clothed and the other completely naked—in a contemporary picnic setting, accompanied by two young men dressed in contemporary clothing. Such behavior was considered indecent, and therefore, according to nineteenth-century standards, the painting itself was indecent. But perhaps what shocked the public most was that the naked woman shamelessly smiled at the viewer.

Equally controversial—and ultimately more important to the future of art—was Manet's style. The composition was perceived as loosely organized, especially with regard to the discontinuity that exists between the central group in the foreground and the woman in the background. The objects and figures, particularly the nude, were perceived as too flat. In traditional painting, chiaroscuro was predicated on light entering from the side—having the effect of making each figure seem sculptural. Manet's people, on the other hand, appear to be exposed to light from the front—such as that from a noonday sun or from a flashbulb. Even Courbet complained of this effect, saying that it made Manet's paintings look like playing cards.

The criticism of Manet's style notwithstanding, the public was probably more upset with the picture's realism than with its purported lack of realism. The woman's pose and facial expression—a subtle mixture of sex, detachment, and defiance—were, if anything, too lifelike for the time. The lack of traditional shading, if anything, enhances the naturalism rather than detracting from it. Manet, who was an ardent student of Velasquez's art (Chapter 11), was well aware of the discrepancies between art and life, especially between the art establishment of his day and modern life as he perceived it.

Monet and the Impressionists

Another young Parisian artist, Claude Monet was for a time Manet's close associate. Like Manet, Monet favored contemporary subjects, particularly the urban middle class (although he portrayed them dressed). He also challenged established traditions of color, chiaroscuro, and composition. Indeed, Monet's early work was similar to Manet's, sharing the traits of flatness and directness of approach. But Monet was to go far beyond Manet in developing an original style of art. *La Grenouillère* (Figure 12-3), a scene of city dwellers enjoying an afternoon at a floating restaurant on the River Siene, is a case in point. The effect of rippling water is especially vivid; a closer look reveals that Monet constructed the picture out of nothing more than bright daubs of paint—not a single ripple or object has been "drawn" in the conventional sense.

In the 1870s Monet became the central figure of a small group of artists who eventually adopted the name *Impressionism* for their style, a term invented by a journalist who wished to ridicule their work. Other members included Edgar Degas (Figure 4-11), Berthe Morisot, Camille Pissarro (Figure 7-14), Auguste Renoir, Alfred Sisley, and the American expatriate Mary Cassatt (Figure 4-12).

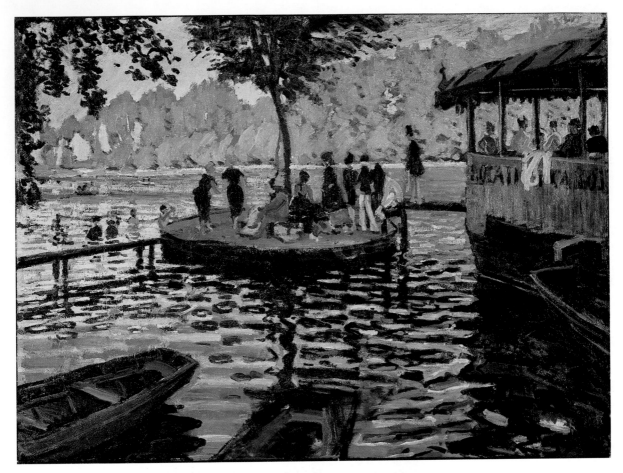

12-3 Claude Monet, *La Grenouillère*, 1869. Oil on canvas, 29⅜″ × 39¼″. The
Metropolitan Museum of Art. Bequest of Mrs. H.O. Havermeyer, 1929. The H.O.
Havermeyer Collection.

Like Monet, they had been influenced by the directness of
Manet's paintings and shared his taste for contemporary subject
matter—especially the life of the Parisian middle-classes who pos-
sessed the leisure and the means to enjoy the races, regattas, concerts,
restaurants, and weekend outings.

Degas, who liked to capture slices of this life, sometimes imi-
tated in his work the transient effects of candid photography. But
just as often these effects were based on a design strategy having
nothing to do with photography. Like many progressive artists of
the 1880s, Degas admired Japanese woodcuts (Figure 12-4), and he
assimilated their characteristics into his own work. The off-center
composition, diagonals, flat planes, and cropping of objects and
figures—all Japanese devices—can be seen in *The Millinery Shop*

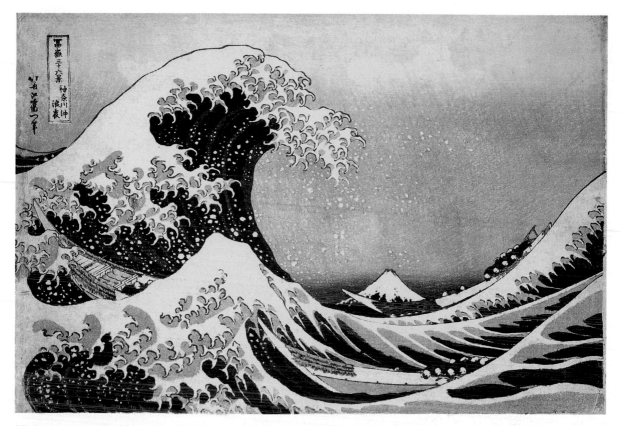

12-4 Hokusai, *The Great Wave*, Tokugawa period, approx 1823–1829. Woodcut, 10″ × 14¾″ Museum of Fine Arts, Boston.

(Figure 12-5). These devices create not only a deceptive sense of informality but also interesting visual tensions. The modiste (saleswoman) holding up a hat with a stockinged hand is not only off center, she looks away from the center. Visually, this pull to the right is offset by the frothy hats on the left. Other tensions consist of the high eye level, the diagonal of the table, and the contrast between the starkness of the table and the frivolity of the hats. Degas' works are also interesting because of the subtle ways in which they evoke a mood. To express the casual chic of such a shop he used low-saturation hues—pale yellows and yellow-oranges set against equally soft blues and blue-greens—applied with loose and spontaneous strokes. The understated keynote of the mood, however, is the modiste who inspects a hat with professional detachment.

The Impressionists usually preferred outdoor subjects in Paris or in its suburbs—such as Pontoise (Figure 7-14)—painting scenes

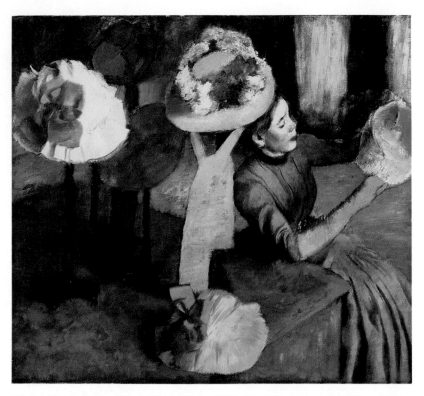

12-5 Edgar Degas, *The Millinery Shop*, 1879–84. Oil on canvas, 38⅞″ × 42⅞″. Art Institute of Chicago. (Mr. and Mrs. Lewis Larned Coburn Memorial Collection). Photograph © 1990 The Art Institute of Chicago. All rights reserved.

"on location" to capture their vitality and freshness. As a body of works, Impressionism portrays a sunny, seemingly blithe world. At the same time these works are impersonal—as detached as the expressions on the faces of Manet's and Degas' women—and notably lacking in romanticism or sentimentality. If there is a romantic note at all, it is to be found in the daylight that was the glory of this style.

The Impressionists' methods of applying paint—often with short strokes and bits of color—were indirectly influenced by the broken color and flickering effects found in the landscapes of Constable (Figure 7-10). Their preference for flat planes and bold design is traceable, as we saw, to their fascination with Japanese prints. But their overriding obsession was with the phenomena of the world of vision—the raw materials of light and color—and the search for their equivalents in oil paint. Sometimes this led to an almost total neglect of the underlying physical structure of things. Monet, more systematically than any of the others, pursued a study of the effects of light by selecting a particular object—it did not matter whether it was a haystack or a Gothic cathedral (Figure 12-6)—and painted it numerous times under differing light condi-

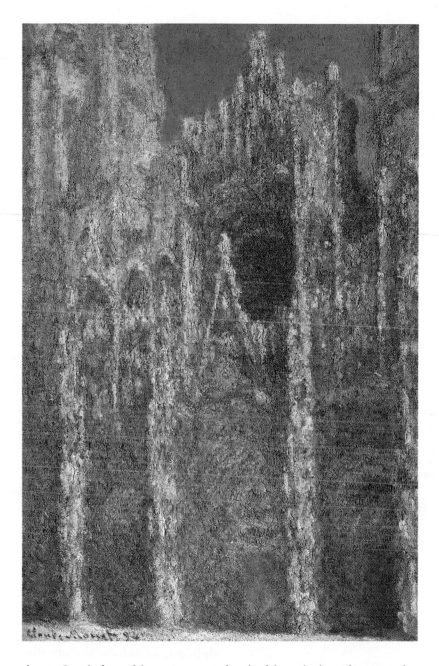

12-6 Claude Monet, *Rouen Cathedral, Sunset*, 1894. Oil on canvas, 39½″ × 25¾″. Courtesy Museum of Fine Arts, Boston (Juliana Cheney Edwards Collection).

tions. Carried to this extreme, color in his paintings became detached from the objects represented; it came to have a life of its own, and suggested the possibility of an abstract art of colors, textures, and shapes that did not necessarily resemble those of the everyday world. Ironically, the Impressionists' contributions to realistic painting actually helped lead art away from realism.

THE BIRTH OF THE AVANT-GARDE

There was still another legacy that Manet passed on to later generations. The furor over *Luncheon on the Grass*, rather than repelling other artists, attracted many to Manet's way of thinking. The scandal itself helped bring about Manet's leadership among the more progressive young painters whose works were also attacked because of their unorthodox styles. If it did anything, ostracism served to encourage them; beginning in 1874, the Impressionists had the audacity to sponsor their own series of public exhibitions.

By the 1890s, the Impressionists had obtained the acceptance and acclaim of the official art world that had spurned their work earlier. But the lag in recognition and the temporary hostility between the artists and their public is a predicament that has continued to exist in the art world almost to the present day. Since the late nineteenth century, there has been an *avant-garde*—a small number of artists whose understanding of art is more advanced than that of their contemporaries and who are for that reason perceived by the general public to be nonconformist and experimental.

Rodin

One artist who especially exemplified the independent spirit of the times was Auguste Rodin, a sculptor the same age as Monet. While Rodin received enthusiastic support from the avant-garde painters, he also succeeded in gaining recognition from the general public. At the time academic sculpture was, if anything, in worse shape than academic painting, and the artistic and spiritual vacuum being filled by the bold works of young Rodin was appreciated even by some members of the art establishment.

However, Rodin's unusual ideas and style were not always greeted with wholehearted acceptance. His first major public monument—begun in 1884 for the city of Calais—engulfed him in a decade of controversy. The purpose of the monument was to honor the fourteenth-century heroes of Calais who offered to sacrifice their lives to the English army to save the entire city from destruction. Rodin elected to depict all six men at the moment each made the decision to sacrifice himself. However, the sponsors objected to his plans, preferring a more traditional monument with a statue of a single heroic figure to symbolize all six. But Rodin refused to compromise, and for a while the sponsors went along. However, when they saw the preparatory models for the six figures they objected once again, this time to the style. Rodin's roughly finished, extremely emotionalized figures bore none of the marks of conventional sculpture—which at that time were noble gestures, carefully planned proportions, and highly polished surfaces. Yet, despite the

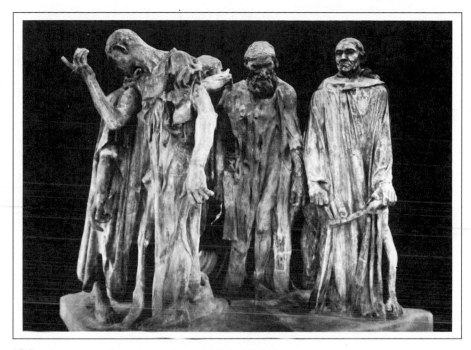

12-7 Auguste Rodin, *The Burghers of Calais*, 1884–86. Bronze, approx. 82″ × 94″ × 75″. Musée Rodin, Paris. Copyright 1990 ARS N.Y/ADAGP

objections and other problems that arose, Rodin stuck to his original idea. *The Burghers of Calais* (Figure 12-7) was finally installed in the city in 1895.

The prolific textures of Rodin's bronze are reminiscent of Monet's broken colors and reflect Rodin's interest in the Impressionists' methods. The vibrant surface affects the play of light, sometimes giving the figures the appearance of movement. Often when a Rodin sculpture first received notice, critics accused him of casting from life, so suspicious were they of the energetic modeling of the surfaces. The right kind of lighting can imbue a Rodin with an uncanny degree of life; on the other hand, the busy texture, like the many daubs in Monet's painting, can dissolve the form to such an extent that one becomes conscious only of its glittering abstract surface.

But the gravity of the subject matter and the heavy drama of Rodin's *Burghers* have little in common with the emotional detachment of most Impressionist painting. The heroic sacrifice of these historical figures is a world away from the sun-filled, passive landscapes of Impressionism. It was to be the emotionalism of Rodin's works—not their Impressionistic tendencies—that would have the greatest influence on early twentieth-century sculpture.

POST-IMPRESSIONISTS

By the late 1880s, when Impressionism was on the verge of its popular triumph, the avant-garde had already passed into the hands of new artists. Three of these—Cézanne, Van Gogh, and Gauguin—deserve special attention. While all three had been associated to a greater or lesser degree with the Impressionist movement, each broke away to pursue his own separate artistic goals. In different ways all three began to renounce pictorial reality. Collectively these three are often referred to as *Post-Impressionists* because their individual styles crystallized later than Impressionism's and their work was a more advanced phase of the Modern movement. But these men and their work were so different from one another that Post-Impressionism, unlike Impressionism, never really amounted to a single movement.

Cézanne

Paul Cézanne—whose art was among the most influential in the Modern movement—hardly resembled the self-assertive hero-artist of the avant-garde. Unlike Manet or Rodin, during his most productive years as an artist he was a conservative and serious provincial who attended early mass and spent the rest of the day at work on his paintings. But even though he was isolated from the activities of Paris, Cézanne almost rewrote the rules of painting.

The key to these rules had to do with a new translation of reality. Artists before Cézanne, including the Impressionists, generally attempted in one way or another to imitate the appearances of nature. Although Cézanne did not disregard appearances entirely, he substantially altered them in the process of painting—which to him was a difficult, methodical labor of penetrating the essence of a subject. Above all he wanted to capture the subject's inherent solidity. He did this for each apple in *Still Life with Basket of Apples* (Figure 12-8) by juxtaposing distinct hues rather than shading with intermediate values. This de-emphasis of chiaroscuro was, of course, started by Manet and continued by the Impressionists, but they de-emphasized the solidity of objects in order to capture fleeting effects of reflected sunlight. This would not do for Cézanne, who methodically applied slablike strokes of red, orange, and yellow as he built each apple. This method of constructing forms is found throughout the painting. The white cloth, for example, has qualities of weight and tangibility that are never found in Impressionist works.

Cézanne's translation of reality also took liberties with the traditional rules of perspective and foreshortening. *Still Life with Basket of*

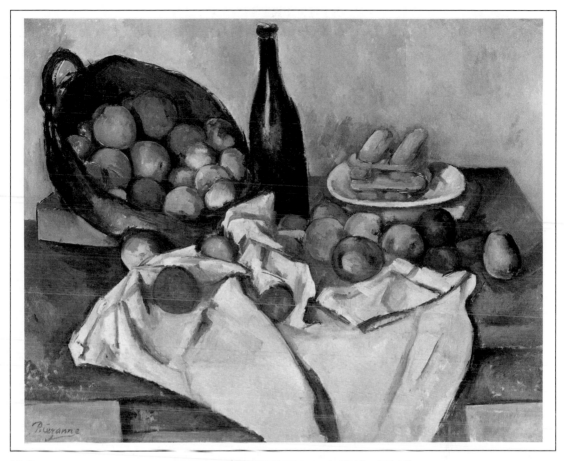

12-8 Paul Cézanne, *The Basket of Apples*, c. 1895. Oil on canvas, 25¾″ × 32″. The Art Institute of Chicago (Helen Birch Bartlett Memorial Collection).

Apples intermingles a number of contradictory viewpoints: The cookies stacked on the plate do not all lie on parallel planes, the bottle is tilted, and the surface of the table is distinctly higher on the right than on the left. These liberties are even more pronounced in his landscape painting *Mont Sainte-Victoire Seen from the Bibémus Quarry* (Figure 12-9). Rather than use a traditional one- or two-point perspective system, Cézanne combined the rock surfaces, trees, and bits of sky into a multiperspective system of several focal points. Such a system may in fact represent the conditions of normal vision more truthfully than traditional perspective. (Our field of vision is broad, but we can only focus on one small area at a time. Therefore when we scan a scene, we focus on several different points while not being conscious of all of them.) But the overall

12-9 Paul Cézanne, *Mont Sainte-Victorie Seen from Bibémus Quarry*, c. 1897. Oil on canvas, 25⅛″ × 31½″. Baltimore Museum of Art (The Cone Collection founded by Dr. Claribel Cone and Miss Etta BMA).

effect in a Cézanne painting is not that of visual reality but of visual energy. Although the competing viewpoints produce a certain amount of tension, they have been played off against one another to create a vital stability. Cézanne was a master at balancing opposing forces.

We can see from these works that another important element of Cézanne's approach to painting is his emphasis on composition. Every canvas was a problem to solve, not in transcribing nature but in translating the energy and order of nature into painted surface. Every color and arrangement of objects had their purpose in the harmony of the whole. The many distortions and dislocations, far from being arbitrary, were absolutely necessary to this harmony.

Because of a substantial family inheritance, Cézanne did not

paint for money. (Until the last decade of his life he scarcely sold a painting). He did not paint for the public either. No works of his were ever accepted by the official Salon, and when they were shown in the Impressionist exhibits of the 1870s, they were the object of ridicule. He eventually left Paris and returned to his family's home in Provence, where he spent the rest of his years pursuing his demanding art to satisfy himself. He lived long enough, however, to see his art receive recognition and come to be valued by a new and much younger avant-garde.

Van Gogh

The tragic life of Vincent Van Gogh, born in Holland of Dutch Reformed missionaries, paralleled that of Cézanne in some respects. Unlike the Impressionists, neither artist was urbane and charming; Van Gogh, especially, who was given to fits of depression, alienated people. Both started their careers late; both worked in Paris before moving to the south of France. As artists, both were outsiders as far as the official art world was concerned; both were on the edges of Impressionism. In the works of both, abstraction began to take precedence over traditional realism, but in different ways: Cézanne's interest lay in discovering and translating the essential structure of nature; Van Gogh's interest was that of possessing and expressing the intense human meanings of everything around him.

Not long after arriving in Arles Van Gogh wrote to his sister " . . . at present the palette is distinctly colorful, sky blue, orange, pink, vermilion, bright yellow, bright green, bright wine-red, violet." The fresh air and warmth of that first spring in southern France had a salutary effect on Van Gogh's art and, at least for a time, his feelings about life. Each painting of orchards, fields, drawbridges, and the like tended to suggest optimism. The letter to his sister could have been about *View of Arles with Irises in the Foreground* (Figure 12-10). Painted in May, this work is a celebration of spring and an affirmation of life in general. The strong colors and bold shapes woven together by thick, lively brushstrokes not only radiate the joy of spring but reveal the artistic self-confidence Van Gogh had acquired in only eight years. Every form—iris, buttercup, tree, building—is superbly delineated from inside to outside, with each stroke doing the job of drawing as well as painting. *View of Arles*, like so many paintings he made in his first months there, demonstrates that Van Gogh—in spite of his tendency to become depressed— could make very positive paintings. Southern France in the spring had brought out his enthusiasm for life; according to one art historian, "the painting of Arles was a return to Eden."

12-10 Vincent van Gogh, *View of Arles with Irises*, 1888. Oil on canvas, 21¼″ × 25½″. Vincent van Gogh Foundation/National Museum Vincent van Gogh, Amsterdam.

That fall Paul Gauguin had arrived in Arles at the invitation of Van Gogh, who hoped that the two would form the nucleus of a brotherhood of artists—a dream Van Gogh had had since Paris. He admired, almost worshiped, Gauguin—a mystic, adventurer, notorious debauchee, and a potentially important painter of the Modern movement. Unfortunately, Gauguin either could not or would not return Van Gogh's admiration, and his instinct for sarcasm and provocation found an easy target in the sensitive younger artist. The circumstances of their association led to a series of nervous breakdowns for Van Gogh, including the now-legendary story of his cutting off an earlobe and presenting it to a prostitute on Christmas Eve of 1888. From this time on, he was in and out of hospitals until he committed suicide in the summer of 1890.

12-11 Vincent van Gogh. *The Starry Night.* 1889. Oil on canvas, 29″ × 36¼″. Collection the Museum of Modern Art, New York (acquired through the Lillie P. Bliss Bequest).

During this time, however, he never ceased to paint and draw. Much of his work from this period, not surprisingly, is even more subjective and charged with even greater energy than his earlier pieces. *The Starry Night* (Figure 12-11), painted from the window of his room in the hospital at St. Rémy-de-Provence, is overflowing with excited forms. At the lower right is a village sheltered by the mountains and dominated by a church spire reminiscent of those in Holland. Commanding the left side is the flamelike shape of a huge cypress tree—an ancient symbol of death—which extends from bottom to top and overlaps the dramatic sky, the main feature of the picture. The town is painted with short, measured strokes, and is relatively quiet; the tree is painted with long, thick, serpentine strokes and is quite restless; the sky, a phantasmagoria of celestial activity depicted with sweeps and spirals of thickly applied paint, represents a stage of delirium.

The feeling of vertigo prompted by the waving, spinning forms suggests an impending disaster that could be either cosmic or personal. In any case, *The Starry Night* conveys emotion primarily through shapes, textures, and lines rather than subject matter and symbolism. Van Gogh's paintings, like those of Cézanne, were discovered by avant-garde artists of the early twentieth century. In Van Gogh's case, these artists were inspired by the intensity of his color and the emotionalism of his forms. Van Gogh was the spiritual ancestor of all the expressionistic arts movements of the twentieth century.

Gauguin

Paul Gauguin, the third major Post-Impressionist painter, aggressively pioneered the same basic principle as Cézanne and Van Gogh—that the elements of form have artistic power in their own right. A profound colorist, his paintings regularly display an exotic palette of purples, pinks, yellow-greens, and bright oranges; yet their effect is usually ingratiating and never as provocative as Van Gogh's vivid colors. Instead of Cézanne's multiple planes and viewpoints, Gauguin's forms are generally flat and endowed with an ornamental vigor suggestive of tropical plants and reflective of Japanese prints. And instead of Van Gogh's thick texture of brushstrokes, Gauguin's painting surface is relatively smooth. In *Vision after the Sermon, Jacob Wrestling with the Angel* (Figure 12-12), the artist simplified and stylized the bonnets of the peasant women to stress their abstract shapes and lines. The field where the struggle takes place tilts upward to provide a vertical backdrop for the foreground shapes, and is painted red-orange to contrast with the white of the bonnets and the greens and blues in the rest of the picture. But despite his emphasis on abstract form, Gauguin did not disregard the importance of subject matter and religious content. His mysticism and love of myth are reflected in *Vision after the Sermon,* as are his decorative tendencies. Indeed, the simplicity of the images lends the picture a naive flavor that heightens the sense of piety and mystery. Gauguin chose freely from primitive religions as well as Christianity for his themes. In fact, his enthusiasm for primitive culture, together with a distaste for "civilization," eventually led him to settle in Tahiti.

While still in France, Gauguin was a prominent figure in the avant-garde movement of the late 1880s. Gregarious and verbal, he was given to expounding on art—especially his theories about the "autonomy" of color, shape, and line. In this respect he differed markedly from his friend Van Gogh, who manifested these theories

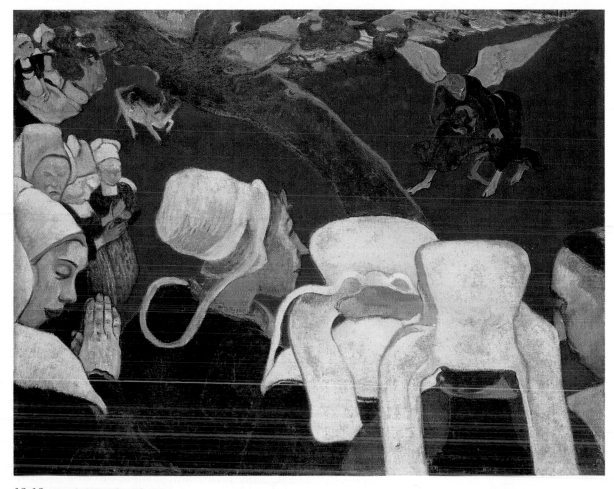

12-12 Paul Gauguin, *The Vision after the Sermon (Jacob Wrestling with the Angel)*, 1888. Oil on canvas, 28¾″ × 36¼″. National Gallery of Scotland, Edinburgh.

in his art but was too backward socially to circulate his ideas beyond writing letters to his family. Gauguin had a striking personality, and young artists were naturally drawn to him. At informal gatherings in Pont-Aven, a small fishing village on the coast of Brittany, he kept them spellbound talking about his theories. His influence extended beyond artists. The Symbolists, an intellectual movement mostly of poets, saw an embodiment of their own ideas in his intensification of color and simplification of form as a means of expressing a mystical reality. An experimental avant-garde of the literary world, the Symbolists were also obsessed with the dilemmas of conveying the invisible realities of the inner life through outer visible forms.

Because of his following of young artists and his contacts with the Symbolists, Gauguin had a more immediate impact on art than

either Cézanne or Van Gogh. This impact was instrumental in creating a climate for a new art to develop and for the work of all three of these artists to achieve recognition and acceptance.

FIN DE SIÈCLE

The 1890s, known as the *fin de siècle,* or end of the century, were years of great artistic activity but few real advances. The ideas implied in the works of the three principal Post-Impressionists were particularly influential at this time, even though the artists themselves were no longer part of the Parisian art world. Van Gogh was dead, Cézanne was sequestered in Provence, and Gauguin was in self-imposed exile in the South Pacific. Gauguin's ideas, especially, were receiving increased attention. His popularity with the Symbolists—who wrote about him in their magazine—helped provide him an audience. The Nabis, a group of young artists which was an outgrowth of his Pont-Aven following, spread his theories still further. Moreover, his tendencies toward stylized images and decorative patterns were beginning to be reflected in the popular arts of the time—particularly posters and newspaper caricatures.

Georges Seurat, who died in 1891, was another artist whose ideas continued to receive a great deal of attention in avant-garde circles. Although more closely related to Impressionism, Seurat's work carried an aspect of that style to an extreme that had not been anticipated by the Impressionists themselves. He invented *Pointillism,* a quasi-scientific approach to painting in which an entire picture is made with small strokes or dots of bright color (Figure 2-1). When seen from a normal viewing distance, the separate strokes or dots blend in the observer's eye. A very methodical artist, Seurat took great care in composing his paintings while working in a studio from studies he had made outdoors. As a result, his works were not as spontaneous as those of the Impressionists (most of which were painted outdoors), but the luminosity effected by the Pointillist dots implied a degree of abstraction and thus certain possibilities for those artists seeking new approaches.

Another major artist of the period was Henri de Toulouse-Lautrec, whose paintings represent still another variation on Impressionism. In *At the Moulin Rouge* (Figure 12-13), a painting about a bawdy nightclub in Paris, Toulouse-Lautrec's loose brushwork, cropped foreground figure, high eye level, and strong design were clearly influenced by both Impressionism and Japanese prints. He used this artistic vocabulary not to depict radiant sunlit scenes but to celebrate the artificial lights and shadows of the night. An aristocrat and a cripple with a man's body on a child's legs, he showed a perverse empathy for the "society" of the Parisian brothels and cab-

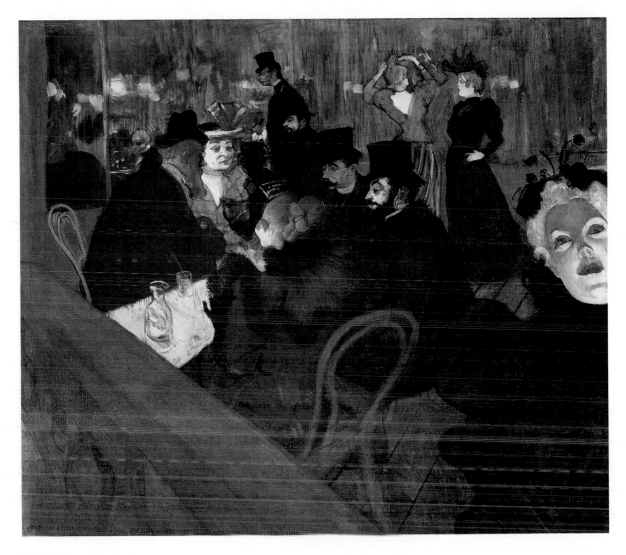

12-13 Henri de Toulouse-
Lautrec, *At the Moulin Rouge*, 1892.
Oil on canvas, 47½" × 55¼".
Courtesy of the Art Institute of
Chicago (Helen Birch Bartlett
Memorial Collection). © 1989 The
Art Institute of Chicago. All rights
reserved.

arets. His paintings and lithographs, which combine sympathy and
keen observation with a tinge of satire, reflect something of the
cynicism that was symptomatic of the *fin de siècle.*

The intellectual climate of the time also contained a profoundly
defeatist attitude about modern life. Anxieties stemming from the
unresolved social problems of a new industrial-urban society had a
spiritual counterpart in the disturbing questions and self-doubts
that surfaced in the writings of poets and philosophers. Much of
the art of the generation wallowed in mysticism and eroticism. The
most poignant expression of this general climate is found in the art
of Edvard Munch, whose painting *The Scream* (Figure 12-14) both

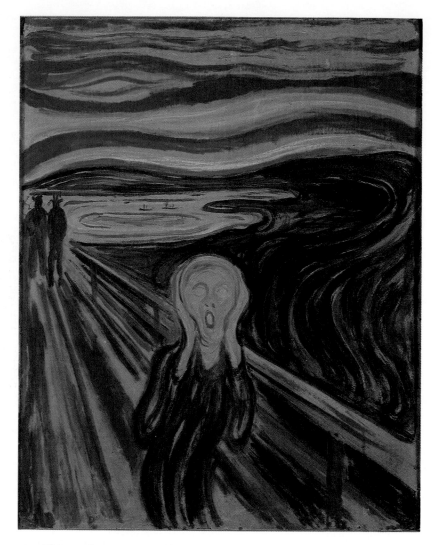

12-14 Edvard Munch, *The Scream*, 1893. Tempera on board, 36″ × 29″. Munch-Museet. Oslo Kommunes Kunstsammlinjer.

signifies and protests against the spiritual crises of the day. Its curvilinear patterns and serpentine lines, traits shared by the works of Van Gogh (Figure 12-11) and Gauguin (Figure 12-12), evoke here the sensations of nausea, despair, even paranoia. A Norwegian, Munch spent the most creative part of his life in the cities of Berlin and Paris. And like Van Gogh, he showed sensitivity and a talent for expressing intense psychological experiences.

Art Nouveau, a decorative movement that flourished all over Europe, was the equivalent of Symbolist aesthetics in the realm of applied arts. Its practitioners, rejecting traditional ornamental styles, sought to base Art Nouveau on natural motifs taken from the world of plants. The graphics of this style are known for strik-

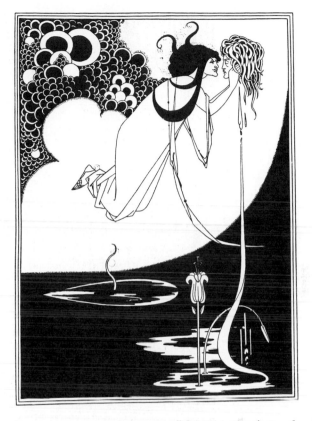

12-15 Aubrey Beardsley, *The Climax*, 1894. Drawing. Originally published in Oscar Wilde's *Salome, A Tragedy in One Act.*

ing patterns reminiscent of Japanese prints; the lurid, "whiplash" lines are almost a caricature of the lyrical forms in the paintings of artists like Gauguin and Van Gogh. The drawings of Aubrey Beardsley perhaps epitomize Art Nouveau graphics. His illustrations for Oscar Wilde's *Salome* (Figure 12-15)—in which lust and morbid fascination are set in starkly elegant black and white—reflect as much as anything the decadence of the 1890s. The fact that a popular art form like Art Nouveau could flaunt such modernist tendencies suggests that the ideas of the Modern movement were achieving visibility among even the public at large.

SUMMARY

The modern period, in which change appears almost to have become a permanent condition, has witnessed the retreat from Realism as well as the most rapid evolution of styles in the entire history of art. In reviewing the start of that period, we began with Manet and the Impressionists and ended with Art Nouveau—by which time the aesthetic revolution was well underway.

CHAPTER

13

THE EARLY TWENTIETH CENTURY

THE FIRST TWO DECADES of the twentieth century was a period of considerable changes and advancements in the art world. A new avant-garde or big new idea seemed to emerge every year. While new breakthroughs continued to dismay the critics and to be met with varying degrees of resistance, they were no longer denounced out of hand. Twentieth-century critics, mindful of what happened to their nineteenth-century predecessors regarding Impressionism, were wary of making the same kinds of mistakes.

MATISSE AND THE FAUVES

The first of the major twentieth-century artists was Henri Matisse, who had begun to paint after completing law studies. He first tried to work in the style of Impressionism and then became acquainted with the work of Cézanne—whose discipline was more suited to his own logical mind. He was also attracted for a time to Seurat's work, but found that Seurat's tedious technique did not appeal to him—although this study of Seurat did improve his understanding of color. He discovered Van Gogh's work at a retrospective exhibit, where he also met other artists, including André Derain (Figure 2-11), who were under the spell of this emotional use of color. Through his association with them, Matisse came under the same spell—incorporating the audacity of bold color with his analytical temperament. After spending the summer of 1905 painting in a village on the Mediterranean, he joined others to show paintings in a salon specializing in progressive art. The work of Matisse and his friends so exasperated one critic that he called the group of painters *Fauves* ("wild beasts" in French).

The critic's quip was aimed at paintings like *Window at Collioure* (Figure 13-1). While it is true that the colors in this work do not

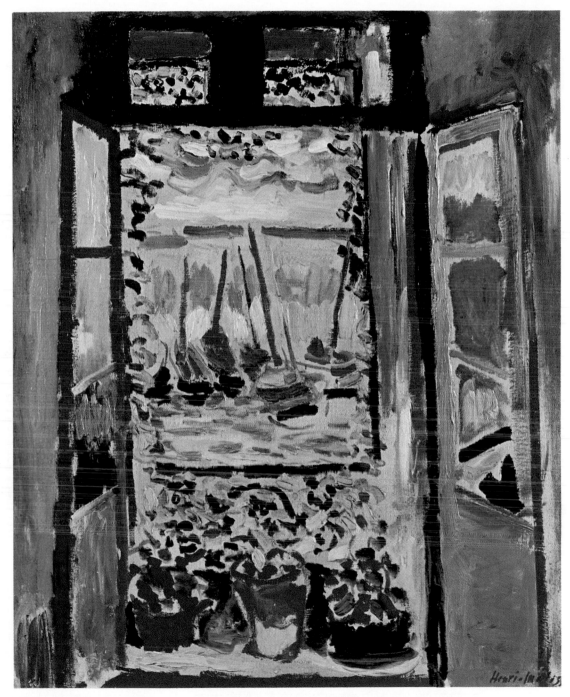

13-1 Henri Matisse, *Window at Collioure*, 1905. Oil on canvas, 21¾″ × 18⅛″.
Private collection.

resemble the colors of the objects they represent, their role is far from wild or arbitrary. The subject matter, a slice of the Mediterranean shore seen through a window, is important because it furnishes a pretext for exploring interesting color harmonies. The largest areas of color—blue-green, light-orange, and pink—are interlocked in rectangular shapes on either side of the window. The marina scene within the window is composed of small areas of these colors, in addition to spots of yellow, blue, and black. The consequence of the similarities and contrasts among these hues is that the eye is guided through the picture in interesting, sometimes unexpected, ways. Despite their brightness, they are harmonious. The artist's experience with Pointillism was helpful, although intuition may have played a bigger role in his manipulations of color. The picture does, indeed, evoke the refreshing experience of being on a seashore. But it does so by means of vivacious color, not the imitation of appearances.

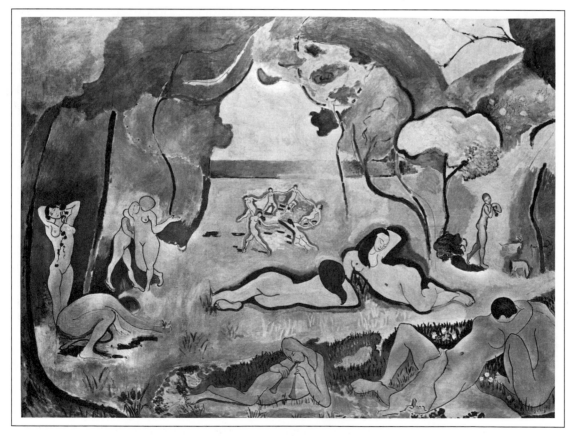

13-2 Henri Matisse, *Joy of Life,* 1905–06. Oil on canvas, 68½″ × 93¾″. Photograph
© Copyright 1991 by The Barnes Foundation.

Despite the merit of such works, the critic's label stuck. The 1905 salon has since earned a place in history as the "Fauves show" and become recognized as the first exhibit of twentieth-century art—that is, "modern art" as we know it today. As a movement, the Fauves, or Fauvism, was short-lived. Only a few of the nine original members went on to become well known artists.

Almost as soon as Matisse had achieved his controversial success with Fauvism, he felt compelled to consolidate his gains as the leading innovative artist of the time. He examined the work of his predecessors—the Impressionists, Cézanne, Seurat, Van Gogh, and even the other Fauves—and developed a style that incorporated their advances while remaining completely his own. *Joy of Life* (Figure 13-2), a large canvas of rather conventional subject matter—a pastoral setting of naked nymphs and lovers—is the result of that effort. Like *Window at Collioure*, this one subverts all the conventions of pictorial realism while extolling color for color's sake. The difference is that now the shapes and lines are fluid, the tonal areas are continuous. In short, *Joy of Life* is more refined. The Fauve has been tamed, but without sacrificing freedom of color and abstract form. In the final analysis, its flat, curvilinear shapes are more reminiscent of Gauguin's work than of Cézanne's or Van Gogh's. The joy in *Joy of Life* is conveyed not by the figures of the dancing nymphs but by rhythmic line and luscious color—signatures of a style Matisse pursued for the rest of his life.

GERMAN EXPRESSIONISM

Such was the strength of this new spirit in art that the Fauves had counterparts in other European countries, particularly Germany, where a band of young artists calling themselves *Die Brücke* (The Bridge) developed a related style at about the same time the Fauves made their splash in Paris. A few years later, another group called *Der Blaue Reiter* (The Blue Rider), consisting of Germans and expatriates such as the Russian Wassily Kandinsky, formed a loosely knit fellowship dedicated to similar artistic ideals. The work of these groups and other artists in Germany—active from just before World War I until the reign of Adolf Hitler—has come to be known collectively as German Expressionism. Among the many artists involved were Käthe Kollwitz (Figure 2-30) and Oskar Kokoschka (Figure 8-28).

The brief Fauvist movement was a stimulus to the early German Expressionists. Its image-provoking label symbolized their own sense of rebellion, and the liberation of color and shape from the rules of conventional realism corresponded to their own artistic strivings. But there was a crucial difference in approach between

the Germans and the French. The themes and subject matter used by the French were essentially unprovocative; color was used for color's sake. Matisse served up a delectable and challenging concoction of color and form as food for the viewer's mind and senses. On the other hand, the Germans' themes were usually provocative— and the German artists used color and distorted form not for their own ends but for the sake of expressing the artists' deeply felt personal reactions to life. Thus these artists were the true spiritual heirs of the late-nineteenth-century artists Van Gogh and Munch.

Paula Modersohn-Becker, who was not affiliated with Die Brücke or Der Blaue Reiter, is generally regarded as the earliest of the German Expressionists. She was the first German artist to respond to Post-Impressionism and make use of it in an original way, much as the Fauves were at about the same time. The robust shapes in *Old Peasant Woman Praying* (Figure 13-3) are reminiscent of the vigorous patterns of Gauguin and the Nabis; the strong planes of the face, indicating the structure of the head, reflect the work of Cézanne; and the emotional approach to the subject recalls Van Gogh's work. Modersohn-Becker emphasized the dignity of the

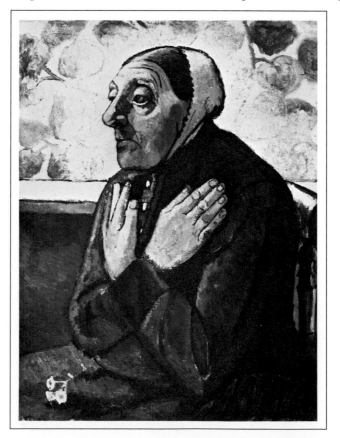

13-3 Paula Modersohn-Becker. *Old Peasant Woman Praying*, c. 1905. Oil on canvas, 29¾″ × 22¾″. The Detroit Institute of Arts (gift of Robert H. Tannahill). © The Detroit Institute of Arts.

woman by the simplicity and monumentality of the figure, which fills most of the composition. The directness, primitive tendencies, and human concern of her art were much admired by the German Expressionists, and she would no doubt have been a leader in their movement had it not been for her untimely death at the age of 31.

Of all the early Expressionists in Germany, only Kandinsky occupied himself more with the abstract elements of form and color than with human emotions. He was fond of equating the elements of painting with those of music, feeling that they could be treated in much the same way. Abstract painting can be said to have been born in 1910, when Kandinsky painted his first completely abstract work. His earliest experiments, consisting of floating colors and lines, were somewhat amorphous (Figure 13-4); his later works were often organized around geometric figures floating in rainbow-colored space. But even his most amorphous works, unlike those by the Abstract Expressionists (Chapter 14) made around 35

13-4 Wassily Kandinsky, *Improvisation* (Little Painting with Yellow), 1914. Oil on canvas, 30¾″ × 39⅞″. Philadelphia Museum of Art (Louise and Walter Arensberg Collection).

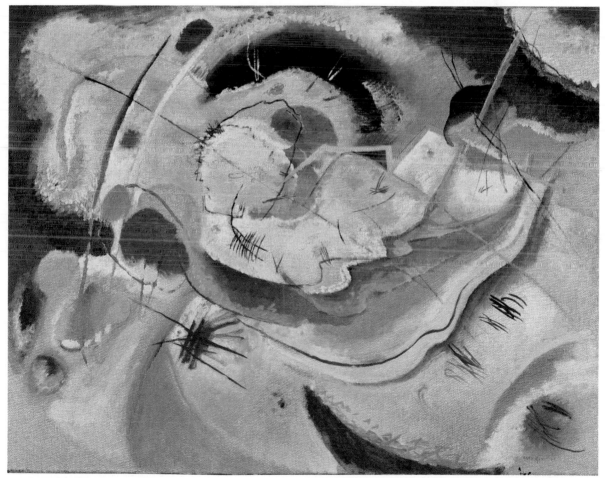

years later, contain a certain number of dominant shapes, colors, and lines to guide the eye. In order to counteract the temptation to seek "real" images in his work and to emphasize the intent to provide a perception of pure form, he often titled his paintings as if they were musical compositions.

Prior to World War I, Max Beckmann was a successful conservative painter. Enlisted as a medical orderly in the German army during the war, he suffered a nervous collapse and had to be discharged. He was so shattered by his war experiences that at first he could not even paint. When he resumed painting he began to change his style and eventually arrived at the disturbing and disjunctive imagery seen in *Departure* (Figure 13-5). The painting is in the form of a triptych, a three-section work of the type once used for religious subjects and placed above altars. But instead of the holy acts of saints, this triptych is an allegory either of Beckmann's experiences in World War I or of the depravity, violence, and fear common in Germany during the years before World War II. In the two side panels people are being tortured and mutilated; in the center some people in classical costumes stand in a fishing boat,

13-5 Max Beckmann, *Departure*, 1932–33. Oil on canvas, triptych, center panel 74¾″ × 45⅜″, side panels each 7′¾″ × 39¼″. Collection, The Museum of Modern Art, New York. Given anonymously.

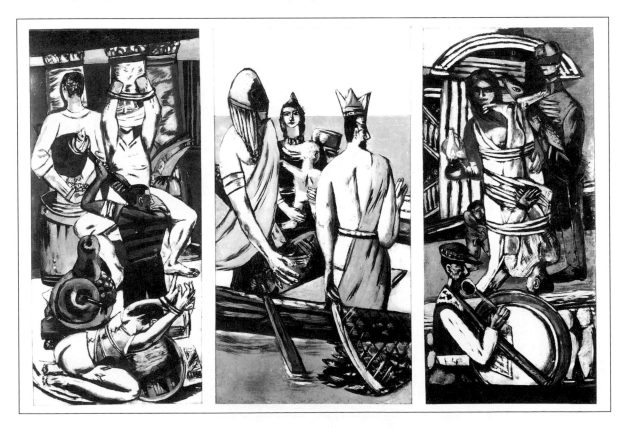

perhaps departing as the title suggests, perhaps even going into exile (as Beckmann himself was soon to do). Featuring abrupt transformations and alien combinations of images and themes, Beckmann's style was adapted from both Cubism and Surrealism.

German Expressionism included sculpture as well as painting. The rough finish and emotionalism of Rodin's sculptures (Figure 12-7) were the primary inspiration to Wilhelm Lehmbruck, who introduced these qualities into his own work. But the elongation and distortion of his *Standing Youth* (Figure 13-6)—a typical Expressionist strategy for eliciting intense emotion—represent a tampering with proportions that even the bold Rodin would not have dared. Lehmbruck's sculptures convey a depth of concern about human life that was characteristic of German Expressionism in general.

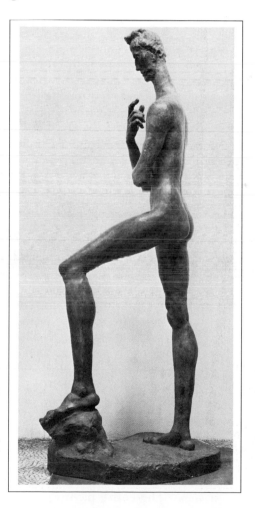

13-6 Wilhelm Lehmbruck, *Standing Youth*, 1913. Cast stone, 7′8″ high at base 36″ × 26¾″. Collection, The Museum of Modern Art, New York (gift of Abby Aldrich Rockefeller).

PICASSO AND CUBISM

In 1905, the year of the Fauves exhibit, Pablo Picasso was a struggling young painter in Paris. A native of Spain (where he received his training) Picasso visited Paris in 1901 and returned to stay in 1903. During his early years there, he began to seek new sources of inspiration in an attempt to catch up with the Modern movement. In addition to Post-Impressionism, he studied African sculpture and pre-Roman Spanish sculpture. By 1905 he was beginning to assimilate these influences into his work, as his experiments in style showed increasing originality.

There is reason to believe that Matisse's *Joy of Life* inspired the young Picasso to make a landmark work of his own. In 1907, after working for several months, Picasso unveiled *Les Demoiselles d'Avignon* (Figure 13-7), a painting that turned out to be more a mockery of Matisse's approach than a tribute to it. An incongruous collection of female anatomy, *Les Demoiselles* seems radical today, even after almost a century of modern art. In 1907 it was so radical it surpassed the Fauves. Matisse himself was shocked, calling it an outrage and a mockery of the Modern movement. *Les Demoiselles* savaged not only the female nude, but all traditions of basic form and composition dating to Masaccio. Yet, behind its seeming irrationality there is precedent and method. The breaking up of the forms into planes, together with the push and pull of shallow depth, had been learned from Cézanne. The severity of some of the planes—especially those of the faces on the right—was influenced by African sculpture. Picasso was the first, but not the only, twentieth-century artist to adapt primitive art to his painting. Ignored for centuries by Europeans who could appreciate only realistic art in the Western tradition, primitive art objects were finally being recognized for their aesthetic values. At the same time, their abstract forms and directness of communication provided inspiration for modern artists in search of new artistic solutions. The Fauves rummaged in junk shops for African masks; the members of Die Brücke were attracted to Melanesian art.

Les Demoiselles was the first in a long series of bold experiments with structure in painting. Together with Georges Braque, Picasso launched a major new artistic style called *Cubism*. While the Expressionists and the Fauves charged into color, the Cubists retreated to an art of values alone—painting in grays and browns in order to concentrate on structure. And while Matisse attempted to stress flat patterns, Picasso and Braque resorted to techniques that created the impression of shallow, three-dimensional space.

Georges Braque's *Violin and Palette* (Figure 13-8) is a representative work from the early phase of this style, known as *Analytic Cubism*. The entire picture is a medley of fractured objects trans-

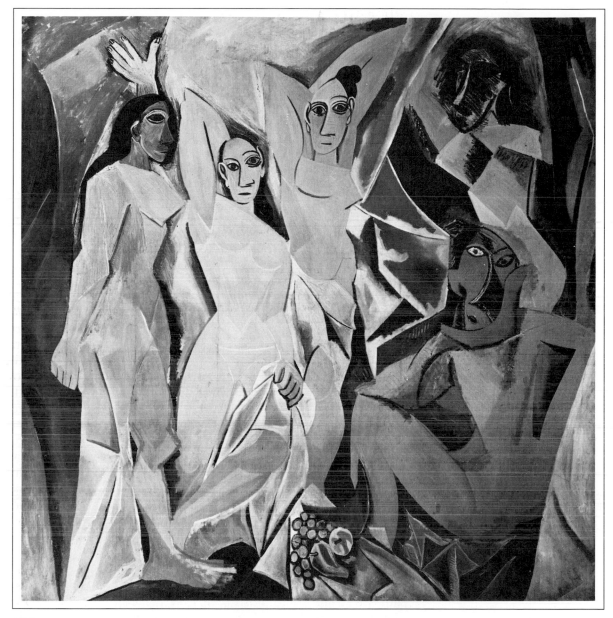

13-7 Pablo Picasso, *Les Demoiselles d'Avignon*, 1907. Oil on canvas, 8' × 7'8". Collection, The Museum of Modern Art, New York (acquired through the Lillie P. Bliss Bequest).

formed into angular, interlocking, translucent planes—recalling the brushwork and the multiple planes in Cézanne's *Still Life* (Figure 12-9). But this system goes far beyond Cézanne's by completely ignoring the original shapes of the objects—such as the violin—and remaking them so that one can see their surfaces from several angles simultaneously. The space around the object becomes part

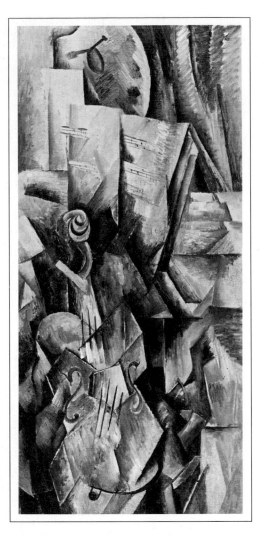

13-8 Georges Braque, *Violin and Palette*, 1910. Oil on canvas, 36¼″ × 16⅞″. Collection, The Solomon R. Guggenheim Museum, New York. Photo: David Heald. Photograph © 1990. The Solomon R. Guggenheim Foundation.

of it, so that the whole composition is suggestive of a multifaceted gem. The color—more subdued and conservative than any seen since before Manet's breakthrough nearly half a century earlier— does not detract from the shallow but intricate spatial relationships. Thus, while this art roughly parallels Matisse's in its degree of abstraction, it disfigures reality with different means and for different reasons. Matisse looked to nature for lyrical harmonies of color and pattern; Picasso and Braque systematically broke nature into abstract volumes and rhythms.

By 1912 Analytic Cubism had been fully developed and had inspired other movements. But Picasso and Braque were ready to move on to something else. They experimented with adding pieces

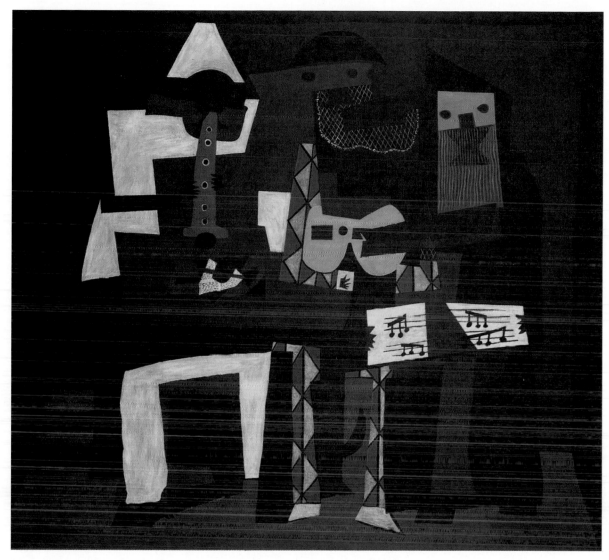

13-9 Pablo Picasso, *Three Musicians*, 1921. Oil on canvas, approx 6′7″ × 7′3¾″. Collection, The Museum of Modern Art, New York (Mrs. Simon Guggenheim Fund).

of material—newspaper clippings, cloth, wood veneers, and so forth—to their paintings, and thus invented a medium known as collage (Chapter 4). These experiments soon led to *Synthetic Cubism* which, unlike Analytic Cubism, tended toward flatness and depended less on real objects as a starting point. Rather than a system of shaded planes, Synthetic Cubism features flat, overlapping shapes; rather than monochromatic browns and blacks, it specializes, like the art of collage, in color variety and vivid surface textures. In addition, Picasso's *Three Musicians* (Figure 13-9) has a piquant whimsy that is rarely, if ever, found in sober Analytic

Cubism. The translucency and multiple viewpoints of the earlier style were sacrificed for a livelier aesthetic surface. About the only thing the two have in common are angularity of shape and line, a trait found in Léger's *The City* (Figure 2-15) and in Picasso's own *First Steps* (Figure 1-3) which also employ the Cubist idiom.

Elsewhere, the Cubist impulse took still other forms. In Italy, a particularly dynamic version was produced under the name of *Futurism* that directly influenced the work of the American Joseph Stella (Figure 10-8). In France it launched a multitude of styles and affected a great many artists, even those who, like Marc Chagall, were involved in very different pursuits (Figure 8-27). In Russia, where a generation of avant-garde artists had appeared on the eve of the Bolshevik Revolution, it was influential in the drive of the *Constructivists* toward a nearly pure geometry that reached its ultimate expression in the landmark painting by Kasimir Malevich, *White on White* (Figure 13-10).

Cubism was also responsible for the geometrical abstraction of Piet Mondrian, a Dutchman. Beginning with a variation on Analytic Cubism, Mondrian's work became progressively simpler until he arrived at a basic geometric style that he called *Neoplasticism*. The principles of this style can be perceived in *Composition* (Figure 13-11), an austere display of rectangles, thin black bars and primary

13-10 Kasimir Malevich, *Suprematist Composition: White on White*, 1918. Oil on canvas, 31¼" × 31¼". Collection, The Museum of Modern Art, New York.

colors. The simplicity of the work belies its variety. No two rectangles are the same size and shape; none of the colors are repeated; the composition is extremely off-center with red, the strongest and largest color, occupying a corner; even the bars vary slightly in thickness. The task of the artist was to achieve a perfect and sublime balance from this variety. According to Mondrian it was a matter of establishing equilibrium " . . . through the balance of unequal but equivalent oppositions." He raised the issue of balance almost to that of a religion—"rising above all suffering and joy is balance"—and hoped that his art would satisfy the spiritual need that people have to discover the universal harmony within them. Whether or not Mondrian ever realized such a lofty goal, his art did influence the applied arts of product design, interior design, and architecture for several years. Malevich and Mondrian had discovered the road to total abstraction in the faceted planes of Cubism as

13-11 Piet Mondrian, *Composition*, 1929. Oil on canvas, 17¾″ × 17¾″. Collection, The Solomon R. Guggenheim Museum, New York. Photo: Myles Aronowitz. Photograph © 1990 The Solomon R. Guggenheim Foundation.

13-12 Umberto Boccioni, *Development of a Bottle in Space*, 1912. Silvered Bronze, (cast 1931) 15″ × 12⅞″ × 23¾″. Collection, The Museum of Modern Art, New York (Aristide Maillol Fund).

Kandinsky had in the bold colors and impetuous brushwork of German Expressionism.

Cubist painting naturally had its equivalents in the art of sculpture. The breaking up of the image into exaggerated and fragmented planes that tried to re-create the appearance of volume led inevitably to experiments with real space. Picasso and Braque had developed collage, which they expanded into assemblages (Chapter 4). Picasso apparently used these constructions of wood or metal largely as studies for his painting. However, Italian sculptor Umberto Boccioni explored Cubist ideas to develop his sculpture. Boccioni's *Development of a Bottle in Space* (Figure 13-12) is far more dynamic than the works that were done in Paris: In addition to breaking up the forms in order to reveal their structure, he imposed a swirling instability on the composition. Where Picasso's collages and assemblages are destined to hang against a wall, Boccioni's bottle insists on in-the-round viewing. With its clashing planes and varied perspectives, it seems like a more direct descendant of Cézanne's still lifes than any Cubist painting.

DUCHAMP AND DADA

Up to this time, the battles of the aesthetic revolution had been fought and won mostly on French soil. America had felt only a few of the shock waves coming from the European continent and no city in America had as yet experienced a bombshell comparable to

those of Manet's *Luncheon on the Grass* or the Fauves exhibit—until the International Exhibition of Modern Art of 1913. This exhibition, now known as the Armory Show, contained more American works than others—but it was the European collection, especially the recent French works, that created all the stir.

The painting that inspired the most comment of all was Marcel Duchamp's *Nude Descending a Staircase* (Figure 13-13). One wag called it "an explosion in a shingle factory;" Theodore Roosevelt said that it reminded him of a Navajo blanket. Ironically, the Americans had attacked the right artist for the wrong reasons: Duchamp proved to be one of the twentieth century's most controversial artists; however, his *Nude Descending a Staircase*, the paint-

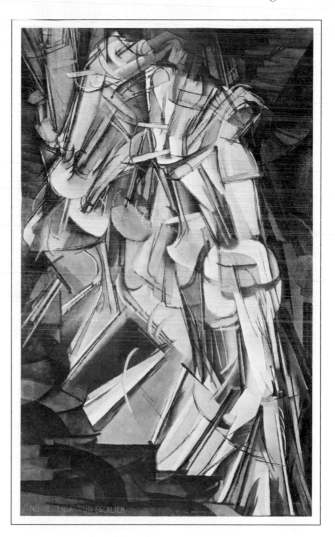

13-13 Marcel Duchamp, *Nude Descending a Staircase, No. 2*, 1912. Oil on canvas, 58″ × 35″. Philadelphia Museum of Art (the Louise and Walter Arensberg Collection).

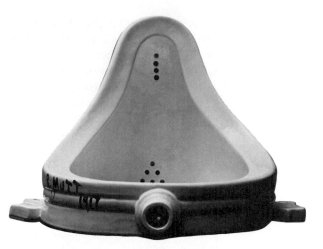

13-14 Marcel Duchamp (signed R. Mutt), *Fountain*, 1917. Porcelain, 24⅝″ high. Arturo Schwarz Collection, Milan, Italy.

ing that attracted so much attention in the 1913 show, was a comparatively tame version of Cubism, having neither the raw shock of *Les Demoiselles* nor the novelty of the latest collage inventions.

But many of the artworks created by Duchamp in the years following the *Nude* were radical even by today's standards: for example, a sculpture of 1917 entitled *Fountain* (Figure 13-14) consisted of a urinal turned on its side. These radical artistic gestures, christened *readymades* by Duchamp, added a confounding feature to an already changing and bewildering art scene. The assumption that the artist controlled the form in some personal manner had never before been challenged. Duchamp seemed to be demonstrating by these acts that the premise of the uniqueness of form did not really matter, that a randomly selected object—even a banal one— could also be thought of as art, and that a mass-produced urinal could rest in a museum alongside a Cézanne.

The works of Duchamp have come to be associated with *Dada*, an intellectual movement characterized by cynicism and buffoonery launched in Zurich in 1916. During World War I, that city had become a haven for refugees of all kinds, including writers and artists who felt pessimistic about the state of European civilization— an outlook they expressed in actions and works considered preposterous at the time. Poetry was created by drawing words out of a hat, pictures by randomly arranging cut-out shapes. Even the name Dada (French babytalk for "rocking horse") was selected by opening a dictionary and taking the first word that appeared. Implied in these kinds of actions was an attack on the meaning of any cultural endeavor, including art. Although Dada artists were sympathetic to the avant-garde because of its own reputation for recklessness, their contemporaries were not spared their sarcasm. Yet, in spite of the impudence and absurdity, the stunts of the Dadaists gave rise to a

reassessment of cultural values and to the discovery of new approaches to meaning—especially meaning relating to unconscious associations. "Automatic drawing," a sort of spontaneous doodling, was one of the experiments Dada artists pursued to promote the notion of releasing subconscious forces in the creation of art.

The Dada movement faded away in the early 1920s leaving few, if any, lasting works of art. But the Dada artists, for all their perversities, did leave a legacy. Duchamp's readymades anticipated the art of assemblage; Kurt Schwitters' *Merzbau* (Figure 5-15) was a forerunner of happenings and environments (Chapter 5); and automatic drawing was used by some of the artists of the next art movement (Surrealism)—and later by Abstract Expressionists (Chapter 14). Further, Dada was instrumental in generating the twentieth-century preoccupation with the ironic, the absurd, and the unconscious—notions that frame the foundation of *Surrealism*.

SURREALISM

Surrealism, the last major movement before the end of World War II, began as basically a literary movement but ended up being more important in the visual arts than in literature. Unlike most movements, which occur more or less spontaneously, Surrealism was formally founded and christened by Dada poet Andre Breton and his associates. Breton even wrote a manifesto (1924) outlining the purpose of Surrealism: to merge dream and reality into an "absolute reality, a super-reality." In Breton's conception of the movement, the unconscious—whether in dreams or in the undirected play of thought that occurs when one is awake—was to be given the highest priority. Surrealism, then, was the antithesis of reason or logic. The movement's sources were Symbolist poetry and art, Picasso's Cubist works (which Surrealists said were based on the artist's unconscious), Dada poetry and art, and the writings of Sigmund Freud—especially *Interpretation of Dreams* published in 1900.

The super-reality of Surrealism had been anticipated by Giorgio de Chirico (Figure 13-15), who began painting pictures of hauntingly deserted plazas as early as 1913. The exaggerated open spaces painted in a tense and contradictory perspective, the long shadows, and the ambiguous architecture conspire to create the kind of ominous and mysterious sensation we often experience in our dreams. But they also suggest the magical life of lifeless things— a carryover from childhood, when we might have projected fantasy identities onto inanimate objects. His style, although somewhat unorthodox, is basically realistic. It is the subject matter that is truly original. Typical is the hauntingly alien environment of *The Sooth-*

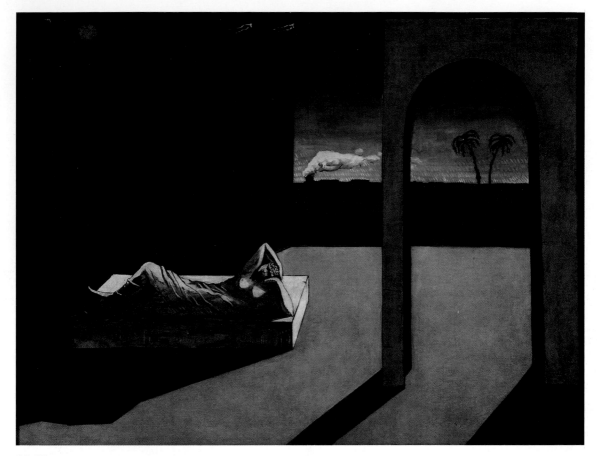

13-15 Giorgio de Chirico, *The Soothsayer's Recompense*, 1913. Oil on canvas, 53½″ × 71″. Philadelphia Museum of Art, (the Louise and Walter Arensberg Collection).

sayer's Recompense in which a deserted square, a classical statue, a detached arch, and a pair of palm trees coexist uneasily. The heavy stillness is stressed both by the silent passing of a train on the horizon and by the pasage of time measured by the clock on the building. Such alien and melancholy combinations are typical of a type of Surrealism that favored, to a greater or lesser degree, the use of pictorial realism. Most importantly, de Chirico's art—which he referred to as metaphysical painting—unearthed possibilities for dealing with unconscious experiences.

The impulse to paint dream phenomena led some artists in a direction that seemed contrary to that of the Modern movement. Salvador Dalí (Figure 13-16) dusted off the old methods of chiaroscuro and perspective in order to represent the irrational world of dreams as vividly as possible; hence hallucinatory images and the

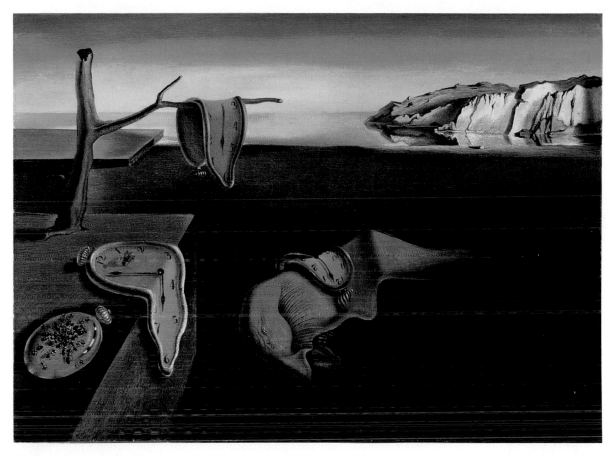

13-16 Salvador Dalí, *The Persistence of Memory*, 1931. Oil on canvas, 9½″ × 13″. The Museum of Modern Art, New York. Given anonymously.

inhabitants of the dark world of the unconscious assume in his paintings the authority of photographs. Intrigued by the theories of Freud, Dalí was incredibly resourceful in inventing all sorts of dream fantasies that employed not only alien combinations but things made of alien materials and depicted in an alien scale. Witness his enormous limp watches.

René Magritte also painted in a more or less realistic style, but did not choose to dramatize either the style or content of his work. His paintings are evocative rather than provocative. Typically, they pose puzzles about what we perceive or think with simple images reminiscent of de Chirico's. For example, we view *The Empire of Light, II* (Figure 13-17) as a nighttime scene and wonder why the sky is blue and the clouds are white, or visualize it as a daytime scene and puzzle over the fact that the street is dark and the windows and street lamp are illuminated. Logic is being mocked to create a new experience out of two opposing realities.

Not all Surrealistic art was realistic (sometimes referred to as *veristic* Surrealism). Some artists employed automatic drawing to

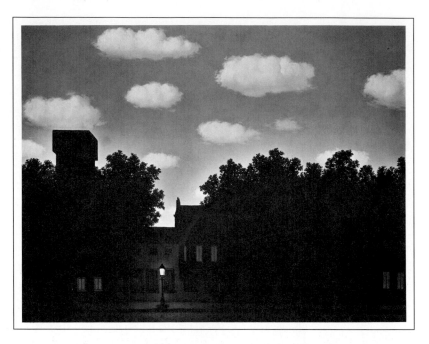

13-17 René Magritte, *The Empire of Light, II*, 1950. Oil on canvas, 31″ × 39″. Collection, The Museum of Modern Art, New York (gift of D. and J. de Menil).

allow the unconscious to dominate in the creation of their works—a process that inevitably led to some form of abstractionism. Others, using more conventional painting methods, managed nevertheless to suggest that the unconscious was dominant, that their imagery was the result of automatic thought processes and free associations. The free forms and naive images in *The Harlequin's Carnival* (Figure 13-18) by Joan Miró give this impression. How much of this is truly free association and how much is calculation is difficult to say. Although his images are often vaguely demoniac, Miró's paintings emphasize the playful, rather than the dark side of the unconscious. Instead of attempting to illustrate a child's nightmare as de Chirico or Dalí might, Miró represents how a child might express it in his or her own illustration. Yet there was nothing childish about Miró's talent or his art. He was unusually creative in coming up with ways to combine the senses of mystery and humor, and his art came to be one of the most important influences on the American abstract artists of the 1940s—whose form of painting was to be the next big breakthrough in the world of art.

SUMMARY

Although some of the examples in this chapter were produced after World War I, it is important to emphasize that the breakthroughs

13-18 Joan Miró, *The Harlequin's Carnival*, 1924–25. Oil on canvas, 26″ × 36⅝″. Albright-Knox Art Gallery, Buffalo, New York (Room of Contemporary Art Fund, 1940).

themselves occurred between 1905 and 1914, perhaps the most fertile decade in the history of art. Fauvism, Die Brücke, Der Blaue Reiter, *Les Demoiselles d'Avignon,* Analytical Cubism, Futurism, Synthetic Cubism, collage, assemblage, all emerged within those years. Kandinsky created his first abstract watercolor in 1910; Mondrian's austere style had arrived at a stage of grid-like flatness as early as 1914, although it was further refined in the next decade; Dada did not officially begin until 1916, but its rash innovations were anticipated by Duchamp's readymades, the first of which appeared in 1913; and Surrealist painting was precisely foreshadowed by de Chirico's metaphysical pictures, begun as early as 1911.

Other than the idea of emphasizing the unconscious in the production of art on the part of Dada and Surrealism, no significant breakthroughs took place between the two world wars. The aesthetic revolution had not ended, but it seemed to be slowed—concentrating more on consolidating the advances made earlier than on making new ones.

THE LATE TWENTIETH CENTURY

T HE NEXT IMPORTANT STAGE of the Modern movement occurred in the United States, with major breakthroughs occurring just after World War II. Even though these breakthroughs took place on American soil, they were essentially grounded in ideas and approaches initiated in Europe. But before looking at this phase of the aesthetic revolution, a review of the status of American art prior to the end of the war and a consideration of the major factors that would prove influential in these later developments will be helpful.

Even before the 1913 Armory Show, the work of such artists as Matisse and Picasso had been exhibited in New York in the gallery of photographer–art dealer Alfred Stieglitz. In addition to dealing in Modern art, Stieglitz published an avant-garde magazine that printed articles by American artists and writers who were followers of the new developments in Europe. Included among those artists were Stieglitz's wife, Georgia O'Keeffe (Figure 10-9 and Figure 10-10), Joseph Stella (Figure 10-8), Charles Sheeler (Figure 4-8), and the Canadian Emily Carr (Figure 7-15). But with relatively few American artists experimenting with newer approaches, the growth of an indigenous Modern movement was meager. Further, their work had little influence outside the United States, and it was not popular in this country—not even among American collectors interested in Modern art. (Most of the American collectors preferred the works of Matisse and Picasso.)

In the 1930s, the development of Modern art in America almost stopped. American artists, like the American people who had become isolationists during the Great Depression, concentrated on American themes and worked in rather conservative styles (Chapter 7). The dominant art of the time was Regionalism, exemplified by the works of Grant Wood (Figure 7–16) and Edward Hopper (Figure 10–11). This art had even less credibility internationally

than Modernism. Europeans persisted in thinking of American culture, especially its painting, as provincial. This opinion, moreover, was shared by many American artists and intellectuals, especially the younger ones.

During the 1940s, however, various forces were already at work to change both American art and its status on the world stage, and New York was to be the crucible of this change. European Modernist painting and sculpture were appearing in greater and greater numbers in that city's collections, particularly that of the up-and-coming Museum of Modern Art. Young American artists were becoming exposed to the likes of collage, Synthetic Cubism, Surrealism (both veristic and abstract), and the works of Kandinsky. Many European artists were fleeing to the United States because of the political crises on their own continent. These emigres—including Beckmann, Chagall, Dalí, Duchamp, Gabo, Hofmann, Mondrian, and the artist-poet Breton—settled mostly in New York. Among the various groups, the Surrealists had made the biggest impression on young Americans.

Still another important force was a philosophy called *Existentialism*. The writings of Jean-Paul Sartre—a leader of the Existential movement and a member of the French resistance—were extremely influential on both sides of the Atlantic. He and other Existential writers rejected all moral and philosophical absolutes, including belief in God. While this meant that people were free to shape their own destinies, it also meant that they were physically and spiritually abandoned. To artists, Existentialism removed the barriers to creativity, but it also left them without guidelines or standards. This tended to place a great deal of responsibility on the individual artist and his or her subjective experience. Whether young American painters read Sartre or not, they had reached similar conclusions on their own and were already searching deeply within themselves to liberate this source. According to Willem de Kooning: "We weren't influenced directly by Existentialism, but it was in the air, and we felt it without knowing too much about it. We were in touch with the mood."

This was a period of expectation, but also of great uncertainty. Young painters like de Kooning, Jackson Pollock, and Arshile Gorky were struggling to find their artistic identities within a tradition that offered them a choice between a discredited local Modernism or a popular, but provincial Regionalism—neither of which was acceptable. Without a strong tradition (either to work within or react against) or even a mythology of American artists, they often experienced the deep despair to which Existentialists refer. Gorky, who successfully assimilated influences from Picasso, Miró, and Kandinsky, as in his *The Liver is the Cock's Comb* (Figure 14-1),

14-1 Arshile Gorky, *The Liver Is the Cock's Comb*, 1944. Oil on canvas, 73¼″ × 98″. Albright-Knox Art Gallery, New York (gift of Seymour H. Knox, 1956).

showed the earliest promise. The strong colors and undulating design bring to mind Kandinsky's abstractions; the squiggly lines and images, Miró's Surrealism; and the push-and-pull of spatial depth, Picasso's Cubism. Despite the European influences, however, Gorky's painting manifests the nucleus of an original American style that was soon to explode into prominence.

ABSTRACT EXPRESSIONISM

Chromatic Abstraction

What had been a struggling avant-garde in the 1940s grew to be the first home-grown American style to achieve international respect: *Abstract Expressionism.* In the 1950s it was *the* style. One branch of the style, *chromatic abstraction,* emphasized color in a new way. Unlike Gorky's canvasses, which are filled with many lively shapes,

14-2 Mark Rothko, *Four Darks in Red*, 1958. Oil on canvas, 102″ × 116¼″. Collection of Whitney Museum of American Art. Purchase with funds from the friends of the Whitney Museum of American Art, Mr. and Mrs. Eugene M. Schwartz, Mrs. Samuel A. Seaver and Charles Simon.

these are filled with large, softly inflected areas of color that tend to monopolize the visual field of anyone standing within normal viewing distance. By eliminating extraneous details, and paring their designs down to one or two shapes, chromatic painters aimed to engulf the viewer in a broad field of color. Mark Rothko, for example, specialized in large luminous rectangles that seem to float in space. In some paintings, Rothko dulled the hues and made each rectangle relatively equal in value in order to minimize contrast. In others, like *Four Darks in Red* (Figure 14-2), he used such closely related hues (in this case red-violet and red) that contrast was at a minimum to begin with. Chromatic canvasses are passive rather

than active, intended not to assault the senses but to soothe them, and perhaps to evoke meditative responses. Although in the early 1950s this branch of Abstract Expressionism received less attention than action painting, by the late 1950s it grew to be an important influence on the next generation of abstract artists.

Action Painting

The other branch of Abstract Expressionism—often called *action painting*—was more dramatic and better known. Unlike a chromatic painting, an action painting has a much higher level of energy. Its

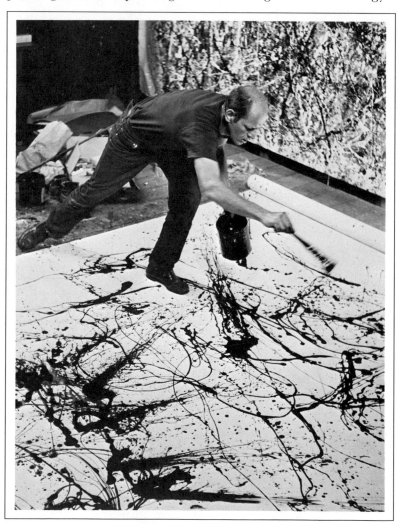

14-3 Jackson Pollock painting, 1950.

paint surface is agitated and its abstract shapes and colors are highly animated—lending credence to the notion that the work was created out of some inner necessity. The works of Jackson Pollock, especially, have come to symbolize the style, and Pollock himself the American artist as romantic rebel. His fiery temperament, together with his brooding art, established a myth of American creativity. During the 1940s, Pollock, like Gorky, borrowed from Picasso and Miró, but his style was more turbulent—as if he had poured his own anger onto the canvas. By the mid 1940s his work began to attract the attention of critics and the patronage of Peggy Guggenheim, a wealthy heiress. This bit of success, however, was just a prelude to his breakthroughs in the late 1940s when he began his famous "drip" paintings. Spreading a large canvas on the floor, Pollock would spill, splash, fling, and drag paint across its surface while walking on it (Figure 14-3). The result of this method can be seen in the teeming webs of lines in *One (Number 31)* (Figure 14-4). Varying in color, length, width, and viscosity, the lines reflect the patterns and rhythms of the process in which they were made. Pollock had not only dispensed with imagery—indeed with form itself, as it had been known to this point—but also with the traditional techniques of painting. Starting a canvas with little premedi-

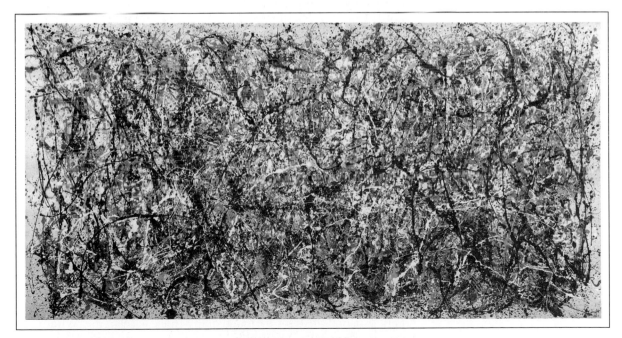

14-4 Jackson Pollock, *One (Number 31)*, 1950. Oil and enamel paint on canvas, 8'10" × 17'5⅝". Collection the Museum of Modern Art, New York (Sidney and Harriot Janis Collection Fund).

tation, he would develop it intuitively as he went along. According to Pollock:

> When I am *in* my painting, I'm not aware of what I'm doing. It is only after a sort of "get acquainted" period that I see what I have been about. I have no fears about making changes, destroying the image, etc., because the painting has a life of its own. I try to let it come through. It is only when I lose contact with the painting that the result is a mess. Otherwise there is pure harmony, an easy give and take, and the painting comes out well.

By a leap of insight, he arrived at the idea of painting as a psychological event—supposedly eliminating the gap between the subjective world of the artist's emotions and the concrete world of paint and canvas.

While all action paintings are, in a sense, records of an artist's gestures (consisting of what Pollock described as "energized marks of paint") not all of them resemble Pollock's, nor do they all involve his particular methods. Contrast his nervous, weblike lines with Franz Kline's broad, athletic slashes of black in *Mahoning* (Figure 14-5). The use of one color clearly reveals each of the artist's gestures; the starkness of black on white brings to mind a basic positive–negative relationship (perhaps male–female, life–death, and so on). Kline's crisscrossing bars could also refer to a landscape of steel construction (or destruction) set against an urban sky. De Kooning's highly agitated paintings, in which brushstrokes sweep in all directions, represent still another approach. While the savagery of his gestures perhaps best epitomizes the style, his tendency to use flesh tones and pastel hues, and to involve an image, however vague, of a human, are exceptions to the rule. Recall his *Woman I* (Figure 8-20). Finally, the work of Hans Hofmann (Figure 3-2) represents a more sober approach. While his paintings are gestural, they also manifest qualities suggesting that Hofmann consciously attended to their overall design. (In addition to Pollock, Kline, de Kooning, and Hofmann, other artists involved in action painting were Philip Guston, Robert Motherwell, and Clyfford Still.)

The year 1947, when Pollock began drip painting, was an important time in Europe, too. There, a number of gallery showings revealed that several artists—many working separately—shared similar goals. Under a number of different labels—such as *Art Informel, Abstraction Lyrique,* and *Tachisme*—this painting featured freely brushed abstract forms, usually thick with paint. What is all the more interesting about this phenomenon is that the art world in Europe was largely unaware of the Abstract Expressionists in

14-5 Franz Kline, *Mahoning*, 1956. Oil on canvas, 80″ × 100″. Collection of Whitney Museum of American Art, New York. Purchase, with funds from Friends of the Whitney Museum of American Art.

America until 1950, when these painters' works were shown there rather extensively. A major exhibition held in Paris that year featured representatives of both the European and American avant-garde. In general the American abstract art was bolder and more dramatic, the European more lyrical and stressing a greater sensitivity to the subtle possibilities of the new style. One European branch emphasized texture above all else, relying on the evocative power of the material. The French artist Jean Dubuffet (Figure 2-32) sometimes created working surfaces out of cut-up pieces of canvas, thick glue, and asphalt. He would knead, trowel, and scrape them, allowing the material itself to suggest the way in which it should be manipulated.

In retrospect, the most important consequences of Abstract Expressionism appear to have been more cultural than aesthetic. For one thing, the relationship between European and American art had changed; for the first time in history the latter was looked upon as a vital force in the art world. Now European artists had to

run to keep pace with a vigorous new American competition. And, ironically, even as American art broke out of provincialism, its new avant-garde began to acquire a strong (sometimes arrogant) sense of national identity. Abstract Expressionism had a romantic quality and a distinctly American accent. Its raw style and defiance of conventions fit the image Americans had of themselves as being boldly individualistic.

ABSTRACT SCULPTURE

During the 1950s, developments in sculpture were generally overshadowed by the exuberant world of abstract painting. Although the aesthetic advances immediately after World War II were pioneered by painters, sculptors were attuned to the new thinking and skillfully expressed it in their own way.

In the late 1940s, a number of sculptors developed techniques for working with metal that corresponded roughly to the spontaneous methods of Abstract Expressionist painters. Their dramatic works often equalled those of Kline or de Kooning in boldness. Some, following the lead of Julio González (Figure 5-5), shaped their works by welding successive layers of metal, capitalizing on the naturally rough residues and the oxides resulting from the welding process. However, unlike most Abstract Expressionists, these sculptors were addicted to biological forms, their works often resembling such things as animal skeletons, spiny plants, seed pods, and thorns. Many were influenced by the works of Henry Moore and Hepworth (Figure 2-25) in England and were reacting against what they considered to be the arid impersonality of geometrical abstraction in sculpture (represented by Naum Gabo, Figure 5-7).

The closest tie between the abstract sculpture and Abstract Expressionist painting of the 1950s is found in the work of David Smith. Trained as a painter, he first came under the influence of the work of such artists as Kandinksy, Miró, and Mondrian. But a summer job in a car factory—where he learned to cut and weld metal—together with his discovery of the welded sculptures of Picasso and González, stimulated him to pursue the art of steel sculpture. Throughout his career he saw the aims of sculpture and painting as being essentially the same, saying that they were separated by only one dimension. He was not averse to painting on his sculptures, sometimes covering a piece with layers of epoxy, zinc, or auto enamel. But the most basic relationship between a painting and Smith's early sculpture, such as *Hudson River Landscape*, was the sculpture's frontality (Figure 14-6). Rather than being intended for

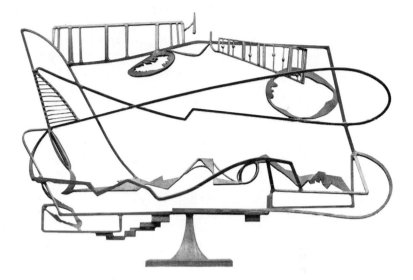

14-6 David Smith, *Hudson River Landscape*, 1951. Welded steel, 6′3″ × 49½″ × 16¾″. Collection of Whitney Museum American Art, New York.

in-the-round viewing, most of his works were designed to be seen from one angle.

COLOR-FIELD

Abstract Expressionism dominated the 1950s. But not all forms of abstract art at that time were strictly tied to its way of thinking. One form, known as *Color-Field*, resembles Abstract Expressionism, but was based on a different set of premises. Unlike Abstract Expressionists, Color-Field painters were not interested in personal expression. They felt that the proper role of abstract art was not to investigate one's psyche but problems of color and space.

As early as 1952 Helen Frankenthaler experimented with staining raw canvas with thin washes of paint. The subdued effects she derived from this method are somewhat reminiscent of Rothko's paintings, except that hers bear more variety of shape and color. Frankenthaler's technique was supposedly influenced by Pollock's drip style, but unlike him she used raw canvas rather than sized canvas (Chapter 4). She was the first to experiment with staining, allowing the paint to run, spread, and sink into the fabric in unexpected ways. *Mountains and Sea* (Figure 14-7), completed in 1952 and the first painting of this kind, is somewhat tentative. In the early 1960s when she switched from oils to acrylics, she expanded

14-7 Helen Frankenthaler, *Mountains and Sea*, 1952. Oil on canvas, 7′2⅝″ × 9′9¼″.
Collection of the artist, on extended loan to the National Gallery of Art,
Washington, D.C.

her range of techniques to include practically every way that paint can be spread—pouring, flooding, sponging, even warping the canvas—and her style became stronger in form and color. When others followed her lead and took up the practice of staining, someone invented the label "Color-Field."

Morris Louis discovered the staining technique when he met Frankenthaler. He then went on to develop a style of his own that involved pouring acrylics in broad, smooth floods to create overlapping "veils" of color (Figure 14-8). Later, he poured the paint to form separate stripes of color that stood out against the bare canvas. Although they were somewhat irregular, these stripes did introduce to his style a certain amount of simplicity, repetition, and symmetry—qualities not usually found in Color-Field paintings.

14-8 Morris Louis, *Dalet Kaf*, 1958. Acrylic resin (Magna) on canvas,
100½" × 142½". Collection of the Modern Art Museum of Fort Worth. Purchase made
possible by a grant from the Anne Burnett and Charles Tandy Foundation.

Meanwhile, the shift in sensibility away from the subjective and
gestural painting style of the Abstract Expressionists was beginning
to be reflected in the work of more and more artists.

ASSEMBLAGE

The art of assemblage, invented by Picasso and Braque as early as
1914 (Chapter 13), experienced a revival in the mid 1950s. Pollock
had experimented with the addition of pebbles and other small
objects to the painting surface, much as Dubuffet had done. To the
younger American artists, this direction seemed particularly prom-
ising. If personal expression could be accomplished by the sponta-
neous spreading of paint or other materials, it could also be accom-
plished—with perhaps richer possibilities—by the spontaneous

assembling of objects. Also, like Color Field, assemblage posed a challenge to the authority of Abstract Expressionism, but from a different direction. Frankenthaler and her followers, by focusing on formal effects rather than self-discovery, sought to make abstract art more pure. Assemblage artists, by introducing alien materials and ideas, made it less pure.

Robert Rauschenberg and Jasper Johns—the two artists who experimented most radically and most successfully with assemblage in the fifties—were experienced painters who grew out of Abstract Expressionism. Rauschenberg would attach objects such as torn photographs, neckties, broken umbrellas, clocks, old trousers, or pillows to a vigorously painted surface. Although Rauschenberg called these works "combine-paintings," some of them developed

14-9 Robert Rauschenberg, *Winterpool*, 1959. Combine painting, 88½″ × 58½″. Private collection.

into rather substantial three-dimensional objects (Figure 14-9). His use of objects ran counter to the basic methods of Abstract Expressionism, but his bravura use of paint revealed a profound understanding of those methods. The rich coating of drips and smears that permeates and surrounds everything in a Rauschenberg work surprisingly creates unity out of what might otherwise be a meaningless collection of items.

Jasper Johns's assemblages generally employ less variety—their paint surfaces emphasizing Abstract Expressionism's heavy textures more than its brushstrokes. Johns is known mainly for his elaboration of such flat images as targets or flags that he would form with thick paint, wax, and bits of paper. One such painting, *Target with Plaster Casts* (Figure 14-10), combines a large target with a series of plaster casts of parts of the human body set in tiny boxes

14-10 Jasper Johns, *Target with Plaster Casts,* 1955. Encaustic collage on canvas, with wood construction and plaster casts, 51″ × 44″ × 3½″. Collection Mr. and Mrs. Leo Castelli, New York.

above the bull's-eye—a mildly unsettling juxtaposition reminiscent of those found in the paintings of Magritte (Figure 13-17).

In discussing their work, Rauschenberg and Johns have tended to discourage the search for special meanings for their objects and images. Yet their inspired combinations do breed interpretations:

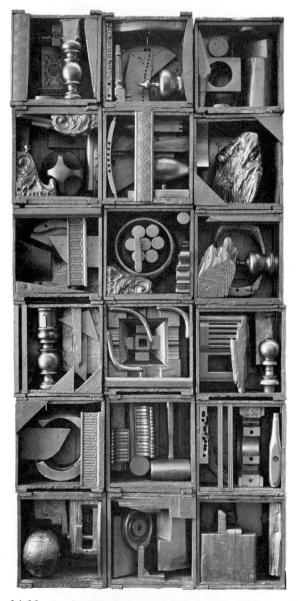

14-11 Louise Nevelson, *Royal Tide I,* 1960. Gilded wood, 96″ × 40″ × 8″. Private collection. Photograph courtesy the Pace Gallery, New York.

Rauschenberg's rapid flux of images and surface effects can easily be seen as an expression of hectic times or of a junk-filled, modern industrial culture. Johns's ironic images, which include American flags and maps as well as targets, explore the relationships between sign and art and essay the possibilities of incorporating popular myths in art. In the context of the late 1950s, their works were provocative—an avant-garde assault on the Abstract Expressionist establishment. Although they were berated for their impurity and lack of seriousness, today they are looked upon as transitional between Abstract Expressionism and some of the major developments of the next decade.

Not all assemblages of the late 1950s were hectic, disturbing, or provocative. Louise Nevelson's works, like those of Rothko and Color-Field artists, tended to emphasize order and calm. Although she utilized discarded objects, Nevelson imposed order on an otherwise random assortment by restricting her materials mostly to wood, painting them a single color, and structuring the assemblage with repeated forms (usually the rectangular shapes of boxes). These primarily frontal works are open to the viewer and filled with simple shapes and fragments such as chair legs, knobs, and scrap lumber (Figure 14-11). The series of niches often creates a subtle interplay between surface and depth, positive and negative. By themselves, neither the niches nor the objects have any particular meaning, but together in the assemblage they generate images suggesting cluttered cupboards or medieval altarpieces.

POP ART

The 1960s, one of the most tumultuous decades in American history, was also the scene of tumultuous changes in art. The rather sudden success of *Pop Art* in the early part of that decade had a profound impact on the art world. Simply stated, Pop Art celebrated and satirized popular culture—particularly the most banal and debased aspects of that culture. Because of America's prominence as an originator of popular artifacts—from soft drinks to Hollywood movies—it was only natural that American artists were the most successful of the Pop Art movement. But England had also become an important source of popular culture, and English artists figured strongly as well—especially in the area of music. In fact the earliest works of Pop Art were created by London-based avant-garde artists who expressed a particular interest in the connections between popular culture and art. Many of the hallmarks of Pop Art—humor, parody, imitation of advertising art—were already present in their experimental works of the 1950s.

Many works of Pop Art appear to be so different from those of Abstract Expressionism that Pop Art is often thought of as a total break with the past. But there is an ambiguous continuity between the two. Pop Art is certainly a part of the total Modern movement, for many of its traits—ready-made images and irony, to mention two—have precedents in earlier art movements, especially Dada and Surrealism. Furthermore, many Pop artists began as Abstract Expressionists, and—even though they were reacting against the older school—their vision of the world was at least somewhat affected by it.

Still, there are striking differences between Pop Art and Abstract Expressionism. The latter is serious and high minded—so much so that it is entirely removed from the ordinary world. This is due partly to its being abstract, of course, but also to the fact that its adherents were contemptuous of American culture, particularly its popular culture. Imagine how they must have reacted to *Whaam!* by Roy Lichtenstein (Figure 14-12), supposedly a deadpan imitation of an adventure comic, an icon of popular culture. This work would appear to be a confirmation of that culture with all its dehumanizing tendencies. Worse, its hard-edged, commercial style is a denial of everything Abstract Expressionism stands for; even the rocket smoke and the explosion were mechanically outlined and filled in with flat colors. But in fact, Lichtenstein's work is neither a defiance of art nor a servile imitation of popular culture. The comic-strip idiom was to Lichtenstein simply another vehicle for

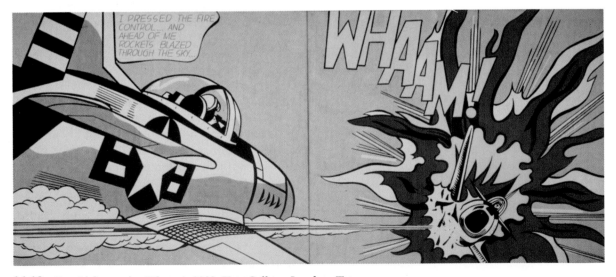

14-12 Roy Lichtenstein, *Whaam!*, 1963. Tate Gallery, London. Tate Gallery/Art Resource, N.Y.

developing a formal design. Moreover, by radically enlarging a comic-strip frame, he brought to the viewer's attention not only the fact that comics are very conventionalized (including even the "realistic" adventure variety), but also the ways in which their forms serve as visual signifiers. Lichtenstein, therefore, brought people to confront aspects of their culture that, because of habit and apathy, go unnoticed. In an interview titled "What is Pop Art?" he stated:

> Well, it *is* an involvement with what I think to be the most brazen and threatening characteristics of our culture, things we hate, but which are also powerful in their impingement on us. I think art since Cézanne has become extremely romantic and unrealistic, feeding on art; it is utopian. It has had less and less to do with the world, it looks inward. . . .

Pop Art's vision of the world is not so cool that it precludes any judgment of what it sees. It is full of implied social commentary in its choice and its treatment of subject matter. The whole question of American themes that had been a major problem for earlier generations of artists (Chapter 10) never even arose for the Pop artists, who plunged gleefully into the consumer society around them for their material. Just as Lichtenstein expanded the comic-book look into an art form that accurately reflected the emotional and intellectual level of the nation, Andy Warhol used serial imagery and mass-production techniques to emphasize the shallowness of American sexual myths (Figure 8-21). Tom Wesselmann echoed Warhol's theme by presenting the Great American Nude as just another slick commodity (Figure 8-22). Robert Indiana's *LOVE* (Figure 4-23), originally intended to bring attention to the national obsession with sex, ended up as a monument to universal love. English Pop artist David Hockney playfully satirized California life styles (Figure 10-14); years later, post-Pop artist Gilbert Sanchez Lujan did the same from an ethnic point of view (Figure 10-15).

The implied commentary of Claes Oldenburg's *Yale Lipstick* (Figure 14-13) touches on art, education, and the military in addition to commercialism and sex. The twenty-four-foot-high sculpture is intended to mock those sculptures that are large in scale and noble in theme and are constructed in public squares to inspire a sense of grandeur and tradition. Although the lipstick sculpture is large, it is hardly noble and inspires only a sense of the absurd. Instead of a public figure or a commemorative obelisk, Oldenburg created a gigantic version of a very common object. And instead of building a solid base, he mounted the form on bulldozer treads that suggest the sculpture may be moved from one place to another. The monumental treatment of the commonplace and the mobility

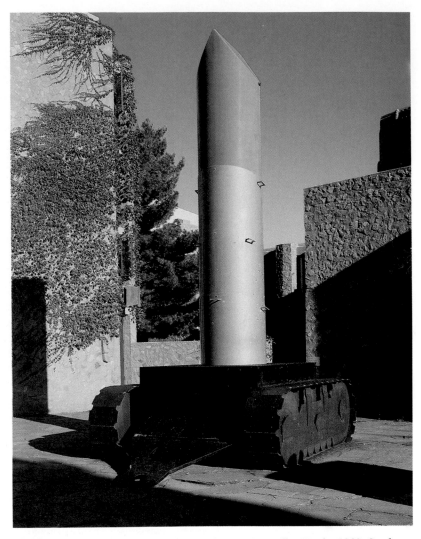

14-13 Claes Oldenburg, *Lipstick Ascending on Caterpillar Tracks*, 1969. Steel, aluminum, fiberglass, and paint, 24′ high. Yale University Art Gallery (gift of the Colossal Keepsake Corporation).

of the public work are only the beginning of this work's contradictions, however. Viewing it, we become aware that this object designed for women has a suggestively masculine shape. Yet, set on treads, it also bears a close resemblance to a cannon. These simple variations on the traditional object lead us to interpret a symbol of sexual desire as a symbol of aggression.

Oldenburg's visual games were well suited to the confusion of the times. The lipstick piece was such a focal point of controversy on the Yale campus in 1969—at the height of the Vietnam War—

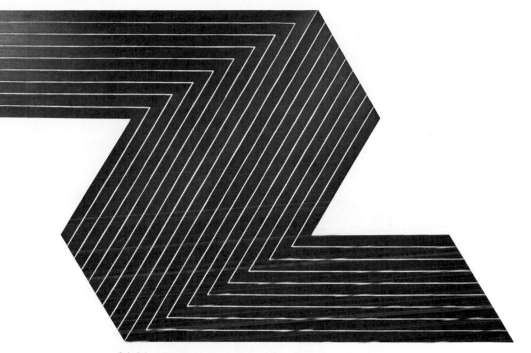

14-14 Frank Stella, *Itata*, 1964. Metallic powder in polymer emulsion on canvas, 77″ × 122″. Private collection.

that it became a victim of graffiti and radical posters, and was eventually moved to a less conspicuous location.

HARD-EDGE AND MINIMAL

Hard-Edge painting and *Minimal* sculpture constituted the major branch of abstract art in the sixties. Hard-Edge painting was a continuation of Color-Field, but rather than veils of color, it features sharply-contoured, smoothly-painted geometric shapes (some have called it "ABC" art because it is so basic and simple). It was a reflection of the desire on the part of many artists in the 1960s to put even greater distance between their work and the energetic gestures of the Abstract Expressionists. Although it seems to hark back to the paintings of Mondrian (Figure 13-11), Hard-Edge represents a very different approach to geometrical abstraction. Hard-Edge painters, like Frank Stella, Ellsworth Kelly (Figure 2-14) and Agnes Martin (Figure 2-28), did not share Mondrian's mystical ideas about order and harmony and were not at all opposed to making straightforward, symmetrical compositions. The dry and simple patterns of Frank Stella's painting *Itata* (Figure 14-14) resemble the cool, unemotional images of Pop more closely than those of other abstract

art—whether by Mondrian or the Abstract Expressionists. Just as the previous generation had been influenced by the subjective views of Existentialism, the new generation of abstract painters was influenced by the objectivism of analytical philosophy—especially the branch led by Ludwig Wittgenstein, who championed a common-sense view of the world through a disciplined analysis of language. This approach was reflected in the matter-of-fact, disciplined character of Hard-Edge art.

Frank Stella aimed at consolidating a painting into a single, indivisible image and employed several devices to accomplish this:

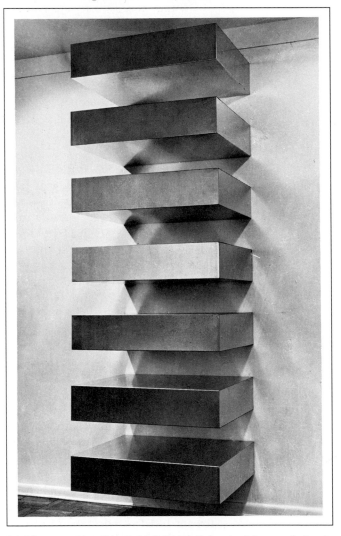

14-15 Donald Judd, *Untitled*, 1966. Galvanized iron and aluminum, seven boxes measuring 9″ × 40″ × 31″ with 9″ intervals. Private collection.

His works are usually symmetrical, limited to two unmodulated colors, painted on raw canvas to increase the flattening effect, and structured in narrow bands that ran parallel to the edges of the frame to echo the overall shape. His intention was to make paintings that would not refer to anything else. They are only about themselves—an ultimate step in the exclusion of content. As Stella once put it, "only what can be seen there is there." In its metamorphosis from window-on-the-world to self-referring object, painting had sought to divest itself of content and the ability to trigger emotional reactions.

Minimal sculpture was based on essentially the same sensibility and philosophy as Hard-Edge painting, rejecting dynamic compositional effects and preferring the most elementary arrangements of forms. The extra dimension of sculpture, however, greatly multiplied the number of relationships between elements that the artist might work with and helped to reinforce the sense that the artwork was an object. Some Minimalist sculptors attempted to develop these aspects by creating works of several elements in which the space between parts became almost as important as the solid structures. The fluorescent-light sculptures of Dan Flavin (Figure 5-14) were among the first and most radical experiments in changing the space and making the viewer more aware of it. Donald Judd's wall sculptures— sets of metal boxes attached to the wall one above the other—present a similar idea on a smaller scale, stressing a single form through a persistent repetition of the form and equal intervals of the same dimensions (Figure 14-15). Just as Hard-Edge painting was far removed from the idea of the painting as window, Minimal sculpture aimed at playing a role quite different from that of the traditional statue isolated on top of a pedestal.

OP AND KINETIC ART

Technology pervades all of art—whether the work is a polyester resin and fiberglass sculpture or a fifteenth-century oil painting. Some artistic products, however, make particular use of recent scientific and postindustrial technology.

Op Art, derived from the word *optical,* enjoyed the public limelight just after Pop Art (hence the linguistic alliteration between the names). While using the traditional medium of paint on canvas, the Op artists were notably skillful in applying a scientific understanding of optics. Like Hard-Edge, Op Art is abstract, geometric, and hard-edged—yet differed markedly in that it presents an active rather than a passive visual field.

Op Art grew directly out of the works of Mondrian and the artists and designers of the German Bauhaus and was influenced by the studies of visual perception that were being carried out by many psychologists and scientists from the 1920s onward. The recognized pioneer of this style was the Hungarian-born Victor Vasarely, whose work in Paris in the 1940s and 1950s set an example for many other artists. It was a movement dominated by Europeans and South Americans living in Europe, although a few artists from the United States such as Richard Anuskiewicz (Figure 2-8) did develop related styles. Vasarely's experiments have covered all of the visual elements from color to line and tend to apply the principles discovered to the creation of illusions of space. He is skilled in the art of making a flat surface appear to advance or retreat (Figure 14-16), or establishing a number of levels within a picture with simple, rhythmic abstract patterns and color variations that establish their own nonlinear systems of perspective. Vasarely has also been a leader in the search for a more useful social context for art. Like the American Minimalists, he has rejected the idea of art as an

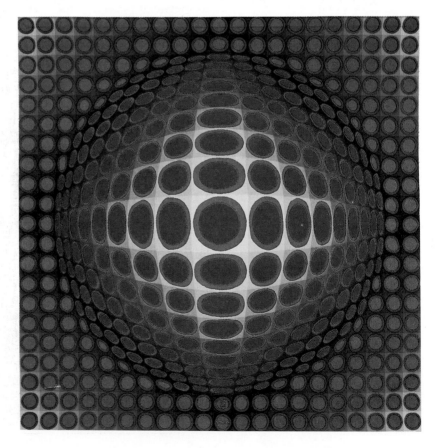

14-16 Victor Vasarely, *Vega-tek*, 1969. Wool Aubusson tapestry, 101″ × 98½″. Private collection.

expressionistic gesture of the individual. Going a step further, he has attempted to find ways to place this art at the service of the public—through murals, industrial design, and mass production. For a time in the mid-1960s—while Op Art was considered fashionable—some designs were adopted, converted, or invented for the decoration of clothing. Other than that, the movement and its social ideas have had little impact in America. Bridget Riley, a British Op artist, has been the most successful in creating the sensation of motion, which she achieves with compact patterns spread over large areas (Figure 3-5). Riley has experimented extensively with color as well and is unique in her studies of graduated tone variations (with which she can add effects of depth to those of motion).

Kinetic art, discussed in Chapter 5, underwent an interesting new period of development during the 1950s and 1960s as well, its aims being closely linked to those of the Op artists. Many of the most impressive of these artists did work in Paris with Vasarely, or at least were acutely aware of what he had done. The Argentinian Julio Le Parc's dazzling murals of light (Figure 14-17) were typical

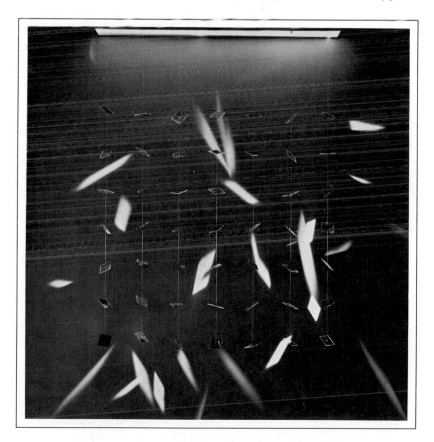

14-17 Julio Le Parc, *Continual Mobile, Continual Light*, 1963. Steel and nylon, 63″ high. The Tate Gallery, London.

of the approach of the European-based artists of the 1960s, who favored extremely simple means and tended to shy away from mechanical devices. Le Parc's Continual Mobiles are descendants, as the name suggests, of the works of Alexander Calder (Figure 5-8) and were constructed of nothing more than pieces of polished metal hung on nylon threads. Ironically, in spite of their simplicity and geometric elements, the reflections these mobiles cast on walls and ceiling recall the slashing brushwork of the Abstract Expressionists.

More advanced kinetic sculpture has not been as common as one might expect in this modern era, and what has been done is not as respectful of the machine as was the painting, sculpture, and architecture of the early part of the century. The impudent contraptions of Jean Tinguely (Figure 5-9) offer more to laugh about than to think about—pumping away and achieving absolutely nothing or performing such tasks as drawing "abstract" pictures.

ART AS ACTIVITY AND IDEA

One of the more interesting developments of the 1960s and 1970s— an important element in the general "opening up" of art—has been the revival of live performances by artists. This phenomenon began with the Futurists in the early years of the century and first attracted interest in the United States with Happenings (Chapter 5). In the late 1960s, new forms evolved that attracted a great many artists. The range of these activities can be extraordinarily broad, from an intensely individual work to monumental operations involving hundreds of people. One example of such an event was the wrapping of one million square feet of Australian coastline by hundreds of volunteers in 1969 (Figure 14-18). The project was the idea of the Bulgarian-born American artist Christo, who began wrapping objects in cloth in the early 1960s. He slowly worked his way up, covering public monuments and buildings, until he reached the super scale of the Australian enterprise. His two major projects in the 1970s were a 200,000-square-foot curtain suspended over a Colorado canyon and a 24½-mile white fence erected in northern California. His major projects in the 1980s were the surrounding of eleven islands in Miami's Biscayne Bay with six million square feet of pink polypropylene fabric, and the covering of the Pont-Neuf, a bridge across the Seine in the heart of Paris. In spite of their enormous costs in materials and labor, and their impressive results, these projects were temporary. Related to Christo's art in

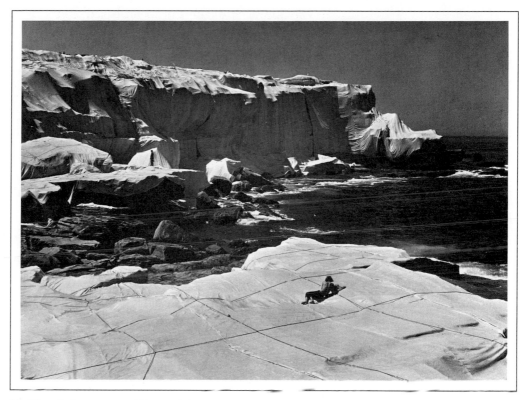

14-18 Christo, *Wrapped Coast*, Little Bay, Australia, 1969. Cloth and rope, 1,000,000 square feet.

scale, but somewhat less temporary, is Earth Art; recall Michael Heizer's *Double Negative* (Figure 5-17).

Performances

Performances are the principal result of art's expansion into theater. They usually involve only the artist (perhaps an assistant) who presents a scripted activity or carries out some form of experiment. One of the most prominent performers was the late Joseph Beuys of Germany, who bridged the gaps between art and life, and the visual and the theatrical, by becoming a sort of living, walking work of art (Figure 14-19). Beuys became an avid promoter of Happenings in the early 1960s. His own "actions," as he called them, were usually performed alone and often involved a wide assortment of materials—wood, metal, rope, tape recorders, skeletons, dead or live animals, felt, and cooking fat. They were rich in symbolism and invented ritual, and many had political overtones as well—

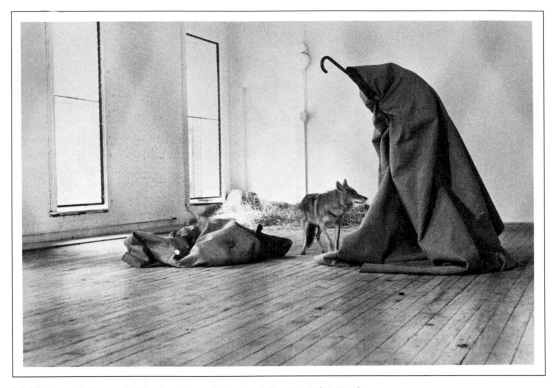

14-19 Joseph Beuys, *I Like America and America Likes Me*, 1974. Performance, three days long. © 1974 Caroline Tisdall, courtesy Ronald Feldman, Fine Arts, New York.

sometimes rather provocative ones. One performance in Aachen literally caused a riot. Adding a dimension to both the symbolism and political overtones of his work is his own biography. A pilot for the German Luftwaffe during the war, Beuys was shot down near the Black Sea and revived by Crimean nomads who wrapped him in layers of felt and fat. Since his death in 1986 he has become something of a cult figure among young German artists.

Performances, unlike dramatic plays, are usually neither preserved in scripts nor replicated on the stage. Thus, once a performance has been presented, its only residue is a description and a photograph (such as the one of Beuys's *I Like America and America Likes Me* in Figure 14-19). To the degree that it depends on photography, this art therefore resembles that of photo-artists Cindy Sherman (Figure 4-24) and Sandy Skoglund (Figure 5-18) who pose themselves or other people in *tableau-vivants* before their cameras. Now, most Performance artists use camcorders and videotape (Chapter 4) for disseminating and preserving their work. The merging of media—in this case, Performance, photography, and video—is typical of recent art.

Conceptual Art

Conceptual Art is another approach to art as idea that developed in the late 1960s. Indeed, Conceptual artists have argued that the creation of art is possible without the use of objects or events. Just as Duchamp has challenged the definition of art by designating certain random, manufactured objects as artworks (Figure 13-14), these artists were prepared to challenge the need for anything but the idea itself.

Conceptual Art was partly an outgrowth of the expansion of art into events and performances. Some projects took up such a large geographical area that the participants were able only to communicate by letter or phone, so the object itself—or any kind of contiguous visual form—no longer existed. Other projects were reduced to such an extent that the idea seemed to overshadow the visual form and the event. In still other projects, because the expense or other considerations made the work impossible to create or perform, the whole thing remained in the proposal stage.

Yet in spite of their emphasis on the idea, Conceptual artists have made concessions to the physical world—since it is impossible, short of telepathy, to communicate an idea without some kind of a medium. They therefore provide a document of some kind for each piece—usually something as simple as a photograph, a tape recording, or even a postcard. John Baldessari's *Cremation Piece,* for example, is documented by a printed statement (Figure 14-20) that

"One of several proposals to rid my life of accumulated art. With this project I will have all of my accumulated paintings cremated by a mortuary. The container of ashes will be interred inside a wall of the Jewish Museum. For the length of the show, there will be a commemorative plaque on the wall behind which the ashes are located. It is a reductive, recycling piece. I consider all these paintings a body of work in the real sense of the word. Will I save my life by losing it? Will a Phoenix arise from the ashes? Will the paintings having become dust become art materials again? I don't know, but I feel better."

14-20 John Baldessari, *Cremation Piece,* 1969 (detail). As shown at The Jewish Museum in the exhibition *Software,* 1970. Photo courtesy Jewish Museum/Art Resource N.Y. Courtesy of artist and Sonnabend Gallery, N.Y.

describes the process of the work and even some of its ramifica-
tions, by photographs of the studio, by the paintings that were
burned and the act of cremation, by the ashes themselves, and by a
plaque that reads *John Anthony Baldessari, May 1953—March 1966.*

The ways in which art has been practiced as idea or as activity
have helped to expand the range of artistic possibilities and, of
course, make definitions even more impossible to establish. Some
forms rely on performance as the medium, others on writing, still
others on normally undetectable means such as radio waves passing
through a room—and the objectives of such art are nearly as nu-
merous as the artists. Rather than leading to a dead end, the de-
emphasis of the art object has produced a seemingly endless num-
ber of possibilities.

RECENT ART

Trying to understand the immediate past is like trying to make
sense out of the blur of sights from the rear of a fast-moving train.
Everything is passing by too rapidly to see clearly and is too close in
time and space to determine which object is important enough to
focus on. This analogy is especially true for recent art: Our present
train of thought seems to be passing through an unusually profuse
and exotic landscape—picking up speed as it goes.

Yet in spite of—perhaps because of—this incredible variety
and speed, no significant new schools of art have appeared on the
scene since the decade of the 1960s. Pop, Color-Field, Hard-Edge,
Minimalism, Performance, and other styles did not continue as
movements into the 1970s—although many of the artists who de-
veloped them have continued to work in those modes. Apparently
the developments of the 1960s left artists with enough ideas to
create and explore for some time to come.

Since there are no longer any constraints about the materials
that may be used in an artwork—dirt, garbage, animals, fat, ashes,
radio waves, even the artist's body—there seem to be few signifi-
cantly original materials left for an artist to employ. But one can
always find new ways to look at the old materials. Alice Aycock's
sculptures are as new as Earth Art and as old as architecture. Using
traditional construction materials such as wood and concrete, she
builds untraditional structures. Typically, they invite the viewer to
enter a space that is inaccessible or uninhabitable. Some are quite
low and partly built into the ground; some are set high above the
ground; others are merely facades. Because of its interesting spatial

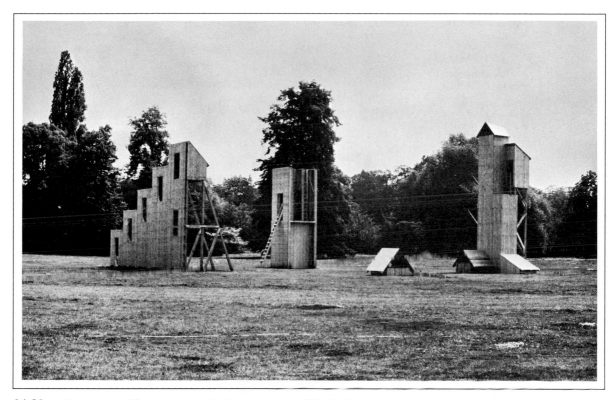

14-21 Alice Aycock, *The Beginnings of a Complex* . . . , 1977. Wood and concrete, tallest tower approximately 30' high. Documenta VI, Kassel, Germany. Photo courtesy of John Weber Gallery, N.Y.

relationships, its clean lines, and even its freshly milled lumber, *The Beginnings of a Complex* . . . (Figure 14-21) appeals to us as an abstract sculpture. But as a shelter, it challenges the imagination. In this latter context we tend to associate it with our own bodies, comparing it to other shelters. Where do the steps lead? Can we sit in it? Stand in it?

Other kinds of recent art involve neither new materials nor particularly novel ways of using old materials. Instead, their novelty concerns the radicalness of the idea behind them—meaning that a Conceptual Art sensibility is involved even though a traditional medium is used to make a relatively conventional painting or sculpture. One type of sculpture, like traditional realistic sculpture, entails making objects that represent things in the real world. But it goes so far in its imitation of the appearances of things that it manages to challenge reality itself. The creators of these "false objects" tend to reproduce everyday articles in their original size, shape, and color, but in an alien material—strawberries of painted bronze or a

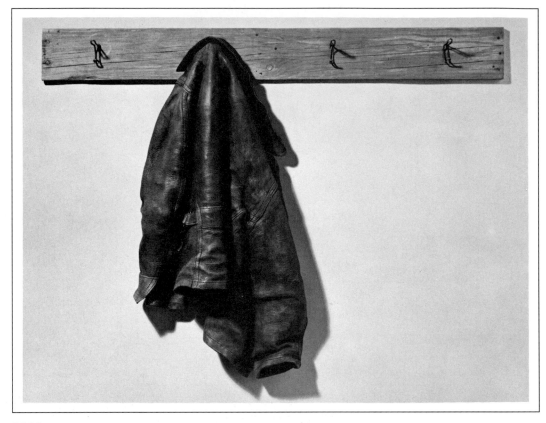

14-22 Marilyn Levine, *Trent's Jacket*, 1976. Ceramic, wood, and metal hooks, 35″ × 18″ × 8″. Private collection. O.K. Harris Works of Art, N.Y., N.Y.

motorcycle of carved wood. Among the most fascinating examples of this type of art are the "leather goods" of Marilyn Levine. A viewer is almost forced to touch *Trent's Jacket* (Figure 14-22) to realize that the material hanging limply on the coat rack is hard ceramic and not supple leather.

The obvious relatives of Levine's false objects are de Andrea's realistic nudes (Figure 5-4). But also related are the paintings of the *Photo-Realists,* whose work often resembles photographs. *Kent* (Figure 14-23) by Chuck Close even simulates photographic focus, blurring the subject's nose—which is too near—and his neck and shoulders—which are too far away. While Close prefers to make large blowups of his friends with acrylic paints and an airbrush, other Photo-Realists use traditional oil paints and brushes. Photo-Realist paintings became popular in the early 1970s, when the art world was satisfied that they were not simply another wave of traditional realist painting but an attempt to make use of the unique

14-23 Chuck Close, *Kent,* 1970–71. Acrylic on canvas, 8'4" × 7'6". Art Gallery of Ontario, Toronto. Purchase, 1971. Photo courtesy Art Gallery of Ontario.

characteristics of the camera. By prodigiously copying photographs in paint, these artists were calling attention to the surface effects of pattern and color peculiar to the camera's special way of seeing. In the wake of Photo-Realism came two developments: Photography (Chapter 4) came into its own as an art form, and traditional realism, as exemplified by the works of such people as Gregor (Figure 7-17) and Pearlstein (Figure 8-23), experienced a significant revival.

Along with the revival of realism, subject matter—almost abandoned during the modern period—has returned. In an age in which the boundaries between the arts have been erased and anything goes, the only rules left to break are those that Modernism itself established. Dottie Attie experiments with the restoration of

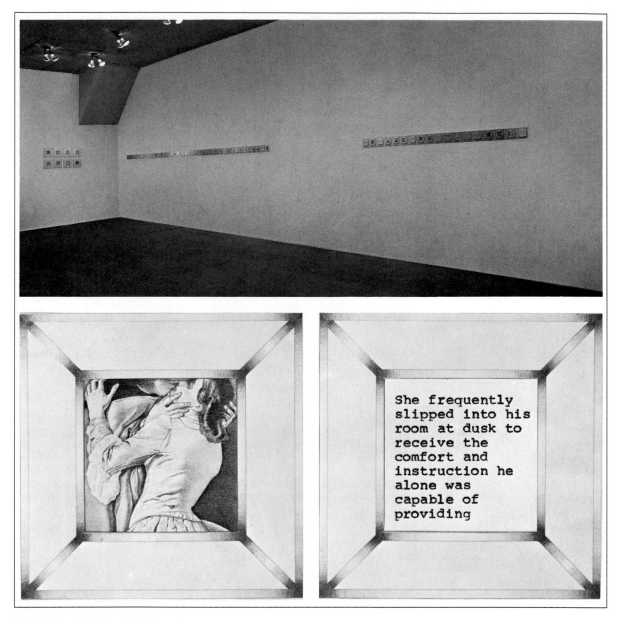

14-24 Dottie Attie, *Carolina and Her Father,* 1978. Pencil on paper, each drawing 4½″ square. Installation at the A.I.R. Gallery, New York. Private collection.

subject matter in a direct and literary way. Her love of drawing and of the great art of the past—particularly that of the Baroque, Neo-classical, and Romantic periods—inspired her to develop an unus-ual form of "narrative art." Attie begins by meticulously drawing a miniature version of an old master painting, usually isolating such details as a face, a pair of hands, or some form of contact between two people. She then frames each of these tiny sketches and alter-

nates them with brief fragments of stories she invents or borrows from books. Mounted on a wall, these miniature narratives sometimes stretch more than 40 feet (Figure 14-24). Typically, the events they suggest are vaguely erotic or perverse. Yet she never openly represent such activities in the pictures or explicitly states them in the texts—but leaves it up to the viewer to draw conclusions. Attie's droll stories are crisp and elegant understatements that stimulate curiosity and arouse the imagination. Significantly, the emphasis in her art is not on the novelty of the form or the medium, but on the novelty of the way in which she manipulates images, subject matter, and narrative content.

Related to this renewed interest in subject matter and content was still another revival: Expressionism, which had been dormant since the early 1960s. Critics were divided over the importance of the phenomenon and the quality of the work associated with it. Was it a significant new wave or simply a reaction to Hard-Edge painting and another of Modernism's many cycles?

However, all writers agreed that— for the first time since Abstract Expressionism—an unusual volume of art featuring thick, vigorously applied paint occurred in both Europe and America in the early part of the 1980s. Although varying from abstract to realistic, the majority of "Neo-Expressionism" is pictorial—apparently satisfying a public hunger for images following three decades or so of abstractionism, minimalism, and conceptualism. Like the drawings of Attie, this art is often narrative, the story content evoked by images or by the title of the work. And like Attie, Neo-Expressionist artists freely delve into the realms of allegory, myth, art history, and history for their sources.

One of the more outstanding Neo-Expressionists in Germany is Anselm Kiefer, whose art, like that of his German-Expressionist ancestors, is serious and often *angst*-ridden. His themes, however, relate more to national anxieties than to personal ones. Kiefer and many young German artists are concerned with investigating their country's past. Invoking the names and images of famous Germans or alluding to events in German history, especially stressful and unpleasant moments of that history, Kiefer seeks to exorcise that past in some cases and to redeem it in others. The setting depicted in *Shulamite* (Figure 14-25) is based on an architect's drawing of a mausoleum for World War II German soldiers, but Kiefer has transformed it into a memorial for Germany's victims. The title refers to the name of a Jewish girl in a poem by a survivor of Auschwitz whose "ashen hair" symbolizes the burning of the Jews. Indeed, the brooding interior and the flames evoke the image of a crematorium. The flames could also signify survival. Kiefer's style, like his themes, is eclectic and ambivalent, combining illusionism

14-25 Anselm Kiefer, *Shulamite*, 1983. Oil, acrylic, emulsion, shellac, and straw
on canvas, with woodcut, 114¼″ × 145¾″. Saatchi Collection, London.

with action painting and touches of collage—and always presented
on an enormous, often overwhelming, scale. While *Shulamite* is ren-
dered in dramatic one-point perspective, its heavily incrusted tex-
ture—created out of an unorthodox use of oil, acrylic, shellac, and
straw—calls attention to its aesthetic surface, as though it had been
painted by a Dubuffet or a Pollock.

Not all Neo-Expressionist works are as epic or obsessed with
history as Kiefer's. Many more focus self-consciously on the role of
art itself, and its problematical relationship to society, especially
late-modern society. *The Idleness of Sisyphus* (Figure 14-26) by Italian
artist Sandro Chia is a case in point. In Greek myth Sisyphus was
condemned eternally to push up the side of a mountain a huge

14-26 Sandro Chia, *The Idleness of Sisyphus*, 1981. Oil on canvas, in two parts, overall 10'2" × 12'8¼", top panel: 6'9" × 12'8¼"; bottom panel: 41" × 12'8¼". Collection, the Museum of Modern Art, New York. Acquired through the Carter Burden Barbara Jakobson, Saidie A. May Funds and Purchase.

stone that rolls down every time it nears the top. The myth is easily interpreted as an allegory on the absurdity and frustrations of modern society. But some critics believe it is about Modern art—Chia's personal debunking of Modernism, reflecting doubts about its efficacy in either revealing or redeeming life. Ironically, the works of Chia and other Neo-Expressionists do well in the art market—despite their authors' ambiguous attitudes about the state of late-Modern art. Unlike earlier generations of artists, such as the German Expressionists or the Abstract Expressionists, these artists have not had to starve while heroically promoting their cause before a Philistine public.

Social commentary—content referring to social injustice and so forth—though arguably present in the works of Neo-Expressionists as well as in the works of Pop artists (for example, Hockney, Lichtenstein, Lujan, Oldenburg, Warhol, and Wesselmann), is at best implied. Since the 1940s when the Modern movement gained

momentum in this country, specific social commentary in art has been rare. [The exceptions have occurred, among black artists, such as Romare Beardon (Figure 4-33) and Jacob Lawrence—who has continued to be active since the 1940s.] As we have seen, much of Modern art is completely detached from the concerns of the world at large—and many in the art world have advocated this precise position. Accordingly, art with explicit social/political content has regularly been repudiated. But again, about the only rules left to break are those established by Modernism itself. Increasingly, dialogue about the relationship between art and society appears in critical writing—and, increasingly, art appears with social content.

Issues that haunt late twentieth-century American society, such as the decaying environment, the homeless, AIDS, racism, and sexism, have been addressed. For example, the photographs of Cindy Sherman (Figure 4-24) and the paintings of Sleigh (Figure 8-9) confront the issues of sexism. The paintings of Leon Golub, per-

14-27 Leon Golub, *Interrogation II*, 1981. Acrylic on canvas, 120″ × 168″. Courtesy Barbara Gladstone Gallery, New York.

haps the most direct and powerful examples of social commentary in recent art, are about political terror, especially that found in totalitarian regimes.

Golub's career began during the time of Abstract Expressionism, and remnants of that movement's style—particularly the large scale and rough textures—are present even in his newest work. Yet Golub was never enthusiastic about the principles of Abstract Expressionism, especially its emphasis on the artist's inner world of subjective feelings. Instead, he preferred to emphasize the outer world by symbolizing the human condition—predominately suffering—through large images of roughly-painted, semiabstract giants. Recently, though, Golub has grown impatient with symbolizing abstract notions, preferring to deal directly with concrete situations, such as kidnapping, imprisonment, torture, death—the entire range of twentieth-century political violence. He begins his images by painting them with acrylic and then scraping them down to the bare canvas—leaving only residues of color. In *Interrogation II* (Figure 14-27), the terrifying vulnerability of a political victim is starkly revealed. As critic Carter Ratcliff explains: ". . . Leon Golub confronts us with the grisly reality of domination, drawing us out of ourselves, rubbing our sensitivity— like his paint—raw."

POST-MODERNISM

During our own *fin de siècle* (end of the century) we should pause to see where we have been—then try to imagine where we are going.

Although the Modern movement was never a unified orderly progression, certain general patterns, or streams of influence, can be identified. One stream, centering on an interest in form, began with Cézanne and linked the Cubists, Constructivists, and Mondrian with the recent geometric art of Minimalism and Op Art. Another stream, concentrating on color, began with the Impressionists and connected Seurat, Matisse, and Kandinsky—as well as such color-oriented abstract artists of our own day as Louis and Frankenthaler. The expressionist tradition of Van Gogh and Munch, flowing through the German and the Abstract Expressionists, extended to recent manifestations of Neo-Expressionism. The radical experimentation and ironies of Dada reemerged in Happenings and Pop Art and were continued by events, performances, and Conceptual Art. These streams are interdependent, often overlapping one another. And many works as well as artists belong to more than one tradition.

Today the terms *Post-Modern* and *Post-Modernism*—implying that the Modern movement has come to an end—are being voiced

more and more by not only those who write on art, but by those who write on any aspect of culture. The fact that Modernism has ended may be debatable; the fact that the perception of its ending exists, however, is not debatable and it is significant. Such a perception scarcely existed, let alone enjoyed prevalence, before the late 1960s.

But other than the end of Modernism, what does the term "Post-Modernism" signify? About the only thing scholars agree on is that the term is vague and semantically unstable. Some view Post-Modernism as a playing out of the agenda of late Modernism. Others see it as a new phase in cultural history, but are unable to describe just what it is. One of the problems stems from the inability to define Modernism itself. Another is the fact that the ending of any major movement is never abrupt or definite. As art historian and critic Robert Hughes explains: "Histories do not break off clean, like a glass rod; they fray, stretch, and come undone, like rope. There was no specific year in which the Renaissance ended; but it did end. . . . So it is with modernism, only more so, because we are much closer to it. . . . "

Any description of Post-Modernism would have to recognize its foreshadowings, even prior to 1960, particularly in the works of such people as Duchamp, Johns, Rauschenberg, and Kaprow. And certainly no clean break exists between the art of today and Pop, Performance, Conceptual, and other neo-Dada manifestations of the 1960s and 1970s. But a new mood—a feeling that Modernism is exhausted and no longer generative—does exist today. Perhaps we should speak of a Post-Modern awareness or "sensibility." If so, we would have to identify the various facets of this sensibility.

Acceptance of Pluralism The 1960s and early 1970s witnessed a number of new movements. Each, like any other avant-garde, had its advocates. But the many rival kinds of art, and their attendant belief systems, contradicted one another and began to strain the credibility of the very concept of an avant-garde. This credibility became even thinner during the 1980s, when the pluralism continued, yet few new ideas, and no major movements, emerged. Further, and even more significantly, the public ceased to be shocked over new developments in art as they had been in the past (recall the scandals of Manet, the Fauves, Cubism, Abstract Expressionism, and Pop Art). The debates for and against new ideas have ended. Now, anything is possible in art; everything is acceptable.

Eclecticism One of the principles of Modernism was originality and faith in the new. To borrow styles, ideas, and motifs from the past was taboo. Attie's copying of a part of an old master painting is clearly a defiance of this principle. Kiefer's and other German artists' veneration of myth and history ironically serves to

"demythologize" Modernism. The revival of Expressionism, to say nothing of the revival of Realism, is another blow to Modernism's "tradition of the new."

Contextualism Much of the art produced today evokes the sense of its own context—that is, an awareness of its socio- and art-historical roots. This is in opposition to most Modernist art, which was thought to be autonomous—isolated from the outside forces of society and history. Post-Modern works not only reject Modernism's elevated stance, but seem to go to special lengths to raise the question of their own problematical place in culture. Both Chia's and Kiefer's works raise this question. Golub's work brings us to confront once again the relationship between art and social morality.

Art about Art Post-Modernism is self-conscious not only about its role in culture but about the role of images in general. Along with semiologists (specialists in the science of signs and symbols), artists have come to the recognition that the world is given to us through language, including the language of art. This has led them to investigate the conventions of that language, sometimes placing more emphasis on the codes used to transmit content than on the content itself. This sort of investigation was anticipated by Pop artists who, by focusing on the icons of popular culture, brought us into closer contact with not only the codes of those icons but their latent messages. Attie's appropriations, in which she employs the codes of masterworks but alters their messages, is another example of this kind of investigation.

The blatant appropriations of Sherrie Levine, in which she copies a modern masterwork, bring to mind the false objects (Figure 14-22) of Marilyn Levine (no relation). At first glance, a viewer might mistake Levine's watercolor, *After Piet Mondrian* (Figure 14-28), for a painting by Mondrian himself—the famous master of geometrical abstractions (Figure 13-11). Prior to making paintings of paintings Levine did photographs of famous photographs. Although she brings us into fresh contact with someone else's art, which in itself is a virtue, Levine is really commenting on the conventions of the art world rather than on those of the artwork in question. She causes us to ponder not only the issue of originality but those of provenance (origin) and attribution (authorship), issues peculiar to the art world that are often taken for granted by the public. Perhaps a harder question to ponder: Are we to respond to her watercolor in the same way we would respond to an authentic Mondrian? Levine's art is quite original—not because of her borrowed style(s), but because of the novelty of her idea.

Because David Salle's paintings incorporate all the characteristics described above, his work is almost a summation of Post-Modernism. It takes its images from a variety of sources—typically

14-28 Sherrie Levine, *"Untitled" (After Piet Mondrian)*, 1984. Pencil, watercolor/ paper, 14″ × 11″. Private collection (Courtesy Mary Boone Gallery, New York).

from popular illustrations and pornography magazines. It also borrows styles, often from such unrelated modes as primitive art, illustration, comics, action painting, minimalism, and assemblage. Salle's art, thus, is pluralistic, eclectic, contextual, and a commentary on art. All this, plus the fact it evokes an appropriate *fin de siècle* mood of cynicism and disenchantment.

Despite the enigmatic combinations, Salle's art does exhibit certain traits—a recognizable Salle signature: the use of rectangular divisions or individual panels, salacious views of women painted in gray monochrome (or *grisaille*), and a series of overlaid and inset

14-29 David Salle, *Jar of Spirits*, 1987. Acrylic and oil on canvas, 96″ × 133½″. Collection Seibu Museum, Tokyo Japan (Courtesy Mary Boone Gallery, New York).

images. True to form, his *Jar of Spirits* (Figure 14-29) is divided into three panels containing grisaille illustrations of women, topped by a fourth, horizontal panel. Between the middle and right panel is an inset containing a jar of spirits. The horizontal panel contains, in addition to two dogs, an oval inset containing an antique chair and a plain oval. The antique-chair image is repeated in the upper part of the left panel as an overlaid line drawing. Each of the women is partially-clad, the two on the left in drum-majorette jackets. The one on the far left, standing before a row of modern chairs, holds what appears to be a light bulb; the other two hold musical instruments.

What are we to make of these images, other than the fact that they are alienated? Perhaps the chair, as a receptacle, represents

the female principle. Perhaps dogs and women, especially fetishized women such as these, are both seen as vulnerable and marginal. The monochrome treatment of the women tends not only to distance them, but to render them insensible. Salle's interpretation of sexuality, like Fischl's in *Noon Watch* (Figure 8-29), becomes a metaphor of frustration. Finally, how does the jar of spirits, the title image, relate to any of this? Perhaps it is empty, signifying the absence of spirit. As critic Eleanor Heartney suggests, "It is not death, as so many commentators have proposed, but the state of having never been alive that haunts Salle's paintings."

Not surprisingly, Salle's art is controversial. Some are offended by the sexism of his female images; others defend Salle's frankness in this regard as socially redeeming in that it addresses sexism. Some are frustrated by his jarring imagery that thwarts meaningful connections; others are stimulated by his daring evocation of an age of media overkill and disjointed meaning. As critic H. H. Arnason contends:

> Thus liberated from the absolutes and narrow logic of traditional modernism, and handed a slate wiped clean by modernism's final binge of self-purification, artists like Salle could use rampant imagination and inherited pictorial sophistication to express a sour, schizoid *fin de siècle* moment with stunning clarity and brilliance.

SUMMARY

The possibility of Modernism's demise brings us full circle to the theme that was aired in the first chapter of this part: the shape of time. Chapter 11 provided a theory to explain change in art as well as an overview of the changes occurring between the early 1400s to the mid 1900s. Many of these changes were categorized by periods or movements—"Renaissance," "Mannerism," "Baroque," and so forth—some of which lasted for nearly a century while others came and went in a matter of decades. In Chapters 12 and 13 we saw the cycles of change in nineteenth- and early twentieth-century art become even shorter as avant-gardes tended to come and go in a matter of years. Now, as we have seen in this chapter, the succession of avant-gardes may have come to an end, and people are talking about a movement called Post-Modernism.

But does Post-Modernism signify the beginning of something new? Or is it just a holding pattern until the end of this century? Without speculating about the future, we can offer at least one useful observation: New centuries have a unique way of rein-

vigorating culture. We witnessed the explosive developments in art that occurred during the first three decades of the twentieth century (the same kinds of striking events took place in music, literature, and science). There is every reason to believe that dramatic developments will accompany the beginning years of the twenty-first century. Perhaps today some relatively unknown artist, like Cézanne 100 years ago, is quietly producing work that will be discovered and extolled in the next century as the harbinger of a new era in art. If so, that subject will be chronicled in a future edition of *Art in Context*.

GLOSSARY

abstract Pertaining to art consisting of patterns or shapes not necessarily resembling anything in the real or imaginary world. Of any art in which subject matter and images are either entirely absent or de-emphasized.

Abstract Expressionism An American abstract art movement beginning in the 1940s and flourishing during the 1950s. It consists of two types of paintings: (1) *Chromatic Abstraction* characterized by large broadly-painted, soft-edged shapes, and (2) *Action Painting* characterized by multiple colors and shapes highly agitated in appearance—as if painted rapidly and spontaneously. Both types are considered highly subjective, created out of the inner necessity of the artist.

Abstraction Lyrique A European equivalent of Abstract Expressionism. See *Abstract Expressionism.*

academic Pertaining to academies. Artwork overly committed to rules, unoriginal, and/or pedantic.

academy A school for artists.

acrylic A synthetic painting medium. A technique of painting in which pigments are mixed with acrylic. A painting by this technique.

aerial perspective Suggesting depth in a picture by the use of progressively cooler hues, more subdued color contrasts, and softer edges for distant things. A method of simulating atmospheric conditions. See *sfumato.*

aesthetic Pertaining to art. Of a sensitivity to art or things beautiful.

aesthetics The study of art and/or theories of beauty.

agora A marketplace in ancient Greece.

air brush An atomizer, or miniature spray gun, used for applying paint. A painting technique in which an airbrush rather than a brush is used.

analogous colors Colors similar in hue such as blue, blue-green, and green. See *hue, color wheel.*

Analytic Cubism See *Cubism.*

anthropomorphic Ascribing human characteristics to nonhuman subjects.

applied arts Products that are functional, but also aesthetically pleasing: furniture, interior decoration, metal work, etc. See *Art Nouveau, fine art, popular art.*

aquatint A method of etching that involves bonding par-

ticles of resin to a plate to create a granular effect. See *etching, intaglio.*

arabesque An ornamental style that uses intricate design, as exemplified by the Ardebil Carpet (Figure 9-7).

arcades A series of arches supported on columns or piers.

arch A principle of construction in which an open space is bridged by a series of wedge-shaped masonry blocks that form a semicircular curve. Characterized by *load-carrying* walls. A structure made by this method. Sometimes referred to as a *true* arch to contrast it with a *corbeled* arch. See Figure 6-6.

architectonic Of artwork that manifests the qualities of architecture: structure, order, monumentality, and so forth.

architecture The process of designing and constructing buildings. A building or buildings.

artifact Any made object.

Art informel A European equivalent of Abstract Expressionism. See *Abstract Expressionism.*

Art Nouveau An applied-arts movement in the late nineteenth and early twentieth centuries. The Art Nouveau style is known for ornate patterns, curvilinear lines and shapes, and plant motifs. Its graphic arts are similar in certain respects to the works of the Post-Impressionists—especially Gauguin.

Ash Can School An American school of painting of the early twentieth century, so called because Ash Can artists drew their subjects from the ordinary life of the American City, including inner-city slums.

assemblage Artwork in which a variety of three-dimensional objects and materials, often unrelated to one another, are combined to form a work of mixed media. See *mixed media, found object.*

assimilation effect A pattern of small units of one color superimposed over a different background color that causes the color underneath to shift its value and hue somewhat toward that of the pattern. See *optical mixing.*

automatic drawing Freely executed lines, shapes, or colors based primarily on the artist's unconscious thoughts and feelings.

avant-garde Literally "forward guard." A group of artists

whose work and philosophy are perceived by the art establishment and general public as nonconformist or experimental. The leaders of an art movement. See *Modern movement.*

balance A perception that opposing parts—right and left, top and bottom, foreground and background—of an artwork are in balance, that the various *visual weights* and *psychological weights* have been equalized. See *composition.*

balloon frame The nineteenth-century name for wood-frame construction.

Baroque Pertaining to a style of art and architecture flourishing in western Europe during the seventeenth century and characterized by grand-scale (or the appearance of such) drama, exuberance, and richness of detail.

barrel vault See *vault.*

basilica In ancient Roman architecture, a large, oblong public building with colonnaded aisles. Christian architects modified the basilica into a longer shape used for a church, usually including several side chapels.

bilateral symmetry Identical elements on either side of a central axis.

biomorphic Suggesting the form of a living organism.

Blaue Reiter, Der (Ger. "The Blue Rider") An association of avant-garde artists who came together in Munich in 1911. See *German Expressionism.*

Body Art Related to Performance and Conceptual Art—where the artist's own body is the focus. See *Performance, Conceptual Art.*

Brücke, Die (Ger. "The Bridge") A group of German avant-garde artists organized in 1905. See *German Expressionism.*

camera A lightproof box with a lens used for capturing the image of a subject on light-sensitive film. See *photography, film negative.*

canon of proportions A set of rules for the proportions of, usually, the ideal human body.

carving Producing a sculpture by cutting, chipping, or hewing wood or stone. A sculpture produced by this method.

casting The process of producing a sculpture by pouring a liquid material that later hardens—such as molten bronze or polyester resin—into a mold. A sculpture made by this process.

ceramic Pertaining to clay that has been changed into a hard substance through baking at a high temperature.

ceramics The art of making objects—vessels or sculptures—out of baked clay. See *coil method, pinch method, potter's wheel,* and *slab method.*

chiaroscuro Literally, "light-dark." Representing the changing effects (particularly the changes in value) of reflected light as it falls on a three-dimensional object or any uneven surface. Often referred to as *shading.* See *value.*

cire perdue See *lost wax.*

Classical Of the period of Greek art from 480 to 323 B.C.

classicism Resembling, imitating, or referring to the art and culture of ancient Greece or Rome. Having the qualities of restraint, order, harmony, and balance. The opposite of romantic art.

closed shape A two-dimensional or three-dimensional shape that is not penetrated by openings or that does not reach out into the surrounding space.

closure The tendency to perceive an incomplete shape as complete; for example, seeing a number of unconnected dots as a single pattern or shape, or perceiving a person sitting behind a desk as a whole person (rather than as just the visible portion of that person).

coil method Ceramic method in which large vessels are formed from winding coils of clay. See *ceramics.*

collage An artwork in which fragments of things—paper, photographs, news clippings, cloth, odds and ends, and so forth—are pasted to a flat surface. See *mixed media.*

color Technically a sensation in the retina of the eye resulting from light waves of varying lengths—but normally a perceived quality of an object. Color is affected by the amount and nature of light falling on an object. Color can be analyzed in terms of its three properties: *hue* (the quality that distinguishes one color from another), *value* (lightness or darkness), and *saturation* (brightness or dullness). Color is considered the most basic of the visual elements because it is through its variations of hue, value, and saturation that we perceive shapes, lines, textures, and space.

color constancy The tendency to perceive the color of an object as unchanging regardless of variations in the amount of light falling on the object.

Color Field An abstract style of painting involving the method of dripping paint invented by Jackson Pollock. However, usually in Color Field painting acrylics are poured on unprimed canvas (rather than oils on primed canvas) to allow the paints to penetrate and stain the canvas.

color harmonies Various combinations of colors considered pleasing; color schemes.

color wheel A circular chart used to display the relationships among the different colors (particularly the hues of those colors). The primaries—red, yellow, and blue—are located at three equidistant points on the circle (forming a triangle). Midway between the primaries are the three secondaries: *green* between yellow and blue, *purple* between blue and red, and *orange* between red and yellow. Large color wheels contain hues between the primaries and secondaries that are related to their neighbors. For example, *blue-green* is between blue and green, *yellow-orange* is between yellow and orange, and so forth.

column A cylindrical vertical support, especially in Egyptian and Greek temple architecture.

commission To hire or contract an artist to do a work of art, such as a mural or portrait (verb); a contract or agreement between an artist and a patron (noun). See *patron.*

complementary colors Colors opposite in hue, such as red and green or yellow and purple. Complementaries are on opposite sides of a color wheel. See *hue, color wheel.*

composition The organization of all the parts of an artwork. The arrangement of the visual elements and other ingredients—images, subject matter, symbols, and so forth—that constitute an artwork. See *unity.*

computer art Art produced with the aid of computers. See *pixel.*

Conceptual Art A theory and practice of art that rejects the use of art objects, maintaining that the essential aspect of an artwork is the idea behind it. Conceptual artists, nevertheless, use objects—photographs, printed matter, audio tapes, and so forth—to document their ideas.

Constructivism A Russian avant-garde appearing shortly before the Revolution that emphasized geometric abstraction.

content The essential meaning of an artwork as distinguished from its form of subject matter. See *theme.*

continuity A single feature or series of features that extends throughout a large part of a composition. An aid to unity. See *unity.*

cool colors Blues, blue-greens, blue-purples—any analogous colors (hues) in which blue predominates. The opposite of *warm colors.* See *analogous colors.*

corbeled arch A method of construction in which an opening is spanned by laying rows of stones in such a way that each row projects inward until they meet at the top (Figure 6-4).

craft art Handmade production of useful objects, such as jewelry, pottery, and quilts.

criticism A systematic analysis of a work of art that may include some or all of the following components: description, formal analysis, interpretation, and judgment.

cross vault A structure consisting of the intersection of two vaults at right angles. See *vault,* Figure 6-9.

Cubism A semiabstract style of art invented by Pablo Picasso and Georges Braque consisting of two types: (1) *Analytic* (c. 1907–1911) in which a subject—typically a still life— is freely represented in monochromatic color by a number of fragmented semitransparent shapes, and (2) *Synthetic* (c. 1912–1913) in which bright colors, vivid textures, and flat jagged shapes vaguely suggest images.

Dada Literally "hobbyhorse." A short-lived arts movement during World War I that began as a protest against the war. Emphasizing parody, anarchy, nihilism, and absurdity (as symbolized by the name), Dada artists customarily expressed themselves through experimental, witty, or outrageous actions—rather than in permanent art objects such as paintings or sculptures.

dome Hemispherical or ovoidal vaulted roof. A radial form of the arch. See *arch,* Figure 6-12.

dominant feature A feature in a picture that stands out most because of its large size, central location, bright color, and/or strong contrast with its surroundings. An aid to unity. See *unity.*

Doric Pertaining to a style of temple architecture developed by the ancient Greeks.

drawing Producing an artwork by making marks— usually of a single color—on a support—usually paper— and including the color of the support as part of the work. An artwork produced by this method. See *medium.*

drypoint A print made from an image scratched by a needle into a copper plate. See *intaglio.*

Earth Art An artwork in which the physical landscape has been altered to create holes, mounds, trenches, and so forth. See *environment.*

edition Copies of a print—usually signed and numbered—made from a single plate.

end-grain Surface of a block of wood cut at a right angle to the grain or direction of growth. See *wood engraving.*

engraving A print made from an image cut by a hard tool into a copper plate. See *intaglio.*

environmental art An artwork that surrounds the viewer on all, or nearly all, sides. See *medium.*

etching A print made from an image cut into a copper plate by means of acid. See *intaglio.*

Existentialism A popular philosophy among intellectuals, including Abstract Expressionists, during and immediately following World War II. Believing that existence precedes essence, Existentialists extol human freedom and reject thought systems that would limit human choice and potential. According to them, however, this freedom tends to breed a sense of loss that in turn leads to loneliness and despair—a pervasive condition of modern life.

expression An idea or feeling communicated by a work of art. See *content.*

Expressionism The artist's personal feelings expressed primarily through distortion of images and vividness of form rather than through realistic depiction of subject matter. Certain art movements of the twentieth century. See *German Expressionism, Abstract Expressionism.*

Fauves (Fr. "Wild Beasts.") An early twentieth-century avant-garde (led by Henri Matisse) whose major contribution to the development of the Modern movement was a controversial exhibit of their work at the Salon d'Automne in 1905. In general, Fauve painting consists of bright arbitrary colors, flat patterns, and distorted stylized images.

ferroconcrete A principle of construction employing concrete reinforced with steel rods or mesh to increase its tensile strength. Reinforced concrete.

fiber Any substance that can be separated into threads or threadlike structures for weaving, braiding, crocheting, knotting, etc.

fiber art Art objects made from fiber. Traditionally these have consisted of wall hangings, blankets, rugs, quilts, etc., but today fiber artists also make sculptures and assemblages.

figure An image of the human body. A shape. See *shape, figure-ground*.

figure-ground principle In perception, the tendency to divide a visual pattern into two kinds of shapes—figure and ground—with the figure(s) appearing to be on top of and surrounded by the ground. In art, figure and ground are often referred to, respectively, as *positive* shape(s) and *negative* shape(s). See *shape*.

film The art of making motion pictures. A motion picture.

film negative A light-sensitive sheet of celluloid that—after being exposed to light in a camera and developed in a darkroom—bears a translucent, negative image of the subject. See *photography*.

fine art Paintings, drawings, sculpture, and like art, typically found in museums and galleries and/or discussed in art books and art magazines. Distinguished from *applied arts* or *popular art*.

flying buttress An exterior wall support for a Gothic Building consisting of a buttress (in this case a tall, narrow masonry pier) connected with a wall at some distance from it by a half arch. See *arch, Gothic*, Figure 6-16.

foreshortening Shortening the depth dimension (lines withdrawing in depth) in a picture to create a three-dimensional illusion.

form The particular characteristics of an artwork's visual elements (colors, shapes, lines, textures, and space) as distinguished from its subject matter or content. A three-dimensional shape. See *style, composition, shape*.

formalism A twentieth-century doctrine of art criticism that stressed the analysis of an artwork's form rather than its content.

found image A picture—usually a photograph or reproduction—removed from one context, such as a newspaper or magazine, and placed in a new context, such as a collage. See *collage*.

found object A nonart object removed from its original context and placed in an art context—such as an art gallery—or combined with other objects to form an assemblage. See *assemblage*.

frame construction A principle of construction in which narrow lightweight members of wood and/or metal are joined to form a framework that will support the walls and roof. Characterized by *nonload-carrying* walls. A building made by such a method.

fresco A technique of painting on wet plaster with pigments mixed with water. A painting made by this technique.

fresco a secco A painting on dry plaster.

Futurism An Italian art movement of the early twentieth century that sought to express the dynamism of modern life and technology through a style based on Cubism. See *Cubism*.

genre art Art in which the subject matter is of everyday, ordinary life.

geodesic dome A principle of construction in which hollow lightweight metal rods are joined to form a series of triangles or hexagonal pyramids that in turn forms a dome or shell. A geodesic dome can be covered with a thin sheet of metal, plywood, clear plastic, or like material.

geometric shapes Shapes having uniformly straight or curved edges and surfaces. These can be either two-dimensional forms such as rectangles, triangles, polygons, and circles (or combinations thereof) or three-dimensional forms such as cubes, pyramids, spheres, and hemispheres (or combinations thereof). Geometric shapes are distinguished from *organic shapes*.

German Expressionism An early twentieth-century art movement consisting of small avant-garde groups and other progressive artists of central and northern Europe. The paintings of the German Expressionists, like those of the Fauves, are characterized by arbitrary colors, flatness, and distortions. But unlike the latter, the German Expressionists emphasized serious content—especially that of an intensely personal point of view.

gesso Plaster prepared with glue for use as a ground in painting.

gestural Of painting or drawing strokes apparently made by broad gestures of the hand and arm, and usually of thick paint.

glass art The art of making objects—vessels or sculptures—out of glass. Methods include blowing, casting, bending or fusing molten glass.

glaze In painting, a translucent layer of paint over another layer or over a ground. In ceramics, a glossy finish that when fused to the clay body renders it impervious to water. See *ceramics*.

golden section An ideal proportion supposedly based on a divine ratio (approximately 1:1.618). See *canon of proportions, proportion*, Figure 3-11.

Gothic A style or system of architecture developed in western Europe during the twelfth century characterized by *cross vaults, pointed arches*, and *flying buttresses*. Pertaining to such a style.

gouache A method of painting with opaque watercolors.

gradient of texture In a picture, units of texture or detail (such as blades of grass) becoming progressively smaller as they withdraw in depth.

grouping Bringing unity to an artwork by clustering things in groups. See *unity*.

Happening An artwork involving actions of performers, objects, and sometimes the viewer(s). A form of improvisational theater. See *environment, Performance*.

Hard-Edge painting Abstract painting that features clearly defined contours and flat, uninflected colors. See *Minimalism, Op Art*.

harmony A condition in which colors and/or shapes of a work appear to go well together. The opposite of clashing.

hatching Closely-spaced parallel lines to suggest, depending on their thickness and density, different shades of gray. In a line drawing, used for chiaroscuro. See *optical mixing, chiaroscuro.*

highlight That portion of an object where the reflected light is brightest. See *chiaroscuro.*

horizon See *eye-level line.*

Hudson River School An American school of romantic landscape painting during the first half of the nineteenth century. At first drawing their subjects from the mountain scenery of New York state, Hudson River artists branched out to other parts of the United States and to other countries.

hue The quality of a color that distinguishes it from others: as red is distinguished from blue, yellow, or green—and so forth. Scientifically, a hue is identified precisely by measuring its light wave and assigning it a position in the color spectrum. For artistic purposes, a hue is identified by name and by assigning it a position on a color wheel. See *color, color wheel.*

hue contrast Adjacent colors having opposite hues, such as red and green or yellow and purple. See *complementary colors.*

ideal Of architecture that manifests excellence in its proportions, balance and harmony of its parts, and so forth. Of painting, sculpture, or any image—particularly that of the human figure—that represents or fulfills a concept of perfection.

idealism Manifesting or expressing a concept of perfection, particularly in the treatment of the human figure. Typical of classical art. See *classicism.*

idiom See *style.*

idolatry The worship of an image.

Impressionism An art movement during the 1870s and 1880s of mostly Parisian artists who stressed the effects of light through freely executed paintings—usually painted on the site rather than in a studio—with short strokes of bright color. A style characterized by this technique of painting.

ink wash A transparent or semitransparent layer of ink applied by brush to a support such as paper.

intaglio Making a print from a plate whose depressed surfaces only—incised lines and gouges—receive the ink that will be transferred to the print after the raised surfaces are wiped clean. See *engraving, etching,* Figure 4-18.

intensity See *saturation.*

in-the-round sculpture Sculpture that is independent, freestanding, and normally can be viewed from any direction.

Italian Renaissance See *Renaissance.*

kiln A high-fire oven or furnace used for baking pottery.

kinesthetic sense Awareness of one's own body movements. See *space.*

kinetic sculpture A sculpture with moveable parts set in motion by a mechanical and/or natural power source. See *mobiles.*

leading Strips of lead used to hold pieces of stained glass in place.

light and dark See *value.*

line In terms of figure–ground, a narrow elongated figure. In art, a long, thin mark ordinarily made by pencil, chalk, brush, and so forth. An outline around a shape. The edge or boundary of a shape. See *visual elements.*

line of sight An imaginary straight line between the eyes of a viewer and the object being viewed.

linear perspective A systematic method for representing three-dimensional shapes in a picture—as seen by the eye from a given viewpoint. The size and shape of each object and the relationships between objects are determined by the locations of one or more *vanishing points* and an *eye level line* (horizon). See Figures 2-36, 2-37, 2-38.

lithograph A print made by the process of lithography. See *lithography.*

lithography A printmaking technique in which the image is drawn on a flat stone or metal plate with a greasy pencil or liquid. The image is then chemically treated so that the image only receives ink—the remaining surface resisting ink. See *planography.*

load carrying Of a wall or post that supports a roof, as distinguished from a nonload-carrying wall or post. In the case of masonry roofs, ordinarily such walls or posts must be thick and/or numerous. See *arch, masonry, post and lintel.*

lost wax A method of hollow-bronze casting in which a mold is lined with a ⅜″ or less layer of wax, filled with a solid core of plaster, and heated to melt the wax, leaving a ⅜″ or less cavity between mold and core into which molten bronze is poured. Sometimes called *cire perdue.* See *casting.*

lunette A semicircular or triangular area of wall between a window opening and the vault above it. See *cross vault.*

mandala A Hindu or Buddhist graphic symbol of the universe.

masonry The use of stone, brick, or cement blocks to build a structure. Characterized by *load-carrying* walls. That part of a structure, such as "stonework" or "brickwork," made with masonry materials. See *principle of construction.*

mass Three-dimensional shape. See *shape.*

mastaba A small, flat-top Egyptian tomb.

medieval Pertaining to the Middle Ages. See *Middle Ages.*

medium The materials and techniques used to make an artwork. A particular category of art such as painting, sculpture, environment, and so forth.

metal frame See *frame construction.*

metals and jewelry The art of making precious objects—

jewelry, vessels, or small sculptures—out of metal, often with gold and silver. Methods include casting, annealing, bending, cutting, soldering, and electroforming.

Middle Ages The period of Western European history from the decline of the Roman Empire to the beginning of the Renaissance (A.D. 476 to *c.* A.D. 1400).

middle value A value (or color) that is neither particularly light nor particularly dark. Gray. See *value*.

minaret A tall prayer tower attached to or nearby a mosque, usually surrounded by balconies.

Minimalism An abstract style that flourished in the late 1960s characterized by the use of simple geometric shapes, straightforward symmetrical compositions, and extreme parsimony.

mixed media Artworks in which two or more media are combined—often in an incongruous way. Artworks in which two-dimensional approaches are combined with sculptural approaches.

mobile An abstract sculpture with movable parts—rods and thin forms connected by swivels—set in motion by air currents. See *kinetic sculpture*.

modeling Producing a sculpture from a pliable material such as clay or wax, by manipulating the material with the hands or with shaping tools such as paddles or knives.

Modern art The various kinds of art made since the 1860s and associated with the Modern movement. See *Modern movement*.

Modern movement The series of changes in art and in events related to those changes in art that began in the 1860s. For the most part, the changes moved away from realism and toward greater use of abstract modes.

monochromatic Of an artwork having only one color. Typically the color exhibits varieties in its value and saturation but not in its basic hue. See *color*.

mosaic A design composed of small pieces of colored material (glass, stone, marble) called tessera, set in plaster.

mosque A place of worship for Moslems.

muezzin A Muslim crier who announces the hour of daily prayer.

multiple-point perspective A picture drawn in linear perspective that uses more than one vanishing point—usually two. See *linear perspective*, Figure 2-37.

mural Literally, "wall." A picture painted directly onto a wall. See *fresco*.

negative shape See *figure-ground*.

Neoclassicism Literally "new" classicism. A movement in the visual arts of the late eighteenth and early nineteenth centuries in which artists and critics sought inspiration from the art of ancient Greece and Rome (particularly early Rome) and emphasized in their own artwork the qualities of simplicity, order, and balance. See *classicism*.

Neoplatonism A revival of the writings and ideas of Plato (fourth century B.C. Greek philosopher) that flourished in Renaissance Italy, particularly in Florence.

neutral color/neutral A color so low in saturation that it lacks an identifiable hue: gray, brown, white, and black. See *saturation*.

nonload-carrying Of a wall attached to a frame structure. A wall that does not support a roof. As distinguished from a load-carrying wall. See *frame construction*.

oculus A round opening in a dome.

oil A technique of painting in which pigments are mixed with oil, usually linseed oil. A painting made by this technique.

Op Art An abstract style of art popular in the early 1960s that emphasized optical effects through the use of geometric patterns.

open sculpture A sculptural form penetrated by one or more openings. Sculpture, such as a welded sculpture, in which the parts are pieced together around empty space(s).

open shape A two-dimensional or three-dimensional shape penetrated by openings.

optical mixing Perceiving a single color yet looking at numerous colors applied close together. For example, from a distance side-by-side dots of red and yellow appear orange; dots of black and white appear gray, and so forth.

optical painting See *Op Art*.

organic shapes Shapes having irregular edges or surfaces as distinguished from *geometric shapes*. Shapes resembling things existing in nature (whether animate or inanimate).

pagan Not Christian or Jewish—particularly in reference to the art and mythology of ancient Greece or Rome.

painting Producing an artwork by applying *pigments* mixed with a *vehicle* (a liquid such as water or oil) to a *support* (a surface of some kind, such as canvas or wood). An artwork produced by this method. See *medium*.

Paleolithic Literally "old stone." Of a hunter–gatherer culture that existed from 30,000 to 10,000 years ago.

patron A person, usually of wealth and high social station, who purchases art or provides financial support for an artist in exchange for his or her work.

Performance An artwork involving an act or stunt by the artist rather than a tangible object such as a painting or sculpture. See *Happening*.

persistence of vision The condition of a visual impression remaining on the retina for a brief time after the stimulus has been removed.

photograph An artwork produced by means of photography. Light-sensitive paper (called contact paper) exposed in a darkroom to light passed through a film negative and then developed. See *photography*.

photography Producing an artwork by capturing the image of a subject on light-sensitive materials by means of a camera and a chemical process termed developing. See *medium*.

Photo-Realism Realistic painting of the early 1970s based on the direct copying of photographs.

Pietà Literally "pity." An image of the dead Christ mourned by Mary.

pigment Coloring matter. A substance of a particular color that when mixed with a vehicle can be used to make a painting. See *painting*.

pinch method Ceramic method in which cups and small bowls can be formed by progressively pinching the shape from a fist-sized ball. See *ceramics*.

pixel The smallest unit in computer art. A pixel can be translated into a dot with specified x–y coordinates on a video screen. See *computer art*.

planography Making prints from a plane-surface plate. Ink is retained by portions of the surface because of their chemical variations (lithography) or their physical variations (serigraphy or silkscreen). See *lithograph, lithography, serigraphy, silkscreen,* Figure 4-21.

plate A wooden block, metal sheet, flat stone, or silkscreen used in printmaking. See *printmaking, woodcut, engraving, etching, lithograph, silkscreen.*

Pointillism A painting method, favored by Georges Seurat, that consists of applying paint in tiny dots of relatively pure color.

Pop Art An art movement of the 1960s that satirized popular culture (sometimes, high culture) through deadpan imitations of advertisements, signs, illustrations, and so forth. Because of its blatant use of subject matter as well as hard-edged shapes and bright colors, Pop Art was perceived as a reaction against Abstract Expressionism.

popular art Chiefly products of the entertainment, advertising, and news industries: television shows, movies, commercials, billboards, illustrations, comic strips, news photography, and so forth. Distinguished from *fine art*.

positive shape See *figure-ground*.

post and lintel A principle of construction in which the horizontal members—lintels or beams—that span an open space are supported by vertical members—posts, columns, walls, piers, and so forth. Characterized by *load-carrying* walls.

Post-Impressionists A late nineteenth-century avant-garde consisting chiefly of Cézanne, Gauguin, and Van Gogh, whose paintings resemble those of the Impressionists in their use of bright color. However, rather than emphasizing the effects of light, these artists aimed at exploring the formal structure of art or expressing their personal feelings.

Post-Modernism A loosely defined term referring to a new cycle in Western art history following Modernism. See *Modern movement*.

potter's wheel A revolving disk on which a ball of clay can be formed into a round vessel. See *ceramics*.

primary colors The hues of yellow, red, and blue. Theoretically, all other hues are produced from these three.

Combining equal amounts of any two will produce a secondary color, such as orange (from yellow and red). See *color wheel, hue*.

prime objects A successful major innovation in the style of an artwork or artifact.

principle of construction The particular materials and technology used to build a structure. See *architecture*.

principle of design Guidelines for composing a work of art. See *composition*.

print (1) A woodcut, etching, engraving, lithograph, silkscreen, or the like. One of several impressions made from an inked plate. See *printmaking*. (2) A photograph. One of several copies of a single film negative. See *photograph*.

printmaking Producing a number of identical artworks, *prints,* by impressing paper against an inked *plate* on which an image has been carved, drawn, or stenciled. See *medium*.

proportion The comparative relationships between a whole and its parts or between only the parts themselves—with respect to size, height, length, or width.

psychic improvisation See *automatic drawing*.

psychological weight The relative symbolic or emotional importance of a feature in an artwork. See *balance*.

putto (putti) The figure of an infant boy, usually shown as an angel.

radial symmetry Identical elements branching out in all directions from a common center.

readymade Term used by Marcel Duchamp to refer to a banal object transformed into an artwork. See *found object*.

realism A relatively high degree of resemblance between the form of a painting or sculpture and what the eye sees. Also the use of "true-to-life" subject matter rather than fantastic or idealized subject matter.

rectilinear Characterized by straight lines.

Regionalism An American school of art of the 1930s and 1940s whose subjects were drawn from different regions of the United States—principally from those of the rural Midwest.

relief printing Making prints from a plate whose raised surfaces only receive the ink that will be transferred to the print. See *woodcut,* Figure 4-15.

Renaissance Literally "rebirth." A cultural surge in the arts founded largely on a revival of classical art that began in fifteenth-century Italy and eventually spread to all of western Europe.

rhythm Repetition of similar elements or features. See *grouping, similarity, continuity*.

Rococo A style of art characterized by elaborate and delicate ornamentation. Rococo developed out of the Baroque style in the 1700s. See *Baroque*.

Romanticism A nineteenth-century arts movement that emphasized the values of subjectivity, passionate emotion, and artistic freedom—all tending toward visionary, dramatic, or exotic themes. A reaction against Neoclassicism.

salon A distinguished cultural event, usually held annually or on some regular basis. An art exhibit of this type. The place where such an event is held.

Salon des Refusés An exhibition mounted in Paris in 1863 for works rejected that year by the official Salon.

saturation The relative purity of a color from bright to dull. Sometimes referred to as intensity. See *color*.

scale Relative size.

sculpture The process of producing three-dimensional art. A three-dimensional artwork. See *medium*.

secondary colors The hues of green, orange, and violet. See *primary colors*.

serigraphy A stencil method of printmaking using a silk-screen as a plate. See *planography, silkscreen*.

sfumato Literally "smoke." In a picture, the effect of hazy atmosphere produced by blurring or softening the outlines of objects and figures.

shading See *chiaroscuro*.

shape That quality of a thing pertaining to the limits of its external edge or surface. Shape is either *two-dimensional* (having height and width) or *three-dimensional* (having height, width, and depth). See *visual elements, figure-ground*.

shape constancy The tendency to perceive the shape of a three-dimensional object as unchanging regardless of any change in the position of the object with respect to the viewer.

silkscreen A plate used in the silkscreen or serigraphy process consisting of a frame of mesh material through which ink passes and an attached stencil(s) that blocks the passage of ink. A print made by the silkscreen or serigraphy process. See *serigraphy, printmaking*.

similarity The resemblance between two or more things in an artwork, usually with respect to one of the visual elements—color, shape, and so forth. An aid to unity. See *unity*.

simulated texture Texture(s) represented in a picture or realistic sculpture as distinguished from the texture of the artwork itself.

single-point perspective A picture drawn in linear perspective with only one vanishing point. See *linear perspective*, Figure 2-36.

size constancy The tendency to perceive the size of an object as unchanging regardless of any change in the distance between the object and the viewer. See *shape constancy*.

size/sizing A viscous substance applied in a thin layer to a porous surface such as canvas. Used on canvas before the application of oil paints. See *oil*.

skyscraper A towering building with an elevator.

slab method Ceramic method in which slabs of clay are joined to create forms with flat sides. See *ceramics*.

space The area between and around three-dimensional objects or shapes; the area within open or hollow shapes.

Although space is experienced by moving within it (using our kinesthetic sense), its boundaries and limits—as defined by the shapes it touches—can be perceived visually. See *visual elements*.

spectrum The visible colors diffracted by passage of white light through a prism.

split complementary An arrangement of colors consisting of a hue opposed by the hues on either side of its complement. See *hue, color wheel*.

still life A picture of small objects—typically things found in a home or studio.

structured movement See *rhythm*.

stupa A dome-shaped mound that serves as a Buddhist shrine.

style The distinguishing traits of an artwork that identify it as having been produced by a particular artist, school of art, period, or culture. The way in which an artwork is made, designed, or composed as distinguished from its subject matter or content. See *form*.

stylize In an artwork, emphasis on the manner in which a thing is represented rather than the way it appears to the eye. To make an image conform to the rules of a particular style. See *style, pictorial convention*.

subject/subject matter The people or objects represented in an artwork. See *image, theme*.

support Any surface—canvas, wood, paper, wall, and so forth—on which a painting or drawing can be made.

Surrealism A theory and practice of art that seeks to portray subconscious experiences or dream phenomena. An art and literary movement of the 1920s, Surrealistic paintings vary from realistic styles—often depicting dreams or other exotic subjects—to semiabstract styles containing primitive or childlike images.

symbol A feature in an artwork that signifies something else—as the cypress tree in "The Starry Night" symbolizes death (Figure 12-11).

Symbolists A literary avant-garde of the late nineteenth century whose theories and approach paralleled those of the Post-Impressionists—especially Gauguin. See *Post-Impressionists*.

Synthetic Cubism See *Cubism*.

tableau vivant(s) A scene or picture of people posing.

Tachisme A European equivalent of Abstract Expressionism. See *Abstract Expressionism*.

tactile Concerning the sense of touch. See *texture*.

tatami Straw mat used as a floor covering in Japanese homes.

tempera A technique of painting in which pigments are mixed with water and casein, glue, or egg yolk (traditionally the latter). A painting made by this technique.

tensile strength The ability of a construction member (such as a lintel), when spanning a given arc, to withstand

the stress of its own weight or the weight of something resting on it.

tertiary color A color produced by mixing a secondary color and an adjacent primary color—e.g., blue-green, yellow-orange, etc. See *hue, color wheel.*

tessera (tesserae) Small pieces of colored stone, glass, or marble used in making mosaics.

texture The surface quality of things: smooth, rough, soft, glossy, matte, and so forth. Although generally perceived through the sense of touch, texture can also be seen. See *visual elements.*

theme The subject and/or underlying idea of an artwork. Subject matter is ordinarily less general and less abstract than theme. For example, the subject matter of Toulouse-Lautrec's painting (Figure 12-13) is "people at a cabaret"; the theme is "decadence." See *content.*

tokonoma A semi-sacred alcove in the living room of a Japanese home.

triad colors Equidistant colors on the color wheel, such as red, yellow, and blue or green, purple, and orange. See *hue, color wheel.*

two-point perspective See *multiple-point perspective.*

unity Literally the state of being one. In a work of art, a perception that each thing fits, harmonizes, and functions well with everything else in the work. As opposed to a perception that one or more things do not fit, harmonize, or work well—in the extreme, a perception of chaos. The means for providing unity include the use of *grouping, similarity, continuity,* and *dominant feature.* See *composition.*

value The relative lightness or darkness of a color. Values of a color (with an unchanging hue and saturation) can be located on a scale from white to black. See *color.*

value contrast Adjacent colors with opposite values such as dark blue and light blue or black and white. See *value.*

vanishing point The point in a picture at which all parallel lines that withdraw in depth converge. See *linear perspective.*

vault A continuous arch resembling a tunnel or half barrel used to span a rectangular space. See *arch,* Figure 6-6.

vehicle A liquid such as water or oil with which pigments can be mixed. See *painting.*

video art Art using the technology of television and video tape.

visual elements Colors, shapes, lines, textures, and space.

visual weight In an artwork, a feature's relative size, color brightness, and degree of contrast compared to its surroundings. See *balance.*

volume See *space.*

warm colors Red, yellow, orange, red-orange, yellow-orange, red-purple, and yellow-orange. Any analogous colors (hues) in which red and/or yellow predominate. The opposite of *cool colors.* See *analogous colors.*

wash A translucent layer of color applied with brush. See *watercolor.*

watercolor Pigment suspended in water combined with water-soluble gum as a binder to make a translucent paint over white paper.

weight shift Term used to describe the posture of a human figure when its weight is distributed mostly over one foot.

welding Producing sculpture by joining pieces of molten metal.

woodcut A print made from an image cut in a surface of a wooden block that runs with the grain. See *relief print.*

wood engraving A print made from an image cut in the end-grain surface of a wooden block. See *relief printing.*

CHRONOLOGY

ERA/DATE	TITLE	ARTIST	FIGURE
15,000–10,000 B.C.	*Bellowing Bison and Fragments of Another Galloping Bison*, Altamira, Spain		(7-2)
15,000–10,000 B.C.	*Hall of Bulls*, Lascaux, France		(7-1)
2599–2571 B.C.	*Pair Statue of Mycerinus and His Queen*		(8-2)
2500 B.C.	*Hippopotamus Hunt*, Tomb of Ti		(7-3)
615–600 B.C.	*Kouros*		(8-1)
480 B.C.	*Kritios Boy*		(8-3)
450 B.C.	*Doryphoros*	after Polyclitus	(8-4)
448–432 B.C.	The Parthenon, Acropolis, Athens		(6-3)
400s B.C.	Acropolis, Athens		(6-27)
330 B.C.	*Apollo Belvedere*		(8-5)
330 B.C.	*Cnidian Aphrodite*	after Praxiteles	(8-10)
early third century B.C.	*Venus de Medici*	Roman copy	(8-11)
237–212 B.C.	Temple of Horus, Edfu, Egypt		(6-2)
100–0 B.C.	Wall painting transferred to panel, from the villa of Agrippa Postumus		(7-4)
10 A.D.	Roman aqueduct, Segovia, Spain		(6-7)
70–82 A.D.	Colosseum, Rome		(6-10)
118–125 A.D.	The Pantheon, Rome		(6-13)
250 A.D.	Synagogue from Dura Europos, view of north-west corner		(9-1)
430 A.D.	*The Parting of Lot and Abraham* from Santa Maria Maggiore		(4-1)
400–500 A.D.	Haniwa Horse, Japanese		(2-34)
500 A.D.	*Great Dragon*, Maya, Quirigua, Mexico		(3-13)
700 A.D.	Temple Group, Maya, Uaxactun, Mexico reconstruction drawing by T. Proskouriakoff		(6-5)
750–800 A.D.	*The Buddha Bathing Before His First Sermon*, relief on interior wall of Borobudur, Java		(9-3)
900 A.D.	Walls of the Kandarya Mahadeva Temple		(8-24)
900–1000 A.D.	Detail of the Kandarya Mahadeva Temple		(8-26)
900–1100 A.D.	Ife King figure, Yoruba		(5-2)

ERA/DATE	TITLE	ARTIST	FIGURE
1000 A.D.	*Christ's Entry into Jerusalem* from the *Gospel Book of Otto III*		(7-6)
1100s	*Clear Day in the Valley*	Tung Yuan	(3-12)
1100s	*Clearing Autumn Skies Over Mountains and Valleys*	Makimono Kuo Hsi	(7-5)
1100s	Detail of the Royal Portals, Chartres Cathedral		(8-25)
1194	Chartres Cathedral, view of nave		(6-15)
1200s	*The Poet Li Po*	Lang K'ai	(2-18)
1310	*Madonna Enthroned*	Giotto	(4-3)
1300s	*Meeting at the Golden Gate*	Giotto	(4-2)
1300s	*The Virgin of Paris*, Cathedral of Notre Dame		(8-12)
1403	*St. Francis' Sermon to the Birds*	Taddeo di Bartolo	(7-7)
1411–1413	*St. Mark*	Donatello	(11-6)
1427	*The Tribute Money*	Masaccio	(11-7)
1432	detail of *God the Father* from the *Ghent Altarpiece*	Hubert and Jan van Eyck	(4-5)
1435	*The Meeting of Solomon and the Queen of Sheba*, detail of the *Gates of Paradise* doors	Lorenzo Ghiberti	(5-3)
1436	The Cathedral of Florence, Dome	Filippo Brunelleschi	(6-18)
1465	*Battle of Naked Men*	Antonio Pollaiuolo	(8-6)
1480	*The Birth of Venus*	Sandro Botticelli	(8-13)
1495–1498	*The Last Supper*	Leonardo da Vinci	(11-8)
1496	*The Riders on the Four Horses from the Apocalypse*	Albrecht Dürer	(2-7)
1501–1504	*David*	Michelangelo	(8-7)
1503–1505	*Mona Lisa*	Leonardo da Vinci	(7-8)
1508–1512	Ceiling of the Sistine Chapel	Michelangelo	(9-8)
1508–1512	*Creation of the Sun and the Moon*, detail from the Sistine Chapel ceiling	Michelangelo	(9-9)
1509–1511	*The School of Athens*	Raphael	(2-27, 2-39)
1514	*Barbara Dürer*	Albrecht Dürer	(2-26)
1535	*Madonna and Child*	Lucas Cranach	(1-4)
1537	Capitoline Hill, Rome	Michelangelo	(2-35)
1538	*Venus of Urbino*	Titian	(8-14)
1540	Carpet from the tomb mosque of Shah Tahmasp at Ardebil, Iran		(9-7)

ERA/DATE	TITLE	ARTIST	FIGURE
1592–1594	*The Last Supper*	Tintoretto	(11-9)
1601	*The Conversion of St. Paul*	Caravaggio	(11-10)
1617–1618	*The Lion Hunt*	Peter Paul Rubens	(3-4)
1620	*Judith Slaying Holofernes*	Artemisia Gentileschi	(11-11)
1623	*David*	Gianlorenzo Bernini	(5-1)
1631	*The Presentation of Jesus in the Temple*	Rembrandt van Rijn	(9-11)
1636	*The Judgment of Paris*	Peter Paul Rubens	(8-15)
1645–1652	Interior of the Cornaro Chapel	Gianlorenzo Bernini	(5-10)
1649	*Christ Healing the Sick and Receiving Little Children*	Rembrandt van Rijn	(9-12)
1653	*Three Trees*	Rembrandt	(4-18)
1656	*Las Meninas*	Diego Velásquez	(11-12)
1658–1660	*Interior of a Courtyard*	Pieter de Hooch	(3-6)
1717	*A Pilgrimage to Cythera*	Jean-Antoine Watteau	(11-13)
1766	*The Swing*	Jean-Honoré Fragonard	(11-14)
1784	*Oath of the Horatii*	Jacques Louis David	(11-15)
1797–1798	*The Bogeyman is Coming*	Francisco Goya	(4-19)
1800	*Portrait of a Negress*	Marie Guillemine Benoist	(8-16)
1814	*The Third of May, 1808*	Francisco Goya	(3-3)
1821	*The Hay Wain*	John Constable	(7-10)
1823–1829	*The Great Wave*	Hokusai	(12-4)
1830	*Liberty Leading the People*	Eugene Delacroix	(11-16)
1837	*Snowstorm, Avalanche and Innundation in the Val d'Aosta*	Joseph Mallard William Turner	(7-11)
1846	*The Oxbow*	Thomas Cole	(7-12)
1847	*Romans of the Decadence*	Thomas Couture	(12-1)
1849	*Watching the Cargo*	George Caleb Bingham	(10-2)
1849	*Burial at Ornans*	Gustave Courbet	(11-17)
1851	*Blue Hole, Flood Waters, Little Miami River*	Robert S. Duncanson	(10-1)
1851	Crystal Palace, London	Joseph Paxton	(6-19)
1863	*The Rocky Moutains*	Albert Bierstadt	(7-13)
1863	*Luncheon on the Grass*	Édouard Manet	(12-2)

ERA/DATE	TITLE	ARTIST	FIGURE
1863	*Olympia*	Édouard Manet	(8-18)
1865–1867	The Galleria of Vittorio Emanuele, Milan		(6-34)
1869	*La Grenouillère*	Claude Monet	(12-3)
1871	*The Country School*	Winslow Homer	(10-4)
1872	*The Banks of the Oise, Pontoise*	Camille Pissarro	(7-14)
1873	*The Berry Pickers*	Winslow Homer	(4-7)
1875	title page of *The Ancient Mariner*	Gustave Doré	(4-15)
1876–1877	*The Age of Bronze*	Auguste Rodin	(8-8)
1879	*The Birth of Venus*	Guillaume-Adolphe Bouguereau	(8-17)
1879–1884	*The Millinery Shop*	Edgar Degas	(12-5)
1882	*Flowers in a Crystal Vase*	Édouard Manet	(2-33)
1882	*The Daughters of Edward D. Boit*	John Singer Sargent	(10-3)
1883–1884	*Bathing at Asnières*	Georges Seurat	(2-1)
1883–1884	*Seated Boy with Straw Hat*	Georges Seurat	(2-6)
1884–1886	*The Burghers of Calais*	Auguste Rodin	(12-7)
1888	*The Vision After the Sermon (Jacob Wrestling with the Angel)*	Paul Gauguin	(12-12)
1888	*View of Arles with Irises*	Vincent Van Gogh	(12-10)
1889	*The Starry Night*	Vincent Van Gogh	(12-11)
1890–1892	*After the Bath*	Edgar Degas	(4-10)
1892	*At the Moulin Rouge*	Henri de Toulouse-Lautrec	(12-13)
1893	*The Scream*	Edvard Munch	(12-14)
1893	*Banjo Lesson*	Henry Ossawa Tanner	(10-5)
1894	*The Climax*	Aubrey Beardsley	(12-15)
1894	*Rouen Cathedral Sunset*	Claude Monet	(12-6)
1894	Guaranty Building	Louis Sullivan	(6-20)
1895	*The Basket of Apples*	Paul Cézanne	(12-8)
1897	*Mont Sainte-Victoire Seen from Bibemus Quarry*	Paul Cézanne	(12-9)
1898	two details from the *Garden City* proposal	Ebenezer Howard	(6-32)
1901	*Sara in a Large Flowered Hat, Looking Right, Holding Her Dog*	Mary Cassatt	(4-11)
1905–1906	*London Bridge*	André Derain	(2-11)
1905	*Window at Collioure*	Henri Matisse	(13-1)
1905–1906	*Joy of Life*	Henri Matisse	(13-2)

ERA/DATE	TITLE	ARTIST	FIGURE
1905	*Old Peasant Woman Praying*	Paula Modersohn-Becker	(13-3)
1907	*Stag at Sharkey's*	George Bellows	(10-7)
1907–1908	*Le Luxe II*	Henri Matisse	(8-19)
1907	*Les Demoiselles d'Avignon*	Pablo Picasso	(13-7)
1908	*Palazzo Da Mula, Venice*	Claude Monet	(2-13)
1909	Robie House, Chicago	Frank Lloyd Wright	(6-39)
1910	*The Kiss*	Constantin Brancusi	(2-23)
1910	*Violin and Palette*	Georges Braque	(13-8)
1912	*Development of a Bottle in Space*	Umberto Boccioni	(13-12)
1912	*Nude Descending a Staircase No. 2*	Marcel Duchamp	(13-13)
1913	*The Soothsayer's Recompense*	Giorgio de Chirico	(13-15)
1913	*Standing Youth*	Wilhelm Lehmbruck	(13-6)
1913	*Toll Collectors*	Charles M. Russell	(10-6)
1914	*Improvisation*	Wassily Kandinsky	(13-4)
1914	*The Tempest*	Oskar Kokoschka	(8-28)
1917–1918	*Double Portrait with Wineglass*	Marc Chagall	(8-27)
1917	*Fountain*	Marcel Duchamp	(13-14)
1918	*Suprematist Composition: White on White*	Kasimir Malevich	(13-10)
1919	*Fritzi*	Felix Klee	(4-9)
1919	*The City*	Fernand Léger	(2-15)
1920–1922	*The Voice of the City of New York Interpreted: the Skyscrapers*	Joseph Stella	(10-8)
1921	*Three Musicians*	Pablo Picasso	(13-9)
1922	Sketch from the *Ideal City* proposal	Le Corbusier	(6-33)
1924	*Self-Portrait*	Käthe Kollwitz	(4-16)
1924–1925	*The Harlequin's Carnival*	Joan Miró	(13-18)
1924	*Red Canna*	Georgia O'Keeffe	(10-9)
1924–1937	*Merzbau*	Kurt Schwitters	(5-15)
1925	Tribune Tower	Raymond Hood and John Meade Howells	(6-21)
1925	*House by the Railroad*	Edward Hopper	(10-11)
1926	*City Night*	Georgia O'Keeffe	(10-10)
1929–1930	*Into the World There Came a Soul Called Ida (the Lord in His Heaven and I in My Room Below)*	Ivan Le Lorraine Albright	(2-31)
1929	*Composition*	Piet Mondrian	(13-11)

ERA/DATE	TITLE	ARTIST	FIGURE
1931–1932	*Forest, British Columbia*	Emily Carr	(7-15)
1931	*The Persistence of Memory*	Salvador Dali	(13-16)
1932–1933	*Departure*	Max Beckmann	(13-5)
1934	*Death Seizing a Woman*	Käthe Kollwitz	(2-30)
1935	*Feline Felicity*	Charles Sheeler	(4-8)
1935	*Head*	Julio González	(5-5)
1936	*Migrant Mother, Nipomo, California*	Dorothea Lange	(4-23)
1936	*Composition in Blue, Yellow and Black*	Piet Mondrian	(9-14)
1936	*Untitled (Mother and Child)*	Diego Rivera	(4-13)
1936	*Spring Turning*	Grant Wood	(7-16)
1938	*Day and Night*	M. C. Escher	(2-16)
1940	*Blind Bird*	Morris Graves	(3-16)
1942	*Tombstones*	Jacob Lawrence	(10-12)
1943	*First Steps*	Pablo Picasso	(1-3)
1944	*The Liver is the Cock's Comb*	Arshile Gorky	(14-1)
1947	*Pendour*	Barbara Hepworth	(2-25)
1947–1952	Unité d'Habitation, Marseilles	Le Corbusier	(6-24)
1948	*Christina's World*	Andrew Wyeth	(10-13)
1950–1952	*Woman I*	Willem de Kooning	(8-20)
1950	*Tree of Fluids (Body of a Lady)*	Jean Dubuffet	(2-32)
1950	*Linear Construction*	Naum Gabo	(5-7)
1950	still from *Rashomon*	Akira Kurosawa	(4-27)
1950	*The Empire of Light, II*	René Magritte	(13-17)
1950	*One (Number 31)*	Jackson Pollock	(14-4)
1951	*No. 3*	Jackson Pollock	(2-29)
1951	*Hudson River Landscape*	David Smith	(14-6)
1952	*Mountains and Sea*	Helen Frankenthaler	(14-7)
1952	*Preacher*	Charles White	(2-20)
1955	*Target with Plaster Casts*	Jasper Johns	(14-10)
1956	*Mahoning*	Franz Kline	(14-5)
1956–1958	Seagram Building	Ludwig Mies van der Rohe and Philip Johnson	(6-22)
1957	*IKB 175*	Yves Klein	(3-15)
1958	*Dalet Kaf*	Morris Louis	(14-8)
1958	*Four Darks in Red*	Mark Rothko	(14-2)
1959	*18 Happenings in 6 Parts*	Allan Kaprow	(5-16)
1959	*Winterpool*	Robert Rauschenberg	(14-9)

ERA/DATE	TITLE	ARTIST	FIGURE
1959–1972	Sydney Opera House, Australia	Jörn Utzon	(6-25)
1960	*Untitled*	Ellsworth Kelly	(2-14)
1960	*Royal Tide I*	Louise Nevelson	(14-11)
1960	*Homage to New York*	Jean Tinguely	(5-9)
1961	*Sumac*	Alexander Calder	(5-8)
1962	*Marilyn Monroe Diptych*	Andy Warhol	(8-21)
1963	*All Things Do Live in the Three*	Richard Anuskiewicz	(2-8)
1963	*Continual Mobile, Continual Light*	Julio Le Parc	(14-17)
1963	*Whaam!*	Roy Lichtenstein	(14-12)
1964	*Pittsburgh Memory*	Romare Bearden	(4-33)
1964	*'Exodus' tapestry*	Marc Chagall	(9-15)
1964	Marina City, Chicago	Bertrand Goldberg	(6-40)
1964	*Current*	Bridget Riley	(3-5)
1964	*Itata*	Frank Stella	(14-14)
1964	*Untitled*	Jerry N. Uelsmann	(4-25)
1965	*Rhapsody*	Hans Hofmann	(3-2)
1965	*Stations of the Cross #12*	Barnett Newman	(9-16)
1966	*Untitled*	Donald Judd	(14-15)
1966	Jefferson National Expansion Memorial	Eero Saarinen	(3-9)
1967	United States Pavilion, Expo 67, Montreal	Buckminster Fuller	(6-26)
1967	*A Bigger Splash*	David Hockney	(10-14)
1967	*Love*	Robert Indiana	(4-22)
1967	*Bust of Sylvette*	Pablo Picasso	(2-22)
1967	Habitat, Montreal	Safdie, David, Barott, and Boulva	(6-28)
1968	*Great American Nude No. 99*	Tom Wesselmann	(8-22)
1969	*Cremation Piece*	John Baldessari	(14-20)
1969	*Wrapped Coast*	Christo	(14-18)
1969–1970	*Double Negative*	Michael Heizer	(5-17)
1969	*Lipstick Ascending on Catepillar Tracks*	Claes Oldenburg	(14-13)
1969	*Vega-tek*	Victor Vasarely	(14-16)
1970–1971	*Kent*	Chuck Close	(14-23)
1971	*Super Indian #2 (with ice cream cone)*	Fritz Scholder	(10-16)
1974	*I Like America and America Likes Me*	Joseph Beuys	(14-19)
1975	*Seahorses*	Sam Gilliam	(4-6)
1976	*Clothed Artist and Model*	John de Andrea	(5-4)
1976	*Trent's Jacket*	Marilyn Levine	(14-22)
1976	*Walter Finley Seated Nude*	Sylvia Sleigh	(8-9)

ERA/DATE	TITLE	ARTIST	FIGURE
1977	*The Beginnings of a Complex . . .*	Alice Aycock	(14-21)
1977	*Artifact for Keeping Secrets*	Colo	(5-11)
1977	*Drawing in Space, No. 1*	Richard Hunt	(2-24)
1977	Georges Pompidou National Center of Art and Culture	Richard Rogers and Renzo Piano	(6-23)
1978	*Carolina and Her Father*	Dottie Attie	(14-24)
1980	*Two Models, One Seated on Floor in Kimono*	Philip Pearlstein	(8-23)
1980	*Daydream*	Andrew Wyeth	(4-4)
1981	*The Idleness of Sisyphus*	Sandro Chia	(14-26)
1981	*Interrogation II*	Leon Golub	(14-27)
1982	*Dawn Shadows*	Louise Nevelson	(5-6)
1983	*Noon Watch*	Eric Fishl	(8-29)
1983	*Shulamite*	Anselm Kiefer	(14-25)
1983	*3-D:* Installation at Holly Solomon Gallery	Judy Pfaff	(3-14)
1983	*Untitled*	Cindy Sherman	(4-24)
1983–1984	*7th Street Altarpiece*	Kent Twitchell	(9-17)
1984	*"Untitled" (After Piet Mondrian)*	Sherrie Levine	(14-28)
1984	*Video Drive-In,* Grant Park, Chicago		(4-30)
1985	*Holder Neckpiece, 2 Val 7-785*	Tina Fung-Holder	(5-29)
1985	*Views of Hotel Well III*	David Hockney	(4-21)
1985	*Rhythm/Color: The Concord Cotillion*	Michael James	(5-31)
1985	*Face Vase*	Howard Kottler	(5-25)
1985	*In Utero*	Lenore Tawney	(5-12)
1986	*Fleur*	Chunghi Choo	(5-30)
1986	*Untitled* (fondly to Margo)	Dan Flavin	(5-14)
1986	*Covered Vessel*	Karen Karnes	(5-24)
1986	*Ocean*	Yoichiro Kawaguchi	(4-32)
1986	*Cruising Turtle Island*	Gilbert Lujan	(10-15)
1986	*Family of Robots: Baby*	Nam June Paik	(4-29)
1986	*Voyage into the Flatlands*	Amy Roberts	(5-28)
1986	*Beyond Picasso*	Lilliam Schwartz	(4-31)
1987	*Illinois Flatscape*	Harold Gregor	(7-17)
1987	*Contiguous Fragment Series*	Joel Myers	(5-27)
1987	*Jar of Spirits*	David Salle	(14-29)
1987	*A Breeze at Work*	Sandy Skoglund	(5-18)
1988	*Untitled #8*	Agnes Martin	(2-28)

BIBLIOGRAPHY

CHAPTER 1

Arnheim, Rudolf. *Art and Visual Perception: A Psychology of the Creative Eye*. Berkeley and Los Angeles: University of California Press, 1954.

Barr, Alfred. *Picasso—Fifty Years of His Art*. New York: Museum of Modern Art, 1946.

Fast, Julius. *Body Language*. New York: Simon & Schuster, Pocket Books, 1971.

Goodman, Nelson. *Languages of Art: An Approach to a Theory of Symbols*. Indianapolis: Bobbs-Merrill Co., 1968.

Kubler, George A. *The Shape of Time: Remarks on the History of Things*. New Haven, CT. Yale University Press, 1962.

Langer, Susanne K. *Philosophy in a New Key: A Study in the Symbolism of Reason, Rite, and Art*. 3rd ed. Cambridge, MA: Harvard University Press, 1976.

Segall, M. H., Campbell, D. T., and Herskovits, M. J. *The Influence of Culture on Visual Perception*. Indianapolis: Bobbs-Merrill Co., 1966.

CHAPTER 2

Albers, Josef. *Interaction of Color*. Rev. ed. New Haven, CT: Yale University Press, 1972.

Arnheim, Rudolf. *Visual Thinking*. Berkeley and Los Angeles: University of California Press, 1969.

Birren, Faber. *Principles of Color*. New York: Van Nostrand Reinhold Co., 1969.

Bloomer, Carolyn M. *Principles of Visual Perception*. New York: Van Nostrand Reinhold Co., 1976.

Clark, Kenneth. *Looking at Pictures*. Boston: Beacon Press, 1968.

Ehrenzweig, Anton. *The Hidden Order of Art: A Study in the Psychology of Artistic Imagination*. Berkeley and Los Angeles: University of California Press, 1967.

Gibson, James J. *The Perception of the Visual World*. Boston: Houghton Mifflin Co., 1950.

_____. *The Senses Considered as Perceptual Systems*. Boston: Houghton Mifflin Co., 1966.

Gombrich, E. H. *Art and Illusion: A Study in the Psychology of Pictorial Presentation*. 2nd ed. Princeton: Princeton University Press, 1961.

Gombrich, E. H., Hochberg, J., and Black, M. *Art, Perception and Reality*. Baltimore: Johns Hopkins University Press, 1972.

Gregory, R. L. *Eye and Brain*. New York: McGraw-Hill, 1966.

Hogg, James, Ed. *Psychology and the Visual Arts*. Baltimore: Penguin Books, 1970.

Kepes, Gyorgy. *Language of Vision*. Chicago: Paul Theobald & Co., 1945.

Kohler, Wolfgang. *Gestalt Psychology*. New ed. New York: Liveright, 1970.

Russell, John. *Seurat*. New York. Praeger Publishers, 1965.

CHAPTER 3

Alloway, Lawrence. *Topics in American Art Since 1945*. New York: Norton, 1975.

Beardsley, Monroe C. *Aesthetics: Problems in the Philosophy of Criticism*. 2nd ed. Indianapolis: Hackett Publishing Company, Inc., 1981.

Feldman, Edmund B. *Varieties of Visual Experience: Art, Image, and Idea*. Englewood Cliffs, NJ: Prentice-Hall, Inc., 1987.

Geldzahler, Henry. "Determining Aesthetic Values." In *Theories of Contemporary Art*, edited by Hertz, Richard. Englewood Cliffs, NJ: Prentice-Hall, Inc., 1985.

Rosenberg, Harold. *The Anxious Object: Art Today and Its Audience*. New York: Horizon Press, 1964.

CHAPTER 4

Bobker, Lee R. *Elements of Film*. New York: Harcourt Brace and World, 1969.

Bontemps, Arna A; Ed. *Forever Free: Art by African-American Women*. Catalog of show. Normal, IL: University Gallery, Illinois State University, 1980.

Carey, Frances, and Griffiths, Antony. *The Print in Germany 1880–1933: The Age of Expressionism*. London: British Museums Publications, 1984.

Castleman, Riva. *American Impressions: Prints since Pollock*. New York: Knopf, 1985.

de Mare, Eric. *The Victorian Woodblock Illustrators*. London: Gordon Fraser, 1980.

Friedman, Martin. *Tyler Graphics: The Extended Image*. (Intro.). New York: Minneapolis: Abbeville Press, Walker Art Center, 1987.

Goodman, Cynthia. *Digital Visions: Computers and Art*. New York: Harry N. Abrams; Syracuse: Everson Museum of Art, 1987.

Hagen, Charles. "Video Art: The Fabulous Chameleon." *Artnews* 88 (6), (Summer 1989): 118–123.

Herberts, Kurt. *The Complete Book of Artist's Techniques*. New York: Praeger, 1958.

Ivins, William M., Jr. *Prints and Visual Communication*. Cambridge, MA: M.I.T. Press, 1969.

Mayer, Ralph. *The Artist's Handbook of Materials and Techniques*. 3rd ed. New York: The Viking Press, 1970.

Mendelowitz, Daniel M. *Drawing*. New York: Holt, Rinehart & Winston, 1967.

Reese, Albert. *American Prize Prints of the 20th Century*. New York: American Artists Group, Inc., 1949.

Solomon, Stanley J. *The Film Idea*. New York: Harcourt Brace Jovanovich, 1972.

Sontag, Susan. *On Photography*. New York: Farrar, Straus & Giroux, 1977.

Wollheim, Richard. *Art and Its Objects: An Introduction to Aesthetics*. New York: Harper & Row, 1968.

Video Tape Review. Catalog of *Video Data Bank*. Chicago: School of the Art Institute, 1986.

CHAPTER 5

Arnason, H. H. *History of Modern Art: Painting, Sculpture, Architecture, Photography*. 3rd ed. Englewood Cliffs, NJ: Prentice-Hall, 1986.

Burnham, Jack. *Beyond Modern Sculpture: The Effects of Science and Technology on the Sculpture of this Century*. New York: Braziller, 1968.

Craven, George M. *Object and Image*. Englewood Cliffs, NJ: Prentice-Hall, 1975.

de la Croix, Horst, Tansey, Richard G., and Kirkpatrick, Diane. *Gardner's Art through the Ages*. 9th ed. San Diego: Harcourt Brace Jovanovich, 1991.

Dyckes, William. *Contemporary Spanish Art*. New York: Art Digest, 1975. *Encyclopedia of World Art*. 15 vols. New York: McGraw-Hill, 1959–1968.

Kirby, Michael, Ed. *Happenings: An Illustrated Anthology*. New York: E. P. Dutton & Co., 1965.

Mayer, Barbara. *Contemporary American Craft Art: A Collector's Guide*. Salt Lake City: Gibbs M. Smith, Inc., 1987.

Popper, Frank. *Origins and Development of Kinetic Art*. Greenwich, CT: New York Graphic Society, 1969.

Read, Herbert. *The Art of Sculpture*. 2nd ed. Princeton: Princeton University Press, 1961.

Seitz, William. *The Art of Assemblage*. New York: Museum of Modern Art, 1961.

Smith, Paul J., and Lucie-Smith, Edward, Eds. *Craft Today: Poetry of the Physical*. New York: Weidenfeld & Nicolson, 1986.

CHAPTER 6

Engel, Heinrich. *The Japanese House: A Tradition for Contemporary Architecture*. Rutland, VT and Tokyo: Charles E. Tuttle Co., 1964.

Evenson, Norma. *Le Corbusier: The Machine and the Grand Design*. New York: George Braziller, 1969.

Furneaux Jordan, Robert. *A Concise History of Western Architecture*. New York: Harcourt Brace Jovanovich, 1970.

Giedion, Sigfried. *Space, Time and Architecture: The Growth of a New Tradition*. 5th rev. ed. Cambridge, MA: Harvard University Press, 1967.

Hobbs, Jack A., and Duncan, Robert L. *Arts, Ideas and Civilization*. Englewood Cliffs, NJ: Prentice-Hall, 1989.

Huxtable, Ada L. *Will They Ever Finish Bruckner Boulevard?* New York: Macmillan, 1970.

Jacobs, J., Ed. *The Great Cathedrals*. New York: American Heritage, 1968.

Jencks, Charles, and Baird, George, Eds. *Meaning in Architecture*. New York: George Braziller, 1970.

Martindale, Andrew. *Gothic Art*. New York: Praeger Publishers, 1967.

Nishihara, Kiyoyuki. *Japanese Houses: Patterns for Living*. Tokyo: Japan Publications, 1967.

Norberg-Schulz, Christian. *Existence, Space and Architecture*. New York: Praeger Publishers, 1971.

———. *Meaning in Western Architecture*. New York: Praeger Publishers, 1975.

Rudofsky, Bernard. *Architecture without Architects: A Short Introduction to Non-Pedigreed Architecture*. Garden City, New York: Doubleday & Co., 1969.

———. *Streets for People*. Garden City, New York: Doubleday & Co., 1969.

Siegel, Arthur, Ed. *Chicago's Famous Buildings*. 4th ed. Chicago: University of Chicago Press, 1980.

Scully, Vincent. *American Architecture and Urbanism: A Historical Essay*. New York: Praeger Publishers, 1969.

———. *Modern Architecture*. Rev. ed. New York: George Braziller, 1974.

Wright, Frank Lloyd. *When Democracy Builds*. Chicago: University of Chicago Press, 1945.

Zucker, Paul. *Town and Square: From the Agora to the Village Green*. New York: Columbia University Press, 1959.

CHAPTER 7

Birmingham Museum of Art (R. S. Appelhof curator). *The Expressionist Landscape*. Seattle: University of Washington Press, 1987.

Bazarov, Konstantin. *Landscape Painting*. London: Octopus Books Ltd., 1981.

Carter, Dagny. *Four Thousand Years of China's Art*. New York: Ronald Press, 1948.

Clark, Kenneth. *Landscape Into Art*. London: John Murray, 1966.

_____. *Leonardo da Vinci*. Baltimore: Penguin Books, Pelican Books, 1968.

Czestochowski, Joseph S. *The American Landscape Tradition. A Study and Gallery of Paintings*. New York: E. P. Dutton, Inc., 1982.

Giedion, Sigfried. *The Eternal Present: The Beginning of Art*. Princeton, NJ: Princeton University Press, 1964.

Hartt, Frederick. *History of Italian Renaissance Art*. New York: Harry N. Abrams, 1969.

Kahler, Heinz. *The Art of Rome and Her Empire*. New York: Crown Publishers, 1963.

Klingender, Francis D. *Animals in Art and Thought to the End of the Middle Ages*. Cambridge, MA: M.I.T. Press, 1971.

Los Angeles County Museum of Art. *A Day in the Country: Impressionism and the French Landscape*. Los Angeles: Los Angeles County Museum of Art, 1984.

Michalowski, Kazimierz. *The Art of Ancient Egypt*. New York: Harry N. Abrams, 1969.

Novak, Barbara. *Nature and Culture: American Landscape and Painting 1825–1875*. New York: Oxford University Press, 1980.

Peacock, Carlos. *John Constable. The Man and His Work*. Rev. ed. Greenwich, CT: New York Graphic Society, 1972.

Richter, Gisela M. A. *Perspective in Greek and Roman Art*. London: Phaidon, 1971.

Shepard, Paul. *Man in the Landscape*. New York: Alfred A. Knopf, 1967.

Willets, William. *Foundations of Chinese Art*. New York: McGraw-Hill, 1965.

CHAPTER 8

Arnason, H. H. *History of Modern Art: Painting, Sculpture, Architecture, Photography*, 3rd ed. Englewood Cliffs, N.J.: Prentice-Hall, 1986.

Berger, John. *Ways of Seeing*. New York: Penguin Books, 1977.

Clark, Kenneth. *The Nude: A Study of Ideal Form*. Garden City, New York: Doubleday & Co., Anchor Books, 1956.

Crespelle, Jean-Paul. *Chagall*. New York: Coward, McCann & Geoghegan, 1970.

Hodin, J. P. *Oskar Kokoschka*. Greenwich, CT: New York Graphic Society, 1966.

Honour, Hugh. *Neo-Classicism*. Harmondsworth, England: Penguin Books, 1968.

Lal, Kanwar. *Immortal Khajuraho*. Delhi: Asia Press, 1965.

Powell, Ann. *The Origins of Western Art*. New York: Harcourt Brace Jovanovich, 1973.

Richter, G. M. A. *A Handbook of Greek Art: A Survey of the Visual Arts of Ancient Greece*. 6th rev. ed. London: Phaidon Press, 1969.

Schefold, Karl. *Myth and Legend in Early Greek Art*. New York: Harry N. Abrams, 1966.

Sewter, A. C. *Baroque and Rococo*. New York: Harcourt Brace Jovanovich, 1972.

Shaman, Sanford, S. "An Interview with Philip Pearlstein." *Art in America* 69 (7), (September 1981).

Storr, Robert. "Desperate Pleasures." *Art in America* 72 (10), (November 1984).

White, Christopher. *Rubens and His World*. New York: Viking Press, 1968.

CHAPTER 9

Altshuler, David, and Altshuler, Linda. "Judaism and Art." In *Art, Creativity, and the Sacred: An Anthology in Religion and Art*, edited by Apostolos-Cappadona. New York: Crossroad Publishing Co., 1989.

Burckhardt, Titus. *Art of Islam: Language and Meaning*. London: World of Islam Festival Publishing Company Ltd., 1976.

Campbell, Joseph. *The Mystic Image*. Princeton, NJ: Princeton University Press, 1974.

Clements, Robert J. *Michelangelo: A Self Portrait*. New York: New York University Press, 1968.

Coomaraswamy, Anada K. "The Origin and Use of Images in India." In *Art, Creativity, and the Sacred: An Anthology in Religion and Art*, edited by Apostolos-Cappadona. New York: Crossroad Publishing Co., 1989.

De Tolnay, Charles. *The Art and Thought of Michelangelo*. New York: Pantheon, 1964.

Eliade, Mircea. "The Sacred and the Modern Artist." In *Art, Creativity, and the Sacred: An Anthology in Religion and Art*, edited by Apostolos-Cappadona. New York: Crossroad Publishing Co., 1989.

Gilkey, Langdon B. "Can Art Fill the Vacuum?" In *Art, Creativity, and the Sacred: An Anthology in Religion and Art*, edited by Apostolos-Cappadona. New York: Crossroad Publishing Co., 1989.

Hauser, Arnold. *The Social History of Art*. Vols. 1 and 2. New York: Alfred A. Knopf, 1951.

Huntington, Susan. *The Art of Ancient India*. New York: Weatherhill, 1985.

Kandinsky, Wassily. *Concerning the Spiritual in Art and Painting in Particular*. New York: Wittenborn, Shultz, 1947.

Loehr, Max. *Buddhist Thought and Imagery*. Cambridge, MA: Harvard University Press, 1961.

Miller, Samuel H. *The Dilemma of Modern Belief*. New York: Harper and Row, 1964.

Muller, Joseph-Emile. *Rembrandt*. Trans. by Brian Hooley. New York: Harry N. Abrams, 1969.

Pelican, Jaroslav. *Jesus through the Centuries: His Place in the History of Culture*. New Haven, CT: Yale University Press, 1985.

Rosenberg, Jacob. *Rembrandt: Life and Work*. New York: Phaidon Press, 1964.

Rowland, Benjamin, Jr. *The Evolution of the Buddha Image*. New York: Harry N. Abrams, Inc., 1963.

Seckel, Dietrich. *The Art of Buddhism*. New York: Crown Publishers, 1963.

Snellgrove, David, Ed. *The Image of the Buddha*. Paris: UNESCO, 1978.

Taylor, Joshua D. "The Religious Impulse in American Art." In *Art, Creativity, and the Sacred: An Anthology in Religion and Art*, edited by Apostolos-Cappadona. New York: Crossroad Publishing Co., 1989.

Tillich, Paul. *Theology of Culture*. New York: Oxford University Press, 1959.

Wigoder, Geoffrey, Ed. *Jewish Art and Civilization*. Vols. 1 and 2. New York: Walker and Co., 1972.

CHAPTER 10

Arnason, H. H. *History of Modern Art: Painting, Sculpture, Architecture, Photography*. 3rd ed. Englewood Cliffs, N.J.: Prentice-Hall, 1986.

Bontemps, Arna Alexander, Ed. *Choosing: An Exhibit of Changing Perspectives in Modern Art and Art Criticism by Black Americans, 1925–1985*. Hampton, VA: Jacqueline Fonvielle-Bontemps, Hampton University, 1985.

Brown, Milton, Hunter, Sam, Jacobus, John, Rosenblum, Naomi, and Sokol, David. *American Art: Painting, Sculpture, Architecture, Decorative Arts, Photography*. New York: Harry N. Abrams, Inc., 1979.

Driskell, David C. *Two Centuries of Black American Art*. New York: Alfred A. Knopf, 1976.

Fine, Elsa H. *The Afro-American Artist: A Search for Identity*. New York: Holt, Rinehart & Winston, 1973.

Goodrich, Lloyd. *Edward Hopper*. New York: Harry N. Abrams, 1971.

Hartigan, Lynda Roscoe. *Sharing Traditions: Five Black Artists in Nineteenth-Century America*. Washington, D.C.: Smithsonian Institution Press, 1985.

McCoubrey, John W., Ed. *American Art 1700–1960: Sources and Documents*. Englewood Cliffs, NJ: Prentice-Hall, 1965.

McLanathan, Richard. *The American Tradition in the Arts*. New York: Harcourt Brace Jovanovich, 1968.

Owings, Nathaniel A. *The American Aesthetic*. New York: Harper & Row, 1969.

Parry, Ellwood. *The Image of the Indian and the Black Man in American Art, 1590–1900*. New York: George Braziller, 1974.

Rose, Barbara. *American Art Since 1900*. New York: Praeger Publishers, 1967.

Taylor, Joshua. *America as Art*. Washington, D.C.: National Collection of Fine Arts, 1976.

Tighe, Mary Ann, and Lang, Elizabeth E. *Art America*. New York: McGraw-Hill, 1977.

Wilmerding, John. *American Art*. New York: Penguin Books, 1976.

CHAPTER 11

de La Croix, Horst, Tansey, Richard G., and Kirkpatrick, Diane. *Gardner's Art through the Ages*. 9th ed. San Diego: Harcourt Brace Jovanovich, 1991.

Harris, Ann Sutherland, and Nochlin, Linda. *Women Artists: 1550–1950*. Los Angeles: Los Angeles County Museum of Art, 1977.

Hartt, Frederick. *History of Italian Renaissance Art: Painting, Sculpture and Architecture*. New York: Harry N. Abrams, Inc., 1970.

Hauser, Arnold. *The Social History of Art*, Vols. 1 and 2. New York: Alfred A. Knopf, 1951.

Hobbs, Jack A., and Duncan, Robert L. *Arts, Ideas and Civilization*. Englewood Cliffs, NJ: Prentice-Hall, 1989.

Honour, Hugh. *Neo-Classicism*. Harmondsworth, England: Penguin Books, 1968.

———. *Romanticism*. London: Penquin Books Ltd., 1979.

Kubler, George A. *The Shape of Time: Remarks on the History of Things*. New Haven, CT: Yale University Press, 1962.

CHAPTER 12

Badt, Kurt. *The Art of Cézanne*. Trans. by Sheila A. Ogilvie. Berkeley and Los Angeles: University of California Press, 1965.

Balakian, Anna. *The Symbolist Movement: A Critical Approach*. New York: New York University Press, 1977.

Bell, Clive. *Art*. New York: G. P. Putnam's Sons, Capricorn, 1959.

Boudaille, Georges. *Gauguin*. Trans. by Elisa Jaffa. New York: Tudor, 1964.

Champigneulle, Bernard. *Rodin*. Trans. by J. Maxwell Brownjohn. New York: Harry N. Abrams, 1967.

Duret, Theodore. *Manet and the French Impressionists*. Trans. by J. E. Crawford Fitch. Freeport, NY: Books for Libraries Press, 1971.

Hamilton, George H. *Manet and His Critics*. New York: W. W. Norton & Co., 1969.

Harris, A. S., and Nochlin, L. *Women Artists, 1550–1950*. New York: Alfred A. Knopf, 1977.

Hess, Thomas B., and Ashbery, John, Eds. *Avant-Garde Art*. New York: Macmillan, 1971.

Loengren, Sven. *The Genesis of Modernism*. Indianapolis: Indiana University Press, 1971.

Rewald, John. *Post Impressionism: From Van Gogh to Gauguin*. New York: Museum of Modern Art, 1962.

Schapiro, Meyer. *Vincent Van Gogh*. New York: Harry N. Abrams, 1970.

Slocombe, George. *Rebels of Art*. Port Washington, N.Y.: Kennikat Press Corp., 1969.

Tralbaut, Marc E. *Van Gogh*. New York: Viking Press, 1969.

Van Gogh, Vincent. *Letters of Vincent Van Gogh*. Edited by Mark Roskill. New York: Atheneum, 1963.

CHAPTER 13

Barr, Alfred. *Matisse: His Art and His Public*. New York: Museum of Modern Art, 1951.

Bowness, Alan. *Modern European Art*. New York: Harcourt Brace Jovanovich, 1972.

Canaday, John. *Mainstreams of Modern Art*. 2nd ed. New York: Holt, Rinehart and Winston, Inc., 1981.

Chipp, Herschel B. *Theories of Modern Art: A Source Book by Artists and Critics*. Berkeley and Los Angeles: University of California Press, 1968.

de la Croix, Horst, Tansey, Richard G., and Kirkpatrick, Diane. *Gardner's Art through the Ages*. 9th ed. San Diego: Harcourt Brace Jovanovich, 1991.

Diehl, Gaston. *The Fauves*. New York: Harry N. Abrams, 1975.

Dorval, Bernard. *The School of Paris*. Trans. by Cornelia Brookfield and Ellen Hart. New York: Alfred A. Knopf, 1977.

Haftmann, Werner. *Painting in the Twentieth Century*. Vol. 1, *An Analysis of the Artists and Their Work*. New York: Praeger Publishers, 1965.

Harris, Ann Sutherland, and Nochlin, Linda. *Women Artists: 1550–1950*. Los Angeles: Los Angeles County Museum of Art, 1977.

Jean, Marcel, and Mezei, Arpad. *The History of Surrealist Painting*. Trans. by Simon Watson Taylor. New York: Grove Press, 1960.

Madsen, Stephan T. *Sources of Art Nouveau*. Trans. by R. I. Christopherson. New York: McGraw-Hill, 1967.

Mondrian, Pieter Cornelis. *Plastic Art and Pure Plastic Art*. New York: George Wittenborn, 1945.

Neumeyer, Alfred. *The Search for Meaning in Modern Art: Die Kunst in Unserer Zeit*. Trans. by R. Angress. Englewood Cliffs, NJ: Prentice-Hall, 1965.

Penrose, Roland. *Picasso: His Life and Work*. Rev. ed. New York: Harper & Row, 1973.

Read, Herbert. *The Art of Sculpture*. 2nd ed. Princeton: Princeton University Press, 1961.

Rickey, George. *Constructivism*. New York: George Braziller, 1967.

Rosenblum, Robert. *Cubism and Twentieth-Century Art*. New York: Harry N. Abrams, 1968.

Rubin, William S. *Dada, Surrealism and Their Heritage*. New York: Museum of Modern Art, 1968.

Selz, Peter. *German Expressionist Painting*. Berkeley and Los Angeles: University of California Press, 1974.

CHAPTER 14

Amaya, Mario. *Pop Art . . . and After*. New York: Viking Press, 1972.

Arnason, H. H. *History of Modern Art: Painting, Sculpture, Architecture, Photography*. 3rd ed. Englewood Cliffs, NJ: Prentice-Hall, Inc., 1986.

Ashton, Dore. *A Reading of Modern Art*. Cleveland: Press of Case Western Reserve University, 1969.

————. *The New York School: A Cultural Reckoning*. New York: Viking Press, 1973.

Battcock, Gregory, Ed. *Idea Art: A Critique*. New York: E. P. Dutton & Co., 1973.

————, Ed. *Minimal Art: A Critical Anthology*. New York: E. P. Dutton & Co., 1968.

————, Ed. *The New Art: A Critical Anthology*. Rev. ed. New York: E. P. Dutton & Co., 1973.

————. *Super Realism: A Critical Anthology*. New York: E. P. Dutton & Co., 1975.

Burnham, Jack. *Beyond Modern Sculpture*. New York: George Braziller, 1968.

Gottlieb, Carla. *Beyond Modern Art*. New York: E. P. Dutton & Co., 1976.

Hobbs, Jack A., and Duncan, Robert L. *Arts, Ideas and Civilization*. Englewood Cliffs, NJ: Prentice-Hall, 1989.

Hughes, Robert. *The Shock of the New*. New York: Alfred A. Knopf, 1981.

Hunter, Sam, and Jacobus, John. *American Art of the Twentieth Century*. New York: Harry N. Abrams, 1973.

Leymarie, Jean, Ed. *Art Since Mid-Century*. Greenwich, CT: New York Graphic Society, 1971.

Meyer, Ursula. *Conceptual Art*. New York: E. P. Dutton & Co., 1972.

Muller, Gregoire. *The New Avant Garde*. New York: Praeger Publishers, 1972.

Popper, Frank. *Origins and Development of Kinetic Art*. Greenwich, CT: New York Graphic Society, 1969.

Rose, Barbara. *American Art Since 1900*. Rev. ed. New York: Praeger Publishers, 1967.

Russell, John. *The Meanings of Modern Art*. New York: Harper & Row, Publishers, Inc., 1981.

Sandler, Irving. *The Triumph of American Painting: A History of Abstract Expressionism*. New York: Praeger Publishers, 1973.

Sontag, Susan. *Against Interpretation and Other Essays*. New York: Farrar, Straus & Giroux, 1966.

ILLUSTRATION CREDITS

Part I: Elizabeth Murray, *More than You Know,* 1983, oil on 10 canvases, 111″ × 108″ × 8″. Courtesy Paula Cooper Gallery, N.Y.
Part II: Michelangelo, *David.* Scala/Art Resource, N.Y.
Part III: The Louvre Pyramid Courtyard. ©The Stock Market/Ben Simmons 1990.

CHAPTER 1
Fig. 1-1: Museum für Volkerkunde. Staatliche Museen Preussbischer Kulturbesitz, Berlin. 1-3: Copyright 1990 ARS N.Y./SPADEM. 1-4: Marburg/Art Resource, N.Y.

CHAPTER 2
Fig. 2-5: William Dyckes. 2-8: Geoffry Clements Photography. 2-11: Copyright 1990 ARS N.Y./ADAGP. 2-13: Art Resource, N.Y. 2-15: Copyright 1990 ARS N.Y./SPADEM. 2-16: Photo courtesy Vorpal Gallery, N.Y. 2-21: Kate Morgan Guttman. 2-22: William Dyckes. Copyright 1990 ARS N.Y./SPADEM. 2-23: Copyright 1990 ARS N.Y./ADAGP. 2-26:Foto: Jörg P. Anders. 2-29: Copyright 1990 Pollock-Krasner Foundation/ARS N.Y. 2-32: Copyright 1990 ARS N.Y./ADAGP. 2-33: SEF/Art Resource, N.Y. 2-35: Art Resource, N.Y. 2-36, 2-37, 2-38: Sally F. Morris.

CHAPTER 3
Fig. 3-4: Photograph by Joachim Blauel-ARTOTHEK. 3-7: Foto MAS. 3-9: Photo courtesy of the St. Louis Convention and Visitors Commission. 3-13: Archaeological Institute of America, reproduced from *Art & Archaeology,* IV, 6, Copyright 1916. 3-14: Photo: D. James Dee, N.Y., N.Y. 3-15: Copyright 1990 ARS N.Y./ADAGP.

CHAPTER 4
Fig. 4-1, 4-2, 4-3: Scala/Art Resource, N.Y. 4-5: Giraudon/Art Resource, N.Y. 4-21: Photo: Steven Sloman. 4-24: Photo courtesy Metro Pictures, N.Y. 4-25: Jerry N. Uelsmann, 5701 S.W. 17th Drive, Gainesville, FL. 32608. 4-26: Culver Pictures, Inc. 4-27: Bettman Archives. 4-28: Photo courtesy of Panasonic Company. 4-30: Photo courtesy of the Video Data Bank, the School of the Art Institute of Chicago. 4-32: By Yoichiro Kawaguchi.

CHAPTER 5
Fig. 5-1, 5-3: Art Resource, N.Y. 5-5, 5-8: Copyright 1990 ARS N.Y./ADAGP. 5-4: Jim Strong. 5-9: © David Gahr 1961. 5-10: Scala/Art Resource, N.Y. 5-12: Photo courtesy

of artist. 5-13: Photo courtesy of author. 5-14: Photo ©1986 by: Douglas M. Parker, Los Angeles, CA., U.S.A. 5-15: Copyright 1990 ARS N.Y./ADAGP. 5-16: Fred W. McDarrah. 5-19, 5-20, 5-21, 5-22: Photo by Barbara Caldwell. 5-23: HBJ Collection. 5-24: Photograph courtesy of artist. 5-25: Photo: Thom Sempere. 5-26: Permission by Harvey K. Littleton. Photo by Brian Westveer. 5-27: Photo: Ken Kashian. 5-28: Photo: Kevin LaTona. 5-30: Courtesy of the artist. 5-31: Photo by David Caras.

CHAPTER 6
Fig. 6-2: Art Resource, N.Y. 6-3: Scala/Art Resource, N.Y. 6-5: From *An Album of Maya Architecture,* by Tatiana Proskouriakoff. New edition ©1963 by University of Oklahoma Press. 6-7: Trans World Airlines. 6-10: HBJ Collection. 6-13: Anderson/Art Resource, N.Y. 6-15: Scala/Art Resource, N.Y. 6-17: Photo Draeger, Paris. 6-18: D.P.I., Inc. 6-19: British Architectural Library, RIBA, London. 6-20: HBJ Collection. 6-21: Hedrich-Blessing. 6-23: Oscar Savio. 6-24: Copyright 1990 ARS N.Y./SPADEM. 6-25: Australian Information Service. 6-26: Canadian Consulate General, N.Y. 6-27: Scala/Art Resource, N.Y. 6-28: National Archives of Canada/Expo '67 2265-8. 6-29: ©Wendy V. Watriss/Woodfin Camp. 6-30: From "The Dogon People" by Fritz Morgenthaler, ©1969 Barrie and Jenkins, Ltd., London. Reprinted from *Meaning in Architecture,* Charles Jencks and George Baird, eds., George Braziller, Inc., N.Y., 1970. 6-31: From *Art Through the Ages,* 6th edition by Helen Gardner, ©1975 by Harcourt Brace Jovanovich, Inc. Reproduced by permission of the publisher. 6-32: The Art & Architecture Division of the New York Public Library, Astor, Lenox, and Tilden Foundations. 6-33: The Art & Architecture Division of the New York Public Library, Astor, Lenox, and Tilden Foundations. Copyright 1990 ARS N.Y./SPADEM. 6-34: Art Resource, N.Y. 6-35: Photography: Linda Bransom. 6-36: Doug Long, Photocraft. 6-37: From *The Japanese House,* by Heinrich Engel, Charles E. Tuttle Co., Inc., Tokyo, Japan. Reproduced with the permission of the publisher. 6-38: Shashinka Photo Library. 6-39: Chicago Architectural Photography, Chicago. 6-40: Hedrich-Blessing. 6-41: Susan Holtz. 6-42: Atelier 5, Bern, Switzerland.

CHAPTER 7
Fig. 7-1: Photo Hans Hinz-Allschwil-Basel. 7-2: Neg. #16222. Courtesy Department of Library Services Ameri-

Index

Italicized numbers represent the appearance of the illustration.

450

A B C D E F G H I J
0 1 2 3 4 5 6 7 8 9